AMBITIOUS FORM
GIAMBOLOGNA, AMMANATI, AND DANTI IN FLORENCE

AMBITIOUS FORM
GIAMBOLOGNA, AMMANATI, AND DANTI IN FLORENCE

Michael W. Cole

PRINCETON UNIVERSITY PRESS
PRINCETON AND OXFORD

Published by Princeton University Press,
41 William Street, Princeton, New Jersey 08540
In the United Kingdom: Princeton University Press,
6 Oxford Street, Woodstock, Oxfordshire OX20 1TW

Library of Congress Cataloging-in-Publication Data

Cole, Michael Wayne, 1969–
Ambitious form : Giambologna, Ammanati, and Danti in
Florence / Michael Cole.
p. cm.
Includes bibliographical references and index.
ISBN 978-0-691-14744-4 (hardcover : alk. paper) 1. Sculpture,
Italian—Italy—Florence—History—16th century. 2. Art and architecture—
Italy—Florence—History—16th century. 3. Art—Political aspects—Italy—
Florence—History—16th century. 4. Giambologna, 1529–1608—Criticism
and interpretation. 5. Ammanati, Bartolomeo, 1511–1592—Criticism and
interpretation. 6. Danti, Vincenzo, 1530–1576—Criticism and interpretation.
I. Title. II. Title: Giambologna, Ammanati, and Danti in Florence.
NB615.C65 2011
730.92′245—dc22
2010030255

British Library Cataloging-in-Publication Data is available
This book has been composed in Goudy Oldstyle
Printed on acid-free paper. ∞
press.princeton.edu
Printed in Canada
10 9 8 7 6 5 4 3 2 1

CONTENTS

AMBITIOUS FORM
GIAMBOLOGNA, AMMANATI, AND DANTI IN FLORENCE

INTRODUCTION

In October 1580, the Urbinate ambassador Simone Fortuna reported to his employer on a meeting he had had with Giambologna, the star artist of Grand Duke Francesco de' Medici's Florentine court. The Flemish sculptor, he wrote, was "the best person you could ever meet, not greedy in the least, as his absolute pennilessness shows. Everything he does is in the pursuit of glory, and he has ambition in the extreme to match Michelangelo. In the judgment of many, he has already done this, and they say that if he lives much longer he will overtake him. The Duke, too, is of this opinion."[1] From Fortuna's day to ours, no cliché would dominate accounts of Giambologna more tenaciously than this: that his art, like that of every other major late sixteenth-century sculptor, essentially amounted to the emulation of his great predecessor. As the letter demonstrates, the artist himself promoted this perception. Yet to take Michelangelo as a primary point of comparison is to miss everything distinctive about Giambologna's sculpture. Giambologna, by contrast to Michelangelo, had no background in painting. He rarely drew, and he seems to have set his hand to marble sculptures with some reluctance. He was, on the other hand, a skilled caster, producing as many works in metal as in stone. He eschewed the non-finito, favoring a refined polish. He contentedly turned out as many small figures as large ones, and he gained fame for his representation of the female form. He commanded a large studio, and he appears to have been sociable, collaborating frequently and extensively with others. If one were to look, in sum, for an early modern antithesis to everything Michelangelo represented, this would be it.

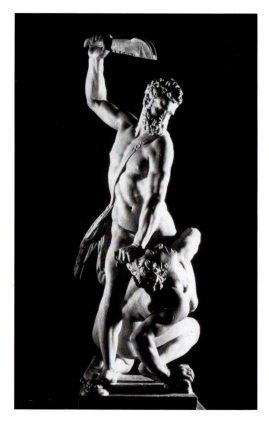

I.1. Giambologna, *Samson and a Philistine*. Marble. Victoria and Albert Museum, London.

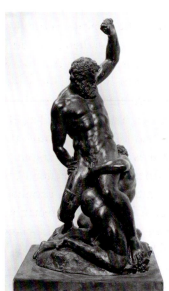

I.2. Anonymous artist, after lost Michelangelo model, *Samson Slaying Two Philistines*. Bronze. Museo Nazionale del Bargello, Florence.

In the later sixteenth and early seventeenth centuries, Michelangelo had acquired the status almost of an "ancient," and the study of his works formed part of the curriculum for anyone learning the trade. Still, for an artist like Giambologna to tell others that he wished to "equal" Michelangelo—long dead at the time the Fleming spoke with the ambassador—was to distract them from the contemporary scene the sculptor was in fact trying to negotiate. To illustrate his case, Giambologna might well have pointed to his marble *Samson and a Philistine* (fig. I.1), then on display in a Medici garden. Everyone in Florence would have identified that subject with a Michelangelo invention (fig. I.2), a copy of which Giambologna even holds in a contemporary portrait (see fig. 1.14). The *Samson*, though, was a work Michelangelo had never actually executed in a permanent material; in truth, there was no autograph Michelangelo *Samson* against which anyone could have measured Giambologna's marble.[2] What his viewers might immediately have compared with the sculpture were the two-figure marble groups that contemporaries like Vincenzo Danti were producing (fig. I.3), even as they whispered that Giambologna relied entirely on assistants to do his carving. Noticing where the *Samson* stood, they might have remembered that Giambologna had lost the competition to make the city's only public fountain—a massive installation with a colossal Neptune at its center—shortly before. And they might have remarked that Bartolomeo Ammanati, the winner of that commission, had anticipated Giambologna by two years in using a battle between nude men in a fountain context (fig. I.4). Comparing Giambologna to Michelangelo deracinated Giambologna and apotheosized him. It disguised the interests of the potentates who enabled him to work, the rivalries, serious or petty, in which he found himself, the "period eye" with which audiences measured his achievements.

Nor is this only true for Giambologna. In the early 1570s, Danti carved a portrait usually referred to with the title "Cosimo I as Augustus" for the "testata," or connecting wing, of the recently built Uffizi (fig. I.5). Pose aside, its closest models are two Michelangelo statues, the Medici *capitani* from the New Sacristy in San Lorenzo: the three portraits all sport leather breastplates and pteruges, as well as boots with a draping tongue at the shin; from the Lorenzo portrait Danti further took the squared neckline with its ornamental border and mask (fig. I.6), from the Giuliano a Leonine helmet (fig. I.7). The original positioning of Danti's figure between the recumbent marbles personifying Rigor and Equity (see fig. 5.4), imitations of Michelangelo's *Times of Day*, would have made the allusions all the more unmistakable. Yet if this is Danti's primary point of reference, his statue undoes Michelangelo's chapel as much as it repeats it. Michelangelo's sepulchral space expressed grief over the end of a Medici line, the end of a golden age.

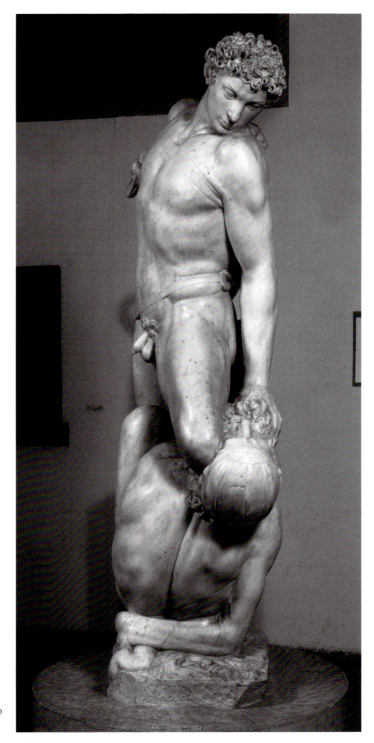

I.3. Danti, *Honor and Deceit*. Marble. Museo
Nazionale del Bargello, Florence.

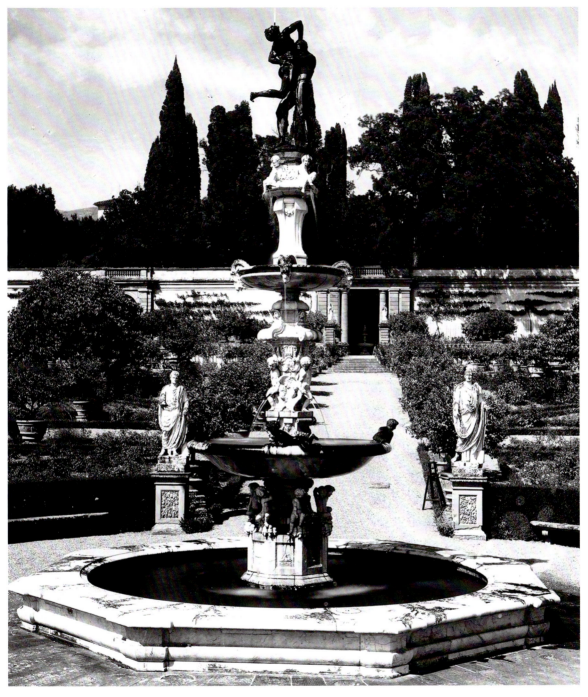

I.4. Ammanati, *Hercules and Antaeus* (in situ, atop the fountain designed by Niccolò Tribolo). Bronze. Villa Medici at Castello.

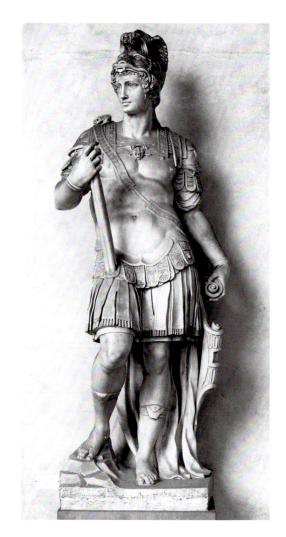

I.5. Danti, "Cosimo I as Augustus." Marble. Museo Nazionale del Bargello, Florence

Danti's triumphantly risen figure could only have come to occupy the place it does at the height of Medici power; it marks a return from the dead.

And once seen this way, the statue looks less like a variation on Michelangelo's original figures than on a relief (fig. I.8) that Giambologna had produced in the early 1560s, probably just after the death of Cosimo's sons Garzia and Giovanni in 1562.[3] The left-hand side of the sculpture is crowded with figures of demise: an old man tries to warm himself by a fire, a river god exhausts his waters, Saturn eats his children, the Parks weave the thread of fate. The primary narrative, however, is that of Mercury leading an armored figure away from this realm, out of a space of ruins and into a modern loggia. Most scholars have identified the figure as Cosimo's

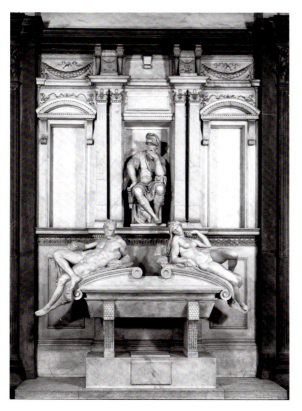

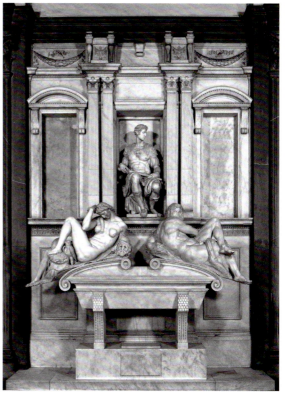

I.6. Michelangelo, Tomb of Lorenzo di Piero de' Medici, Duke of Urbino. Marble. New Sacristy, San Lorenzo, Florence.

I.7. Michelangelo, Giuliano di Lorenzo de' Medici, Duke of Nemours. Marble. New Sacristy, San Lorenzo, Florence.

surviving son Francesco, but the most certain thing we can say is that it is a Medici portrait: in hairstyle, physique, and costume, it resembles Michelangelo's Lorenzo and Giuliano (whom Michelangelo famously denied to be likenesses) more than any living person. The relief not only resurrects a Michelangleo character but also guides him to a new home, joining a recumbent nude who already replays the role that the *Times* did. Cupid, flying above, suggests that this is Venus, origin of the Augustan line to which the Medici compared themselves.[4] The container of fruit on which she leans, however, identifies her equally with springtime, and thus with a new cycle of family life.

Both Giambologna and Danti took up Michelangelo's principle of abstraction, a move that lends all four protagonists a certain interchangeability. The later portraits are not so much depictions of Francesco or Cosimo as they are embodiments

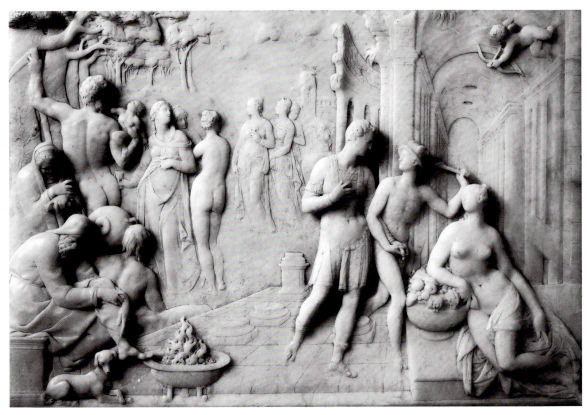

I.8. Giambologna, *Allegory*. Alabaster. Museo del Prado, Madrid.

of the Medici line in general. To be sure, Giambologna and Danti take up Michelangelo inventions; they do so, however, only to remove these from the narrative Michelangelo himself had created, writing new parts that were appropriate to the ducal regime. Regarding the late sixteenth-century sculptors as mere formalists, generating successive variations on Michelangelo's inventions, yields little; we understand Giambologna and Danti better, and we see the politics connecting both, when we place them in dialogue with one another—or when we use one to make sense of the other.

We need a more embedded history of sculpture in the period, all the more so since the standard comparative account of the period between Michelangelo and Bernini remains John Pope-Hennessy's *Italian High Renaissance and Baroque Sculpture*, first published almost half a century ago.[5] That book's very title should already have raised questions about the author's commitment to making sense

of a sculpture that did not support the label "Renaissance" or "Baroque," and indeed, Pope-Hennessy's distaste for what happened between roughly 1550 and 1620 surfaces on nearly every page that treats those years. Baccio Bandinelli, Pope-Hennessy writes, "was an artist from whose composition the element of craftsmanship had been left out."[6] Tribolo and Pierino da Vinci were "less aspiring sculptors whose minds operated on a smaller scale." Leone Leoni "was almost totally devoid of . . . disinterested artistic aspirations."[7] Vincenzo de' Rossi was "a coarse, ungainly sculptor," who "attempted vainly to reconcile a zest for violent action with a perverted brand of formal ingenuity."[8] The best thing a sculptor could achieve, to follow Pope-Hennessy's account, was admission to the "school of Michelangelo." Danti escapes disparagement only because he "applied himself to the problems of the statue with the same seriousness as Pierino, and from a standpoint that was not entirely dissimilar, since his main article of faith was belief in Michelangelo."[9] Giovanni Angelo Montorsoli gets sympathetic words because "he was influenced, to the depth of his creative being, by Michelangelo."[10]

At times, Pope-Hennessy seemed to value progressive thinking: he despairs, for example, of Florence's Accademia del Disegno, which he regarded as "a restrictive body" whose "unifying bond was a determination to evade the challenge of living art."[11] On the whole, though, he did not see the modern. How, the reader must ask, is one to appreciate the late Renaissance sculptor's engagement with "living art" when the text says of Ammanati only that "his taste and style were formed in Venice in the studio of Sansovino," that "the style of Vincenzo de' Rossi was a projection of Bandinelli's," or that Giovanni Caccini's reliefs depend "from the marble reliefs carved by Giovanni Bandini about 1575 for the Gaddi Chapel in Santa Maria Novella, and thus, at one remove, from [Bandini's teacher] Bandinelli"?[12] When the text goes on to attack what it calls the "journalistic tendency" in some sculpture, it implies that making something of-the-day meant making something that could never be classic.[13]

Giambologna was the single artist active in the decades after the death of Michelangelo for whom Pope-Hennessy expressed real admiration, but the notion that the Fleming worked as a giant among dwarves required a narrative according to which he, too, only looked backward: to the designs of Michelangelo, which Giambologna "first combined and then adapted"; to an earlier training in Flanders; and ultimately, to the same kind of Hellenistic sources that would later open the mind of the young Gianlorenzo Bernini.[14] Pope-Hennessy's best sculptors were those without a culture. And while subsequent scholarship has delivered a considerably clearer sense of the extent of the oeuvres of the artists he treated, and especially of the circumstances by which their works entered various collections, no

one has challenged this basic narrative or the intellectual and aesthetic premises that guided Pope-Hennessy's presentation of the period as a whole. Since it first appeared in 1963, *Italian High Renaissance and Baroque Sculpture* has gone through multiple editions, but few of the artists on whom Pope-Hennessy wrote have received sustained attention, and the books and exhibitions dedicated to Giambologna—an exception, now as then—have treated the artist largely in isolation. Even the most up-to-date scholarship repeats the mantra that the successors to Michelangelo pursued an "ideal," paying no attention to what was happening around them.

Ambition

Ammanati, Danti, and Giambologna all arrived in Florence toward the middle of the 1550s, and their convergence changed the aims of sculpture and the criteria by which it was judged, inaugurating a half century of sculptural production that counts among the most dynamic in the history of the West. Despite the energies that Florence's Museo Nazionale have committed to highlighting the achievements of all three, the work still remains poorly appreciated or understood outside of the city. In part, this is because art histories of the late sixteenth and early seventeenth centuries still center on Bologna and Rome, the places associated with painters like Caravaggio and the Carracci, giving little attention to the city that for a time held its own as the most important sculptural center on the continent. In part it is because the sculpture of the period falls outside the conventional chronological divisions that continue to structure teaching and writing on the broader field. Where this art enters the story, it is in accounts of Mannerism, which focus on style but on the whole do not ask why a sculptor might choose to make objects in one way rather than another; iconic monuments are reduced to exemplifying the "figura serpentinata," a phrase used once by a blind man from Milan who certainly knew almost nothing about what was happening to the south in his day.

This book attempts a more grounded evaluation, starting not with the question "was this sculpture better than that?" but "what were the rules of the game?" Answering that will require a closer look at the conflicts and, to use Pope-Hennessy's word, "aspirations" of a given moment. For this, it will be more helpful to regard the material at issue not as "academic" but as "courtly."[15] Fortuna's report on Giambologna's impoverishment, for example, probably requires qualification: even if the artist himself complained in these years about watching "servants and students" laughing as they left his shop to earn riches and honor using models he had invented, the sculptor was, by 1580, the premier Medici artist, and by the

middle of the following decade his savings permitted him to build an impressive burial chapel.[16] The lines quoted above in the letter record less a fact than an idea: that poverty signaled seriousness, that the sculptor put his art above a desire for money. As Giambologna himself reminded his employer: "I refused enormous offers both from the king of Spain and from the Emperor in Germany." One way of historicizing ambition—Fortuna's word—in this period is to look at the way art as such defined itself in opposition to other interests: wealth, propaganda, religion.

To maintain that the Florentine sculptor's ambition was a function of his status as a courtier invites a focus on the artist's patronage. Ammanati and Danti attempted to displace Bandinelli as the chief sculptors to Duke Cosimo I; Giambologna made nearly all of his surviving works while in the successive employ of Cosimo's two sons, Francesco (1541–1587), who became Grand Duke in 1574, and Francesco's younger brother, Ferdinando (1549–1609). All three artists, while working for the Medici dukes, enjoyed the steady income of a guaranteed state salary, for which they traded away their right to travel at will and to take commissions from whomever they pleased: on one occasion, the duke prohibited Giambologna from working for a Medici cousin, the Queen of France; on another, the sculptor offered to make works for a prospective foreign patron "in secret," so as to avoid having to seek an exceptional dispensation.[17] With their posts came the expectation that the artists would conceive and deliver works that would impress on viewers their employers' magnificence, dynastic prestige, and commitment to the often systematic beautification of the territories they oversaw. The early modern state put its artists on a large stage, spurring them to make sense of and keep pace with what other court artists were doing for their own sovereigns. It was in Ferdinando's own interests, as much as the artist's, that the duke could finally insist in 1604 that "Cavaliere Giovanni Bologna . . . is today the best sculptor in the world."[18]

The sculptors worked primarily for a single individual, but the things they made addressed a broader public. Over the course of their careers, they would build palaces and churches; reconfigure open, accessible spaces both in Florence and in its territories; and send more portable works to other courts across Europe. The indifference they could show to any kind of market must have seemed a liberation as much as a limitation. This is not to say, however, that the Medici dukes deserve the adulation some recent fans of their collections have offered them. These were men who crushed the residual early republics of Europe, who unhesitatingly jailed enemies or dispossessed them of home and property, and who invaded and colonized foreign territories, strategically using sculpture along the way. Exhibitions celebrating the dukes' "treasures" and their "magnificence" have sometimes helped to render invisible these rulers' brutality, and any study of patronage runs the risk of looking at a society only from top down, of adopting the voice of the

court panegyrist flattering a tyrant. This book will consequently attempt throughout to situate the objects it treats within rather than above political, religious, and even military conflicts; it will argue that we should try to look at such objects from the point of view not just of the people who commissioned or owned them but also of those whom the dukes worked against. That said, the book's primary goal is to move the study of sculpture away from source hunting and toward a more historicized art criticism; for this it will be necessary to consider carefully the kinds of patronage that made particular goals possible.

Competition

Baldinucci reports that when Ammanati returned to his native Florence in the mid-1550s, "he found fortune and a spacious field in which to demonstrate his virtues."[19] The language echoes that which Vasari used when reporting on how Giambologna, "a youth of pride and *virtù*," challenged Ammanati in the competition for the *Neptune* fountain: Giambologna "did not think he would get to make the marble giant," Vasari wrote, "but he wanted at least to demonstrate his *virtù* and make everyone appreciate who he was." The notion that sculpture demonstrated the artist's *virtù* runs through the biographical literature of the period, but just what did that virtue look like? Fortuna tells us of Giambologna's "ambition to rival Michelangelo (*d'arrivare Michelangelo*)," but he says little further about what such a matching might amount to. Eventually, ambition would become a defining condition of sculptural modernism, but few scholars have asked what artists in these years were really *after*.[20]

Attending carefully to the personal significance of subject matter, and not just to style, can help. In an infamous public letter that Ammanati wrote to his fellow academicians in 1582, he maintained: "we all know that most of the men who employ us do not give us any invention whatsoever, but leave everything to our judgment, saying 'here I would like a garden, here a fountain, here a pool, and so forth.'"[21] Evidence of various kinds suggests that Ammanati and his contemporaries did indeed have a lot of leeway in what they made—even in religious commissions—so long as they delivered pieces of the right size and material that fit the expected environment. This comes as something of a surprise, given that the period at issue is the one that historians of religion conventionally identify with the Counter-Reformation, when church authorities are supposed to have reined artists in, exercising a newly strict control over the things artists made. That Florence in particular maintained the importance it did reflects the protections that the dukes (mostly) afforded to those who worked for them.

Academic affiliations, too—*pace* Pope-Hennessy—may have helped define art in a way that encouraged sculptors to pursue their own purposes, allowing them to claim possession of the ideas that guided the pieces they made. The fundamental theoretical concept in central Italy after the founding of Florence's academy in 1563 was that of *disegno*, and though this is frequently treated in relation to drawing or design, two possible English translations of the word, it equally involved what in English would be called an artist's "designs," his purposes. This is the sense in which Giambologna used the word when he wrote to Grand Duchess Bianca Capello that he would like to see "every good design of hers and his rendered in color," or when Grand Duke Ferdinando wrote that he did not "want to impede [Pietro] Francavilla in his designs or his fortune."[22] We do not need to put too much weight on these turns of phrase to see how the metaphors let one kind of "design" shade into another, or to understand why one contemporary emblem of *disegno*, artistic and otherwise, was that of the archer trying to strike a target.[23] Fortuna, too, regarded ambition as something that directed the artist: it compelled Giambologna, literally, to "arrive" at a goal.

Sculptors formulated their aims through exchanges with one another, continually assessing what they were doing. Consider a remark by the forty-year-old Pietro Bernini, shortly after leaving Florence to work in Naples:

> You see in the variety of styles the valor of the artificers and the emulation and stimulus they will represent to whoever comes after them; it makes everyone desire to emerge victorious and to try to defeat others. Talking here with others about such things ignites my desire for this kind of undertaking, and I perceive the difficulty of attaining for myself that great fame which one must hope to achieve only by means of worthy works.[24]

Ambitious sculptors, the letter suggests, wanted much the same thing, and they regarded their relationship to their own field as an agonistic one. That Renaissance and Baroque artists frequently found themselves in dramatic competition, of course, is now a commonplace.[25] Still, most writing on the period tends to put the guiding lights above all that. The history of Renaissance art continues to follow the conventions of the monograph, starring heroic individuals whose best works defy comparison.

The documentary record alone should make us question this. Early writers make it clear that sculptors and their partisans mocked one another's shortcomings, publicly: Danti's early difficulties with large bronzes, Giambologna's with stone. No one was above politicking to his rival's disadvantage. In November 1577, for example, Giambologna's friend, Niccolò Gaddi, wrote to the Cavaliere Serguidi that the artist would be making more progress on the two figures he was

carving for the duke's garden at Pratolino if the men most able to assist him were not working instead with Danti.[26] At another point, Giambologna tried to persuade the duke to reduce Danti to a kind of assistant, overseeing the quarrying of marbles for Giambologna's own works so that the Fleming could stay in Florence and devote himself to bronzes.[27] Episodes like these reveal the inevitable frictions that resulted from the subordination of the Florentine art world to a hierarchical order with a single overlord. Collaborations could be forced, and the audacious artist, modeling himself on Raphael or Vasari, could try to turn the situation to his advantage, regarding the whole city as a potential workshop.[28] Other incidents, however, are considerably more mean-spirited. In July 1578, Ammanati wrote about some damage to the quarries at Severezza, reporting that he "had been told" Giambologna was among those responsible.[29] He recommended that the "delinquents" be identified and that an example be made of them. Ammanati's ostensibly self-flagellating 1582 letter to the Academy, lamenting the production of nude sculptures for public display, was delivered within days of Giambologna's completion of his monumental, lascivious *Sabine*. And most vicious of all was the sculptor Michelangelo Naccherino's denunciation of Giambologna, his former teacher, to the Inquisition in 1589, the year the older artist unveiled his most impressive piece of religious architecture. These are not the acts of people who focused uncompromisingly on the legacy of Michelangelo, but rather the gestures of envious strivers who did not want to stand in the shadows of contemporaries. We can only assume that artists so intent on undermining one another would also have paid close attention to the work their rivals produced. Where ambition translates into specific kinds of artistic decisions, we should expect those decisions to have been made in relation to what else was happening in the city.

Toward Architecture

This book aims to identify and characterize the primary issues that arose for sculptors between the final years of Michelangelo's activity and the advent of Bernini, pursuing this through a comparative account of the Florentine careers of Giambologna, Ammanati, and Danti. While touching on other important figures of the moment as well, it maintains that the work of these three in particular is best understood in dialogue. The three are distinguished not only by their status as the most technically gifted sculptors of their day, but also by their close association after 1560 with theory and criticism—even if, in all three cases, the surviving evidence of this association requires inference and interpretation. Danti published only the first book of what he had projected as a much lengthier treatise.

Ammanati worked on a treatise that never saw publication at all and that survives only in fragmentary form. Giambologna, an immigrant whose native language was not Italian, wrote little, though other commentators understood his works, too, to engage the literature of art.[30]

Not every aspect of the three artists' paths aligns in a way that allows equal treatment. Giambologna and Danti were near contemporaries, both born in the late 1520s; Ammanati, a generation older than both, had the initial support of Vasari, and on his arrival he immediately established himself as the dominant member of the triad. The sculptors' difference in age may be one reason why so few scholars have thought about the figures (and writings) of one in relation to the other two. Danti left Florence in 1573, and his importance for the other two immediately waned thereafter; Ammanati died in 1592, leaving Giambologna without real rivals for the last years of his life. Giambologna was also a more productive sculptor than either Danti or Ammanati, and his activities are rather better documented.

Nevertheless, the careers of the three sculptors followed paths that betrayed their shared concerns, with Danti and Giambologna frequently responding in almost serial fashion to Ammanati. The old Florentine sculptor Benvenuto Cellini, watching his young successors vie for positions, foreshadowed this when, in the 1560s, he wrote his short, polemic discourse "On Architecture." The essay begins with the assertion that architecture "is the second daughter of sculpture," constructing a genealogic relationship that made architecture sculpture's dependent. His implication, that sculptors should be especially capable of designing buildings, sounds self-congratulatory, but it is really more defensive than that. In composing the text, Cellini set out to show he knew something about a field in which, looking at Ammanati, he regretted having never really worked.

The sculptor's ability and especially his desire to become an architect, in fact, turns out to be the central topic of a parable Cellini goes on to recount about a semifictional artist from Ferrara. In the days of Duke Ercole d'Este, he writes, there lived a certain vassal who supported himself as a maker of "Moorish buttons." Feeling "called" by the art of architecture, the haberdasher persuaded the duke to let him test his abilities, renaming himself "Terzo," and presenting himself as the follower of Michelangelo and Antonio da Sangallo. The artist's nickname already hints at the trajectory of Cellini's story, the exposure of the button maker's vanity both for thinking that he could make a kind of work that was beyond him and for attributing to himself such an honorable place in the history of art. Cellini undermines Terzo's self-fashioning by rejecting the button maker's lineage. The first architect, he maintains, was "an excellent sculptor of ours" named Brunelleschi; Brunelleschi's second, lesser follower was the "woodworker" (*maestro di legname*)

Antonio da Sangallo, and the true "Terzo" (lit., "Third") was Michelangelo, who had undertaken architecture with nothing other than "the force of his marvelous sculpture." Being a sculptor prepared one for things that being a button maker did not.

Cellini's discourse concerns 1560s Florence, not an earlier Ferrara, or even the days of Michelangelo, identifying the most ennobled and debased forms of the contemporary sculptor's work. The former goldsmith chose his counterexample to the properly formed architect with care. It may be, as Cellini insists at the outset, that "architecture is an art of the greatest necessity to man, like his clothing and his armor, and by means of its beautiful ornaments it becomes a marvelous thing." Terzo was mistaken, though, if he thought that architecture was nothing more than a decorated outfit. Such ornamental labors, Cellini implies, are what those who would become architects had to define themselves *against*.

In the days of Brunelleschi and Ghiberti, the maker of churches and the maker of church doors might have considered themselves to belong to one and the same field, and throughout the Renaissance, some architects conceived structures in terms of bodies.[31] Against this equivalence, though, ran ideas like those in Alberti's *De re aedificatoria*, which treated sculpture simply as a form of figural ornament. This treatise had been published in the vernacular for the first time in Florence in 1550, and by the time Cellini was writing in the 1560s, the sculptor might well be concerned with priorities. Cellini's insistence that architecture is the child of sculpture, in other words, contested what was becoming a standard view, that the dependency was exactly the reverse. Reframing the question as one of professional formation, finally, Cellini tacitly acknowledged the new hierarchy in which sculptors in his day found themselves.

The apparently dependent nature of sculpture would have been reinforced when sculptors looked around at the other figurative arts. Whereas painters had been experimenting for nearly a century with the gallery picture, the print, and the drawing, all of which could be conceived with some autonomy, circulated as gifts or sold on the open market, sculpture, through the end of the sixteenth century, remained largely inextricable from its sites. There were, to be sure, statues like Donatello's *Judith* or Michelangelo's *David*, which those in power had decided to move from one place to another, but the vast majority of sculpture was intended for a specific room, wall, or square. Michelangelo's choice to work on the *Prisoners* even after he knew they were unlikely to go into the tomb for which they had originally been conceived, like Cellini's later carving of a *Narcissus* on the mere speculation that it might work well in a garden, departed radically from standard practice. One plot of this book is the path sculptors followed from the sited work to the liberated object and back. That story takes place, however, across the

increasingly common biographical narrative of the sculptor finding his way into architecture.

This could happen by different routes. The sculptor might, most simply, try to become an architect in the conventional sense. This is what Jacopo Sansovino had done when he moved to Venice after the Sack of Rome in 1527, serving as *proto* to the Procurators of S. Marco and supervising various building projects that the church took on.[32] Among these was the Marciana Library, across from the doge's palace, and among Sansovino's assistants on that project was Ammanati. Ammanati spent much of his own subsequent career traveling between centers, but it was the move to Florence in the late 1550s that let him eventually specialize in independent architectural commissions, including renovations of the Pitti Palace and of palaces belonging to the Grifoni, Giugni, and Ramirez di Montalvo families.[33] The opportunities that Florence offered him were the mirror image of those it presented to Vincenzo Danti, and when that sculptor left the city in 1572, it was to be chief architect of his native Perugia. According to one tradition, Giambologna worked under Ammanati on Palazzo Grifoni, designing consoles. This would be relevant background for the eventual competition between the artists, and for the Fleming's quite serious later architectural pursuits, though the earliest documentation of the collaboration is Giovanni Cinelli's 1677 reedition of a late Renaissance guidebook.[34] More likely is that Giambologna was responsible for the renovation of Bernardo Vecchietti's palace after 1578, the years in which he was working on the *Altar of Liberty* in Lucca. After 1580, his interests were primarily architectural, as he took on designs for at least three chapels, for the facade of Florence cathedral (1586–87), for the altar of the hospital of Santa Maria Nuova (signed and dated 1591, now in Santo Stefano), for the altar of Pisa cathedral, and for his own house (received as a gift from Duke Ferdinando in 1596).[35]

Sculpture might, as Cellini thought, prepare the way into architecture, but becoming an architect did not necessarily mean leaving sculpture behind, especially when architectural projects involved extensive ornament. The opportunities that opened to the likes of Ammanati and Danti, moreover, suggest how a sculptor could pursue architecture using his own traditional materials and techniques. The *Altar of Liberty* would seem to have played an analogous role for Giambologna as Ammanati's and Danti's tombs played for them; in 1579, the year of its completion, Duke Francesco referred to Giambologna as "my sculptor and architect."[36]

Cellini, finally, raises one last possibility as well: that sculptors might try to reduce their objects and the architect's to a single common denominator. If Sangallo the woodworker qualified for Cellini as Italy's second architect, this can only have been on account of the models he produced; further along in the text, the author suggests that Michelangelo was able to impose his vision at St. Peter's because

Sangallo had died before finishing the *modello* he was making. It was with models that architects proposed projects to patrons, and it is telling that Cellini himself used models so extensively, even producing one in wood—the material architects favored—for the base of his *Perseus*.[37] The model could serve as a manifestation of the sculptor's *disegno*, his role as the ideator of the artwork and the overseer of the shop that produced it. At the same time, the reliance on models to a certain extent differentiated the practice of sculptors from that of drawing-based fields—including Cellini's own, goldsmithery. Relative to painters, few sculptors drew extensively, and those who did used drawings primarily for study, seldom as part of the design process. Making models in wood or other materials transformed invention from the translation of an idea to a hands-on experimentation. It also construed architecture itself as an activity in which visualization in three dimensions was essential. Significantly, the earliest evidence of sculptors wanting to become architects coincides with the practice of using models; the sculptor's function as a modeler will be a central topic of this book.

Books about sculpture tend to draw overly restrictive boundaries around just what that medium included. Cellini, like all those who wrote versions of a *paragone* argument, implied that sculpture existed as a category apart; in many cases it is easier to talk about a sculptor than a sculpture, however. And to see the sculptors of the late Renaissance as aspiring architects is to give new shapes to their careers. In the case of Giambologna, it corrects against a peculiar aspect of the historiography, the fact that the majority of the literature on the artist takes the form of exhibition catalogs. Though often excellent, these have made minor works, including small bronzes produced by assistants for export, the subject of extensive analysis, while giving scant attention to the magnificent ensembles in the various Italian cities where he worked.[38] It is remarkable that there has to date been little published analytical literature on the Salviati Chapel in San Marco, one of the most beautiful spaces in Florence. There is even less on the artist's burial chapel in the Santissima Annunziata, a space so damaged by the flood of 1966 that it has remained difficult to assess. Catalogs give the impression that Giambologna was a fundamentally secular artist, and the first half of his career, when most of his secular compositions originate, has been much better studied than the second. The situation with Ammanati is comparable: a number of excellent essays treat individual monuments, but the only synthetic account of his sculpture covers the early career exclusively, and the best general monograph omits the sculpture entirely.[39]

Scholars have sometimes divided both Giambologna's and Ammanati's careers into an early, more worldly period and a later religious one.[40] This is not entirely without basis, and Ammanati's increasingly close ties to the Jesuits in his late years

had consequences for the whole Florentine scene. Such divisions, nevertheless, prove untidy at best. One of the last sculptures Ammanati ever made was his *Ops* (see fig. 2.12); the pose and the discrete drapery make the figure more modest than his own earlier *Ceres* (see fig. 3.10) but the subject is essentially the same. Crucifixes, conversely, count among the earliest portable objects Giambologna produced, and he made his *Christ at the Column* around the same time as his first small secular bronzes of the 1570s. No documented version of the *Hercules and Lichas* predates 1589, the year Giambologna unveiled his second chapel, and the project that most obsessed him in the 1590s was *Hercules and the Centaur*. Nor is there any way to argue that sculptures in different categories—sacred versus secular, early versus late—engaged independent sets of concerns. The dukes (and often their wives) encouraged the artists' activities in both realms, and they distributed both kinds of objects to other courts. When the Grimaldi commissioned their chapel in Genoa, they used a *Sabine* Giambologna had sent to Ottavio Farnese in Parma as a point of reference to explain the kind of beauty they were after.[41] The small objects that now make it repeatedly into exhibitions are inseparable from the larger ones. This, too, comes out in the Grimaldi contract, as it does in the frequency with which modestly scaled models served as prototypes for life-size or even colossal figures, which were subsequently re-reduced into bronze copies.[42] In the case of Ammanati, and increasingly of Giambologna as well, the idea of architecture subtends nearly everything the artist made, even those works for which the ultimate conditions of display were originally unknowable or indifferent to him.

The Abstract

In attempting to place the sculptors of late sixteenth-century Florence in their own time, one might hope to reconstruct a year-by-year history of their activities. The available written evidence, unfortunately, makes this impossible, though my account does hold to a rough chronology, with each chapter centering on an issue that best comes into focus at a particular moment around particular objects. Chapters 1 and 2 consider the reconception of the sculptural profession in Florence during the three artists' first decade or so there, as the production of models became a center of attention. Chapters 3 and 4 revisit the twin criteria that scholars have most often used to assess Renaissance statuary—its degree of "naturalism" and its success in depicting (or implying) action. These chapters point to the paradox inherent in applying either description to works that consisted largely of motionless representations of the human body, then attempt to resurrect both in slightly different form. The last chapters offer three different perspectives on

what it might mean for a sculptor to aspire to "architecture": making figures that are architectural in conception, using sculptures as the central elements in architectural compositions, and defining assignments in terms of site.

This way of proceeding allows the book to represent the diverse objects of late Renaissance sculpture while also bringing out their shared orientation. To push sculpture in the direction of architecture was to move it, like the figures that became columns in Vitruvius's antiquity, toward something that was barely still figural at all. Danti's treatise casts a particularly sharp light on this, though once we notice how architecture led Italian sculptors into something like abstraction, we will also recognize the degree to which such interests were already there from the beginning. Moderns scholars may write of the *olimpica astrazione* in a statue like Danti's own *Cosimo I as Augustus*, but Ammanati himself refers to the *Hercules* he made for Marco Mantova Benevides simply as "the colossus," to the *Neptune* as "the giant," and to the surrounding monsters as *ignudi*.[43] Giambologna similarly could designate works he sent to other places by names as vague as *la femina*, "the woman." To make models was often to move from a specific iconography to a more generic common denominator. To cast those models as statuettes was to create works that did not take their start from a larger program or place. The architecture of sculpture was not always a building.

1

MODELS

The Professional Modeler

What did the late Renaissance sculptor actually *do*? With drawings and paintings, it is customary to focus on the artist's hand, yet sculpture, much more than these media, was typically a corporate undertaking. Consider Cellini's *Perseus*. It would be difficult to think of a late sixteenth-century sculpture that foregrounded an individualized artist more insistently than this: Cellini not only signed the work—and signed it, following Michelangelo, with the verb *faciebat*, an imperfect tense that implied a duration for a single agent's "making"—he also wrote poems about it and placed the story of its creation at the center of an autobiography. Yet Cellini's account books reveal that while the *Perseus* was underway, the master employed three professional bronze casters to help pour the figures, nine goldsmiths to clean and chase them, four marble sculptors to execute the base, as well as three blacksmiths, two masons, four other stoneworkers, and a host of unnamed assistants whose activities are less easy to specify. This was hardly unusual. Wherever the documentary record thickens—around Sansovino in Venice, for example, where Ammanati learned his trade, or around Giambologna's Salviati Chapel—it shows similarly collaborative enterprises.[1]

This situation is well enough known to specialists, and they have reacted to it in two ways. Connoisseurs have devoted themselves to sorting out the different hands involved in the production even of figures and monuments where the

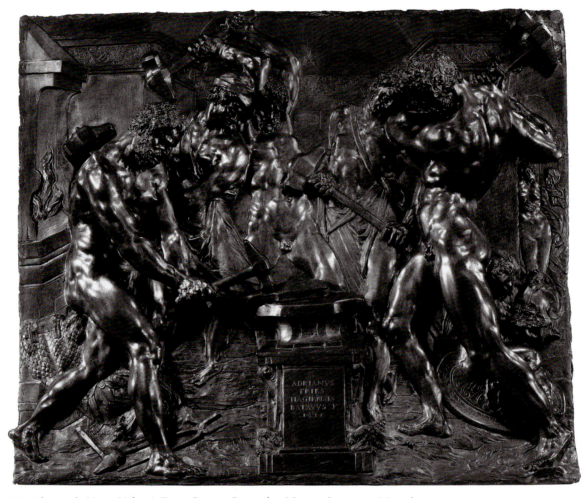

1.1. Adriaen de Vries, *Vulcan's Forge*. Bronze. Bayrisches Nationalmuseum, Munich.

principal attribution is secure.[2] This practice goes back at least as far as the seventeenth century, when Cinelli tried to determine just who carved the ornaments on Ammanati's palaces, and when Baldinucci credited Pietro Francavilla and Pietro Tacca with the execution of "Giambologna" compositions.[3] It continues today in most exhibition catalogs, as authors debate just who chased this or that small bronze. Those seeking to preserve the idea of a signature personality, meanwhile, have turned instead to the familiar late sixteenth-century principle that what the real artist contributed to any painting, sculpture, or architect was its design. Whoever was involved in the preparation or finishing of an individual figure, the

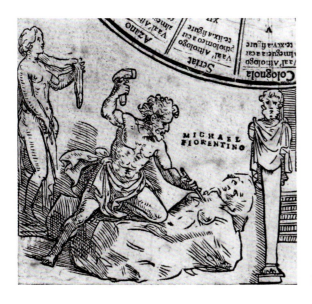

1.2. Michelangelo sculpting. Woodcut from Sigismondo Fanti, *Trionfo di Fortuna* (Venice, 1527).

implicit argument goes, the fact that heads of shops played a supervisory role in the projects they undertook continues to justify the monographic exhibition; with most sculptures, we will look for one artist who took responsibility for the work's conception, and assistants who were given the more menial tasks of carrying it out. The two approaches are complementary; together they sustain the idea of a singular artist's role in works acknowledged to be collaborative, organizing different kinds of labors according to a hierarchy.

What both of these approaches miss, however, is the way that artists invested in particular practices, rather than in an abstracted entrepreneurial position, as they cultivated public personas. Even in the age of the Academy, not all sculptors eagerly subordinated manual labor to design, associating themselves only with the concept or form behind a sculpture; many continued to embrace the most physical aspects of their crafts, to the point of exaggerating these for effect. When Adriaen de Vries, an artist who trained under Giambologna in Florence in the early 1580s, took up Vulcan as a subject (fig. 1.1), he may well have done so in the knowledge that Danti had written a poem presenting his own art on analogy with that of the mythical smith.[4] As an *image* of labor, moreover, the scene De Vries depicts has more to do with the idea of sculpture that Michelangelo had come to betoken (fig. 1.2) than it does with the cast (not hammered) objects that De Vries mostly made. To characterize De Vries as an artist in historical terms, it is sufficient neither to separate his own role in their production from that of his assistants—a task that,

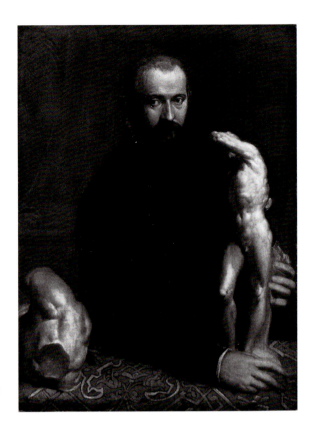

1.3. Paolo Veronese, *Alessandro Vittoria in His Studio*. Oil on canvas. Metropolitan Museum of Art, New York.

lacking documents, is in any case often impossible—nor to imagine him primarily as the chief of operations, a planner or engineer rather than a worker. The man who signed the anvil linked himself to a particular kind of artistic act, even if in doing so he offered a selective and even misrepresentative view on to what actually happened in his shop.[5]

Then there are practices that seem to undermine the whole distinction between the hand and the intellect. Drawing, for example, had as much to with the manipulation of materials as it did with ideation.[6] And in the last decades of the sixteenth century, the category of sculptural labor that emerged most prominently was that of modeling figures in wax and clay.[7] One image that signals this is a portrait Paolo Veronese painted around 1575, showing the sculptor Alessandro Vittoria (fig. 1.3). The design Vittoria holds had served him more than a decade earlier, when commissioned to produce a *St. Sebastian* for the church of San Francesco della Vigna in Venice. Shortly thereafter, he made a second, nearly identical figure in the form of a small bronze. Both statues were prominent and distinguished, yet Veronese

associated the artist not with the carving of stone or the casting of metal, but rather with the model he would have had to make for both. The painter and his subject probably decided that showing the model, rather than the finished work, would credit Vittoria as the thinker behind the statue. At the same time, Vittoria's pose in the painting strongly suggests that the wax (?) figure came from his own hand.

Nearly all Italian sculptors must have worked with materials of the sort shown in Veronese's portrait: Baldinucci tells us that in the course of competing for the *Neptune* commission—one year before Vittoria began his marble *Sebastian*—Ammanati executed a "small model in wax," a second in wood, and then, at the instruction of the duke, a third, full-scale model in stucco.[8] Other documents suggest that such a sequential procedure was not uncommon for sculptors in general. Still, no secure models by Ammanati or by many other sculptors from these years survive; we have dozens, by contrast, from Giambologna (fig. 1.4), and this requires explanation.[9] That so many of these works come down to us implies not only that Giambologna himself put a certain amount of stock in fragile, ephemeral objects, but also that both he and his contemporaries regarded them, as few people had previously, as things worth preserving. The inventory taken of his studio on his death indicates that he displayed his models on small *mensole* (consoles) that projected out from the walls—a configuration that evokes his favored mode of installing life-size works (see fig. 6.11).[10] In 1568, Cosimo Bartoli wrote to Vasari: "I had [Giambologna's] horse and another small work, and I had them cast for my pleasure," suggesting that models were also among the items *leaving* Giambologna's shop.[11] The description Raffaello Borghini gave in 1584 of the villa of Giambologna's first important patron, Bernardo Vecchietti, even announces that Giambologna's uncast models could hold their own against sculptures in other media: "The first room has its walls covered with models by Giambologna and statues by other masters, as well as with paintings and drawings."[12] Whatever consensus evolves about the nature and extent of the surviving physical evidence for Giambologna's work as a modeler—a newly lively debate—that body of work has to be understood in relation to who Giambologna wanted to be as an artist.

What to Do in Rome

Baldinucci tells us that Ammanati came from Settignano, a town just north of Florence famous for its stonecutters. He initially entered the shop of Baccio Bandinelli, but unhappy there, he moved to Venice to work with the Florentine expatriate Jacopo Sansovino. Returning in the mid-1530s, he devoted himself to studying Michelangelo's newly exhibited statues in the Medici Chapel, though

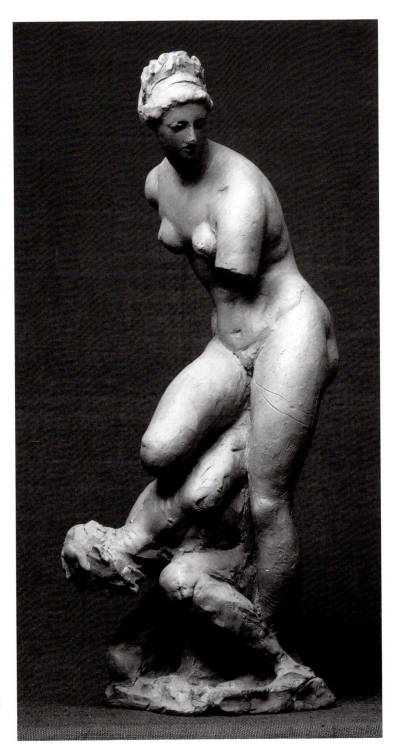

1.4. Giambologna, *Florence Triumphant over Pisa*. Terra-cotta. Victoria and Albert Museum, London.

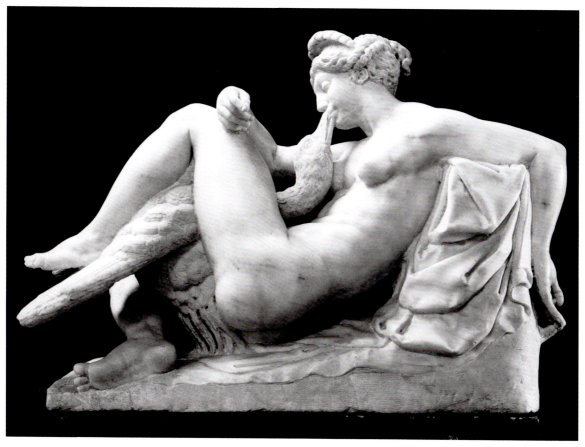

1.5. Ammanati, *Leda and the Swan*. Marble. Museo Nazionale del Bargello, Florence.

his developing architectural sensibility led him to think through the relationship between two- and three-dimensional designs as well.

His few surviving sculptures from the period include a marble *Leda* sent to the Duke of Urbino (fig. 1.5).[13] Essentially a study piece, the small-scale work translates a now lost Michelangelo drawing into three dimensions. It shows Ammanati attempting to master the kinds of figural inventions that defined Michelangelo's artistry, but the choice to carry out the composition in stone also reflects an awareness that the sculptor did not work in absolute liberty, that he always had to deal with the given block. If, as is likely, Ammanati translated the drawing into a wax or terra-cotta model before beginning to sculpt, he would have made that model, as Baldinucci says of the same artist's *Neptune* model, "according to what he believed he could extract from the marble."

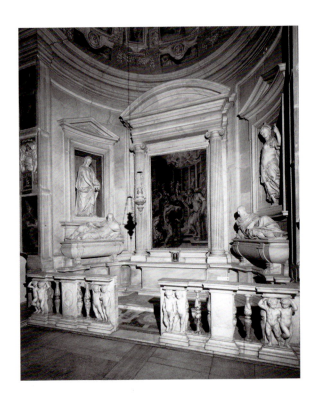

1.6. Ammanati, De Monte Chapel. San Pietro in Montorio, Rome.

After another period of travels—Urbino, Venice, Padua, Loreto (where he married the poet Laura Battiferri)—Ammanati landed in Rome, where, Baldinucci reports, "he set about making studies of ancient architecture."[14] Such an interest may have been sparked by the kinds of projects he used to support himself in these years: the paired De Monte tombs in San Pietro in Montorio, for example (fig. 1.6), required him to think not just about individual monuments but also about a coordinated figural space, as did the courtyard and grotto for the Villa Giulia. Perhaps Baldinucci saw the fruits of a Roman curriculum in Ammanati's later Florentine buildings, or perhaps he knew the manuscript of Ammanati's now fragmentary treatise, which comprised sample plans of all the kinds of buildings that a designer in a major urban center might be called upon to design. No surviving objects, in any case, contradict the impression Baldinucci leaves, that Ammanati's studies in the 1550s, done on paper, focused mostly on architecture.

Of Danti we get a somewhat vaguer picture. About two decades Ammanati's junior, Danti had trained with his father in Perugia, and this connection probably secured the boy a place in the shop of the Roman goldsmith Panfilio Marchesi.[15] When at liberty, Danti must have spent time with the city's monuments,

and recent scholars have suggested that he used the opportunity to look not only at Michelangelo but also at the work of painters and printmakers like Battista Franco, Perino del Vaga, and Francesco Salviati. Any such conclusion must remain speculative, nevertheless, for no documented works from this period survive, and none of Danti's early biographers associate any drawings or other studies with his time in the city.

Giambologna's activities in Rome, finally, look different still. While northern Italians had been coming to the city to study ancient buildings and sculptures for a century and a half, the Fleming's trip required more arduous travel. Quattrocento artists like Rogier van der Weyden, who had made a pilgrimage to Rome for the jubilee year of 1450, seem to have been rare. Only in the sixteenth century did Flemish artists begin to go south for the sake of art rather than religion. Jan Gossaert, in Rome in 1508, was a pioneer; by the later 1520s, though, influential teachers like Bernaert van Orley and Jan van Scorel were expecting such trips from ambitious students, and by the 1520s Rome was host to a proper (if still small) Flemish community, including Pieter Coecke van Aelst, Pedro de Campaña, Michiel Coxie, and Maerten van Heemskerck.[16] Giambologna's biographers make a point of specifying that he had worked with "Jacopo Beuch," by whom they presumably mean Jacques Dubroeucq; that they deemed this worthy of record hints that Giambologna was proud enough of the studio out of which he had come to tell Italians about it. Dubroeucq's own study trip to Italy would have provided an immediate example of what an artist who wished to work knowledgably for the cosmopolitan Northern courts had to do, and Baldinucci quite reasonably concluded that Giambologna came to Rome both on account of his own curiosity and because he had been "encouraged in this by his master."[17]

Commonly, visiting Flemings passed their time filling notebooks with drawings that would provided a cache of material for the works they expected to make once they returned back north. The sheets that survive suggest that Flemings went to Rome primarily to learn about antiquities. Young, lacking connections, and mostly unable to speak the language, these artists rarely got the kind of opportunity Ammanati and even the young Danti secured with relative ease.[18] If Flemings struggled to achieve the double life possible for the Italian artist in Rome, however—learning about the ancient world while also engaging with the current scene—they, too, seem gradually to have begun looking not just at ruins but also at what their contemporaries were doing. When Frans Floris was in Rome in 1542, making drawings after sarcophagi, the talk of the town would have been Michelangelo's *Last Judgment*, which had been unveiled the year before. Upon his return to Antwerp, Floris painted a series of works that show what an impression it had made. When Hieronymus Cock was in Rome between 1546 and 1548, he mostly

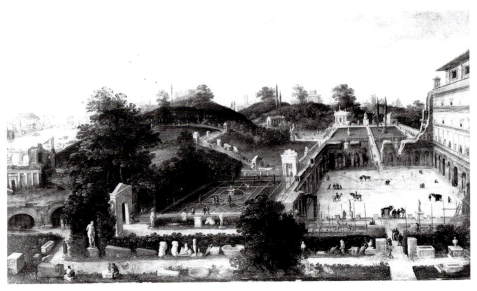

1.7. Hendrik III van Cleve, *Artists Drawing in the Cesi Garden*. Oil on canvas. Národní Galerie, Prague.

drew ruined buildings; yet when the reproductive engraver Cornelis Cort, sent by Cock, arrived in Italy a little over a decade later, the younger artist concerned himself especially with finding ways to translate into print the new effects of color that Titian and other Venetian painters had achieved, and when the writer Karel van Mander visited Florence and Rome beginning in 1574, he attempted above all to absorb the terms in which Giorgio Vasari and other critics were evaluating the best Italian painters and sculptors.[19] With this attention to modern and not just ancient Italian art came an awareness of local techniques. When Willem de Tetrode briefly joined workshops first in Florence and then in Rome around midcentury, he not only found a way to support his studies but also mastered the materials Italian patrons tended to have their sculptors employ, making himself a viable candidate for Italian commissions.

This background helps make sense of the scene Hendrik III van Cleve shows in a painting now in Prague (fig. 1.7). The setting is the palace of Cardinal Federico Cesi, whose garden held a significant collection of ancient sculptures, some of which had certainly been restored by expert marble craftsmen like Ammanati. These sculptures feature prominently in Cleve's image, and the company lining the path at the lower edge of the picture probably reflects the collection of drawings Cleve himself had made in Rome between 1551 and 1555.[20] Generically, the painting is unmistakably Flemish, with its bird's-eye view, its panoramic landscape,

1.8. Detail of Cleve, *Cesi Garden*.

and its scenes of promenade. The material, though, depends entirely on the practices that had grown up around the *Studienreise*.

Among the most remarkable features of the painting is the episode at the lower left, showing a man preparing a model after an ancient marble Hercules (fig. 1.8). A relatively early image of plein-air sketching, the motif may suggest Cleve's wish to remind viewers that he had been present at the site he depicts. That a Northern artist would have copied Cesi's sculpture was, by the early 1550s, banal— Heemskerck drawings of the collection survive, and Cleve's own teacher, Frans Floris, had probably made his own. What was not typical, though, was for artists to make their studies in the form of three-dimensional models rather than works on paper.

The artist in Cleve's painting seems to be working in wax or clay; he does not wield the kind of instruments necessary for cutting harder materials, and there

is no indication that a larger piece of wood or stone has been cut away. Yet wax and clay were not materials that Cleve would have learned to use back home. Antwerp, Cleve's base, had no real tradition of bronze casting—a technique that required preparatory models—and models were not considered necessary for sculpture in wood or even in the soft stones favored for Flemish sculpture.[21] If the artist in the picture is a Northerner, the painter shows him not only reproducing the forms of antiquities but also learning to make those forms using the methods of modern Italians.

The timing of Cleve's studies in the Cesi garden coincides almost exactly with the earliest documented objects of the kind Cleve describes. Borghini reports that after Giambologna arrived in Rome, he "stayed for a couple of years, totally engrossed in study, copying all the celebrated figures that there are there."[22] More surprising, were it not for Cleve's painting, might be Borghini's further specification that Giambologna's studies were in wax and clay, rather than on paper, a detail that Baldinucci found plausible, writing that Giambologna "went to Rome, where, in the two years he remained there, he *modeled* as beautifully as you have ever seen."[23] Making models after antiquities had an obvious analogy to drawing, and Cleve's modeler works in the company of a draftsman. But modeling, unlike drawing, is not something Giambologna would have learned from his earliest teachers. If anything, the employment of materials Italians had primarily used for preparatory purposes to record what the artist saw has more in common with other recent visitors from the north. A suggestive comparison here again is the Fleming Tetrode, who in 1559 moved from Rome to Pitigliano, where he made a series of bronze reductions of famous Roman antiquities for Count Nicolò Orsini. That he could do this implies that Tetrode had previously created a series of three-dimensional *ricordi*, precisely the kind of study pieces Giambologna's biographers ascribe to him, during the years he was in the Papal city. Frits Scholten, in the catalog of his important 2003 Tetrode exhibition at the Frick Collection, notes that, apart from the Pitigliano bronzes, no evidence connects any of Tetrode's small works in metal to Italy. In the case of nearly every small bronze, Scholten infers that Tetrode produced a model in Florence or Rome that served as the basis for a cast he carried out upon his return North one decade later.[24]

Ammanati, Danti, and Giambologna all left Rome with expanded professional sensibilities. Ammanati, from his contributions to the De Monte Chapel and the Villa Giulia, would arrive in Florence already thinking as much about buildings as figures. Danti, in the years between his return to Perugia and his own later move to Tuscany, would produce a massive bronze portrait of Julius III, an object that depended upon his now mature command of metals but that stood more in line with papal tombs than with anything likely to have come out of his father's shop

or indeed anything in Umbria. Giambologna, finally, had learned to think big by working small, reducing Rome's lessons into a series of three-dimensional forms he could transport to a different place and employ for works in various media.

The Cost of Modeling

If Giambologna's activities in Rome differed from those of Ammanati and Danti, the same is true of his initial purposes in Florence. The artist probably arrived there between 1556 and 1558, though none of his surviving sculptures has a strong claim to a date before 1559. When Raffaello Borghini reports that Bernardo Vecchietti persuaded the homeward-bound Giambologna to stop over so that he might "continue his studies," or when the publisher Sermartelli—who, like Borghini, knew the artist personally—remarks how "staying here, [Giambologna] could study and learn," they give the impression of an artist operating outside any professional network.[25] They imply that Giambologna essentially built a reputation without completing the kind of apprenticeship through which his Italian contemporaries passed, and the material and textual evidence alike raises questions about just what kinds of sculpture Giambologna would by this point have been capable of executing. Having not been trained as a goldsmith, Giambologna would not initially have been a very helpful assistant to a bronze caster. Though he took a very early interest in metal objects, possibly at Vecchietti's encouragement, there is no evidence that he produced any himself during his first years in the city.[26] At the same time, the sort of skills he could in theory have developed under Dubroeucq did not automatically qualify him to work in marble, the primary stone used for sculpture in Florence. Giambologna's earliest surviving work in any medium may well be the coat of arms that Baldinucci claims the sculptor made for the Palazzo di Parte Guelfa, a building completed by Vasari in 1559. That the sculptor chose to work in soft *pietra serena* reminds us that Dubroeucq himself had specialized in alabaster, a still more yielding material; Giambologna used this, too, in his first Florentine years, for the allegorical relief now in the Prado (see fig. I.8).[27]

When Ammanati came to Florence in 1555, he immediately went to work on a multifigure fountain, the major components of which were to be done in marble. Giambologna arrived shortly thereafter, and his early biographers suggest that contemporaries measured him against this standard. Borghini writes that after accepting Vecchietti's offer of free lodging,

> [Giambologna returned to] his studies with great zeal. After making much progress, he began to be recognized by other artists as a man of great prowess—though they said that he was only good at modeling in clay and wax. Thus,

Giambologna wanted to show that he was also able to prove his talent in marble and begged Vecchietti to let him have the marble to make something.

The result, Borghini continues, was a "beautiful Venus," though the identity of this work remains uncertain, and it may or may not survive.[28] Any evidence that once existed of Giambologna's early abilities in stone, in fact, has now vanished, and viewers in Borghini's own day do not seem have had much more before their eyes. The primary historical value of his story is that it records the belief, still circulating in 1584, that Giambologna had carved his first marble specifically to disprove local rumors that he could not handle the task.

Such rumors proved especially damaging when Giambologna entered the 1559 competition for the *Neptune* assignment. Borghini reports that each contestant "had to make a model, and the opportunity was to go to the one who did the best."[29] In the event, however, the quality of the models seems not to have been the determining factor in the outcome:

> Then it happened that, there having to be made a fountain in the Piazza, many artificers offered to make models, among them Bartolomeo Ammanati, Benvenuto Cellini, Vincenzo Danti and the young Giambologna, whose model was certainly judged the best, and to whom the work would have been assigned, had the grand duke not been afraid of putting at risk the outsized marble into which the figure of Neptune was to be carved, by entrusting it to the hands of a youth who, however valorous, was not accustomed, by long practice, to working [this material].[30]

Though Baldinucci penned these lines a century after the fact, they frame the relative strengths of top two finishers in absolutely plausible ways. The sculptor Leone Leoni, who witnessed the competition, wrote to Michelangelo that Giambologna had essentially been disqualified from the outset ("Il Fiamengho è condanato in le spese") even though his model was admirably "clean."[31]

The inscriptions on Giambologna's late sculptures suggest that he had, by the end of his career, found a different response to this kind of criticism, subordinating the actual execution of a marble sculpture to the preparation of its model. The inscription on his 1594 portrait of Grand Duke Ferdinando I in Arezzo is one we might sooner expect to find on a print than a sculpture: IOANNES BONONIA I / PETRUS FRANCAVILLA BELGIAE F. (Giovanni Bologna invented [this], Pietro Francavilla of Belgium made it.) The inscription on a nearly contemporary portrait of the duke sent to Pisa reads: "EX ARCHETYPO IOHAN. BONON. BELG. PETRUS A FRANCAVILLA CAMERACENSIS FECIT PISIS AD MDXCIIII." (Based on a model by Giovanni Bologna of Belgium, Pietro Francavilla of Cambray made this in Pisa in 1594.)[32] But the trade-off for this division

of credit was the constant suspicion that there was really *nothing* to be seen of Giambologna's hand.

As early as 1585, Accursio Baldi wondered about the significance of Giambologna's collaborations with Domenico Portigiano:

> Neither Donatello nor those Della Robbias, very famous sculptors that they were, were less distinguished for not knowing how to fire their works without the help of furnace-operators. Does it then detract from the praise due to Giambologna for his excellence, not to mention that due to others, that it is not he, but a monk from San Marco, who casts all of his figures and reliefs?[33]

Baldinucci extended the same assertion to cover the Fleming's works in stone, suggesting that Francavilla had carved not only the ones that bear his signature but most the others as well. For at least the last century, it has troubled art historians that "Giambologna" was in fact not an author in the way that, say, the writer of a Renaissance poem was. Werner Gramberg's classic 1936 monograph on the artist, most dramatically, started with radical premise that once Giambologna had a flock of students, his name became little more than a "collector's idea for the production of an entire workshop team." Wishing to concentrate on autograph works, and assuming that Giambologna at a certain point dissolved into a studio or school, Gramberg limited his book to an analysis of the Fleming's *Wanderjahre*.[34]

What Michelangelo Did

A well-known poem by Michelangelo, one on which the Florentine poet and philosopher Benedetto Varchi had published a commentary, proposed that the sculptor's task was to arrive at the "concetto" (concept/conceit) contained within the superfluities of a block of stone.[35] An object like Ammanati's *Leda*—or indeed the *Neptune* (fig. 1.9), Ammanati's design for which Michelangelo allegedly approved—suggest that this is just what the marble specialist took the study of his predecessor to involve. The binding motifs that Danti would employ both in his early *Honor and Deceit* and in the *Madonna and Child* he carved for the Florentine church of Santa Croce would go so far as to make this notion an element of subject matter.[36]

Changing perceptions of Michelangelo's art, however, also allowed an alternative, one centered on modeling. In what is perhaps the most famous passage in his *Life of Giambologna*, Baldinucci reported that in the Fleming's senescence,

> he used to recount to his friends how, having one day made a model of his own invention, which he had finished, as we commonly say, with his breath, he went to show it to the great Michelangelo. Michelangelo took the model in hand, and

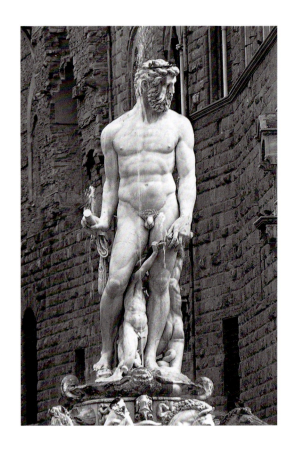

1.9. Ammamati, *Neptune Fountain* (detail). Marble. Piazza della Signoria, Florence.

immediately ruined it, but as seemed best to him, giving it a new attitude and resolving it, with marvelous bravura, into the total opposite of what the young man had made, saying, "Now, first go learn how to sketch [*bozzare*], and then how to finish."[37]

The passage sounds embroidered, even if Baldinucci composed his *Lives* by surveying the descendants of the artists about whom he wished to write. What does date to Giambologna's lifetime, though, is the image of Michelangelo's own inventive practices that forms the basis of the story. In the tomb that Florentines constructed for Michelangelo in the church of Santa Croce in Florence, the personification of Painting holds a model as its identifying attribute (fig. 1.10). Borghini reports that the designers originally intended this to be a figure of Sculpture, and that Battista Lorenzi changed the identification late in the project.[38] Even if that is the case, though, it is notable that Florentine academicians of the

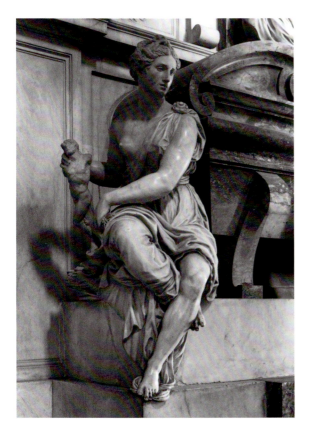

1.10. Battista Lorenzi, Allegory of Painting, from the Tomb of Michelangelo. Marble. Santa Croce, Florence.

1560s imagined Michelangelo's art of sculpture not as an art of chiseling but as one of making small three-dimensional figures.

Later sixteenth-century texts give the impression that it was perfectly appropriate to show Michelangelo with a model in hand. Armenini, for example, asked:

Who is there who does not yet recognize that, having before oneself a figure or two in full relief, one can, merely by turning them so that they face in different directions, draw from them many figures for one's painting, and all differing from one another? It is in this way that the *Judgment* of Michelangelo should be considered, its artist having used the means I am relating. Some, in fact, say that he made certain figures of wax with his own hand, and that he twisted their members as he wished, first softening their joints in warm water, so that, re-softened, they would come out well.[39]

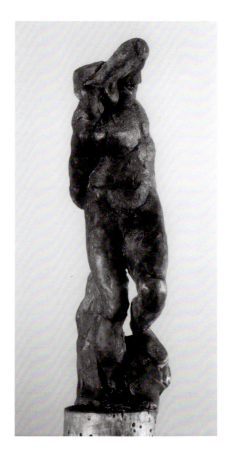

1.11. Late sixteenth-century Florence artist, after Michelangelo (?), *Slave*. Red Wax.

To follow Armenini's account, the *Last Judgment*, as a picture, hardly constituted a composition at all; it was simply a wall-sized demonstration of the different ways in which wax bodies could be turned.

Stories like this suggest that the artist who used models to study Michelangelo's sculptures might not only have recognized that those forms had to be recorded from multiple points of view but also have believed he was replicating the way that Michelangelo himself had worked. This perception has contributed to some of the thorniest connoisseurial questions. We know, for example, that Danti, among others, made models after Michelangelo's allegories in the Medici Chapel.[40] What, though, do we make of the red wax *Slave* (fig. 1.11) in the Victoria and Albert Museum? Early twentieth-century Michelangelo scholars considered this an autograph work, and sharp eyes from John Pope-Hennessy to Peta Motture have sustained these attributions, but other authorities have regarded it instead as

a copy.[41] If they are right, the model would have to be a Florentine study from the later sixteenth century, made by an artist who had access to the *Slave* before it was embedded in a wall in the 1590s. Friedrich Kriegbaum went so far as to attribute the figure to Giambologna, a doubtful proposal, though one that gives the object an entirely plausible function.[42]

The same problem, in turn, affects Giambologna's own models. The most recent debate about these has centered on whether those that survive, especially the wax studies of individual figures, are by the master himself or rather by a student or follower who copied his compositions. Scholars worry about the removal of major designs from Giambologna's oeuvre, but what the revisionist account in fact suggests is that Giambologna's students learned to make statues in his manner, following the same process by which he had attempted to imitate Michelangelo.[43] Federico Zuccaro's chalk portrait of the artist (fig. 1.12) underscores the point. The image implies that the model of Michelangelo's *Samson* that Giambologna holds is one the Fleming himself had made. But the choice of subjects is doubly significant. The *Samson* was already more strongly associated with modeling than any other Michelangelo sculpture, since the sculptor never completed the marble work and since the design could have been known to Giambologna only though bronze copies, that is, casts of models done after it. What Zuccaro was suggesting, in other words, was not merely that Giambologna's own art could be identified with modeling, but that it was precisely in this respect that Giambologna engaged the work of his great predecessor.

Giambologna's may never have fully redressed his youthful weaknesses: Borghini reports that even at the age of fifty, the sculptor continued to be dogged by the charge that he was unable to carve marble. The avenue that remained open was for him to play to his strengths. While Michelangelo had an almost idolatrous relationship to the marble block, Giambologna's models provided a way to avoid any such attachment, leaving the execution of stone works to assistants. The things Ammanati carved in the 1550s and early 1560s, touchstones for Danti's generation, make it impossible to look at Michelangelo without thinking about marble, whereas with Giambologna, one idea that emerges very early in his career is that the final object was of only secondary importance.

The issue here is not imitation per se, but rather the creation of a space that was at once inside and outside the tradition that went under the name "Michelangelo." Michelangelo was coming to stand as the exemplary universal artist, the artist who equally and uniquely commanded painting, sculpture, and architecture; Giambologna, Ammanati, and their contemporaries, however, were looking for ways to establish a narrower field on which claimants to his legacy could compete, reframing the competition in ways advantageous to them.

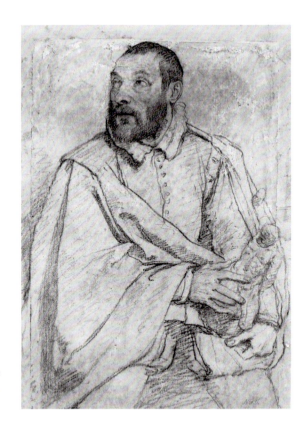

1.12. Federico Zuccaro, *Portrait of Giambologna*.
Chalk on paper. National Gallery of Scotland,
Edinburgh.

Remodeling

Samson also served as the subject for one of Giambologna's first works of marble
(see fig. I.1).[44] The statue must have been underway by early 1566, when Giam-
bologna departed for Bologna, for Duke Francesco wrote to him on April 18 of
that year, asking him to come back to Florence and complete it; the 1568 edition
of Vasari's *Lives* refers to it as being almost done. No documentation has yet come
to light regarding its initial display, though it seems to have been moved early on
from Francesco's "Casino" in the northern part of the city to the Giardino dei
Semplici, where it was used as fountain. It probably stood on the basin of *marmo
mistio* that Matteo Inghirami acquired in 1569; Baldinucci describes a basin sup-
ported by "monsters," and a drawing in the Uffizi, of uncertain authorship, shows
the *Samson* on a fountain with apes around the base.[45] The apes do not survive, but
they must have been bronze, such that the composition as a whole would include

the same combination of marble strongman and bronze border figures that Ammanati would eventually use in his Neptune fountain (fig. 1.13).[46]

Duke Ferdinando, who inherited the work, admired it immensely, so much so that when the Duke of Lerma requested a statue that resembled it, Ferdinando replied that he would never find one. He then summoned Giambologna, who "told us that he is ready to make another statue of the same size and beauty as that, and to do so inside of one year, but that he would like to change the invention so as not to seem to have imitated the earlier work."[47] The activities Giambologna's biographers attributed to him in his youth, like the Zuccaro drawing, suggest that models served at least in part as replicas of the masterworks he hoped to understand. This remark, however, with its implication that invention represented virtually the opposite of imitation, suggests another possibility for how a new work might relate to an existing masterpiece, as a variation more than a double. The possibility bears on the *Samson* itself no less than on its prospective 1604 sequel, since this, in its unmistakable reference to Michelangelo, rethinks the composition rather than repeating it.

Armenini's characterization of the invention behind the *Last Judgment* suggests that Michelangelo simply pulled new ideas from his head, or enacted them on the figure in hand, but in Florence models seem to have been put to more emulative ends. Documents indicate that Giambologna's conception for the *Samson* took shape in a wax or clay invention that eventually entered the possession of Giovanni Francesco Grazzini. This is now lost, but it seems safe to assume that the composition constituted a variation on the presumably earlier study model Giambologna had made after Michelangelo's *Samson*, the object he holds in Zuccaro's drawing. The sequence of figures that the invention of the *Samson* comprised—Michelangelo's model, Giambologna's copy after it, the Grazzini variation, the Casino statue, the proposed sequel—begins to look like a series of reenactments of the episode Baldinucci recounts, only with the roles reversed, and with Ammanati as much as Michelangelo in the artist's sights. Giambologna would reproduce Michelangelo's model, then successively and repeatedly resolve it into new attitudes. Baldinucci reminds us that such acts might look like the ruination of an older form no less than the creation of a new one, that modeling was a notional act of violence. The choice of *Samson*, who slays and subordinates his enemies by twisting them into the ground, may have appealed to Giambologna for this reason, too.

Giambologna's emulation of Ammanati in the *Samson*, happening as it did with reference to Michelangelo and at the level of the model, bears comparison with another work conceived in just the same years, the *Florence Triumphant over Pisa* (see fig. 1.4; fig. 1.14). After Michelangelo's death in 1564, the sculptor's nephew

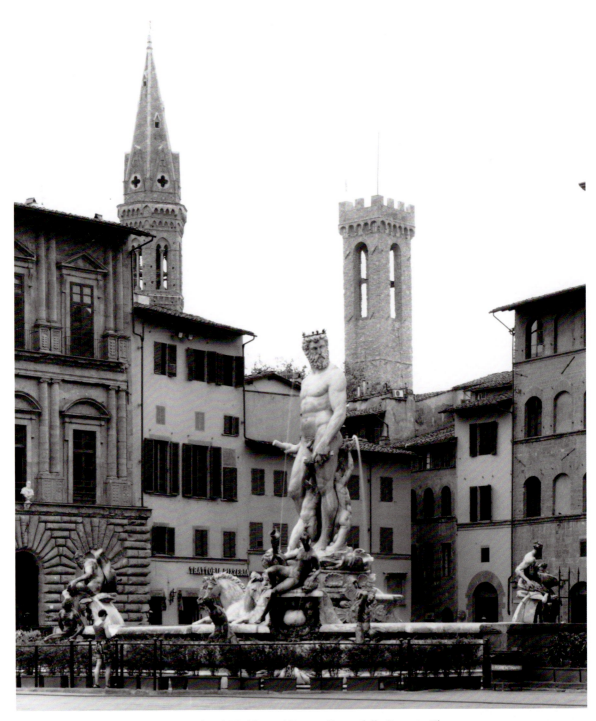

1.13. Ammanati, *Neptune Fountain*. Colored Marbles and Bronze. Piazza della Signoria, Florence.

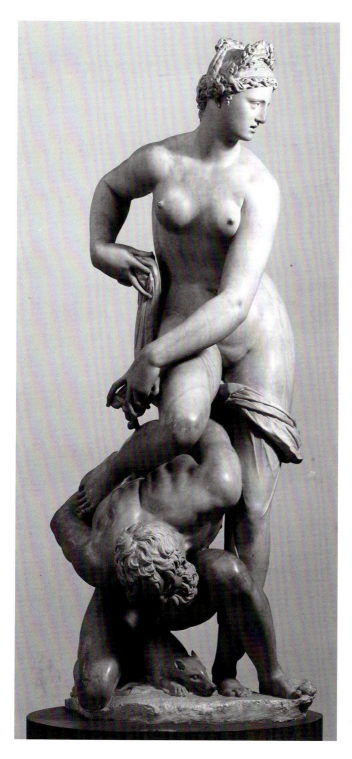

1.14. Giambologna, *Florence Triumphant over Pisa*. Marble. Museo Nazionale del Bargello, Florence.

Leonardo had given Duke Cosimo the *Victory* (fig. 1.15), a marble Michelangelo seems to have abandoned when he had departed Florence three decades earlier. In preparation for the wedding of Francesco I and Joanna of Austria, Cosimo had the Great Council Hall in the Palazzo Vecchio decorated with scenes relating to two Florentine military triumphs: the *Victory* would go against a wall showing the conquest of Siena, and a new statue by Giambologna the wall opposite, which Vasari's team was painting with scenes showing the city's triumph over Pisa. Shortly after Giambologna's return from Bologna, he delivered a whitewashed plaster model that could serve as a placeholder during the wedding festivities.[48] The sculptor replaced this provisional version (the one that ornaments the hall today) with a marble after finishing the *Samson*.[49]

These circumstances have led scholars to see Giambologna's statue almost exclusively in relation to the Michelangelo pair it faced, though the first change Giambologna introduced to the composition—showing a female rather than a male on top—likely came from a different place, namely, the centerpiece Ammanati had carved for his Mario Nari tomb nearly two decades earlier (fig. 1.16). The figures Ammanati had produced for this were never assembled as planned, but the main element, which Baldinucci referred to only as "la vittoria" ("Victory"), had ended up in the courtyard through which the members of the Accademia del Disegno entered their chapel in the church of the Santissima Annunziata.[50] Giambologna, that is, would not only have known the work, but would also have known it as an independent object, extracted from the context from which it had been made and standing against a wall at ground level.

Like the *Samson*, the triumph in *Florence and Pisa* takes the form of an antithesis, where the grace and effortlessness of a victor counterposes the pained contortion of a figure beneath.[51] The rhetoric is one of overpowerment, made plain at once through the muscularity of the hero and through the physical "forcelessness" of the victim. To the prince, no doubt, the work would have appealed in part for its cruel flattery, its visualization of the position he had assumed relative to his subject cities. For the artist, though, it would have allowed a different domain of fantasy. The Council Hall assignment allowed Giambologna to achieve a "victory" over Ammanati, rearranging the limbs of the marble across town, and presenting the result as an exclusive successor to Michelangelo's own invention.

Bent Bodies

Throughout Giambologna's early works, even those that do not specifically entail triumphal themes, his invention takes similar forms. The putti he made for

1.15. Michelangelo, *Victory*. Marble. Palazzo Vecchio, Florence.

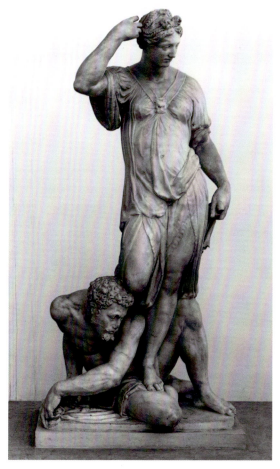

1.16. Ammanati, *Victory*. Marble. Museo Nazionale del Bargello, Florence.

another fountain, for example, do not, like Donatello's and Verrocchio's earlier sprites, primarily express playful joy, but rather struggle, trying to reel in fish. Contemporaries responded to this. When Heinrich Schickhardt, the court architect of the Duke of Würtemberg, saw the *Florence and Pisa* during a visit to Florence, he remarked that the work consisted of "a woman, much greater than life-size, upon a man who, marvelously bent together [*zusammengebogen*], kneels or stands, both figures naked, [and] made most artfully."[52] For Schickhardt, bending *was* the art.

The possibility that viewers could draw this kind of conclusion, even that the works invited it, does not bear only on works where one character's actions

upon another seem to justify its contorted pose, nor was it exclusive to Giam-
bologna. Consider, again, Ammanati's *Neptune* fountain. Malcolm Campbell
has proposed an elegant reading of the overall conceit, according to which the
basin itself (originally higher) would signify a tidal surge, "the fauns and satyrs
crouched below, not as much 'gracefully supporting' this stone wave as appearing
to splash in it while above them, grander in scale and eminently more reserved
in demeanor, the aquatic creatures casually rode the crest of the same wave."[53]
Yet these very adult nudes could not be more different from the putti that tra-
ditionally established a tone of playfulness on Florentine fountains, including
the one for which Ammanati had made his *Hercules*, and they adopt attitudes
(fig. 1.17) that would pain any living model. Like Giambologna's *Philistine*, they
announce their own forcelessness, offering a figural antithesis to the powerful,
self-contained *Neptune* who stands over them. At the same time, nothing here
evidently causes or motivates the figures' contortion; however well they might suit
the victory theme that ran through all the sculptures of the Piazza della Signoria,
they could just as well support an inference like Schickhardt's, that their primary
function was to prove their inventor's art.

The bronzes, moreover, which were completed only in the 1570s, replaced stucco
figures that had surrounded Ammanati's marble colossus at the time of Joanna of
Austria's 1565 ceremonial entry into the city.[54] This suggests a sequence of pro-
duction much like the one Baldinucci described for the marble itself, whereby the
large figures replicated inventions carried out on a much smaller scale. Within the
larger composition, the bronzes in particular reinforce the impression that certain
forms of modeling, embraced by competitive sculptors who took themselves to
be following Michelangelo's example, achieved their visual force through their
implications of violence and subjugation. Ammanati's, like others, involve an in-
directness: they hint that the prince would sooner overwhelm his subjects with
marvel and majesty—in this case the marvel of bringing water to a formerly dry
piazza—and they allow the artist to suggest that he had no interest in violence at
all, that he dwelt only on the beauty that his lovingly rendered creatures embod-
ied. Still, the aesthetic Ammanati and Giambologna pursued aligned the interests
of artist and patron.

The examples we have seen, finally, might seem to associate the "bent together"
figure especially with the modeling of secular sculptures, though, significantly, it
was a discourse on sacred painting that may have made artists and viewers most
aware of the authorial presence this kind of figure asserted. Borghini's *Riposo* gives
a measure of how the new pictorial decorum being enforced by the church en-
tered local conversations. In the course of discussing the artistic invention in the

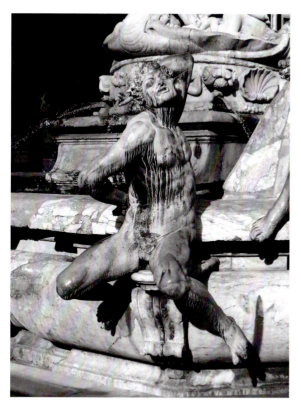

1.17. Ammanati, *Ignudo*, from the *Neptune Fountain*. Piazza della Signoria, Florence.

(subsequently destroyed) frescoes Pontormo painted in San Lorenzo, Borghini's character "Vecchietti"—Giambologna's great supporter—comments:

> But because Giovanandrea Gilio da Fabriano has written about this at length in that dialogue of his on the errors of painters—the one about Michelangelo's *Last Judgment*—suffice it to say this small bit to show how much Pontormo strayed from the truth. As you know, he made a great mountain of hideous bodies, a vulgar thing to see, in which some show themselves to be resuscitating, others already to be resuscitated, and others to be dead, and to lie in unseemly poses. And above this he made some giant putti with contorted gestures, who play trumpets, and I think he wanted these to be recognized as angels.[55]

Borghini takes a critical position developed by a cleric in response to Roman paintings and raises the question of how it might apply to recent Florentine works. Gilio, a Dominican priest who had dedicated his own treatise to Cardinal Alessandro Farnese, had taken Michelangelo to task particularly for the

artist's ubiquitous use of *sforzi* (forced poses), which he found to be at odds with the painter's primary duties. "Modern painters today," Gilio wrote in his 1564 dialogue "On the Errors of History Painters," "have as their first intent to twist [*torcere*] the head, the arms, or the legs of their figures. Thus one says that [their figures] are *sforzate*, and these *sforzi* are sometimes such that it would be better for them not to be there, for [the painters] think little about the subject of their story, if they consider it at all." When Borghini's Vecchietti attacks Pontormo's angels, he does so in part because he found their "gesti sforzati" indecent. He also asserts, however, that the artist, using these poses, has ignored subject matter for the sake of invention—to say "I think he wanted them to be known as angels" is of course to doubt that very thing.

The interest in angels is not accidental, for Gilio himself had singled out Michelangelo's angels as particularly objectionable features of the *Last Judgment*. More than this, though, Borghini's Vecchietti shares Gilio's broader distaste for figures composed to the wrong ends. With regard to the *Immaculate Conception* painted by Francesco Morandini ("Il Poppi"), a painter with whom Giambologna was collaborating at the very moment Borghini published his text, "Vecchietti" states:

> But when it is the case that one has to paint the *Immaculate Conception*, I believe it necessary to take into account many considerations that I do not see in this panel: and I don't know why Adam and Even have to be so contorted [*sforzate*] and have to have such indecent attitudes, rather than standing in a humble pose, either modestly demonstrating their hope of being liberated by means of the Conception from the chains of their sin, or offering thanks to the Virgin for their salvation.[56]

Here again the speakers voice concern that *sforzi* come at the expense of *honore*, as if the pose reduces the figure to nothing more than a nude body. In the speaker's eyes, the interest in such poses originated in considerations external to the picture's own narrative, theological, or devotional rationale.

In part, Borghini is advocating simply that *sforzi*, where present, reflect the nature of a depicted character rather than foregrounding the artifice of their maker. In a discussion that the margin of his book labels as one "on poses" (*sopra l'attitudini*), the most conservative character in the dialogue, Girolamo Michelozzo, comments:

> But passing on to the matter of poses, I say that these need to conform to the story and to the person that is represented. Thus, when painting sacred stories, it is necessary to make the poses of the Patriarchs, the Prophets, the Saints, the Martyrs, and of the Savior, of the Queen of Heaven, and of the Angels serious, modest, and devout, not fierce, and not *isforzate*. But it will be much more fitting

to make those of Tyrants and of their ministers fierce and cruel—but not inde-
cent and lascivious, so as not to decrease devotion, which must be focused on
the Saints that are there as well. When one has to paint wars and struggles, one
can play with poses that are contorted, vigorous, and terrible [*sforzate, gagliarde,
e terribili*], just as, in depicting amorous things, the job is to make the poses soft,
delicate and gracious.[57]

Here Michelozzo tries to rule out a reading of art in terms of what we could
today call indexicality. The artworks' signs, he maintains, must all have internal
explanations; it is not sufficient that a figure looks the way it does only so as to
make reference to the artist who painted it.

The dialogue form allows Borghini to make clear that the positions under dis-
cussion were matters for debate. The author demonstrates his awareness of Gilio's
views, but not being a cleric himself, and writing for a different locality, Borghini
also brackets the more extreme comments, casting doubt on whether he himself
really subscribed to them. When "Michelozzo" complains that the poses in Bronzi-
no's *Noli me tangere* lack devotion, he rebuts the admiration that the sculptor
Sirigatto had just expressed for the painting.[58] And before having "Michelozzo"
opine that the pose of Christ in Vasari's *Resurrection* appears to him to be "rather
too *sforzata*," Borghini has Sirigatto praise the work, among other things for its
skillful disposition of bodies.[59] This suggests that what counts as a *sforzo* might
itself be uncertain, but it also acknowledges that the interests of artists sometimes
differed from those of the church, and that the conclusions a reader drew might
imply a religious or ideological alignment.

When Vecchietti suggests that the participants in the discussion, having fin-
ished talking about Santa Maria Novella, turn their attention to Ogni Santi, Mi-
chelozzo objects. "I never go into that church," he replies,

> so as not to lose my taste for painting. There is a panel there by Carlo da Loro
> that can serve as an example of every kind of indecorousness that we have been
> talking about. For in addition to having badly disposed all of the figures, he
> put in the foreground a large nude woman who shows herself from behind and
> who occupies more than half the panel, and above her he placed the Madonna,
> who seems to stand on this woman's shoulders. And the other figures strike
> *sforzate* and unfitting poses, and they are badly composed and without any de-
> sign whatsoever.[60]

Notably, all the paintings Michelozzo condemns for their *sforzi* have religious
subjects, and all decorated sacred spaces. This allows, at least, that an artist work-
ing with secular themes, and for, say, a garden or palace interior, might invoke a

different kind of license. Gilio himself had sketched alternative rules for treating "poetic" material. It might even be the case that the vocal concerns about the place of *sforzi* in religious art, the all-but-official view of the church that such figures put the communicative function of pictures at risk, only made it more desirable to make such figures in the cordoned realms where this was possible. Commissions like Giambologna's *Florence and Pisa* or Ammanati's *Neptune* or Danti's *Honor and Deceit* appealed not only because their theme of victory lent itself particularly well to the display of artistic mastery, but also because the invention of "the poetic" as a category exempted them from the rules of the religious, letting sculptors push compositions to extremes.

2

PROFESSIONS

Engineering

The commission for the *Neptune* fountain put Ammanati, Danti, and Giambologna in direct competition, as Leone Leoni and other interested parties looked on. Almost as consequential for the history of Florentine sculpture in these years, however, was another series of events.

In the middle of 1558, Duke Cosimo had commissioned Danti to make a monumental bronze statue of *Hercules and Antaeus*. Cosimo must have known about the bronze *Julius III* that was Danti's early Perugian masterpiece, though the duke may also have entrusted the project to Danti because he had seen Cellini, another goldsmith, pull off a similarly large cast just a few years earlier. Whatever the case, Vasari reports that Danti "made a most beautiful wax model, over life size . . . but wanting to cast it in bronze, he could not make it come out, despite the fact that he tried two more times, whether from bad luck or because the metal burned or for another reason."[1] Cellini, no doubt happy to see that his *Perseus* momentarily had no rivals, mocked Danti's failure, comparing the artist to his subject, Hercules, who "lifted up Antaeus, then cast him away." The following year, Ammanati cast the largest bronze produced in Florence since Cellini's, the *Mars Gravidus*, now in the Uffizi (fig. 2.1). That success may have sufficed to persuade the duke that Ammanati could achieve what Danti could not. In late 1559,

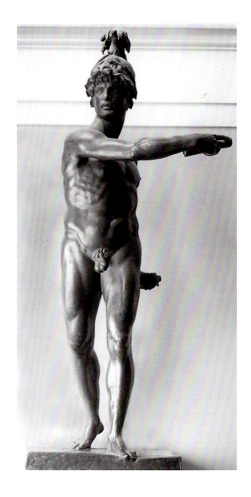

2.1. Ammanati, *Mars Gravidus*. Bronze. Uffizi, Florence.

fulfilling the commission that had stalled under Danti, Ammanati cast his own *Hercules and Antaeus* (see fig. I.4).

That Ammanati of all artists was able to pull this off comes as no surprise, for he consistently demonstrated not just a skill with the chisel and an eye for beauty but also a mechanical ingenuity that set him apart. Ammanati's papers in the Biblioteca Riccardiana show him drawing doorways, mantels, picture frames, tombs, and figures, but also more functional devices. One sketch (fig. 2.2), for example, proposes a design for an iron grate on rollers, intended to facilitate the transport of heavy objects. Ammanati seems to have been a collector and reader of the literature that focused on this kind of invention, including a fascinating unpublished codex now in the Uffizi, which shows page after page of ingenious machines.[2] When, in 1565, the Duke challenged Ammanati to raise the enormous

2.2. Ammanati, drawing of a grate. Chalk on paper.

2.3. Ammanati, sketches of fountains. Ink on paper.

column that had come to Florence from the Baths of Caracalla (see fig. 7.13), the illustrations in the Uffizi text could well have aided in his planning.[3]

As Mazzino Fossi first argued, Ammanati sought out manuscripts of this sort in part because he was attempting to write something similar himself; by 1559, he seems already to have drafted substantial parts of a book he hoped to publish on "The City."[4] The fragment of a draft that survives in the Biblioteca Riccardiana suggests that one section of the treatise would have dealt with artillery; it begins with a reflection on how best to direct cannons against the walls one wants to knock down before proceeding to the more properly architectural question of how to build walls such that guns could not destroy them.[5] The treatise would also have included sections on hydraulics, and it seems safe to conclude that when Ammanati sketched fountains (fig. 2.3), he was as interested in their orchestration of water as he was in their ornamentation.[6] The hollow bronze he took over from Danti allowed Ammanati to extend a conduit up through the elevated

2.4. Ammanati, Ponte Santa Trinita, Florence.

figure's torso; in its original configuration, Antaeus breathed forth a stream that shot nearly twelve meters into the air.[7] The commission for the *Neptune* fountain required the introduction of an aqueduct, and Ammanati's design for the figures incorporated a whole array of gravity-driven jets.[8]

Eventually Ammanati secured an official post as Ducal engineer, partially in recognition of the bridge he ran across the Arno just south of Santa Trinita (fig. 2.4). Like his earlier fountains, this required him to understand the control of water. Contemporaries were dazzled by the structure's lightness and by the way the wide openings allowed river traffic to pass without impediment, but the problem of using a building to straddle a current also occupied the architect in his drawings for the treatise, which included, for example, designs for a mill (fig. 2.5).[9] In other words, the technological interests that led to Ammanati's later title were already well in evidence by 1559, and the casting of bronze reflected these. No less than effective artillery, statues like the *Mars* and the *Hercules* required a mastery of pyrotechnics. And no less than the fountains Ammanati engineered, casting required its overseer to plan the conveyance of liquids.

Ammanati's success limited opportunities for others in Florence, but his example evidently made an impression. When Danti returned to Perugia in 1572, he seems to have been particularly intent to show his command of engineering.

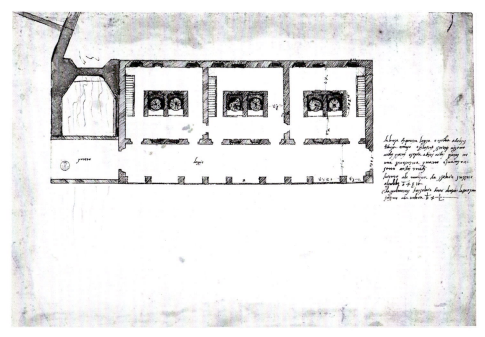

2.5. Ammanati, design for a mill. Ink on paper. Uffizi, Florence.

Borghini notes that in addition to planning fortifications, he "found a way to conduct water into that city without aqueducts, a thing of wonder."[10] There is no reason to think that these ambitions only developed late in life, though Danti's early reputation in Florence may initially have hindered him. Vasari suggests that Danti's misfortunes with the *Hercules and Antaeus* pushed the artist away from bronze and into marble sculpture, and Danti's chief occupations in the 1560s lends some credence to that (see fig. I.3). Though scholars assume that he cast the *Moses and the Brazen Serpent* (see fig. 2.10) relief himself, the professional founder Zanobi Lastricati was put in charge of the modestly sized *sportello* (see fig. 2.22). When, in the course of working on his large bronze figures for the Baptistery (see fig. 4.7), he sought permission to cast them at the monastery of Santa Maria degli Angeli; his patrons, the Calimala, refused, compelling Danti to work at the Sapienza instead. This was the foundry employed by both Ammanati and Giambologna, and Marco Campigli has plausibly suggested that the Calimala wished Danti to have access to experts capable of helping him.[11]

But how did Giambologna come to be able to offer this kind of aid to any-one? In the years that Danti was mastering marble, the Fleming seems to have

2.6. Giambologna, *Fishing Boy.* Bronze. Museo Nazionale del Bargello, Florence.

determined to go the opposite route. Shortly after losing the *Neptune* competition, he produced three bronze fishing boys (fig. 2.6) that would sit on the parapet of a fountain in the Medici garden near the church of San Marco. According to Borghini, he cast these himself. Wherever he developed the ability to do this, his success seems to have spurred Ammanati to convince his patron to expand the initial conception of the *Neptune* fountain so as to include the series of bronze creatures on the edge of the basin (see fig. 1.17). We have already seen that Giambologna, in turn, added bronze monsters to his *Samson* fountain; he initially had the same thought for his *Oceanus*, projecting *mostri* on a parapet that resembled Ammanati's (see fig. 5.16).[12]

In the early 1560s Giambologna also produced the first larger figure to rival Ammanati's, the bronze *Bacchus* he completed for Lattanzio Cortesi (fig. 2.7). The origins of the statue are thinly documented, and at least one recent scholar has questioned its date, though Herbert Keutner persuasively observed more than two decades ago that in going to work for Francesco de' Medici, Giambologna would

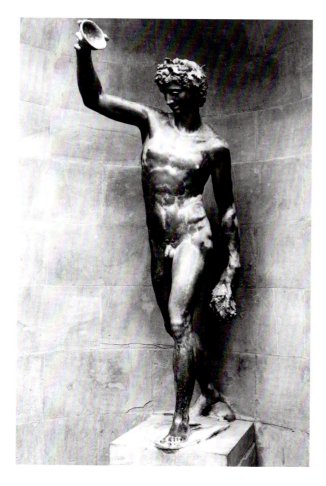

2.7. Giambologna, *Bacchus*. Bronze. Museo Nazionale del Bargello, Florence.

have had to abandon taking commissions from most private patrons.[13] On these grounds, as well as on the basis of Borghini's narrative, Keutner placed the *Bacchus* in the period 1559–61, contemporary with or even predating the sculptor's other early bronzes. The present installation of the *Bacchus* in the Bargello reinforces a traditional comparison to Michelangelo's sculpture showing the same subject, though Keutner's dating makes the energetic bronze look rather like an almost immediate response to Ammanati's *Mars*, the first independent, full-scale, free-standing figure since antiquity to be shown in a full unsupported stride. Keutner saw Giambologna bringing to the *Bacchus* an interest he had already developed in ponderation, equilibrium, and their relationship to motion; the *Mars* would have put these topics insistently before him.[14]

This helps explain why Giambologna also adopted for his god of wine a new physical type, older, more muscular and generally more heroic than the Bacchuses earlier Renaissance sculptors had produced. The Fleming must, moreover, have recognized that the pose Ammanati had given his *Mars* was medium-specific, an arrangement that would have been impossible in stone. To imitate it was to draw attention to Giambologna's own command of the material. Giambologna lent his *Bacchus* a striking purposefulness; the figure stares in the direction of the stream that notionally pours down from the tipped cup he holds above his head. It may not be a coincidence that the first Renaissance *Bacchus* made in bronze was also the first to be shown in the act of pouring liquids. Cellini, reflecting on his *Perseus* in poetry, had punned on the word *gettare*, to pour, referring at once to an image of spilling blood and to his act of casting bronze. The satires on Danti's failure to cast the *Hercules and Antaeus* in the years just before Giambologna undertook his own statue employed much the same pun, in this case comparing the Hercules who "casts" away his enemy to the sculptor who miscasts his metal. The most well known recent writings about the bronzes of Giambologna's chief rivals, in other words, included poems that drew attention to the act of pouring. Did Giambologna, seeking to establish his place among these artists, build a similar witticism into his own work?

The Role of the Caster

If Giambologna did make the *Bacchus* with Ammanati's own demonstrations in mind, and if Ammanati's example spurred sculptors toward engineering, it is easier to see why Giambologna adopted such an adversarial attitude in his first major collaboration. In 1563, probably just after the completion of the *Bacchus*, the sculptor left Florence in order to work on a fountain in Bologna. It was to center on the very subject, *Neptune*, associated with his defeat by Ammanati, and like its Florentine counterpart, the fountain was to ornament its city's most important square (fig. 2.8).[15] Bishop Pier Donato Cesi, the vice-legate representing Pope Pius IV in the city, had sponsored the work; the Pope himself, whose family name was Medici, could hardly have selected the subject he did, or invited a team of Florentine artists to help design and execute it, without intending to rival the Ammanati project then underway.

On August 2 of that year, the overseers had assigned the design of the fountain to Tommaso Laureti, described in the documents as a "painter and architect," but who was also acting as the project's engineer, realizing the water system that

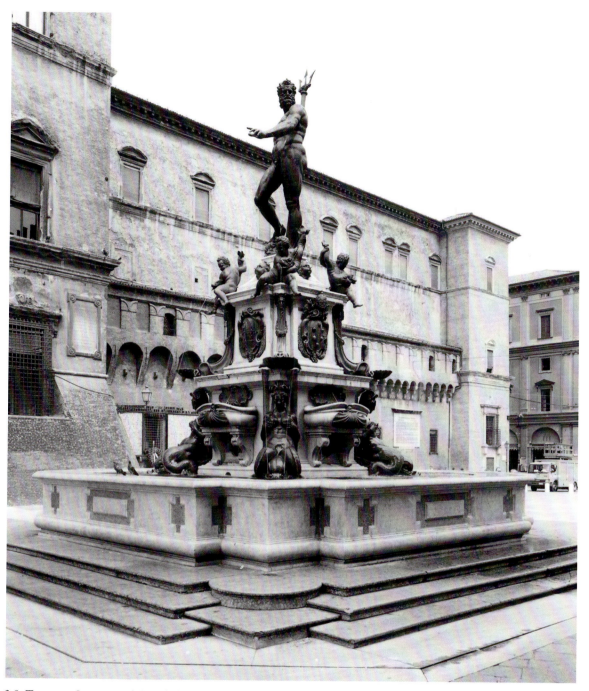

2.8. Tommaso Laureti and Giambologna, *Neptune Fountain*. Piazza Maggiore, Bologna.

would feed the fountain. Almost from the beginning, however, it became clear that casting metal was one thing Laureti was not equipped to do, for less than a week after signing the initial contract, he arranged for representatives "to go to Florence and bring back a master to pour the bronze work." The August 13 entry in the commune's account books indicates more specifically that Giambologna would be the one "to cast the metal work that will go on the fountain," though the reality was less settled, for when the Florentine delegation returned, Giambologna was accompanied by Zanobi Portigiani, and when, on August 20, the two craftsmen jointly signed their own contract, this left Giambologna's profession and anticipated role unspecified, describing Portigiani alone as "the Florentine Caster." One might expect, given Giambologna's already established reputation as a modeler, that he would have taken responsibility for preparing the three-dimensional designs in clay, and that Zanobi would have overseen the foundry, though the account book, at least, does not divide their roles so neatly; the entry for the day the two signed the contract designates the pair as "Zanobi and master Giambologna, masters in bronzework," and a note on August 28 describes both as "founders" (*fonditori*). Yet when it came to the preparation of models for specific figures, the job fell to Giambologna. It was he who, on October 29, received gesso "to make the molds for the harpies."[16] It appears to have been one of Giambologna's assistants who, on 20 May 1564, took a model to Rome to show the pope. And it was Giambologna who received payment on October 22 of the same year as the "sculptor of the bronze figures." Zanobi's role in the project is harder to follow on the basis of the written record, but he does seem to have dealt with the metal. He received wages on 23 January 1565 for "making" the bronze figures ("per fare le figure di bronzo"), and when, on January 23, work came to a halt, the scribe noted that 15,653 pounds of copper and 2,191 of tin remained "in the hands of master Zanobi."

It is also clear that Giambologna's partnership with Zanobi was not a happy one. In July of 1565 Zanobi reported to the Quaranta (Bologna's forty-member senate) that he had been called before the Magistrato degli Otto (the police magistracy),

> who asked me with whom I was having a dispute, and who was my enemy. I replied that I had no disputes and no enemies. They then asked me who my partner was, and when I replied that it was master Gianni the Fleming, they consequently ordered that he be sent for as well. When he appeared, he said that he had satisfactorily completed his part in a commission in which he had been my partner, and that I had wanted to detain him against the will of Prince [Francesco], which I showed not to be true. I also showed the Magistracy the

agreement that had been drawn up between the Narni and us, which your Lord-
ships had me copy. And once they had seen this, the magistrates dismissed me.
As for [Giambologna], I do not understand what he wanted, because he wanted
something that was not reasonable, and here one does justice that is reasonable
to all the magistrates, following the will of His Majesty the Duke and his Majesty
the Prince, God save and maintain them.[17]

In his reported testimony, which put his partnership with Zanobi in the past
tense, Giambologna asserted that he had fulfilled his part of the assignment, im-
plying that he was just there to prepare the models, not supervise the cast.[18]

When the two artists returned to Florence in January 1565, both went to work
on decorations for the wedding of Francesco de' Medici and Joanna of Austria,
though further documents suggest that Giambologna, at least, had made the move
on his own volition, not because he had been summoned.[19] When the duke did
intervene, it was to return the sculptor to Bologna; in the interim, Giambologna
had managed to redefine his role. Cesi's March 1566 letter to Duke Francesco had
referred to the Fleming only as a "scultore," indicating that he was working on the
Neptune "together with master Zanobi, the caster." When Giambologna signed
a second contract two months later, however, he did so "on the condition that
master Zanobi be absolved of his obligation" ("con condizione che sia disobligato
maestro Zanobbio"), and he himself wrote in a letter that he was now going to do
both "his part" and "that of Zanobi."[20]

Considered purely from the perspective of the history of bronze casting, this
turn of events is remarkable. Portigiani, a professional bell maker, may have been
the most experienced living foundry master in Florence—no less an expert than
Cellini had once turned to him for help.[21] In July 1565, however, Portigiani con-
fessed with reference to the *Neptune* that "he was not a man who knew how to
carry out a work such as this by himself."[22] That Giambologna felt more confi-
dence than Zanobi and that his patrons apparently shared this suggests that he
had reason to be sure of himself; here again, the *Bacchus* comes into the picture.[23]
Certainly the duke encouraged Giambologna to return to the project, but the
move also suggests that, sizing up the scene, Giambologna determined that there
was, for the moment, as much honor to be gained from the casting as from the
design of a large public work in bronze, provided the credit would come to him
alone. The gambit worked: in the very days Giambologna was completing his
final tasks in Bologna, Catherine de' Medici began lobbying Prince Francesco to
send Giambologna to Rome, where she hoped (vainly, as it turned out) he would
complete an equestrian monument that Daniele da Volterra's assistants found
themselves unable to cast.[24] In taking charge of the bronze, Giambologna had

begun performing not just for a Bolognese but also for a wider Italian and even Continental audience.

Scaling Down

Giambologna probably cast nothing else on the scale of the *Neptune* for years afterward. By the 1580s, in fact, when Giambologna was designing bronzes for the Salviati Chapel, he was even content to return to a partnership with the Portigiani family; Zanobi's son Domenico, who carried out nearly all the metal works that the Fleming designed for the space.[25] What he did begin producing with unflagging energy, on the other hand, were small bronzes.

Virtually every significant collection of Western sculpture has one or more small bronze figures "by," "from the circle of," or "after" Giambologna. As the labels identifying these figures imply, the pieces typically involve more hands than just the master's, and the literature, consequently, has tended to focus directly or indirectly on quality, sorting out "autograph" works from those by associates or lesser copyists. What is truly remarkable about the group as a whole, though, is not just the quality but also the quantity, the very ubiquity of "Giambologna" bronzes. To give some measure: the great 1978 Giambologna exhibitions in Vienna and London each brought together well over one hundred of these.

The Fleming's importance for the history of the small bronze sets him apart from his contemporaries and predecessors alike. While Ammanati, Francavilla, Pietro Bernini, Vincenzo de' Rossi, and others all left a body of monumental works in Michelangelo's primary medium, marble, Giambologna seems to have carried out very few comparable works in his own hand. No contemporary, by contrast, left anything like Giambologna's bronzes, and there is no real precedent for it in the Florentine tradition.

In what remains the standard study of the small bronze in early modern Italy, Hans Weihrauch remarked that "the considerable number of bronze reductions after the antique and after Michelangelo's main works somewhat disguise the fact that the bronze statuette as an independent artwork, one that indeed originated in Florence, disappears for nearly a half century from the sculptor's program in this same city."[26] Weihrauch went on to look for the exceptions to this observation, making some questionable attributions in the process. Yet if the captions in his book were corrected to reflect current consensus, his point would only be more forceful.

To an extent, the phenomenon represents the least surprising imaginable path for a sculptor who had developed Giambologna's particular specializations. The

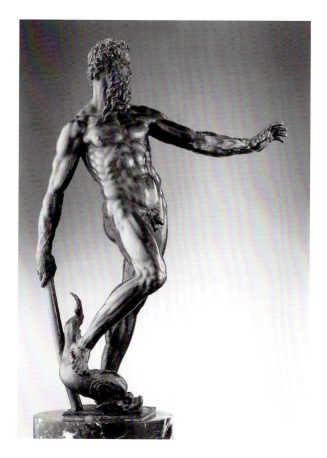

2.9. Giambologna, *Neptune*. Bronze. Museo Civico, Bologna.

small bronze is, in an obvious way, an extension of the model, as the *Neptune* (fig. 2.9), now in Bologna's Museo Civico, illustrates. Scholars have tended to treat this as a model, or at best as a record of one, connecting it to the proposal Giambologna sent to Rome so as to show his patron how the full-scale statue would look. But the small work also had a life of its own, serving as a basis for the replicas now in the Museo de Arte de Ponce in Puerto Rico and in the collection of Sir William Pennington-Ramsden in England.

Every cast work both needed and recorded an original wax or clay form, but Giambologna contributed substantially to a transformation in the status of the model, treating it as an end in itself. Earlier sculptors seem primarily to have approached the model as a form of *disegno*, analogous to a drawing, regarding it as preliminary to something else, as a design *for* something. Small bronzes, however, allowed the reverse conclusion, that models themselves might have exhibition

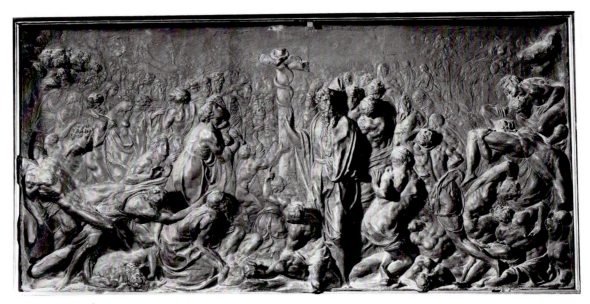

2.10. Danti, *Moses and the Brazen Serpent*. Bronze. Museo Nazionale del Bargello, Florence.

value, and might deserve preservation in a permanent material.[27] By the 1560s, Giambologna had arrived at a sense that the small bronze could ennoble the model by replicating it, and at least initially, he seems to have been all but alone in this. Ammanati, while making numerous figures at life size or larger, did nothing comparable during the first fifteen years he was in Florence. Benvenuto Cellini, who produced four programmatically conceived small bronze figures as part of the base of the *Perseus* (see fig. 3.17), spent the late 1560s working with goldsmiths, and he claims to have restored some ancient bronzes as well, but his desire to be perceived as a maker of monumental works militated again any serious involvement in the production of small independent figures.[28] Danti, for his part, remained active for over two decades after his work on the *Hercules*, designing many figures and even apparently casting at least one relief sculpture—*Moses and the Brazen Serpent* (fig. 2.10)—himself. The only statuette with a real claim on his name, though, is the *Venus Anadyomene* (fig. 2.11) from Francesco I's *studiolo*, a production that followed on the heels of Danti's successful completion of the monumental *Beheading* group on the Florence Baptistry (see fig. 4.7).

The anomaly of the *Venus*, moreover, actually typifies the studiolo as a whole. Domenico Poggini's *Pluto*, Stoldo Lorenzi's *Galatea*, Elia Candid's *Aeolus*, and Ammanati's *Ops* (fig. 2.12) all represent the only securely attributed works in that

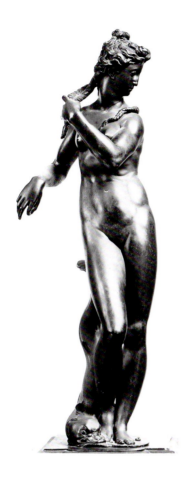

2.11. Danti, *Venus Anadyomene*. Palazzo Vecchio, Florence.

format their makers ever produced. The singularity of the objects is all the more surprising inasmuch as Danti, Poggini, and perhaps Candido were trained as goldsmiths, and were thus more than equipped to carry out works of this sort. The studiolo bronzes are such masterpieces that it is easy to overlook how uncharacteristic they are—and not just in Florence, but in the whole region as well. Leone Leoni, who worked in Milan but with an eye to what was happening in Tuscany, had established himself as a specialist in coins and medals before beginning, in middle age, to produce life-size and over-life-size bronze figures. Having made numerous works for export to Spain, Leoni had no doubt given a good deal of thought to just what could be transported over long distances; nevertheless, his produced no known statuettes. In Rome, as Weihrauch observed, there was a demand for small

2.12. Ammanati, *Ops*. Bronze. Palazzo Vecchio, Florence.

copies after antiquities—essentially bronze reproductions of the kinds of models that Giambologna and Tetrode made while studying in the city. A boom in the production of works of this sort seems to have coincided with Giambologna's earliest small bronze experiments, and a number of the small bronzes that currently surround Giambologna's own on the top floor of the Bargello came from Rome with Ferdinando de' Medici in the late 1580s. Perhaps the only Roman artist of the period to consider bronze a medium for original composition, however, was Gugielmo della Porta, who concentrated on plaquettes, turning out scores of these both on sacred and secular themes. Apart from reliefs, Della Porta's only bronzes of less-than-colossal size were crucifixes.

The artist whose path most closely followed Giambologna's, tellingly, was the marble carver Giovanni Bandini. He produced a *Juno* for Francesco's studiolo, and

a letter from Simone Fortuna remarked on just how unusual this was for him: "he does not have much experience in casting," the ambassador wrote; "nevertheless, he showed me a bronze statuette that he made in competition with many others in the studiolo of the Grand Duke, which is held to be very beautiful."[29] Fortuna eventually helped secure Bandini a post as court sculptor in Urbino, where he immediately began producing small bronzes in quantity, beginning with the *Meleager* now in the Prado.[30] That he determined to cultivate this specialization only in his forties shows that he saw the same opportunity Giambologna did, or more likely, that he profited from the demand Giambologna was newly helping to generate. At the same time, the fact that he could only do this in Urbino draws attention to the exclusive control Giambologna had acquired over Florentine production.

How do we account for this? Certainly material itself must have been a factor. Bronze was rare, and thus precious, far more precious than the high-prestige marble that came from Carrara and Seravezza. Still, it seems to have been possible for individuals outside the court to acquire metals sufficient for experimentation, and when private patrons wanted material to make small replicas of antiquities, they found it. In principle, moreover, the knowledge that bronze was hard to get might even have encouraged a small bronze tradition, since the metal required for a single large bronze could have been used to generate many more small ones. Did the limited opportunities not encourage artists to go after those that arose? When Borghini remarked, in relation to a desk commissioned by Francesco in 1567, that "several gold terms [were] made competitively by Benvenuto Cellini, Bartolommeo Ammanati, Giambologna, Vincenzo Danti, Lorenzo della Nera, and Vincenzo de' Rossi," he essentially implied that the four artists who had submitted designs for the monumental *Neptune* fountain had returned to the ring to confront one another again less than a decade later, this time with metal rather than clay in hand.[31] His roster comprised much the same group of artists who would eventually make statues for the studiolo, and Bandini, at least, seems to have understood his *Juno* as a work "made in competition with" the other statuettes for the room.

Perhaps Bandini's departure from Florence effectively designated Giambologna as the "winner" of the competition that the studiolo represented. Or perhaps the conception of the studiolo itself, with its team of craftsmen and its encyclopedic theme, required a moment of competition that Cosimo and Francesco did not wish to extend; nothing suggests that Duke Francesco ever really let artists vie openly for or within other major commissions, as his father had done (reluctantly) with the *Neptune*. Whatever the reasons, the period that marks the most dramatic upturn in the production of small bronze figures—the last two decades of the century, following Antonio Susini's arrival in Giambologna's shop—attaches virtually no names to Florentine works in this format that Giambologna did not design.

Indeed, Giambologna seems to have controlled nearly every major production in bronze carried out in the Grand Ducal territories from the early 1570s until his death more than three decades later—he even stepped in to approve designs for the doors made around 1600 for Pisa cathedral, the rare monument he did not model himself. This makes the situation with bronze very different from that with marble. To be sure, two of the best marble carvers of the moment, Giovanni Caccini and Pietro Francavilla, both collaborated with Giambologna, Francavilla extensively. Yet Francavilla also produced, largely on his own, the sculptures for the Niccolini chapel in Santa Croce (1588) and for Florence Cathedral (1589), and he signed the 1589 *Jason* for the Palazzo Zanchini and the 1593 *Spring* for the garden of Alessandro Acciaioli (now on the Santa Trinita bridge). Caccini, Vincenzo De' Rossi, Giovanni Bandini, Pietro Bernini, and Taddeo Landini operated with equal independence and managed to win prestigious commissions.

Whereas all the sculptors who had pursued the commission for the *Neptune* fountain continued to make large works in marble through the 1560s and beyond, the studiolo delivered Giambologna a monopoly on the field; those with any technical expertise worked for him.[32] We consequently have to ask not only what drove other artists away from the business but also what it was that made Giambologna himself so willing to stay in it.

Not a Goldsmith

The world of metal sculpture was a tightly controlled one, and it was the dukes, above all, who allowed Giambologna to dominate it. Still, the small bronze may well have been one area in which artists were willing to leave the Fleming alone. The artists most equipped to produce bronzes of any size, but small ones in particular, were those trained as goldsmiths; they knew how to cast precious alloys, how to handle the tools needed to chase and polish metals, and how to gild and brush the completed pieces. Nearly all the small bronzes produced during the first century in which the category can be said to exist—those by Filarete, Riccio, Pollaiuolo, and Antico, among others—were the work of goldsmiths. Giambologna would not have engaged in the serial production of bronzes had he not employed and collaborated with goldsmiths.[33]

Here the sculptor's formation matters. Bronze casting would, at least initially, have come to Giambologna as an unfamiliar technique, but his lack of experience in a goldsmith's shop also had the advantage of letting him approach it with the distance of the amateur. Like Bandini after him, he could embrace the small bronze as an object type without actually *becoming* a goldsmith, and he could thus

circumvent the stigmas to which many of his contemporaries felt subjected. Ammanati, it is worth remembering here, had been brought to Florence by Giorgio Vasari, the painter and architect who in the late 1550s and 1560s assumed programmatic control of much of the decorative work Cosimo was sponsoring, who insinuated himself into the way artists learned their crafts, and who even redefined what constituted the "modern" and the "Florentine." Vasari's views could have a significant impact on the advancement of young artists, and as Marco Collareta has shown, the famous biographer held goldsmiths in particularly low esteem.[34] The 1568 edition of the *Lives* associated goldsmithery with *diligenza* (roughly, "exactitude") and contrasted the craft with the inspired freedom that, as Vasari saw it, marked truly modern artists from Donatello to Michelangelo. This sensibility affected the way Vasari recounted the history of Florentine art; he went so far as to manipulate chronology, establishing false workshop genealogies and backdating the work of Quattrocento goldsmiths like Luca della Robbia so that Donatello (in fact Della Robbia's elder) could seem to supersede him. More significantly, as far as actual sculptural practices were concerned, Vasari brought similar ideas to bear on the work of artists around him. As Collareta noted, the newly founded Accademia del Disegno pointedly excluded goldsmiths. When Domenico Poggini unveiled a marble *Bacchus* in 1554, the year of Cellini's triumph with his *Perseus* (and the year before Vasari's arrival in the city), he proudly described himself as an *aurifex* in the work's inscription. When he wished to join the Academy a decade later, he could only be admitted "for having made numerous marble sculptures and for no longer working in the profession of the goldsmith" and "on the condition that he renounces the [goldsmiths'] company and no longer practices this [craft]."[35]

In these years, artists trained as goldsmiths must have felt compelled to distance themselves from the very fields that best qualified them to make bronzes. Danti's nearly exclusive commitment to works in marble after 1560 may reflect the degree to which the failed *Hercules* had left him shaken, but it also follows the path that the Cellini had mapped in the late 1550s when he tried to redefine himself publicly as an expert in stone rather than metal. Poggini remained active in the metal business through the 1560s, serving as the die cutter for the Florentine mint. Yet he, like Danti, promoted himself primarily with life-size or larger figures in stone from the late 1550s until his death in 1590, and he stopped signing them as he once had.

Giambologna, too, registered the new attitude. Writing to Francesco about two statuettes that he had not delivered as expected, he remarked that "such things are works for goldsmiths rather than for sculptors or for one like me who has already set his hand to bigger figures."[36] At the same time, the Fleming's peculiar formation allowed him a different perspective on the problem; in a subsequent letter,

the artist commented that if His Excellency should wish to order other things from him, "especially models and other fitting little works," he would gladly deliver them, going on to refer the duke to a goldsmith he knew who could help.[37] The letter, significantly, differentiates *oreficeria* (goldsmithery) from *operette* (small works in general). When, in 1580, Fortuna wrote to the Duke of Urbino that Giambologna was prepared to generate "models in wax or clay, which he makes quickly, in his own hand," he added that the artist would then "have the molds, the casts, and the polishing done by the goldsmiths that he keeps just for this purpose."[38] Here again Giambologna identified with the model, now on the principle that the small bronze could serve as a vehicle for serious aspirations.

Clean Bodies

For this, nothing was more important than the way the bronzes *looked*. In his classic essay, Collareta suggested that in producing his reliefs, Danti not only elected to cast a relief that could alternatively have been made with hammer and chisel but also to employ a confident modeling that emulated Michelangelo's *non finito*, "presenting no visible trace of the long and patient labor of reworking" (see fig. 2.10; fig. 2.13).[39] Bronzes like the *Brazen Serpent* and the *Descent from the Cross* were meant to be examined close up, and those who studied them would have seen how Danti shifted the labor of metalwork away from chasing, imitating those masters whom Vasari admired for achieving "impeccable casts, which require no retouching and which are as thin as knife blades."

Cast in 1559, probably by Danti himself, the *Brazen Serpent* in particular rebutted those who, after the *Hercules*, doubted Danti's confidence in the foundry, and its impressive dimensions—significantly larger than the works of similar format by any of his contemporaries—insisted that the artist did not think small. Contemporary writings, nevertheless, raise doubts about the appeal that such defiantly rough surfaces held. If that surface aimed, like the bumpy throat of Giambologna's *Turkey* (fig. 2.14), to convey qualities of the subject it represented, or if the bronze was to be seen at a distance or in dim light, the artist might leave it in a less finished state.[40] But for precious collectibles, coarseness was hardly a virtue.

Leoni reports that the model Giambologna produced for the *Neptune* competition in 1560 distinguished itself from the other entries for having been so "cleanly" worked.[41] Eventually, this came to count among the most common characterizations of the artist. Baldinucci's Giambologna, we will recall, presented to Michelangelo a model "finished, as we are accustomed to saying, with his breath"; Michelangelo, in response, faulted the artist precisely for concerning himself from the start with

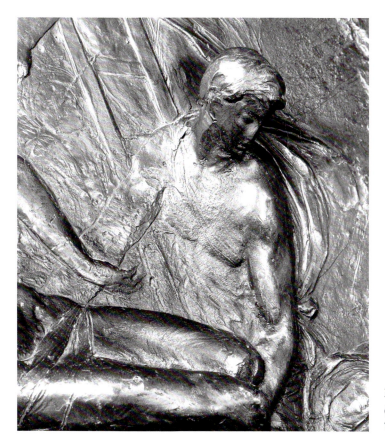

2.13. Danti, *The Descent from the Cross* (detail). Bronze. National Gallery, Washington, DC.

surface. Baldinucci apparently took Giambologna to have employed such a high degree of polish, creating a surface so smooth and "clean," that it evoked the gleam one might try to effect on wood or metal or glass by breathing on it then wiping it with a cloth. The phrase "as we are accustomed to saying" puts the comment in the realm of criticism rather than reported speech; the rhetoric in this case suggests that the encounter about which Baldinucci had heard reinforced his own understanding of a generational break. His recognition of Giambologna's taste for finish is not unjust; Baldinucci failed to see only that this stylistic hallmark differentiated the artist most immediately not from Michelangelo, but from Danti.

One scholar has recently (and polemically) proposed that Giambologna may never have personally chased his bronzes, citing a 1579 letter that the artist wrote to Ottavio Farnese, the Duke of Parma, in evidence of this. The relevant passage in the letter, which concerns two figures the artist had sent North, reads as follows:

2.14. Giambologna, *Turkey*. Bronze.
Museo Nazionale del Bargello, Florence.

Though they may not be perfect to the degree that the greatness and courtesy
of your most Excellent spirit deserves, these statues will be everything that my
weak knowledge is capable of carrying out. They are certainly created with all
the study and diligence that I know (especially in cleaning them), so that if
there is anything good there, the cleaner cannot (as often happens) destroy it
or, in filing, remove it.[42]

The idea of "cleaning" (*rinettare*) features here twice, as the labor to which
Giambologna applied particular *studio* and *diligenza*, and as the primary role of
an assistant (the *rinettore*). The sense of the passage turns on Giambologna's per-
ceived need to control this aspect of the bronze's production himself. It leaves no
ambiguity that his personal aesthetic ran to the "clean" rather than to the "unfin-
ished," that the look he desired depended on the activities of a chaser and not just
of a modeler, even if he delegated some of the necessary work to his assistants.[43]

The attitudes that Vasari had first articulated with force were still normative in
these years. Francesco Bocchi, for example, wrote in 1584 that "nothing is less sat-
isfactory to our own tastes than excessive diligence and a superabundance of orna-
mentation."[44] Yet Bocchi also inflected the idea of *diligenza*, the concept Collareta
showed to be central to Vasari's condemnation of goldsmithery, so as to exclude
the *non-finito* of the unchased cast as an alternative. Apelles, Bocchi remarked,

criticized those who, because they were overly diligent, failed to complete the things they started. The writer distinguished between artists who concerned themselves with "exterior ornaments" and those, like his hero Donatello, who "fixed their eyes on the principle work."[45] Giambologna's own words, similarly, suggest a way in which the artist might defend a certain conception of *diligenza*, challenging the idea that a show of craft in the production of a small object essentially made one a small artist. Giambologna's language implies that he meant his bronzes to play against viewers' expectations for how *diligenza* looked, positioning the statuettes in such a way as to undermine the kind of antithesis on which Vasari and his cohort aimed to restructure the system of the arts in Florence.

Giambologna, no less than Danti, separated his own labors from those of the chaser. Yet unlike Danti, he unapologetically allowed that his works owed much to what the *rinettatore*, literally, the "cleaner," actually did. At times, Giambologna even seems to have thematized his works' polish. The two figures that have the best claim to being the artist's earliest independent small bronzes both represent nude women in the act of stroking themselves with a piece of cloth. One of these (fig. 2.15), now in Vienna, has been identified since Schlosser with the "figurina di metallo" sent to Maximilian I as a diplomatic gift in 1565. The other (fig. 2.16), now in the Bargello, is undocumented before 1584, when it was in the Villa Medici in Rome, though some scholars have dated it to the early 1560s.[46] The most recent Giambologna catalog, by contrast to earlier publications but in keeping with the "Gods and Heroes" theme that structured the exhibition, placed both bronzes under the name "Venus," and indeed the Bargello statue in particular echoes an antique type known in surviving marble versions that Renaissance writers regularly referred to as "Venus." Nevertheless, the turban or towel that Giambologna substitutes for the diadem he would have seen on statues in Rome makes the figure decidedly less divine.[47] With its paucity of attributes, the figure resists specific identification, as if the concern of the designer centered not on who she was, but on what she was doing

The action itself has divided scholars, too, and statues of the type have gone under names ranging from "Venus drying herself" to "Venus after the bath" to "woman bathing." What is clear is that the figure's performance is in some way related to an ablution, that we are to see the surface of the figure in terms of what has been done to it. In both the Florence and the Vienna statues, the artist has taken care to differentiate the tight, angular folds of the cloth the woman holds—which winds around the figure in a way that invites the viewer to handle its body, rotating the statue to inspect it from different points of view—from the skin around which it is drawn and against which it is pressed. That skin itself reveals the actions not only of the filing and pumicing that removed the initial

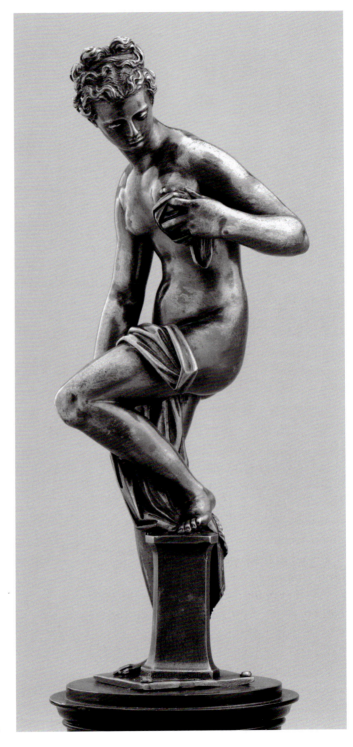

2.15. Giambologna, *Bather*. Bronze.
Kunsthistorisches Museum, Vienna.

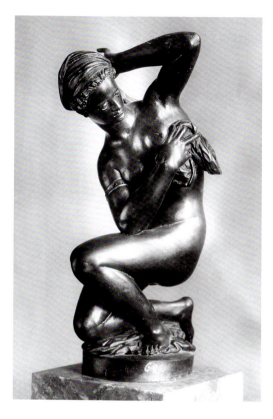

2.16. Giambologna, *Bather*. Bronze. Museo Nazionale del Bargello, Florence.

residue from the cast but also of the wire brush that brought it to a smoothness that would delight the collector's hand no less than his eye. It is a statue that concerns itself more with sensual effect, visual and tactile, than with the mythological episode to which it ostensibly relates, though that effect is also inseparable from its subject matter. What the woman does to herself works as an invitation.

At what point did the *pulizia* that Giambologna aestheticized in works like the bathers degrade into overfastidiousness? How was it possible for the sculptor to aim for one effect without risking the other? Here it is worth underscoring the fact that Giambologna's attraction to the bather theme was not a casual one. He seems personally to have returned to the type at least four times in the arena of the small bronze alone, making it a subject that early viewers would immediately have associated him with. One attraction may have been that, especially to anyone prepared to compare the small bronzes with contemporary paintings and prints

on similar themes, its protagonists would have appeared to be not just nude, but denuded. Giambologna's bathers have exquisitely arranged hair, and a few wear simple studs in their ears, but none are accessorized with pendants, pearls, crowns, or other bejeweled accoutrements. It is as if the artist were trying to create a gulf between the categories of the "finished" and the "decorated."

This is not just true of the small bronze bathers. When, later in life, Giambologna took on larger-scale commissions that invited direct competition with the artists Vasari identified as goldsmiths, one characteristic that set his own inventions apart was their insistent reduction of ornament. Whereas Cellini had used the base of the *Perseus* as an opportunity to let his imagination run wild, Giambologna's pendant to it employed a simple geometric form with a single attached relief. Giambologna's bronze *St. Luke* (fig. 2.17), carried out between 1597 and 1602 for the niche belonging to the Judges and Notaries' Guild at Orsanmichele, shows a robed figure in sandals. Yet by comparison to Verrocchio's *St. Thomas*, whose foot emerges from the corresponding niche on the left bay of the same facade (fig. 2.18), the attire of Giambologna's evangelist is remarkably plain, lacking fictive embroidery on the borders of the cloth and elaborate pattern on the straps that run across the feet.

Copies made after Giambologna's works suggest that even fellow artists regarded him as something of a minimalist. His relief *Allegory* in the Prado (see fig. I.8), as we have seen, responded to a Medici family tragedy. The vagueness of the subject matter, though, allowed it to resonate beyond the Florentine context, and Cosimo had Giambologna and his assistants produce a bronze copy (fig. 2.19) for Emperor Maximilian II in 1564. This, in turn, found its way into the collection

2.17. Giambologna, *St. Luke*, detail. Bronze. Orsanmichele, Florence.

2.18. Andrea del Verrocchio, *St. Thomas*, detail. Bronze. Orsanmichele, Florence.

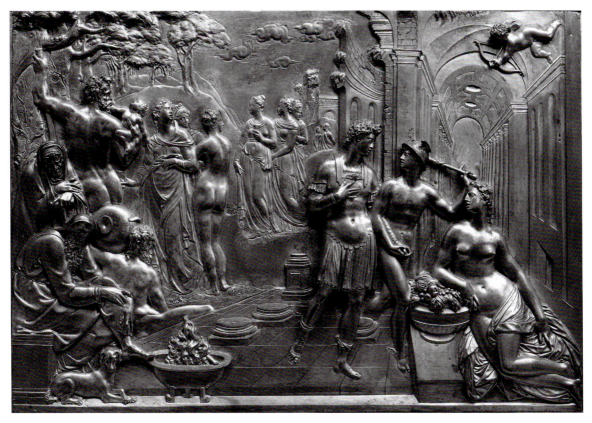

2.19. Giambologna and workshop, *Allegory*. Bronze. Kunsthistorisches Museum, Vienna.

of Rudolf II, who had an additional copy made in silver (fig. 2.20).[48] The bronze is far more hard-edged than the alabaster, a result of the careful reworking it underwent at the hand of a goldsmith after it was cast.[49] The evidence of this labor, though—which contrasts sharply with Danti's *Moses* or *Descent from the Cross*—only shows how distinctively Giambologna had his subordinates operate. Wherever the silversmith who worked for Rudolf could, he added additional pattern to scene. The front side of the platform on which the Cybele in his version leans bears a kind of repeated acanthus; the pedestal on which the man opposite her sits gains a relief sculpture of a striding nude. The hills in the background become rocky. Hints of a landscape appear through the loggia in the distance. Most of all, the smith could not resist the temptation to add decoration to anything in the image resembling a vessel, from the cornucopia at the right to the flaming brazier

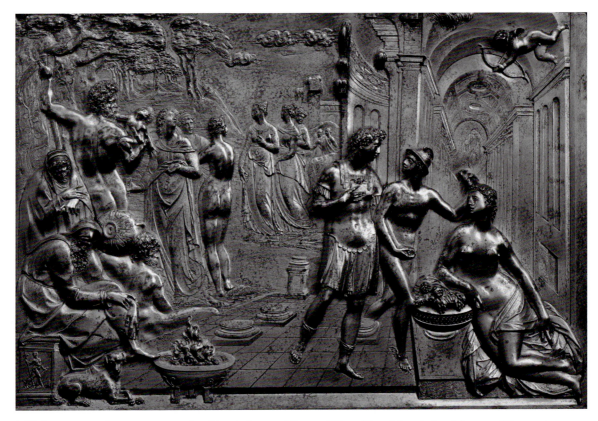

2.20. Late sixteenth-century copy after Giambologna, *Allegory*. Silver. Kunsthistorisches Museum, Vienna.

in the center left foreground, to the urn that the river god behind this holds on his shoulder. The bronze and silver versions of the relief were finished by two men in the same profession, but to the eyes of the Ruldolfine smith, what came out of Giambologna's shop simply appeared too plain.

Scale

One written source that allegedly documents Giambologna's views on the small bronze is a 1594 letter by Scipione Ammirato, which remarks how

Giambologna used to lament that, though God had created him to make colossuses and great machines in sculpture, Grand Duke Francesco, according to

the occasions that presented themselves, had him laboring continually on the production of little birds, fish, lizards, and other tiny animals. Grand Duke Ferdinando liberated him from this boredom, and had him occupy himself with the making of that most noble equestrian statue of that most noble prince, Grand Duke Cosimo, his father.[50]

Scholars have sometimes used the passage to evidence a shift in Giambologna's interests at the end of his career: Dimitrios Zikos, for example, takes Ammirato to imply that while Giambologna continued to furnish models for small sculptures, these had ceased to be his priority.[51] We should be cautious, though, about putting too much stock in Ammirato's characterization of the situation. The letter aims at once to flatter Ferdinando and diminish his predecessor by advertising Giambologna's most impressive recent project, one that Ferdinando had assigned the artist the year he took the throne. The letter's description of the difference between the patronage of the two Medici brothers, however, is hardly accurate. Avery's 1987 catalog dates nearly thirty of Giambologna's surviving small bronzes to Ferdinando's reign, and it was for Francesco, not Ferdinando, that Giambologna made most of his colossal statues, including the *Appenine*, the biggest of them all.

What is most illuminating, in fact, is the way in which Ammirato misrepresents Giambologna's production of bronzes. The subjects on his list—*uccellini, pesciolini, ramarri*—are all things that, if cast in bronze, would have been more or less life size. Ammirato's idea is not just that Francesco limited Giambologna to small works, but that he had compelled the artist to make copies of small things. Little in Giambologna's oeuvre, however, fits this description: the Castello birds (see fig. 2.14 and fig. 4.3), among the best illustrations we have of Giambologna's work as an *animalier*, were hardly *animali minuti*. Ammirato does not, Zikos's inference notwithstanding, even mention models, and this is itself devious, for the antithesis between the "little animal" and the "colossus" conflates the matter of size with that of scale.

The small bronzes produced in central Italy just before Giambologna's earliest works in the format, as we have seen, largely reproduce antiquities, yet remarkably, the antiquities that artists made into modern bronzes were almost never small objects; while antique prototypes could have encouraged artists' and collectors' interests in small bronzes in the first place, it was not these objects that they sought to recreate. Rather, the challenge was to evoke mass without actually providing it. Tetrode's musclemen (fig. 2.21) illustrate the point. This Dutchman, who trained initially in the workshop of Benvenuto Cellini, and whose marble works from these first days in Italy stand out especially for their delicacy, ended up making

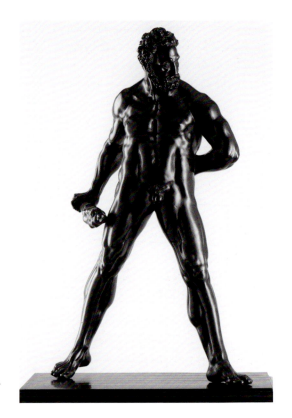

2.21. Willem de Tetrode, *Hercules Pomarius*. Bronze. Rijksmuseum, Amsterdam.

bronzes that go even beyond Cellini's rival Bandinelli as physical types. They give the impression that the transition from marble to bronze required the artist to try to make small objects that were nevertheless insistently not small figures.

Giambologna likewise kept size and scale distinct. Throughout his career, he created designs that, while initially exemplified in a compact model, could be reduced or enlarged, even made monumental; part of what makes heroic statues like the *Neptune* or the *Sabine* or the *Hercules and the Centaur* so marvelous is the fact that they essentially expand figures that first existed in miniature. This is not to say that Giambologna lacked a sense of decorous measure; it is impossible to imagine him conceiving a colossal *Mercury*, for example, and he was as prepared to make a more petite and therefore sweeter marble Venus as he was to lend a triumphal image an imposing mass. Giambologna realized, however, that a small object was not the same thing as a small-scale object; the sculptor did not think through the representation of a bird in bronze the same way he thought through the representation of *Hercules*.

2.22. Danti, *Sportello* (Safe Door). Bronze. Museo Nazionale del Bargello, Florence.

This is one lesson Giambologna could indeed have learned from Michelangelo, though Danti and his fellow goldsmiths would have provided a proximate source. The first relief Danti undertook in Florence, for example, was a safe door that consisted almost entirely of framing elements (fig. 2.22). Its central scene shows a ruler burning books, but the designer gave the majority of the space over to commentaries on the episode: personifications of the ruler's virtues occupy ovals on all four sides; paired *ignudi* flank empty shields; a Peace, with her torch, duplicates and characterizes the main incendiary act, while two bound prisoners fill the space at her sides. The composition works like a miniaturized fresco cycle, shifting scale every time it shifts register.

The sculptor's need to present plans for a large work in the form of a bronze model required him to be able to modify and convey scale in this way. In the 1570s, when Giambologna began to make models that would serve for small bronzes rather than for larger works, he nevertheless brought to the task his experience

2.23. Early sixteenth-century caster, *Crab*. Bronze. Kunsthistorisches Museum, Vienna.

with the Bologna *Neptune*, where the opposite was true. This was especially important in cases like the *Hercules* series, where the works he wished to be judged against were many times larger than the objects he himself designed.

Ammirato's remarks also recall the disparaging comments of Giambologna's rivals: that he was good at small things but unable to make giants. From the Bologna *Neptune* forward, the artist systematically belied this, though the sniping of contemporaries may well have affected the way Giambologna approached the statuette. In part, no doubt, because he perceived the very real possibility his small bronzes offered of being remade as colossi, he turned the task of inventing such bronzes away from the simple mechanics of reproduction. The critic of "fish, lizards, and other tiny animals" essentially characterized bronze representations as life casts, works that required the technical knowledge necessary to operate with molten bronze but that ultimately just replicated something from nature (fig. 2.23). The majority of Giambologna's bronzes, by contrast, stood at some distance from the figures they represented; making a small work that could become a large one meant, first, moving it in the other direction.

Autonomy and Invention

The abundant, almost superfluous framing devices in Danti's *sportello* announce that its figures were both the decorations and the thing decorated; the relief coheres internally, directing itself at nothing beyond the contents of the box it sealed. The purpose of the *Moses* (see fig. 2.10), which Danti completed three months later, remains obscure, through documents attest that it first entered the possession of Danti's Perugian supporter, Sforza Almeni, and from there passed to

2.24. Danti, *Descent from the Cross*. Bronze. National Gallery, Washington, DC.

the duke; by the time of its completion, in other words, it had already become a collectible.

A third relief, the *Descent from the Cross* now in the National Gallery of Art in Washington, DC (fig. 2.24), lacks a comparably secure provenance and may date to a slightly later moment. Unlike the sportello or the *Moses*, the relief is nearly square in format, and Danti draws attention to its borders with elements of the narrative: the cross where Christ hung, too small for his body; the thieves' crosses, which break from any law of perspective in order to inscribe diagonals that point

to the corners; the crowd at the bottom, which stops precisely where the picture field itself does. Italian relief sculptures usually locate the figures that are most fully in the round lowest down in the scene, allowing the shallower projection at the top to create an illusion of depth, but Danti here merges the lower figures' feet and legs back into the ground plane, so that the bottom edge, too, contains everything above it. The frame is not original, and the theater box it creates contradicts Danti's own effects. It is hardly surprising, however, that a later collector would have *wanted* to frame this relief, perceiving the work as an analogue to the gallery picture, independent of any larger ensemble.[52]

Almost without exception, large bronze reliefs before this moment were site specific: they ornamented the bases that supported iconic statues; they decorated the altar zones of churches; they provided narrative sequences for monumental doors. It is on account of this tradition, in no small part, that writers on Danti have been lured into speculating on the locations in one or another chapel for which his bronzes might have been made.[53] By the time the *Moses* entered the duke's *guardaroba*, however, it had come to serve a function more like that of the reliefs artists were making in a similar format but in different materials. The 1587 inventory that mentions Danti's contemporary *Flagellation*, for example—possibly the sculptor's first work in marble—indicates that it was kept in a "cassetta" (a drawer or box) and that it had an "ornamento di noce" (a walnut frame).[54] It belonged to no architectural context. The fate of objects like this may well have inspired Giambologna's similar translation in the early 1560s, when he reproduced his alabaster as a bronze, meant for export.

In a lengthy section of the *Riposo* during which the characters compare the merits of painting and sculpture, "Baccio Valori" reports that painters argue for the superiority of their own field by pointing to its "convenience" (*comodità*),

> showing that painting can be made in books, on canvases, on leather, and on other things that are easy to transport, and that it can easily be sent anywhere in the world, as one sees happening every day with the portraits of Princes and of beautiful women, and with the landscapes of Flemish painters. None of this happens, nor can it, with sculptors.[55]

In the late sixteenth century, as travel became easier and art began more readily to find an international audience, portability became a topic for the *paragone*, the set-piece comparison of the strengths and weaknesses of different media. Borghini's text is typical in that it focuses on ostensible differences between painting and sculpture even as it brings these together more than it pushes them apart; the expected response to any *paragone* argument was to show how it was false. A relief like Danti's *Descent from the Cross* most closely approximates the variety

2.25. Andrea Riccio, *Satyr*. Bronze. Metropolitan Museum of Art, New York.

of painting Borghini had in mind, though the idea that Flemings, in particular, exemplified the new mobility of the object would have caught the attention of Giambologna, too, not only because Valori was characterizing the work of his countrymen but also because Giambologna's earliest Italian sculptures were probably those he planned to take back North with him.

Michael Fried, in a forthcoming book on Caravaggio, discusses what he describes as the "ontological measures" that "secured the preeminence" of the gallery picture in sixteenth- and seventeenth-century Rome, in part by establishing the picture's autonomy.[56] Chronologically, the issues Fried follows correspond almost exactly to the history of the small bronze, the preeminence of which Giambologna and to a lesser extent Danti helped to secure in its own right, and many of the issues Fried raises in regard to painting bear on three-dimensional forms as well. Contributing to the autonomy of the small bronze, for one thing, was Giambologna's integration of bases, or small pedestals, into his designs. This stands in notable contrast to many earlier sixteenth-century bronzes, including Riccio's *Satyr* (fig. 2.25), designed and balanced to stand on any surface with no help. Such

works became a part of the place they were displayed: an ornamental extension of a desk, even a paperweight. Giambologna's bases, in this light, come across as sculptural analogues to the frames of paintings (or to the frames now used for reliefs like Danti's), asserting the works' separation from the surfaces on which the objects stood.

We might also notice how many of the bronzes Giambologna made for export have to do with themes of transportation or cultural translation. Mercury, which he produced in numerous versions beginning in 1564, is the messenger god, a courier (fig. 2.26). Contemporaries regarded the abduction of Helen and the Sabines (fig. 2.27), for their part, as foundation myths establishing an old people in a new land. Encomiasts employed the stories associated with all of these characters in different centers to construct flattering historical origins for a ruling family or local people. Such subjects were useful in diplomatic exchange because they took up a mythological repertory shared across Europe. But the subjects also conformed to a format, reminding viewers that the objects themselves could be taken away from one place and brought to another. Statues like these announce their own mobility.

The letter about Giambologna that Fortuna sent to the Duke of Urbino includes revealing remarks on the small bronze and its attractions:

> Little marble statues do not stand out, and they run the risk of breaking at the slightest disaster or accident, especially when transported and taken from place to place. [With bronzes,] one can be certain of being able to make caprices that go beyond what is ordinary, as [the artist's] fantasy instructs, such that his things are different from others and require much time to consider.[57]

The passage suggests what anyone familiar with stone sculptures might recognize, that they are not only heavy and difficult to move, but also fragile. More surprising, though, is the assertion that bronzes almost uniquely allowed the artist to "far capricci." Fortuna does not explain this remark further, and it is possible that he had in mind nothing more than the comparative limitations imposed by the marble block. At the same time, the writer offers his perception about *fantasia* in bronze in the same breath as his observation about portability, as if the thought that bronzes could be sent from one place to another led him to the belief that they were more appropriate vehicles for invention. This way of reading Fortuna's line would liken bronzes to other portable media more conventionally associated with caprice and invention—works such as the print and the gallery picture, made to be moved.

The repetitiveness of Giambologna's small bronze production, the creation and dispersion of multiples or of closely related figures with only slight variations,

2.26. Giambologna, *Mercury*. Bronze. Kunsthistorisches Museum, Vienna.

inherently worked against the idea that inventions reflected the places for which they were made. Conceiving works without foresight of whatever comprehensive program a building or urban space dictated made it possible to ship those works to different centers or to place them in different settings, as a collector wished. Often, Giambologna generated sculptures to which different subject matter could be brought, such that the object's "invention" did not end with its physical man-ufacture. We have already seen that Giambologna's bathers, his earliest small bronzes, sometimes gained mythological identities and sometimes did not; it was probably one of these figures that Giambologna sent to Ottavio Farnese, the Duke of Parma, in 1579, but we cannot be certain, since the letter Giambologna wrote to

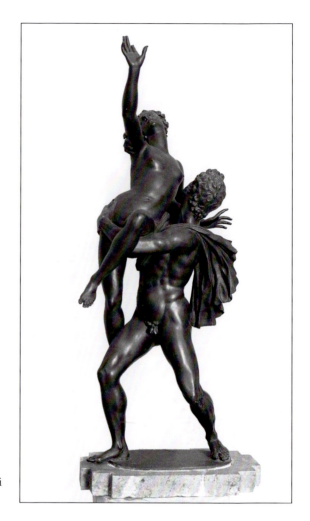

2.27. Giambologna, *Abduction Scene*. Bronze. Museo di
Capodimonte, Naples.

accompany the shipment referred to the figure only as "la femina" (the woman).
That Giambologna was not just writing carelessly, that he intended indefiniteness,
is indicated by the two-figure group to which the same letter refers, "which can
be taken [to show] the abduction of Helen and perhaps of Proserpina—or as one
of the Sabines."[58] Giambologna added that he chose the subject in order to show
off his artfulness; essentially, Giambologna made the same connection Fortuna
did when describing what the artist was prepared to make for yet another duke.
The work that could be moved from place to place allowed and even demanded a
particular kind of creativity, one in which both artist and viewer might play a part.
When Giambologna writes that his figures could be "taken to be" (*che possono*

inferire) this subject or that, the point is that the artist has handed off the question of "fit"; rather than trying to identify the right theme for a given place, he required that of others.[59]

Giambologna was not the only artist who saw the small bronze as a format that lent itself to open-ended subject matter: a letter from Alessandro Vittoria, for example, proposes that the bronze mentioned in the previous chapter could pass either for a *Sebastian* or for a *Marsyas*—in some ways a more daring claim, inasmuch as it left to the viewer the question of when the object represented sacred or secular subject matter. Then again, it may have been the outcry from the church that provoked sculptors to seek out ambiguous themes. When Gilio launched his attack on Michelangelo, he began from the same instincts that would later motivate Johannes Molanus, Gian Paolo Lomazzo, and others to dictate extensive guidelines for how to treat particular themes; he must have hoped that patrons reading his text would instruct their artists to make clearer works. Yet the assertion in a vernacular dialogue that modern artists "pay little or no attention to the subject of the stories they make" could have had the opposite of its desired effect.[60] Gilio was associating modernity with a sort of abstraction; given that he was also offering an interpretation of Michelangelo, the storylessness he decried could well have looked like something the ambitious artist would want to imitate. As Borghini's *Riposo* indicates, Giambologna's supporters read Gilio with care, and when Giambologna himself writes, with regard to the abduction group he sent to Parma, that he chose the theme "to create a field for the knowledge and study of art," it may well be that the suppression or opening out of subject matter, the essentializing of the sculpture so as to privilege type and pose over narrative reference, aimed at a particularly modern variety of emulation.

The very indeterminacy of Giambologna's small bronzes provided the artist with another way to announce that they were not so different from Michelangelo's large marbles. At the same time, the goal of clerics like Gilio was not only to improve the legibility of contemporary art but also to formalize a system of genres, each with its own rules. For the cleric, the crucial distinction maintained between historical scenes, which included religious paintings in churches, and poetic ones, by which he meant in the first place decorations for private palaces. By the 1570s, it may well have seemed that marbles and bronzes were gravitating in different directions, since marbles, which tended to be bound to specific spaces, were controlled by that site in a way that mobile bronzes were not. For the late sixteenth-century sculptor wishing specifically to imitate Michelangelo's "ambiguation" of the figure, bronzes were beginning to offer a distinctive kind of freedom.

3

NATURALISM

Found Objects

The earliest Renaissance treatise devoted to the art of sculpture was Alberti's *De statua*, probably written in the 1460s but published for the first time in Cosimo Bartoli's Italian translation of 1568. In it, the author traced the art to an origin, speculating that the first sculptors

> occasionally observed in a tree-trunk or clod of earth or similar inanimate object certain outlines in which, with slight alterations, something closely resembling the real faces of Nature was represented. They began, then, to diligently observe and study these things, and to try thereby to see whether they could not add, take away or otherwise supply whatever seemed lacking in such a way as to bring about and complete the true likeness. Thus, by correcting and refining the lines and surfaces as the particular object required, they achieved their intention and at the same time experienced pleasure in doing so.[1]

Late sixteenth-century readers of Alberti would have learned that sculpture began as an act of recognition. The sculptor saw an image within something that nature itself had already produced, and, keeping this before his eyes, finished what nature had started.

The first sixteenth-century treatise on sculpture, Pomponius Gauricus's 1504 *De sculptura* (published, like Bartoli's Alberti edition, in Florence), offered a slightly different notion of the art's origins:

> It is not necessary to inquire into whether men began to compete with nature by chance or volition. Whether they started with shadows, with clay, with tree trunks, or with stones, they reproduced an appearance conforming to the object, such that one understands that everything they made was produced by nature and perfected with art.[2]

The reference to shadows notwithstanding, here nature appears as a less fantasmatic force; rather than offering the shades of the image that the sculptor would then follow, nature for Gauricus seems above all to supply materials (clay, wood, stone). Nature "produces" things, whereas art, imitating appearances, "perfects" them by shaping them further.

Origin myths like those of Alberti and Gauricus conformed to Aristotle's idea, articulated in the *Physics*, that "the arts, on the basis of nature, either carry things further than Nature can, or they imitate Nature."[3] Such myths respected the traditional theological distinction between invention, which artists displayed, and creation, of which God alone was capable. They offered a version of Claude Lévi-Strauss's famous antithesis between the "raw" and the "cooked." And they reinforced a topos that ran through much of the sixteenth-century literature of art, according to which all forms of sculpture could be reduced to acts of adding or removing material from something given at the outset. Ultimately, Alberti and Gauricus orient a way of seeing sculpture, one that affected commissions for as well as reactions to objects, whereby the work of nature and the work of the artist, to use Alberti's categories, or the produced and the perfected, to use Gauricus's, remained equally in view.

In the last three decades, the intersection between *artificia* and *naturalia* has become a commonplace in accounts of spaces like the Kunstkammer and the studiolo, where shells and corals might be displayed alongside bronze figures.[4] But the categories bear equally on monumental outdoor ensembles, where marvels of art likewise overlay those of nature. Ammanati's *Neptune*, for example, was occasioned by the excavation in Carrara of a piece of marble some nine braccia high.[5] Similarly, the *Oceanus Fountain* (fig. 3.1), which Giambologna began while his rival's colossus was still underway, originated with Cosimo's determination on how to use an enormous block of granite, excavated long before by Tribolo, that arrived in Florence in 1567.[6] "I have had this stone quarried," says Baldinucci's duke to the artist, "in order to make a beautiful fountain for the garden; let it be your thought

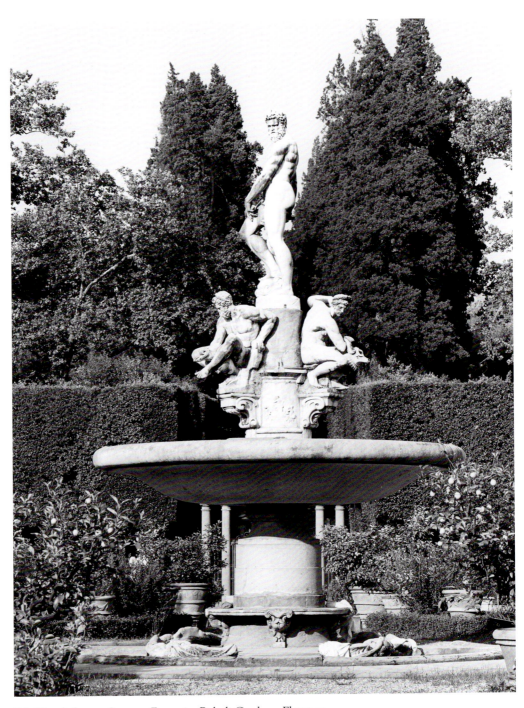

3.1. Giambologna, *Oceanus Fountain*. Boboli Gardens, Florence.

to make this fountain in a such a manner that the basin would do honor to you, and you to the basin."[7]

We have already seen that rivalries between sculptors like Ammanati, Danti, and Giambologna could extend to the quarry. The idea that an artist might have to "honor" the actual stuff that came down from the mountains was a logical extension of this, and it set sculpture apart from siblings like painting. Ammanati himself wrote of "how much art and judgment is necessary for those who would begrace a marble statue, such that the great and fine marbles that have been quarried and transported with the investment of much time and not a little expense are not ruined and mangled on account of inexperience and a lack of art."[8] Baldinucci may have treated the *Oceanus* as little more than an ornament for its base, but it, too, had come from the quarry, and it would have been impressive even before the artist set a hand to it, measuring three and a half meters in height.

There were contrary impulses as well. Alberti himself had encouraged painters not to rely on precious materials, impressing viewers instead with their powers of illusionism, and Vasari relates how Michelangelo excoriated Francesco Francia when he understood the goldsmith "to praise the bronze more than the artifice" in a portrait of *Julius II*.[9] In most of Italy, however, unlike other parts of Europe, neither sculptors nor their patrons wanted sculpture quite to go down painting's path. They avoided polychromy and they continued to favor precious materials like marble and bronze that viewers could not help but admire in their own right. Audiences tended to look *at* rather than *past* the material in which sculptures were made, an inclination artists were wont to encourage. Danti, for example—the sculptor who had taken the brazen serpent (see fig. 2.10) as the subject for his most ambitious bronze relief—gave his 1571 metal *Salome* (see fig. 4.7) a single attribute, the gigantic metal tray she holds under her left arm. Both works made their medium part of their subject. They were naturalistic in Alberti's sense, preserving the visibility of nature's own work.

The Marble in the Statue

Such habits also meant that audiences noticed when a sculptor could not handle one material particularly well. Borghini writes that when, in the 1570s,

[Giambologna] had demonstrated, by making many bronze figures large and small, as well as an infinite number of models, just how excellent he was in his art, he was not able to ignore a number of invidious artificers who, not being so distinguished in such things, confessed that while Giambologna did very well in

making graceful figurines and models in various poses that had a certain prettiness, he had not succeeded very well in what true sculpture comprises, namely, executing large marble figures.[10]

It might initially seem surprising that anyone in Florence in 1580 could have maintained that Giambologna had not "succeeded" in making large marble works: by this date, the *Samson and Philistine*, the *Oceanus*, the *Florence and Pisa*, and the *Altar of Liberty* were all on display. Still, Borghini was in a position to know what he was talking about, for he was composing his dialogue in the year that Giambologna unveiled his *Sabine* (fig. 3.2), and he counted among the writers who frequented the artist's studio. He would have been aware that the sculptor had received extensive assistance with the marbles that had left his shop—more help, it seemed, than most rivals in the profession.

Baldinucci preserves a rumor that probably originated in Giambologna's own lifetime, that just as Francavilla had carried out Giambologna's other marbles, so did he carve the *Sabine* "under guidance of the master."[11] And though Giambologna could not stop rivals from talking, what he could do is design a marble in such a way as to show that the material was a primary concern—that the work was more than just a reproduction of a small bronze. Borghini goes on:

> For this reason, Giambologna, goaded by the spur of virtue, set out to show the world that he knew how to make not only ordinary marble statues, but also many together, and the most difficult that could be done, and that he knew where all of the art of making nudes lay (showing defeated senescence, robust youth, and feminine refinement). Thus he depicted, only to show the excellence of art, and without intending any *historia*, a fierce youth abducting a most beautiful maiden from a weak old man.[12]

The ideas here echo the remarks Giambologna made with regard to the bronzes he had sent to Parma just a few years before. One of the things the statue "argues" is that Giambologna's approach to small bronzes—postponing the fixing of an *historia*—was equally relevant to monumental marbles. At the same time, Giambologna ultimately produced a work that was *about* marble as much as in it.

The marble medium involved technical considerations that bronze did not. In committing himself to using no more than a single piece of stone, the artist had to start with a composition that both stayed within the block's contours and stayed up. His flamelike forms were at least in part structurally motivated, as was his addition of the third figure that would brace the insufficiently supportive legs of the standing man. The size and public nature of the work made it a candidate for comment from local poets, and the absence of an *historia* in particular called for

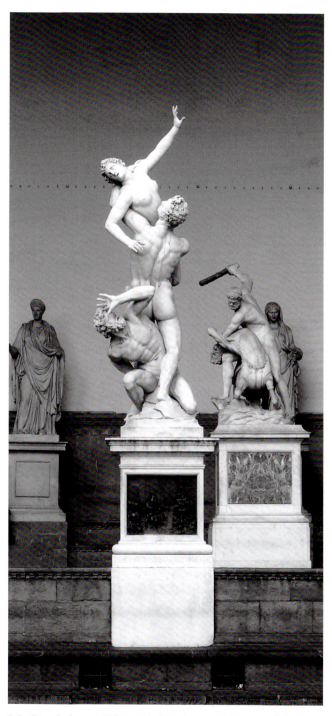

3.2. Giambologna, *Sabine*. Marble. Loggia dei Lanzi, Florence.

interpretation. Most remarkable, though, was Giambologna's decision about how to install the work. The artist had given the bronze abduction group that was the marble's closest precedent an oval base, suggesting that it had no single ideal point of view, and in principle the same thing might have been true of the three-figure design: anyone visiting the stucco model now in the Accademia, for example, can walk around the group and see how the interaction between the characters changes when viewed from different angles. The artist placed the marble group, however, on a rectangular base, determining a strong frontal aspect, one reinforced by the piers of the Loggia dei Lanzi, which blocked side views and made circumambulation of the statue impossible. The relief Giambologna eventually added below the group unequivocally indicated a primary point of view.[13] All of this effectively positioned the (male) beholder unambiguously in front of the statue in the Piazza, such that he would see the young abductor from the back. The protagonist in the marble—by contrast to both the stucco and the bronze—was what Joseph Koerner, in another context, has called a *Rückenfigur*, a type that facilitated identification with the character and its absorption in the woman he holds.[14]

Unlike the poems written upon the unveiling of earlier sculptures such as Cellini's *Perseus* or Bandinelli's *Hercules*, those written on the *Sabine* took this kind of identification as a point of departure. A good example is Francesco Marchi's sonnet, one stanza of which reads "Rapir sentì 'l pensier soura misura, / E restai come immobile, in astratto, / Quando mirai della Sabina il ratto / Ove Arte vince supera natura" (I felt my thoughts ravished beyond measure, and I remained as if immobile, abstracted, when I gazed upon the rape of the Sabine / where art triumphs over nature).[15] The lines focus on the work's thematics of desire, but when Marchi describes himself as "immobile" and "abstracted," he at once compares the state of Giambologna's hero to that of the viewer who stands before it and changes the nature of the action. *Looking at stone* becomes the statue's and the poem's central theme. Compare the similar conceit Vincenzo Alamanni uses:

Mentre io miro il bel Marmo, et scorgo in esso,
D'alta prole infiammar giovin desio
Casta Donna a rapir, rapirmi anchi'io
Sento dentro, e di fuor dal Marmo istesso.
Ma se spirto hai n'un sasso, et moto impresso,
Vivace sì, gentil Bologna mio,
Ben dee securo dall'eterno oblio
Vivere il Nome tuo lungi, e d'appresso.

As I gaze at the beautiful marble, and as I perceive how, in it, the youthful desire of the great progeny becomes inflamed to ravish the chaste lady, I, too, feel

myself ravished inside, and outside I feel like I am made of the marble itself. But if you, my good Giambologna, have pressed such lively spirit and movement into a stone, then your name ought to live long and remain close, secure from eternal oblivion.[16]

Alamanni, like Marchi, takes it to be the young man, as much as the young woman, who is "ravished," a trope that turns the work into an image of inspiration as much as one of sexual violence. The poetic perspective makes the work's marble a metaphor as much as a real material, a feature of its conceit and a condition of its viewing.

Marchi and Alamanni give us evidence only of the *Sabine*'s reception, not of Giambologna's intentions. Giambologna's circumstances, though, placed him in a position to encourage specific kinds of response. The idea of the viewer finding himself in a marblelike state before the work, for example, already appeared in the verses written on Cellini's *Perseus*, and John Shearman went so far as to propose that poems like Marchi's attributed to Giambologna's statue a "Medusa effect," a power to induce petrifying marvel.[17] What differentiates the poems on the *Sabine* from the earlier ones on the *Perseus*, though, is their proposal that any such effect happens in the first place *within* the statue itself, as if the young man is marble because he, like the statue's viewer, is engaged in looking. Giambologna's choice to give his third figure a gesture of stupefaction, moreover, allowed poets to extend similar conceits to him, the white stone paradoxically capturing his frozen state, overcome by heated emotion. Alamanni writes: "Grida in terra abbattuto il curvo Padre, / Nel cui gelato core / Bollon' ira, pietà, sdegno, e dolore" (The bent father, beaten to the ground, cries out; ire, pity, disdain, and sadness all boil in his frozen heart).[18] And Pierfrancesco Cambi offered a set of three epigrams, each offering a different fictive explanation for the statue's marble:

Son gloria de' Sabini, alta Donzella,
　　Che chieggio contr'un'huom di sasso aita,
　　Sol (perche io piacqui altrui) vengo rapita
　　Colpa et honor di chi mi fe si bella.

Empio Roman' dal tuo feroce passo
　　Scorgo il Sabin pianto si disprezza,
　　Ma per punir la tua folle alterezza
　　Io sarò al tuo desir di sasso.

Diceva il predator' Giovane bella
　　Se irata mandi fuor' raggi d'amore
　　Che farai lieta? Struggerotti il core,
　　Se ben tu se di pietra, rispos'ella.[19]

I am the glory of the Sabines, a great lady, and I ask for help against a man made of stone; I alone (because I pleased others) have been ravished, to the guilt and the honor of the one who made me so beautiful.

Impious Roman, from your ferocious step I perceive how you disparage the Sabine cry, but to punish your foolish haughtiness I will be stone to your desire.

The predator said: beautiful Lady, if, when enraged, you emit rays of love, what will you do when you are happy? I will melt your heart, she replied, even if you are made of stone.

The second and third, like other poems written for the occasion, invoke the Petrarchan topos of the stony lady, whose unresponsiveness provokes the poet's labors. Both poems suggest that the action centers on nothing but art—precisely Borghini's contention. The first specifies further that the art at issue is one of sculpture rather than writing: to follow the poet's witty explanation of the action, it is because the artist made his Sabine so beautiful that she has been abducted.

At least three other writers tried out variations on this theme. Bernardo Davanzati treated the whole composition as an allegory, proposing that the young man looks as he does because he burns for the glory that Giambologna himself would, with the statue of the *Sabine*, eventually win.[20] Pietro di Gherardo Capponi, by contrast, assimilated the group to the Pygmalion myth:

Non questo ratto o quello il fabro elesse
in marmo rassembrar, ma vaga e bella
donna mostrarne e 'n leggiadri atti fella,
nuda e lasciva, ond'ogni cor n'ardesse.
Videla ardente giovine e le impresse
baci alle labbra e fisse il guardo in ella;
indi, rivolto all'amorosa stella,
novo Pigmalïon pregando fesse.
La Dea pietosa a le marmoree membra
Diè vita; ond'ei l'abbraccia; ella s'arretra
Dal predator (già tolta al mastro) in preda.
Quand'ecco il timor quella (e fia chi'l creda?)
L'amante il duol, lo stupor l'altro impetra.
Qual meraviglia è s'ognun vivo sembra?[21]

The sculptor did not choose to illustrate this rape or that one in his marble; rather, he wanted to show there a charming and beautiful woman; he put her in a graceful pose, and made her nude and seductive, so that every heart would burn for her. He saw the ardent young woman, and pressed kisses upon her lips,

and he fixed his gaze upon her, whence, turning to the star of love, and he prayed to be made into a new Pygmalion. The pitying Goddess gave life to the marble limbs, and so he embraced her. She, now prey, retreated from the predator—having already been taken from her master. Whence, behold, her fear—and who would believe this could happen?—petrifies her, her lover's suffering him, and the other's stupor him. What marvel is it if all, nevertheless, seem alive?

Like Davanzati, Capponi turns the sculptor of the work into a character within its fiction; he imagines that the stone woman in Giambologna's statue represents just that, a woman of stone, and the man below an artist. To follow Capponi, what Giambologna shows is not an abduction at all, but a sculptor lifting a marble up to the heavens and asking that it be brought to life. In this way, the conceit resembles one that appears in the most elaborate of all the poems written on the work, Cosimo Gacci's long eclogue, which describes a scene in which a statue of Hercules, having come to life to embrace a nymph, transforms, along with the nymph and an old man who was her guardian, back into stone.[22]

The fictions in all of these poems maintain a remarkable literal-mindedness. Repeatedly, the writers remind the reader that what they are looking at is a marble sculpture. Beneath the arch of the Loggia, they agree, is a big stone, one into which it is possible to read any number of imaginary histories. The question they posed to themselves was not just, "What is happening here?" but, "How is it that a *marble* figure has come to stand before us?" And it was by reconceiving his earlier bronze, adjusting its poses and rotating its "face," that Giambologna invited this question. Given his circumstances, the sculptor must have delighted in the opportunity to turn his audience's attention to materials to his advantage.

The Autonomous Marble

By the time Vasari reported it, the moral of his story about the naive viewer who admired Michelangelo's material more than his art could no longer have been that a viewer should *overlook* the media in which sculptors worked. Such an idea ran counter, notably, to the increasingly standard requirement that ambitious compositions be conceived such that the marble sculptor could carry them out in a single block of stone. The expectation arose in part as a kind of emulation of antiquity, an attempt in particular to rival the *Laocoon*, which, according to Pliny, had been executed *ex uno lapide*.[23] But once artists began deriving marbles from or inviting comparison with small bronzes, awareness that a sculptural composition was a single integral thing had a secondary effect, that of moving stones themselves toward a kind of independence.

One surprising aspect of the *Sabine* is its assertion that the multi-ton block doesn't quite *belong* where it stands. It imitates a placeless work like Ammanati's *Victory* or Michelangelo's *Prisoners* not only in its medium and theme but also in its resistance to any architecturally bound program, its openness to competing readings. As we have already seen, poets came up with any number of explanations of who its characters were. And while Borghini claims both that the work had to be named before it could be displayed in public and that he himself had come up with the "Sabines" as a title, he backs off when pressed on exactly who the characters were:

> Giambologna thus depicted the aforementioned Sabine maiden as the young woman who is being lifted up; her abductor represents Talassius. Even if he did not himself take her in public, his men took her for him, and he took her in private, stealing her virginity. And the old man below represents her father, since the story, as I have said, tells that the Romans robbed the Sabines from the arms of their fathers.[24]

The woman, for Borghini, can be identified only by the name of her tribe. The young man may represent Talassius, or he may not; all that can be said for certain is that the group includes a "Roman" and a Sabine maiden's father.

Giambologna only encouraged such uncertainties with the relief he affixed beneath the marble in the very years Borghini was writing. All of the men he prominently depicts there are nude, none is central, and there is no indication that one commands the others; if anything, the artist took pains to obscure whether one of the characters is Talassius or whether all are his subordinates, or for that matter whether any of the characters shown also appear in the marble above. Far from ending discussion or "labeling" the marble, the bronze only reinforces the marble's ambiguities. In this way it is of a piece both with Borghini's text and with the poems on the work, most of which were published with the Medici imprimatur, suggesting that the duke was content to allow the poetic challenge the statue represented to live on with it.

Bandinelli's and Ammanati's colossal additions to the Piazza obviously try to match Michelangelo's *David*, the major figure on their side of the square. Is the same true of Giambologna's *Sabine*? The statue dwarfs Cellini's *Perseus*, requiring a lower base to disguise the difference in size. Unlike Donatello's *Judith*, the work it replaced, its medium differed from that of the object to which it ostensibly serves as a pendant. Writers on Cellini's *Perseus* found that sculpture's environment, no less than its relationship to the statues around it, unavoidable. On the whole, by contrast, contemporary writers on the *Sabine* tended to ignore its predecessors, even to envision scenarios suggesting that the work only *happened* to end up where it did. Borghini writes that "the marvelous work, having been brought

3.3. Gianlorenzo Bernini, *Pluto and Proserpina*. Marble. Galleria Borghese, Rome.

almost to completion, was seen by his Highness Grand Duke Francesco Medici, who, admiring its beauty, decided that it should be placed where we now see it"— as though an appropriate place for the work occurred to him only at the end of Giambologna's labors.[25] And Gacci constructs an imaginary origin for the statue: to follow his fiction, the demigod Hercules, having witnessed the goddess Nemesis petrify a nymph, her abductor, and an old man who had been her protector, uses a magic rope to transport the statue from Seravezza to Florence.[26]

Seravezza was the site of new Medici quarries; Gacci's conceit serves as a re-minder that anyone looking at a sculpture as a block before looking at it as a composition would see it as an object from another place, one that could in theory always be moved again.[27] The *Sabine*, in short, invited a way of seeing that set the statue apart from the setting in which it happened to find itself, that made it, like the contents of a studiolo or Kunstkammer, into a collectible. In the decades to come, such visual habits would enable the rise of a new genre, the marble gallery statue. With Gianlorenzo Bernini's *Pluto and Proserpina* (fig. 3.3), like the *Sabine*

recognizably monolithic, and like the *Sabine* on a theme of abduction or forcible transport, the modern statue could join the company of antiquities, displayed as an ensemble but always individually transferable from the possession of one patron to that of another.[28]

The Block and Its Excavation

Unlike the casting of a bronze, the transformation of a stone block required the artist to engage an original form that he could reduce or disguise, but never quite eliminate. The blocks that came to sculptors were not standard, and drawings like the ones Michelangelo or Bandinelli made, of the pieces available to them, illustrate that the artist considered what he intended to make in dialogue with a preexisting form. The contract Bandinelli entered into for the quarrying of the block that would become his *Hercules* referred to the marble as a "figure" even before the artist had set a hand to it, and such language is not uncommon.[29] Giambologna, writing in May 1569 from the quarries at Seravezza, referred similarly to a block as "the first figure of white marble to come out of that mountain."[30] Late sixteenth-century viewers and artists alike imagined marble blocks as bodies to which something was done, often in surprisingly literal ways.

The marble from which a statue was made was always a "found object" in a sense that bronze was not, because the block always remained present: present to the sculptor to whom it could suggest ideas as well as limitations for his work, present to patrons and viewers who were apt to think in terms of how a sculptor had dealt with the thing he had been given to carve. The provocatively unfinished statues that came out of Michelangelo's Florentine studio on his death in 1564 made this kind of comparison unavoidable.

Faced with such a task, artists often found themselves pulled between two impulses. A contract Pietro Bernini signed in 1598, having returned to Naples from his native Florence, articulates the first. In agreeing to make two statues of Saints Peter and Paul, the sculptor accepted the following terms:

> [The statues] will be seven palms high and two and a half palms wide, carved in the round with the requisite draperies, well bored and worked as the said statues require. [The sculptor will] see that the hands and arms are well drilled and detached as well, and that the statues are filed and cleaned and finished to perfection.[31]

Bernini's patrons explicitly required him to separate the arms of his figures from their bodies, which in practice meant drilling holes through the block then

3.4. Pietro Bernini, *St. Paul*. Marble. Naples Cathedral.

gradually chiseling and filing the empty spaces into the contours of a hand, a sword, or an enshrouding cloth. The more dramatically the sculptor liberated an arm or an attribute from the block, the greater the show of virtuosity. One of the reasons Bernini pulled back the sleeves on statues like the *Paul* (fig. 3.4), or like the *Bartholomew* he carved for the Chiesa dei Gerolamini, was to minimize the impediments on the marble bridge that arm constituted.

The aesthetic to which the Bernini contract and sculptures point was not entirely new. Borghini admired the infants that Tribolo depicted, "all pierced and articulated from the marble" (*tutti traforati e spiccati dal marmo*), and Jacopo da Pontormo wrote as early as 1548 on the "difficulty of an extended arm," remarking on how hard this was to execute without the stone breaking.[32] A young sculptor in the 1560s who wanted to demonstrate his virtuosity could still do so by confronting this very challenge, as Vincenzo Danti did in his portrait of the Cosimo for the *testata* of the Uffizi (see fig. I.5), the right arm of which is propped up only by the fasces it ostensibly holds. Francavilla's independent sculptures similarly present

3.5. Pietro Francavilla, *Janus*. Marble. Palazzo Bianco, Genoa.

the fruits of lessons learned in Florence in these years: that splayed fingers, for example, nearly impossible to make on their own, could be achieved by placing something in the figure's hand: the keys in his *Janus* (fig. 3.5), or the lyre on his *Orpheus*, served as attributes, but they also liberated the sculptor to arrange hands in nearly any way that occurred to him. When we see the barely roughed out struts connecting club to head or billowing drapery in a work like Vincenzo de' Rossi's *Hercules and the Centaur* (figs. 3.6, 3.7), we have to ask whether the artist simply left the work unfinished, or whether he ran up against the limits of what he could do—or for that matter theatricalized the limits of what he knew could be done.

Such an exploration of limits separates the sculpture of the late sixteenth century from the path the aged Michelangelo himself had increasingly taken, a path that, at least until the years around 1570, seemed like it might have strong new Florentine proponents as well. Borghini's 1584 *Riposo* criticized Ammanati for not attempting dramatic flourishes in his *Neptune*, but such criticisms missed the

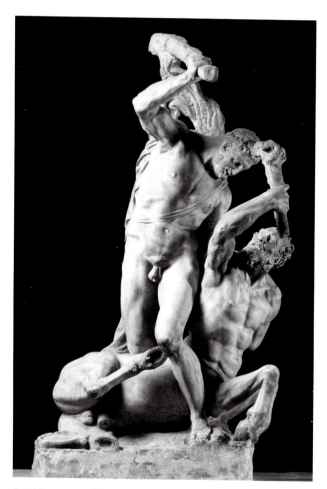

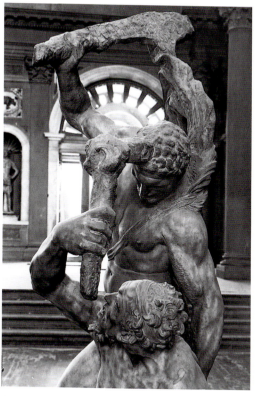

3.7. Vincenzo de' Rossi, *Hercules and the Centaur* (detail). Marble. Palazzo Vecchio, Florence.

3.6. Vincenzo de' Rossi, *Hercules and the Centaur*. Marble. Palazzo Vecchio, Florence.

point—or rather, illustrated a change in goals. As Ammanati wrote to Michelangelo in 1561:

> I started, in the name of God, to work on the marble of the *Neptune*, and in doing this I found myself more compelled by the need to remove as little marble as possible than by a concern that I would not remove enough.[33]

Rumors circulated that Bandinelli had purposely damaged the block, preventing Ammanati from taking the marble in a direction more similar to the *sforzati* bronzes all around it; at the same time, Ammanati was well aware that it was

3.8. Danti, *Honor and Deceit* (detail). Marble. Museo Nazionale del Bargello, Florence.

the marble of the Neptune, as much as anything, that viewers would be looking at, and any stone he chiseled, filed, or drilled away would reduce the inherently impressive block. The force of the work resided in the first place in its mass, and it is no coincidence that Ammanati chose to address Michelangelo, rather than any local advocate, with his thoughts, for he would have known perfectly well that Michelangelo's mature statues tended to keep legs locked together and arms pressed closely against bodies.

Danti's marble *Honor and Deceit* (see fig. I.3; fig. 3.8) demonstrates that sculptors could undertake compressed compositions by choice. Commissioned by Sforza Almeni, a supporter who seems to have sought for Danti of the same kinds of opportunity that Vecchietti provided Giambologna, the marble explores an approach to the block entirely different from that of the *Cosimo* portrait. The columnar composition makes no attempt to hide the shape of the marble pier Almeni secured his protégé; Honor's head corresponds to what would have been

the maximum height of the vertical block; the same figure's left breast nears one of the block's former long surfaces, and its right arm aligns with the surface that ran perpendicular to this, while Deceit's hand seems to press against an invisible surface. The bind that wraps both figures recalls the missing marble that had once contained the figures and evokes Michelangelo's description, in the poem Varchi made famous, of the superfluous marble that "circumscribes" the artist's idea before he goes to work. Bringing the figures in his design closer together allowed Danti to diminish the empty spaces that would have had to be cut between them, saving labor. Folding his figures back onto themselves, similarly, minimized the amount of marble Danti had to cut away, maximizing the figures' size. This last consideration helps explain the artist's decision to bend the top figure in his marble slightly downward, thereby creating the illusion that he had worked on a larger scale even than his materials allowed.[34]

Danti's own shift of mode between the *Cosimo* and the *Honor and Deceit* demonstrates that marble sculptors might well try to negotiate two competing conceptions of virtuosity, on the one hand exploiting the size and even the blockiness of the stones they were given, on the other showing their audacity in cutting it away. Giambologna's *Florence and Pisa* (see fig. 1.14) steers one version of the middle path. Though ostentatiously drilled and filed, allowing the viewer to look right through the marble at multiple points, it differentiates itself from Ammanati in part through a substantial augmentation of mass. Though the earlier *Victory* (see fig. 1.16) stands on her victim's leg, her foot pressing into his flesh, it is Giambologna's woman who makes her weight felt, in part because she is simply bigger-bodied, in part because her pose claims as much space in the statue's upper zone as the man's requires below. If the victim gives the impression of a figure compacted into a space too small for him to comfortably fit, the victor does the opposite, maintaining contact with surfaces and edges that no longer contain her. Part of this work's power resides in its memory of the block.

Fictions of Production

Danti's *Honor and Deceit* constrains not only the victim but also the figure who stands above; it is as though the same exterior agent who removed the outer marble also "bound" the whole composition together. The poets who responded to Giambologna's *Sabine*, similarly, allowed that what preceded the thing we see might not have been a different narrative moment but rather an earlier stage in the making of the work. Their inventions turn attention to how this or that object came to be the one before the viewer's eyes.

3.9. Battista Lorenzi, *Alpheus and Arethusa*. Marble.
Metropolitan Museum of Art, New York.

The personifications used to ornament fountains frequently worked in similar
ways, gesturing to a generative process—whether that of nature or of the artist—
while indicating that the sculpture resulted from this. When Vasari identified a
figure by Pierino da Vinci that by 1568 was standing in the garden of the Villa di
Chiaia in Naples as "a young river holding a vase that pours out water," he im-
plied that the figure not only produced but also represented a liquid form.[35] Much
the same could be said of Battista Lorenzi's *Alpheus and Arethusa*, in the Metro-
politan Museum of Art (fig. 3.9), which shows a woman transformed into a spring
after being pursued by a river god. The two artists' choice to show their figures in
standing poses made both works somewhat unusual; most late sixteenth-century
sculptures of rivers adopted either a pyramidal form that echoed the mountains
from which they originated or an extended incline, feet slightly lower than head,
that embodied that water's flow.[36] Ammanati's *Fountain of Juno* (figs. 3.10, 3.11), a

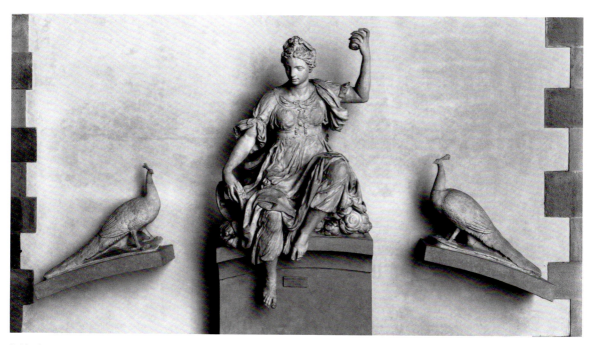

3.10. Ammanati, *Fountain of Juno* (upper figures). Marble. Museo Nazionale del Bargello, Florence.

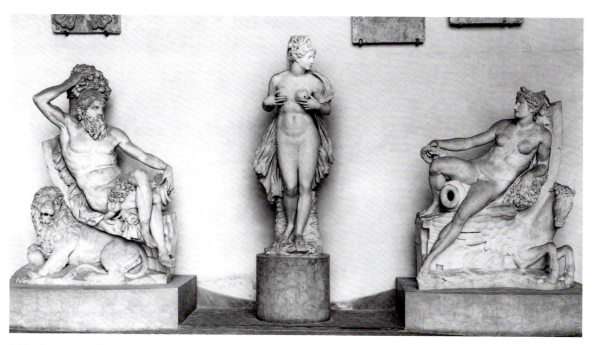

3.11. Ammanati, *Fountain of Juno* (lower figures). Marble. Museo Nazionale del Bargello, Florence.

3.12. Giambologna, *Appenine*. Mixed media. Pratolino.

fountain that, as we shall see, actually takes up a meteorological program, illustrates the convention: its Arno and Hippocrene rivers are the only nonvertical figures in the ensemble. Baldinucci wrote of Giambologna's Boboli fountain (see fig. 3.1) that the "three marble figures representing three rivers" "pour water into the basin, which represents the sea Oceanus."[37] As Baldinucci saw it, the granite basin constituted an abstract but generally homomorphous image of the great container that held all of the world's salt waters. A stone form might personify water, as Giambologna's *Nile* did, but it could also represent a watery form more directly; nothing, moreover, precluded the artist from taking both approaches in the same work.

Giambologna began working on the *Oceanus* in 1571, and he seems to have finished it about a year later. By the time he began work on his gargantuan *Appenine* (fig. 3.12) for the gardens at Pratolino, Ammanati had pushed him toward a still

3.13. Giambologna, clay model for the *Appenine*. Museo Nazionale del Bargello, Florence.

more novel way of thinking about water, its movement, and just what about both could be figured. The roughness of the massive work preserves at least a vestige of the figure's origins in a circa 1581 clay model (fig. 3.13), and the liquid forms of its hair and beard recall those of river gods: Tribolo had sketched rivers in similar poses for the New Sacristy of San Lorenzo. As Herbert Keutner pointed out, the payment for the foundations of the work identify the figure as a representation of the Nile, and Federico Zuccaro (who was close enough to the artist to draw his portrait) referred to what the sculptor had made as a "big river" (*gran fiume*).[38]

The consensus, nevertheless—the position taken by Francesco de Vieri, Ulisse Aldrovandi, and Raffaello Borghini—was that Giambologna had not reconceived the personified river so much as he had reacted to the one major representation of a mountain to be found in a Tuscan garden, the bronze bust Ammanati had made for Castello in 1563–65 (fig. 3.14).[39] Like Ammanati's statue, Giambologna's shows an old man who seems to have risen from the ground. Ammanati's bust-length format suggests an organic relation to the island beneath, and Giambologna's creates the same effect both through its sheer size and through his choice of materials, which, rather than differentiating the figure from its surroundings, hint that they have emerged from the earth. Both works refer to the hills on which the gardens were constructed, and, indeed, neither could work anywhere but the place in which it was found. Their connection to the ground beneath them is marked by the fact that both count among the very few Renaissance statues made for these gardens that are still in situ.

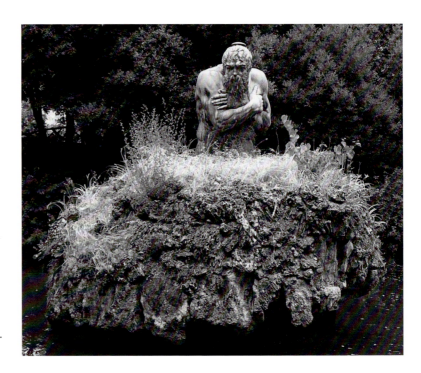

3.14. Ammanati, *Appenine*. Bronze. Villa Medici at Castello.

Ammanati's *Appenine* grasps itself to indicate that it "feels" cold, characterizing the temperatures to be found at high altitudes; originally water shot up from and then fell back down onto its head, giving the impression that the mountain it embodied was not just cold but wet.[40] Readers of Philippe Morel's now classic book on grottos will recognize the spiky formations that seem partially to have fallen from the later Appenine's skin as *spugna*, stalactites of sorts believed in Giambologna's day to be the stones that formed from hardened water. The work's effect is that of a grotto turned inside out.[41] The surface of Giambologna's figure, in other words, rematerializes the water from Ammanati's. If Giambologna's earlier monumental garden sculptures represented water through personification or through the suggestive form of a wide basin, the *Appenine* gives that water a productive past. If the *Bacchus* or the *Oceanus* put the figure in a position of command over water, the *Appenine* reverses the conceit; to follow its fiction, nature itself has generated a giant, using water that rose, fell, and congealed into its form.

Morel takes the *spugna* in grottoes to illustrate the idea of *natura naturans*, nature in process. Giambologna's *Appenine*, though, equally allows the opposite possibility: this is *natura naturata*, the product generated by motions no longer present, the residue of a now-stilled engine.[42] It is as finished as the marble *Sabine*,

just made by different means. In the days when Giambologna's *Appenine*, like Ammanati's, functioned as a fountain—its weight seeming to press forth water from the mouth below—this flowing liquid would only have highlighted the frozenness of the mountain's own surface.

Mercury as Water

The *Appenine*'s fiction of production reduplicates Ammanati's machine, rising from the ground, while the dripping forms that constitute beard and hair record a liquid descent. The figure ossifies a cycle of movement, and this relates it both to a topos from the period's science and to the common features of contemporary fountain design.

The circa 1565 bronze *Triton* (fig. 3.15) now in the Metropolitan Museum of Art may have been the central ornament for the earliest fountain Giambologna independently conceived. Had this blown a stream of water out through the conch it holds, it would have echoed the effect of Ammanati's *Antaeus* (see fig. I.4). In the event, as Regine Schallert has argued, the sculptor's earlier marble, *Samson*, took the triton's envisioned place on the basin at the Medici Casino; some scholars have found the combat scene unsuitable in a fountain context, though we should note that a chief difference between Giambologna's group and Michelangelo's is that the Fleming's directs the dying victim's mouth upward, so that he expires vertically.[43] It, too, showed Giambologna thinking through Ammanati's *Antaeus*.

Giambologna's most original response to the great Castello fountain, however, came out of a series of experiments focused on the figure of Mercury. Debate continues to surround the development of Giambologna's interest in this subject, as well as the status of the various small bronzes that seem to document this, but the current consensus has it that Giambologna designed his first *Mercury* in about 1563, one year after the *Samson*, while he was working on the *Neptune* fountain in Bologna. No three-dimensional record of Giambologna's initial idea survives, though it is likely that the statue would have resembled the form he gave his later versions of the subject; the original commission called for "a bronze image of Mercury descending from heaven."[44] Vasari described a work, perhaps derived from this model, as a *Mercury* "in the act of flying, very ingenious, holding himself up on one leg, and on tip-toe." This statue, sent to Emperor Maximilian II around 1564, is probably the one now in the Kunsthistorisches Museum in Vienna. In the Museo di Capodimonte of Naples, finally, is a *Mercury* generally identified as the one Giambologna sent to Ottavio Farnese in 1579, probably about a year after he completed it.[45]

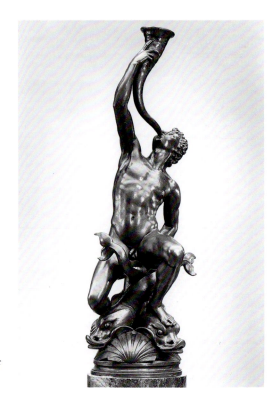

3.15. Giambologna, *Triton*. Bronze. Metropolitan Museum of Art, New York.

As Vasari already appreciated, these early *Mercury* statues, like the small bronze sent to Dresden in 1587, engage the problem of ponderation, a concern that scholars have long seen as central to Giambologna's art. Minimizing the evident support for a large figure had, from the previous century, been one of the ways in which sculptors showed off their virtuosity, and bronze allowed sculptors to do things that were impossible in stone. Giambologna would no doubt have known the figures that Verrocchio and Rustici (fig. 3.16) had made, in the round, with one leg raised, as well as the *Mercury* (fig. 3.17) Cellini included on the base of his *Perseus*, supporting the figure from the back with a metal brace and projecting it from the niche so that it appeared to float, one leg raised, the other merely touching the lion's head beneath it. By the time Giambologna started working through the figure, the choice to represent Mercury in bronze would have come with the expectation that the sculpture engage a specific technical challenge.

Seeing the considerably larger *Mercury* now in the Bargello (fig. 3.18) as an engineering showpiece, one that flaunts the artist's ability to balance a massive piece

3.17. Benvenuto Cellini, *Mercury*. Bronze.
Museo Nazionale del Bargello, Florence.

3.16. Giovanni Francesco Rustici, Mercuri.
Bronze. Fitzwilliam Museum, Cambridge.

of metal on a small point, helps explain the other major change Giambologna
made to his *Mercury* design when, in 1580, he confronted the task of making a
figure that could serve as the centerpiece to a fountain behind the Villa Medici
in Rome: the addition of the billowing head below the figure.[46] From a technical
point of view, the device allowed for a support that was slightly more expansive
than the ball of the foot would have been on its own; even the smaller figures now
in Vienna and Naples required the insertion of an extra piece of metal between
the figure and its base. The breath below the Medici *Mercury*, which small jets of
water would partially have hidden, naturalized the brace.[47] At the same time, the
liquid support added a fiction of production, an allusion to nature's own forces that
aligns the statue with a local tradition of fountain imagery.[48]

 Giambologna presumably added the upwardly directed ventilation to his exist-
ing invention to hide the fact that the figure could not really stand, to use Vasari's
words, "in punto di pie" (on tip-toe). In his own *Triton*, however, Giambologna had
also—following Ammanati—experimented with the idea of developing a fountain
conceit around a figure that blows water up into the air. Even in purely visual terms,
Giambologna's way of expanding his invention helped adapt the *Mercury* to its new
role. Just as the *spugna* makes the *Appenine* look like a garden sculpture, so does the

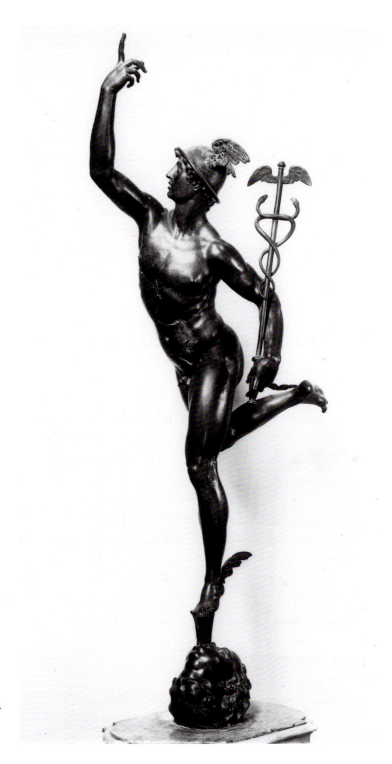

3.18. Giambologna, *Mercury*. Bronze.
Museo Nazionale del Bargello,
Florence.

breath that supports Mercury nearly suffice in its own right to make the statue "fit" a fountain. At the same time, the elision of his earlier *Mercury* invention with the fountain idea lent water a new role, both as substance and as theme. The modifications Giambologna introduced into the conventions of the fountain figure give the impression that the *Mercury*, no less than the *Appenine*, was a product of nature, personified. Other fountains enacted the operation Giambologna portrayed with combinations of metal and water spirits; his combined both in metal before the water was even turned on; the figure continues the breath beneath it. And whereas other fountains had the figure do the breathing, Giambologna made his figure the thing breathed out, as if a body of water had been blown into the air.

Giambologna's contemporaries would not have had to look far for reasons to associate Mercury with water: Ovid, in his *Fasti*, had described a Mercury fountain, and sixteenth-century editions of Aristotle named Mercury as the god who oversaw the element of water.[49] Late sixteenth-century thinkers also had available a common way of describing the kind of thing that transpired beneath Mercury's foot. Their idea, as familiar in Giambologna's time as gravity is today, was that water exemplified the earth's "exhalations."

Derived from the Latin *exhalatio*, which in turn rendered Aristotle's αναθυιασις, exhalation designated the separation and upward expulsion of a lighter, thinner stuff from a baser, heavier element. For Aristotle, exhalations were in the first place geological phenomena; arising from earth and water, they were responsible for the production of lava, salt, and any number of other artifacts.[50] As far as fountains are concerned, however, what mattered most was that exhalations produced rains and winds. As Aristotle explained in the *Meteorologica*:

> In the earth, too, there is, to be sure, much fire and much heat, and the Sun not only draws up the moisture covering the earth's surface, but also, heating the earth itself, dries it out as well. The [resulting] breaths, of which we have previously spoken, are of two kinds, one that is full of vapor and the other smoky, both of which must be made. Of the two, the exhalation that holds a greater amount of moisture is, as we have explained, the origin of rainwater: [the exhalation] that is dry, on the other hand, is the origin and the nature of every wind.[51]

Aristotle observed that rain fell from clouds to the ground, but hypothesized that the water in clouds originated inside the earth. Nature, he surmised, blew vapors up from the ground; it was those vapors, condensing, that then fell back down from the clouds.[52]

The *Meteorologica* was, by 1580, the standard account of how the water cycle operated. The text was widely available in both Latin and Italian editions, and its contents provided basic points of reference for the most up-to-date scientific literature.

One particularly relevant modern writer was Camillo Agrippa, the Roman engineer who had executed the hydraulics for the Medici fountain Giambologna was to decorate. (Giambologna was in Rome in 1572 with Vasari and Ammanati, and he could have visited the site of his future fountain at that time.) Agrippa's 1584 dialogue, "On the generation of winds," connects this topic to the water cycle,[53] and a later dialogue treats the phenomenon he called "terrestrial exhalation" (*l'esalatione terreste*), which he took to be the cause of images people see in the air.[54]

Giambologna, moreover, must have known the key arguments from Aristotle, since the relevant passage from the *Meteorology* had provided the core idea for Ammanati's *Fountain of Juno* (see figs. 3.11, 3.12). Ammanati seems to have completed the figures for this project over an eight-year period beginning in 1555, though Cosimo, its patron, never installed the fountain in its intended location, the Great Council Hall in the Palazzo Vecchio. Few surviving visual and textual responses to the group date from before the 1582, when Duke Francesco had the fountain erected at Pratolino. Tanai de' Medici, a court secretary, then wrote that the ensemble showed how "the earth sucks in the air and then casts forth the water," a curious description since none of its characters seem to "suck in" anything.[55] The broad, even casual language, which he might just as easily have applied to the smaller marble figures on Ammanati's more recent *Neptune Fountain*, suggests the hold that "exhalation" had on the period's meteorological imagination. It is as though Tanai *assumed* that this is what Ammanati had shown, to the point that he did not need the confirmation of close observation.

The *Fountain of Juno* choreographed its water to emerge from the tipped urns of the Arno (left, sitting on a Marzocco and originally paired with a now lost personification of Florence) and the Hippocrene (right, sitting on the Pegasus that caused this to flow, and originally paired with a figure of Temperance). At the center stood Ceres (Earth), and it must have been her action of squeezing water from her breasts, as much as anything, that led Borghini to report that the fountain (which he saw at Pratolino, near Giambologna's newly completed *Appenine*) depicted the "generation" of water.[56] Juno, at the top, holds a tambourine meant to suggest the thunder the gods could cause, and storm clouds gather beneath her. The meteorological point is that the water pressed from the Earth will rise to the sky, then fall as rain, and the stone arc that physically connected the characters may even represent the waters' ascent. Where the two sides come together, Juno presides over a condensation, it, too, materialized in stone.

At the time he made his Medici *Mercury*, Giambologna might only have known Ammanati's individual figures, though drawings of the whole composition did circulate. Whatever he saw, however, Tanai de' Medici's way of reducing the conceit—to a demonstration of how the earth sucks in then casts forth water—could

just as easily describe his own invention. Essentially, Giambologna took the common sixteenth-century notion of exhalations and adjusted the sculptural form so as to place the emphasis on *lift*. This again engages Ammanati's *Hercules and Antaeus*, in which the victim exhales his impressively vertiginous spray of spirits because the strongman has raised him up from the earth. Where Ammanati shows the struggle involved in making water rise, though, Giambologna lends an insistent gracefulness to Mercury's "run." This is not just because the cause of the exhalation, the force deployed within the earth, is suppressed. It is also because for Giambologna, the look of unimpededness, the *lightness* of the risen water, offered an appropriate metaphor for the kind of figure he had designed.

All Western languages use anthropomorphisms to convey liquidity: rivers "run," blood "courses," oceans form "currents." These linguistic coincidences seem especially suggestive when classical etymologies of the name "Mercury" are taken into account: "Mercurrius, it is said, is so-called from *medius currens*, because speech runs [currat] between men [inter homines medius]."[57] Where Giambologna characteristically went beyond Ammanati was in inviting comparison between the action his statue showed and the circumstances of its production. The fact that Giambologna made his statue in bronze amplifies the parallels, for nearly anyone Giambologna would have talked to about his casting operation would have spoken as though the artist were working with water. Metal, being fusible, verged on liquidity, fluidity, and motion. Renaissance metallurgists commonly described bronze as a sort of water. When Cellini—like Giambologna a sculptor, founder, and fountain designer—wrote that metal, upon melting, "turns into water" (*viene in acqua*), he merely expressed the commonplace that the pouring of bronze sculpture meant turning its material, if only momentarily, back into an originary watery state.[58] Florentines in Giambologna's day were perfectly apt to look in a bronze sculpture's imagery for metaphors of its casting. Adriaen de Vries, who was in Giambologna's studio in just these years, eventually made such metaphors an explicit part of his own art, folding the sprues and air vents necessary for the casting mechanism into the imagery of the work.[59] In Italian, such devices were alternatively called *sfiatatoi* (sprues, or, literally, "exhalers") or *venti* (in Italian, both "vents" and "winds").[60]

The *Mercury* we see is one that has already hardened out of breath, out of water, into a frozen, lasting state. Like the *Appenine*, it is an example not of *natura naturans* but of *natura naturata*. And to compare it in this way to the *Appenine* is to say that the *Mercury*, too, ultimately belongs in the context of the Renaissance grotto—precisely what Hubert Gerhard and Friedrich Sustris thought when importing Giambologna's conceit for a grotto at the Residenz in Munich (fig. 3.19).[61] Shown inside, rather than above, the Earth, the most relevant classical point of reference this time may be a different passage from Aristotle:

3.19. Hubert Gerhard and Friedrich Sustris, *Mercury*. Bronze. Residenz, Munich.

All metallic things, all that is fusible or ductile—things such as iron, bronze, or gold—are related to the vaporous exhalation. The vaporous exhalation, when it is enclosed within the earth, or within tightly fitted stones, is compressed by the powerful dryness of those things and solidifies in the manner of dew or frost, once it is excreted.[62]

To follow Aristotle, the exhalation that originated the fountain's water also, under the right conditions, produced metal. Metal was not just a type of water; its very transformations between solidity and breath, impediment and spirit, mimicked water's own. Metallurgic connotations like these would have been especially apt in a region like that around Munich, famous for its mines. But as evidence of the reception of Giambologna's piece, the Gerhard *Mercury* also encourages a particular view of the role of Giambologna's blowing support. It could well be that Giambologna placed his figure atop an exhalation not to identify the force that counteracts the weight of his bronze but rather to fictionalize the shifts in state of which bronze is capable. Mercury's flight is an elegant figure of the grotto's vapor, the exhalation and condensation that constitute at once the artificial and the natural creation that happen within the grotto's space. Frozen amid the stones, Mercury hovers, its once-running body immobilizing the breath that gave it feet.

4

POSE

Sculpture as Taxidermy

Reading the *Sabine* as a piece of marble and the Medici *Mercury* as congealed liquid aligns them with Danti's bound *Honor*, emphasizing their stillness and permanence. Yet this is not what all scholars have seen in the works. Elisabeth Dhanens's great monograph on Giambologna maintained that the particular interest the artist took in themes of motion distinguished him from predecessors like Bandinelli.[1] Claudia Kryza-Gersch, one of the organizers of the beautiful Giambologna exhibition in Vienna in 2006, writes that in Giambologna's *Labors of Hercules*, "the hero is depicted in action . . . caught in the process of executing his task."[2] And Detlef Heikamp, writing on the bronze birds Giambologna and Ammanati together produced for the grotto of the Medici garden at Castello (figs. 4.1, 4.2, 4.3), makes a still more surprising claim, seeing in the sculptures a particular sense of time:

> [Giambologna] captures the animal while it is in movement, or better, captures a single phase of a transitory act that takes place in a fraction of a second. The operation is facilitated in modern times by the technology of the photograph or the cinema, such that various reflexes of motion can be fixed with ease: when, for example, a pigeon is preparing to fly and extends its wings, even just barely, the tail by reflex opens like a fan and points downward. Giambologna, who

4.1. Ammanati, *Falcon*. Bronze. Museo Nazionale del Bargello, Florence.

4.2. Ammanati, *Owl*. Bronze. Museo Nazionale del Bargello, Florence.

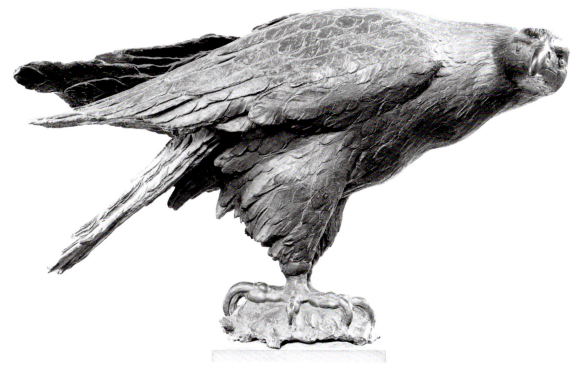

4.3. Giambologna, *Eagle*. Bronze. Museo Nazionale del Bargello, Florence.

knew well the dynamics of concatenated movements thanks to his experience representing horses and other large animals on the run, was now given occasion to extend his abilities to birds as well.[3]

Working against the traditional idea of the period's "mannerism," Heikamp's description of the birds assimilates Giambologna and Ammanati both to a pointedly modern form of naturalism. He sums up this way: "if we knew nothing about the history of the Grotto and its avian bronzes, we might think that they had been created in the positivistic nineteenth century."[4]

Characterizations like these can encourage the assumption that the best sculptures approached the quality of a living, moving being, and they call on us to identify the "moment" the sculptor represented. Yet we should be cautious in bringing a photographic paradigm to artists who lived not only with a different world of technology but also with a radically different understanding of the relationship

between rest and motion. We might ask whether any sixteenth- or seventeenth-century sculptor would really have been able or even wanted to capture an action so quick as to be almost invisible. More fundamentally, though, we need to explore what the alternatives to a fleeting image might look like, what the alternative to the question, "What instant does this image represent?" might be.

After all, it would be hard to think of a premodern medium more dissimilar to photography—particularly in its capacity to fix the transient sight—than sculpture. The instantaneity of the photograph, when such an instant existed at all, was a function of its mechanical registration, what the snap of the shutter controlled. Yet even working with a relatively less laborious technique like modeling in clay, it could take days to create a figure. When sculptors described their work, they emphasized slowness.[5] Even if an artist could see something that took place in a narrow moment, capturing this in an object would have to depend on memory more than on observation, subjecting any depiction to a paraempirical understanding of the world.

The transitory acts Heikamp describes evoke the serial photographs of Eadweard Muybridge or Étienne-Jules Marey. But the sequential images late sixteenth- and early seventeenth-century artists made in response to sculptures did not represent different moments but different points of view (fig. 4.4). They upheld compositional principles that went back at least as far as Danti's *Honor and Deceit*, where the motif of the bind leads the observer around the sculpture, and where the statue itself never quite offers an aspect that feels complete; the cumulative effect of such drawings and prints was not that of witnessing bodies in motion but of discovering different implications within a single arrangement. Contemporary texts, in a related vein, suggest that viewers did not regard movement itself as a collection of instants, but as a condition, the factors of which were available to description. Danti makes just this point, with specific reference to birds, in the treatise he published at the very moment Giambologna and Ammanati were creating their Castello bronzes.

Danti may have conceived his *Treatise on Perfect Proportions* as a belated execution of a project that Michelangelo, to follow the biographer Ascanio Condivi, had conceived but never written, focusing on the relation of anatomy to movement. Unlike Michelangelo, though, Danti thought that animals posed a particular kind of challenge to sculptors who would show off their artfulness:

Beyond the fact that their composition is for the most part different from one to the next, [animate things] must moreover move themselves, and such a movement, [inasmuch as it involves] various parts of the body, increases the artifice and difficulty, for is it necessary not only to compose the parts of a sensate or

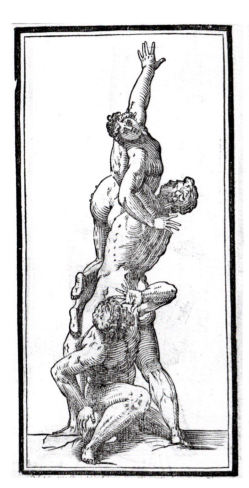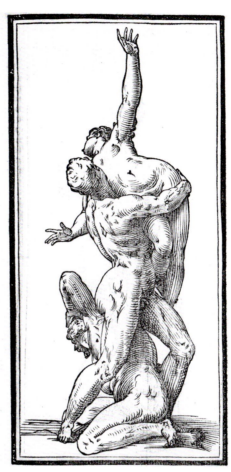

4.4. Woodcuts from *Alcuni composizioni di diversi autori in lode del ritratto della Sabina* (Florence: Bartolomeo Sermartelli, 1583). Beinecke Library, Yale University.

intelligent animal well—that is, such that they correspond to the whole—but also to give those parts a movement and pose.[6]

This way of thinking about the animal has less in common with stop-motion photography than with late Renaissance drawing practices. A sheet by Ammanati himself (fig. 4.5), for example, shows the muscles and bones that allow the arm to occupy a particular position. The artist will not attempt to describe what he sees in a fleeting instant but will demonstrate what he understands about how the animal is put together, how its parts work. Danti specifies that the skillful sculptor will portray animals "in the act of walking, running, jumping or doing other,

4.5. Ammanati, architectural and anatomical sketches. Pen, ink, and chalk on paper. Uffizi, Florence.

similar things, depending on what is fitting," though he also specifies that what the artist does is to take a creature that once moved itself, dismantle it, recompose it, and reanimate it.[7] For all of Danti's talk of "senses," "causes," and the means a species has to pursue its ends, his primary interest is what he calls composition; when he invokes movement, he immediately clarifies that by "movement," he means *attitudine*, pose.

Danti's examination of motion was not a study of transitory states, but rather an investigation into the generic qualities that differentiate species and thereby imply their particular locomotive capacities. His whole approach to the body derives largely from a reading or mediated reception of Aristotle, particularly the *Parts of Animals*, where the Greek philosopher had treated the components of any given animal's body as means that allowed the pursuit of a specific range of ends.[8] What sets his text apart mainly reflects the task he set himself of translating a philosophical and physiological analysis into a set of specifically artistic tasks:

> Thus, having considered what a great variety is found in the sum of parts that compose the whole of any animal (a variety that will be discussed at greater length in the book on the "causes" of figures), what remains to be seen, as I said a short while ago, is the variety that all of these parts accidentally create as they move and create various poses.[9]

Danti would have the sculptor make a calculation, considering the range of effects he might achieve, knowing that the animal was a kind of machine, one that could do certain things and not others.

With regard to birds in particular, observation comes into play less in the study of the living creatures than in dissection, the most useful means by which the artist can comprehend the "causes" that control the visible exterior:

> And if perhaps this does not seem pertinent in the case of birds, since they are covered with feathers that do not allow the muscles to be seen, such will not be the case once we see the effect of those muscles. To be sure, one does not, with birds, see the muscles, because they are covered with feathers, but this does not mean that one does not see the beautiful or ugly composition of its figure as a whole. And in any event, seeking the causes in one of these birds by means of dissection, we will be capable not only of [establishing] their particular proportions but also of shedding a bit of light on all other species of birds universally.[10]

As with animals in general, Danti thought that the way birds were put together constituted at once the natural historical evidence that distinguished them in kind and the design that lent them their beauty. In encouraging artists to arrive at the representation of birds through dissection, though, he makes it clear that the

birds the sculptor will depict are dead, even if posing them constitutes a measure of reanimation.

Danti dedicated his treatise to Duke Cosimo, and he may well have been keeping tabs on the sculptures coming out of the Ducal workshops. Minimally, though, Danti's perspective valuably documents one way that contemporaries thought about the sculptural representation of birds, and about the variety of naturalism this should involve. The *Treatise* helps make sense, for example, of the curious decision to install Ammanati's and Giambologna's birds in a grotto:

> The end of the sensate composition of any figure of an animal is to serve all the operations of the senses sufficiently, and the end of the said senses is to govern the composition, such that by means of sense the body is provided with food. In this manner one end and the other alternately help one another, and together they provoke and pursue generation, which is what nature ultimately desires in them.[11]

To say that the senses and the composition of the bird aimed ultimately at generation, that generation was their final purpose, was to tie the birds back into the idea of nature as a productive system. The association of the body's composition with its species' reproductive means was a common trope in Renaissance zoology and physiology, and within the grotto, the play of water would have reinforced this "generative" aspect of the bronzes: Michel de Montaigne, seeing the birds in June of 1581, wrote of the birds "yielding water here from a beak, here from a wing, here from a talon or an ear or a nose."[12] The installation set the bronzes within the water's prolific stream, the same stream that seemed to harden into *spugna* on the grotto's walls. At the same time, the movement of the water in this case did not drive automata, as it did in some other gardens, but only accentuated the stillness of the birds.

Heikamp has suggested that Giambologna in particular "always preferred to present birds at the moment they alighted or when they were about to launch themselves in flight." But what is it in the avian bronzes that points to anything so serial, allowing a real imagination either of what has happened just before or what will happen next? And what is it about these creatures that suggests the actions they do perform are self-motivated, rather than imposed from without? The variety of fixing that Giambologna and Ammanati both exemplify looks much closer to what Danti envisions—the art of the taxidermist, not the photographer. And if, as scholars have suggested, we regard the grotto as a kind of collection, one conceived on analogy with the *studiolo* or *Kunstkammer*, the bronzes there will more resemble the stuffed, artificially arranged bodies that shared space with artworks and scientific books in such rooms than the living things that flew between the garden's trees.[13]

Action without Motion

The bronze birds yield to pose, and in this way they resemble the artists' human figures. With birds and humans alike, moreover, Giambologna's conception of sculpture as fundamentally a practice of modeling encouraged intensive experimentation with pose and with the representation of action, as some of his early critics, at least, recognized. Here is Baldinucci, writing on the marble *Hercules and the Centaur* (see fig. 7.18) that Giambologna unveiled in 1600 at the Canto de' Carnesecchi in Florence:

> And I would respond to whoever writes, with the sentence of I know not what fencing master, that if that Hercules discharges the blow, it would not be within range to strike the centaur, that if one considers properly, one will clearly discern that Hercules is in the act not of beating the centaur, but rather of drawing up his arm to bring it in position to strike. And if, moreover, such a response as this is not satisfactory, I would go on to say that perhaps Giovanni Bologna himself foresaw this [criticism], but nevertheless, the attitude in his model having turned out so marvelously well, he made the marble statue for *that* reason—that is, to assure himself that the statue would never, to its shame, have to discharge an empty blow, and thus would never provide grounds for others to mock him.[14]

Although the passage presents two different manners in which Hercules' gesture could be taken for an action, it ultimately suggests that that gesture might well not coalesce in this way at all, embodying instead a particularly arresting arrangement of limbs. The criticism that Giambologna failed to properly portray an action, Baldinucci suggests, carries no punch, since the invention of a beautiful pose ultimately justified the artist in ignoring action altogether. As Baldinucci would have it, Giambologna's marble centaur was a kind of portrait of its model, a statue of a statue.

Writers on Giambologna, and to a lesser degree on Ammanati and Danti, have tended to emphasize his proclivity for dynamic narratives, an aspect of his work that seems to make him a precursor of Bernini, of the "Baroque," and ultimately of modernity. Baldinucci's notion that Giambologna's sculpture had to be understood in the first place as a sculpture of models, however—monumentalized "poses" that had been worked out in the first place in wax or clay—encourages a radically different way of looking at the works. Consider the *Bacchus* (see fig. 2.7), which may well be Giambologna's earliest freestanding figure. What sets Giambologna's invention apart from those of Michelangelo or Sansovino, it might seem, is the muscularity

he lends the body, the forcefulness of his figure's forward stride, its active rather than passive relationship to the wine cup it holds. But does the statue really depict any *motion*? Renaissance writers on the arts from Alberti on specified that where there is motion, it must have a direction, but it is impossible to determine just where Giambologna's Bacchus, if he is moving, is moving *to*.[15] He cannot be going forward, as his lifted right heel might seem to suggest, since his left foot is planted squarely on the ground, and his drink falls in such a way that, if he were to go as the right foot directs him, he would walk into its stream; such a motion would have subjected the statue to the same jokes that satirists used against the *Hercules*. The bronze's near transformation of the work from a Bacchus to a John the Baptist at the start of the seventeenth century, moreover, suggests that some viewers saw it not as walking but as reaching—that is, not really moving at all.[16]

Or consider Giambologna's *Neptune* fountain in Bologna, from a few years after this (see fig. 2.8). Cesi had specified in his written program for the statue that it should "hold the trident in his right hand, just as if to strike a blow," yet Giambologna instead turned the right arm behind the figure in a way that seems to paralyze sooner than to empower it.[17] It is difficult to imagine this Neptune doing much of anything, though easy to appreciate the figure, as Baldinucci appreciated the *Centaur*, as the large-scale replica of an exquisitely turned model. One historical task, for those who would make sense of the formal and compositional choices that Giambologna and his contemporaries made—choices that, in their simultaneous pursuit of action and stillness, begin to seem paradoxical—is to reconstruct the critical horizon in which the artist might have arrived at the effects writers like Baldinucci so appreciated.

The Taste for Stillness

In chapter three of his 1766 book, *Laokoon*, Gotthold Ephraim Lessing defined two principles for the visual artist, and for the sculptor in particular. By contrast to the writer, Lessing thought, whose task it was to narrate a sequence of events, the visual artist could "never make use of more than a single moment in ever-changing nature."[18] Yet given that the works such artists made were by nature unmoving, Lessing thought, it was also the case that this single moment on which the artist focused "must express nothing *transitory*."[19] Painting and sculpture, by contrast to poetry, could not show change over time. Rather, their task was to lend momentary subjects "immutable permanence." Whatever the artist showed his characters doing, he needed to take into account that the subject would be performing the act given to him unceasingly.

Scholars who work on premodern art and its literature tend to regard Lessing's text as a watershed. His arguments about the fundamental difference of painting and sculpture from poetry and literature look like a radical break from the tradition of the *paragone*, which treated all the arts as siblings that pursued the same ends, if by different and sometimes even competing means. While the rule for the period between the end of the Middle Ages and the beginning of the modern era was *ut pictura poesis* (as with painting, so with poetry), Lessing turned *pictura* and *poesis* against each other. Drawing out Lessing's protomodernity, however, obscures the more traditional aspects of his thoughts on temporality within the visual arts. Lessing's association of sculpture with permanence, to begin, owes much to the Renaissance commonplace that sculpture's very raison d'être was to perpetuate its subject. Whenever Renaissance and later writers aligned sculpture with commemoration, they anticipated Lessing in suggesting that the function of sculpture was to preserve what would otherwise disappear.

Earlier writers who took sculpture to eternalize what it showed concluded, as Lessing would, that this bore implications both for the kinds of subjects sculpture treated and for the way those subjects had to be handled. Unlike Lessing, they did not focus their attention on the represented figure's *expression*, but they did sustain the idea that sculpture should avoid showing a merely momentary condition. One particularly useful example of this, because it treats the subject at such length, is Gauricus's *De sculptura*.

Gauricus viewed the temporality of the artwork as an extension of perspective, perhaps since both depended on an established (spatial or temporal) point of view. As he saw it, any sculpture could, in theory, represent one of three states. It could, to begin, be static—this was the condition from which the objects received their very name, since the word "statue" derives from the Latin "status," literally "made to stand still." The category of the static included all those statues that showed upright (*recti*), columnar figures, but also those whose figures seemed to be leaning (*obliqui*) or even flexed or bent (*flexi*). The fact that Gauricus distinguished this condition from what he called *otium*—the kind of thing one saw, for example, in images of contemplation—suggests that he associated stasis especially with torsion. Gauricus's stasis, in other words, differed from rest. And he distinguished both stasis and otium, in turn, from the third condition sculpture might represent, that of motion.

Gauricus's discussion of motion in sculpture begins by noting that "the greatest philosophers and Plato" took there to be three kinds of motion: initial, intermediate, and terminal. Here Gauricus refers to classical physics, and more specifically to the idea that motion derived from and depended on impetus. In Gauricus's day, these ideas had been elaborated with great subtlety by Leonardo da Vinci, and

Frank Fehrenbach in particular has argued for their relevance to Leonardo's painting.[20] This only makes it all the more striking that when Gauricus invokes impetus theory, he does so with the sense that this theory ultimately proved *irrelevant* to the visual arts. Though he made a point of demonstrating his awareness of Plato's account, Gauricus declined to apply this to painting or sculpture, and he went on to assert that viewers in his day weren't even especially *interested* in attempts to look for visual renderings of impetus. What his contemporaries most praised, Gauricus writes, are "those states that seem to precede or follow from a motion."[21]

The conclusion is not entirely surprising, given the way the rest of the discussion has gone. In associating flexions with stasis, after all, Gauricus had disqualified the means for representing motion to which the sculptor might most obviously resort. The photographic age has tended to associate torqued bodies with transitional states—Freud famously reconstructed a whole sequence of actions that preceded and followed from Michelangelo's *Moses*—yet Gauricus thought that such bodies ought rather to be regarded as holding a pose. Gauricus's views, by contrast to Lessing's, resulted not from any concern with truth to medium but from a sensitivity to how language shaped an art-critical sensibility. Indeed, when Gauricus writes "illi status laudantur qui vel a motibus facti videbuntur vel in motus tansierint," the word *status* recalls the etymology of "statue" he had elaborated one paragraph earlier, as if "state" and "stillness" were one and the same thing, and were both inseparable from statuary.

None of this is to say, of course, that Renaissance and later statues were entirely removed from a conception of motion. According to Gauricus, viewers did not praise all images of stasis, but rather those "that seem to proceed or follow from a motion." A "flexed" body may represent stillness rather than motion, but it could also imply a motion at one remove, alluding to it rather than embodying it. Gauricus goes on to give a series of examples, framed by the vocabulary of classical rhetoric and illustrated with citations from classic poetry, of the ways this might be done. A sculptor might employ *enárgheia*, "when, in an event, what happened earlier it represented with great evidence." Or he might employ *émphasis*, "when one shows what is about to happen just after a given event." To later readers, familiar with Lessing, it may sound like Gauricus has already arrived at something like the idea of a "pregnant moment" that gives free reign to the imagination of the spectator. Gauricus's whole way of getting to this idea, however, is different, since for him, sculptors refer forward and backward in time to emulate poetry, not to do something specifically visual.

The distance between Gauricus and Lessing comes most into focus when Gauricus explains that the use of *enárgheia* or *émphasis* is really a kind of ornament, a way of showing things with richness and complexity rather than with simplicity

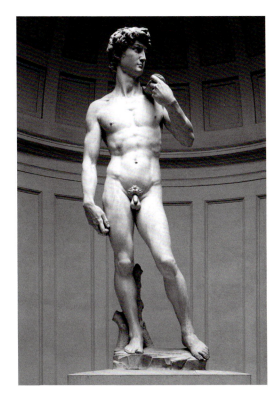

4.6. Michelangelo, *David*. Marble. Accademia, Florence.

and clarity. Heterochronicity is a concern to the sculptor because elevated subjects, things worthy of being portrayed on a grand scale or spoken of with eloquent flourish, demand expansive chronological resonance. A reference to a past or future occurrence is a kind of addition to the work, comparable to the rest of a figure's attributes, which serve primarily to enrich the viewer's sense of that subject's identity.

The point can be illustrated with the most prominent local work completed in the year Gauricus's treatise was published, Michelangelo's *David* (fig. 4.6). The colossal scale of this marble differentiated it sharply from its predecessors, but then so did its nudity. In Gauricus's terms, these two aspects of the work were complementary, for just as the sling David holds could serve as a kind of *émphasis*, alluding to his impending defeat of Goliath, so could the figure's nudity exemplify *enárgheia*, referring to what had happened immediately before in I Samuel 17:38–40:

> And David, having girded his sword upon his armor, began to try if he could walk in armour: for he was not accustomed to it. And David said to Saul: I cannot go thus, for I am not used to it. And he laid them off.

The nudity likens the statue to an antiquity, but it also recalls an earlier narrative episode, the now *completed* action of David removing his armor. The nudity enriches the work by showing the figure in a *status a motibus facti*. The statue as a whole is not completely at odds with the performance of an action, but it is motionless—in fact, one might well wonder whether the youth is meditating briefly before "he took a sling in his hand, and went forth against the Philistine," whether he is actually sizing up the giant he will attack, or whether he is simply wearing the permanent scowl required of sculptures that guard important buildings.

Gauricus's stated opposition to the transitory is significant not because it exerted a particular influence on any individual artist or viewer, but because it theorizes what the art itself would suggest was a shared attitude, one that governed a long tradition of sculptural choices and responses. We have already seen how, in making sense of Giambologna's *Sabine*, poets tended to read it in heterochronic terms, starting with the presence of the marble that constituted the statue and proceeding from that to the imagined events that led to its creation. Gauricus would characterize the narrative elements such poets offered as a kind of temporal ornamentation, a complexity of story that matched the work's complexity of form. At the same time, he makes sense of the poets' insistence on the stoniness of the sculpture, a stillness not compromised by the temporal richness the poems unfold. Their admiration of the work acknowledged and even to an extent depended on its constancy, as if that constancy were not a limitation but an attraction.

The idea of the enduring image was something the advocates for sculpture regularly brought up in the *paragone* debate, and it is not surprising, therefore, that sculptors often approached their subjects in ways that underscored qualities of permanence. Throughout the earlier modern period, in fact, it is extremely rare to find independent statues of figures in motion. Taste itself worked against this, and those artists who did activate their works, like the Florentines Vincenzo de' Rossi or Francesco Mochi, often paid a price for it. (Giovanni Battista Passeri, attacking Mocchi's *Veronica*, even recycled Gauricus's etymologically based reasoning, writing that not being "permanent and immobile," the statue "lost its proper essence.")[22] This sensibility can run counter to our own, formed as it has been by photography and cinema, which encourage us to wonder what instant a depiction represents, and even to see the sculptor's ability to capture an instant as a mark of discriminating naturalism. Aby Warburg's *Pathosformel*, David Summers's chapters on "movement," and the more recent literature dedicated to the ways artists tried to "bring to life" their artworks share the notion that late Renaissance artists, in the name of naturalism, aspired to overcoming the inherent deadness of the sculptural medium.[23] To borrow a phrase from Kenneth Gross, the Renaissance appeared to

hold onto the "dream of the moving statue," and the closer a work came to fulfilling this dream, the more praiseworthy it has seemed.[24]

To be sure, critics recognized "liveliness" and "spiritedness" as virtues, and some sculptural assignments might even seem to have called for the portrayal of action as such. At the same time, these conditions defined a paradoxical challenge: to rival the vividness of poetry while also allowing that the production of a sculpture was an act of perpetuation, to celebrate famous actions without reducing the sculpture to an image of transience, to evoke motion but only indirectly. The imperative of stasis functioned as a kind of compositional control, one that led the sculptor toward a study of displacements.

Danti on Action versus Product

One such displacement depended on readings of ancient philosophy. Danti's *Treatise*, in addition to commenting on the composition of the sculpted body, takes up a distinction Aristotle had made in the *Nicomachean Ethics* between what the contemporary Italian versions of the text termed the *operatione*, what an agent did, and the *operato*, what traces that action left behind.[25] Probably informed by local Aristotelians like Benedetto Varchi and Bernardo Segni, Danti distinguishes between "doing" or "acting" (*fare*) and "producing" (*operare*), clarifying that "with this category that I am calling 'doing'—into which I would place all movement—the effect [of that doing] does not remain in body or in material." In other words, "doing," by contrast to "producing," is over when it's over, leaving no memory of itself.

So far, this is a conventional Aristotelian idea. More original is where Danti takes this, writing that "things that have no visible body or material—the *affetti*, for example—cannot be depicted." For him, the distinction between the operation and the thing it left behind underscored the objectlessness of movement; sculpture, inasmuch as it was a thing, constituted something like the opposite of motion. The conclusion might simply elevate stillness to an ontological principle, except that Danti realized no sculptor could ignore the problem of represented action: ultimately, as he saw it, sculpture called upon the artist to show a motion with a material, which meant that the sculptor's means were always inadequate to his end. The only way the sculptor could get around this, Danti thought, was by focusing not on motion per se, but on the material products that motions yielded. If anger, to take his example, were understood as a movement of the soul, then anger would be unrepresentable, at least in visual form, but if that anger left a trace of itself on the face, sculpture could as it were point back to the moving thing by duplicating its trace.[26] Ultimately, the lesson here is philosophical, not

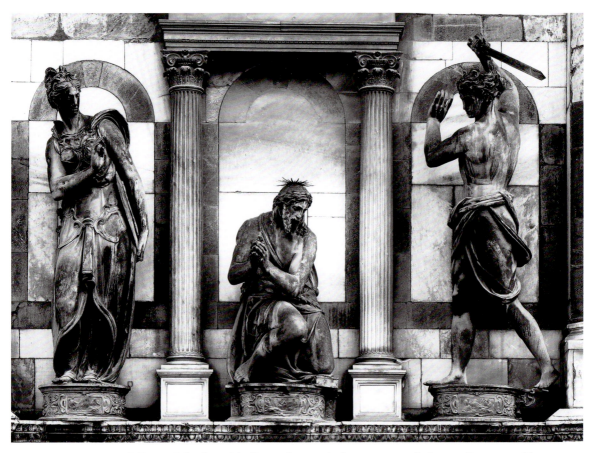

4.7. Danti, *Beheading of the Baptist* (in situ, before restoration). Bronze. Baptistery, Florence.

practical. Danti says nothing about how the artist might depict this or that psychic state; rather, he instructs the viewer in how to regard what he sees. A product of motion is just that, a product. Danti gives us an almost emblematic view of his art, founded on an acute sense for the dissimilar, for the fundamental difference between the statue and the flux of the world. Yet he also allows the artist and the viewer to embrace the material for what it is. The right question to ask of a sculpture is not, "What is this doing?" but "Where did this gesture come from?"

Danti wrote all of this in the years just before he took on the group of statues that are among his most dynamic, the *Beheading* group on the Baptistery (fig. 4.7). Few sixteenth-century sculptures show a more unmistakable interest in motion than these figures, though just what they are doing proves hard to describe. Borghini saw in Salome "cruelty mixed with horror," a description that makes her

at once active (the cruel cause of the event) and passive (the horrified viewer of it).[27] He also characterized her as "waiting to carry" the Baptist's head to her mother—*emphasis*—though here again one might just as easily read her form in terms of *enárgheia*, her sway recalling the dance she performed to set the whole beheading in motion. Danti's executioner is equally ambiguous. The bronze does not quite show an instant in the swing of the sword: it is too far from his target, and a column separates the two bodies. A view from the side makes it clear that the figure is slightly out of balance; his left arm reaches higher up than we might have expected, and the body cants forward from the wall to which it is bolted. The wildness of the man's hair, finally, matches his horrific wide-eyed stare, one that, like Salome's gesture, seems to react to what he sees as much as to act on it. This face, along with the rest of the man's features, make sense only when we recognize the figure not as an illustration of a single simple motion—swinging the sword—but as a collection of qualities defined through their opposition to the kneeling Baptist above the door. The Baptist extends his praying hands toward us and to our left; the executioner turns away to the right. The Baptist has bent down; the executioner has reached up. Most importantly, the Baptist seems controlled by an inner peacefulness, the executioner overcome with fury.

The position that Danti ultimately takes in his treatise, to the effect that sculpture is incapable of depicting motion, may help explain his propensity toward figures that, though beautifully arranged, seem largely static. More broadly significant for the period, though, is Danti's notion that all sculptural forms result from an "operation"; they are the yield of a process rather than a discrete slice of time. It is as though Danti took Gauricus's idea of *enárgheia* and inflected it with a sense of facture: with each of these figures, the question, "what happened earlier," brings us back to Danti's artfulness. Ultimately, Danti offers an Aristotelian version of the point Baldinucci, too, makes with regard to Giambologna's *Centaur*, that the action might not only give the viewer cause to reflect on what has happened or what is about to happen but also might raise the question of what shaped the material in just this way. Baldinucci himself regarded the sculpture's ostensible action as one that referred backward in time, leading the viewer to think not just about the gesture its protagonist made but also about the generation of the sculpture itself. Art did not capture the pose of the figure; it produced it.

Leonardo and the Hercules Series

Heikamp maintained that Giambologna's interest in birds came as a natural extension of his studies of other animals, especially "horses and other large animals

4.8. Lambert Lombard, *Figure Studies*. Pen and ink on paper. Cabinet des estampes, Liège.

on the run." Still, Dhanens's chronology of works in this genre, which no subsequent scholar has seriously challenged, dates all the Fleming's animal sculptures to 1580 and after.[28] This suggests that Giambologna's concerns with the bird designs may reveal less about his work as an *animalier* than about his general approach to the living figure, a subject that he had tackled intensively in the previous decade.

The marble statue that provoked Baldinucci's comments was, like the *Sabine* from the decade before, an over-life-size reproduction of an invention Giambologna had initially worked out on a small scale. The marble medium, associated as it was with petrifaction, may have made the stillness of the work especially apparent. At the same time, it is not incidental that it was just this subject, of all Giambologna's works, that provoked Baldinucci's excursus on the importance of model and pose. Artists had long regarded the Hercules theme as an invitation to explore the varieties of violent gesture. The Fleming Lambert Lombard, for example, sketched a series of sixteen Hercules figures (fig. 4.8)—looking up in astonishment, swinging a club, collapsed on the ground—sometime between his

return from Italy to Liège in 1538 and his death in 1566.[29] If an early statue like the *Bacchus* gives the impression that Giambologna was drawn by inclination to exploring the possibilities of showing human action without motion, the Hercules theme, focusing on labors—or as contemporaries called them, *forze*—required him to work almost systematically through the problem.

The subject was, in important respects, continuous with Giambologna's interests in the 1560s. Duke Francesco must have encouraged Giambologna's engagement with the theme, and we know that some of the earliest versions of the Hercules, cast in silver by a pair of smiths in the artist's employ, ended up in the Tribuna of the Uffizi, displayed on a kind of platform above a miniature arcade.[30] Still, it is difficult to believe that in making these works, Giambologna was simply fulfilling an order. Throughout his remaining life, he and his followers would return repeatedly to the sequence, even when free to determine their own subject matter. And from the beginning, variations on the Hercules theme would have had a competitive edge to them.

Ammanati, of course, had successfully cast the large bronze *Hercules and Antaeus* for Castello in 1559.[31] The competition for the *Neptune* fountain one year later would have allowed artists to tackle a related figural type, and one they knew the duke would install as a pendant to Bandinelli's marble *Hercules* of 1534. Among those who had hoped to participate in that competition was Bandinelli's former assistant Vincenzo de' Rossi. De' Rossi had had tense relations with Bandinelli and years before had moved to Rome; upon Bandinelli's death, however, he wrote to the duke of his wish to submit a model for the *Neptune* fountain, "since there are no works by me in Florence," then offered to give the Duke his monolithic *Paris and Helen*, the first large sculpture on an abduction theme to enter the Medici collection.[32] Shortly thereafter, De' Rossi returned to Florence, where he took over Bandinelli's marble projects for Florence Cathedral. In 1562, De' Rossi asked permission to use a large room across from the space he had been assigned at the cathedral, explaining that "the place where I am working is too small." The duke consented and also put Bandinelli's models at De' Rossi's disposal, turning the cathedral grounds into a base of operations from which De' Rossi would carry out a range of works, including, importantly, a marble series showing the labors of Hercules.[33]

De' Rossi seems to have begun the series around 1562; a drawing in the Cooper Hewitt Museum suggests that the statues were initially intended to ornament a fountain. By the time Vasari published his *Lives* in 1568, two of the marbles, *Hercules and Cacus* and *Hercules and the Centaur* (see fig. 3.6), had probably reached the state in which they are now to be seen. De' Rossi seems to have worked on a third, *Hercules and Antaeus*, in the years immediately following, and his workshop had completed seven of the labors and roughed out the remaining five by 1584, when

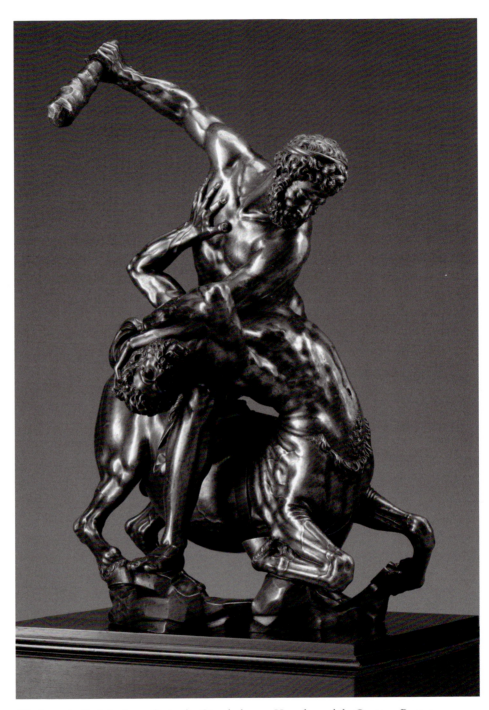

4.9. Antonio Susini, after a design by Giambologna, *Hercules and the Centaur*. Bronze. Kunsthistorisches Museum, Vienna.

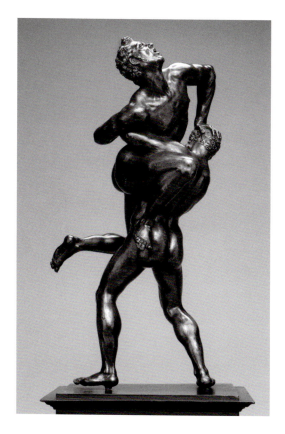

4.10. Giambologna, *Hercules and Antaeus*. Bronze.
Kunsthistorisches Museum, Vienna.

Raffaello Borghini saw them in the cathedral workshop. These remarkable, dy-
namic compositions—Borghini admired their "beautiful, fierce poses"—may well
have shaped Danti's interest in the problem of the sculptural figure who swings a
weapon.[34] They certainly seem to have shaken up the sculptural scene. Between
1573 and 1578, another Bandinelli follower, Giovanni Bandini, challenged De'
Rossi's claim on their teacher's legacy, carving a marble showing *Hercules Slaying
the Hydra of Lerna* for the residence of Giovanni Nicolini.[35] This subject was not
among those De' Rossi himself had completed by his death, suggesting that Ban-
dini, or perhaps his patron, wished to enter unexplored territory. Giambologna,
by contrast, took just the opposite course; the first two scenes from the Hercules
cycle that he elected to treat, those showing the hero's battle with the centaur
(fig. 4.9) and with the giant Antaeus (fig. 4.10), counted among the three De'
Rossi had already completed, as though the Fleming wished to follow De' Rossi's
own sequence, inviting direct comparison with the most prominent active marble

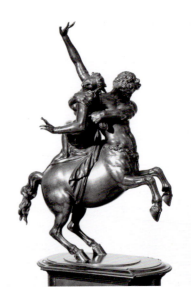

4.11. Giambologna, *Nessus and Deianira*. Bronze. Huntington Library, San Marino.

sculptor in the city. In 1599, a little over a decade after De' Rossi's death, three of the figures that De' Rossi had merely sketched would enter Giambologna's shop for reworking.[36] Dhanens proposed that Giambologna, by contrast to De' Rossi, never had any intention of finishing a whole series of twelve labors; before he quit, though, he had done his own version of Bandini's subject as well.[37]

The *Hercules and the Centaur* was among the first of the silver statues Giambologna's collaborators completed; by 3 July 1576 the silver had been "worked into a labor of Hercules, a figure who kills the centaur with the silver club he holds in his hand." A year later, Giorgio d'Antonio Rancetti had also completed a *Hercules and Antaeus*, and very shortly thereafter, two other Giambologna models, for the hero's battles with the Nemean Lion and with the Hydra, were advanced enough that Michele Mazzafirri could begin working on silver versions of those as well; he cast them in 1581. All four works eventually found themselves in the Tribuna of the Uffizi. In the meantime, Giambologna also produced a related centaur subject, *Nessus and Deianira*, as a gift for the wealthy banker-turned-magistrate Niccolò Gaddi (fig. 4.11).

Gaddi was an antiquarian and amateur naturalist; he occupied an impressive palace on the Piazza Madonna di degli Aldobrandini, just behind the church of San Lorenzo, with a private botanical garden and a significant collection of statues, medals, sundials, and books.[38] He also served as *luogotenente* of the Accademia del Disegno and worked as an advisor to Francesco on matters relating to art,

directing, for example, the festivals surrounding the ceremonial entry of Christina of Lorraine in 1589.[39] The role reflects the associations Gaddi had already developed with artists in the city. Fortuna reports that Giambologna considered him a "close friend"; the artist would take no money for the bronze *Nessus and Deianira* he offered Gaddi, accepting only fifty scudi worth of cloth in thanks.[40]

Gaddi's joint interests in science and art had come together when he participated in the project of generating an abridged version of Leonardo da Vinci's *Trattato della Pittura*. The *Treatise* itself had probably been compiled in the 1550s by a minor student of Leonardo named Francesco Melzi. It essentially extracted from, thematically organized, and in some cases paraphrased passages from the notebooks Leonardo had kept throughout his life, addressing in sequence the topics of the *paragone*, the training of the painter, the movement of the human body, draperies, shadow and light, trees, clouds, and the horizon. The most complete version of the *Treatise* Melzi assembled, a manuscript now in the Vatican, was in northern Italy throughout the later sixteenth century, but sometime during Giambologna's early years in Florence, probably in the 1570s, an abridgment was made. Just who initiated the project of abridging the treatise is only now starting to come into focus; what is clear is that at least by the early 1580s, the streamlined document was of sufficient interest that at least four local literati wanted their own copies. Recent scholars have inferred that these patrons were working in concert with one another, to the extent that the abridged *Trattato* can be said to have been a literary collaboration, one that may have started as early as the 1560s.[41]

Remarkably, Giambologna had close ties to the players involved with three of the four manuscripts of Florentine provenance. The circa 1582 illustrations for a manuscript now in Los Angeles were drawn by Gregorio Pagani, who worked for Giambologna, providing him among other things with designs for the later *Equestrian Monument to Cosimo I* (see fig. 7.1). Both artists were protégés of Bernardo Vecchietti, and Baldinucci's biography suggests that they were also friends.[42] A second manuscript, now in the Biblioteca Riccardiana, was made at the request of Lorenzo Giacomini, a fan of Giambologna's who, in the very years he was editing his Leonardo text, wrote poems in praise of the marble *Sabine*. Finally, there is Gaddi, the earliest known owner of a manuscript now in the Biblioteca Nazionale and the recipient of Giambologna's bronze *Nessus and Deianira*. The gift alone, the only such gift Giambologna is known to have made in his lifetime, suggests that Fortuna had not exaggerated their bond. It is unthinkable that Giambologna was not closely aware of a project of such deep interest to those around him, and through Gaddi, Pagani, and possibly Giacomini as well, he would have had ample opportunity to see and discuss not only the various abridgments of the *Treatise* being produced in Florence but also, perhaps, their still unidentifiable source.

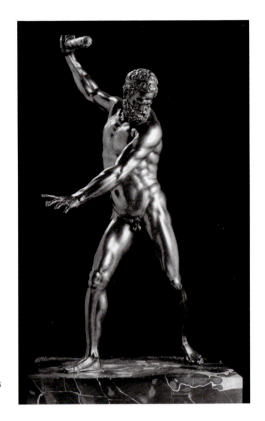

4.12. Giambologna, *Man with a Club*. Bronze. Kunsthistorisches Museum, Vienna.

What most suggests Giambologna had been looking at Leonardo's *Treatise*, though, is the *Hercules* series, invented in just the years that the project of abridging the *Trattato* seems to have been getting underway. To a degree, the decision to work extensively with the Hercules theme was a decision to make a series of variations on his own earlier *Samson and the Philistine*: as Manfred Leithe-Jasper first observed, the *Man with a Club* (fig. 4.12), an independent figure that seems to extract one of the hero's performances from the context of an encounter with any individual enemy, is nearly identical in pose to the marble *Samson*. That composition, in turn, served Giambologna as the basis for the Hercules in the *Centaur* pair: Giambologna just rotated the club-bearing right hand slightly clockwise, turned the left so as to grasp the victim's head, and adjusted the right leg so that it could straddle the horse-body. These are minimal changes, and Hercules performs a nearly identical act in all three versions of the idea.

Giambologna's attention to this pose, however, was also imbricated within the Florentine project of abridging the Leonardo *Treatise*. Although we cannot exclude

4.13. Codex Magliabecchianus 17, 4, fol. 55r. Biblioteca Nazionale Centrale, Florence.

the possibility that Giambologna encountered a drawing even before starting work on the *Samson*, it seems more likely that this happened later—that sometime in the 1570s, Giambologna discovered that Leonardo's *Treatise* had isolated a figure (fig. 4.13) that was remarkably similar to one of his own earlier inventions. The figure in the *Treatise*, in turn, led Giambologna to realize that the pose could be subjected to closer analysis, and he determined to work with it further, both on its own and in the *Hercules and the Centaur*. Such an engagement with Leonardo's pages, where texts and images informed one another, militates against the idea that Giambologna's interest in Leonardo was purely formal. In transferring the act from Samson to Hercules, Giambologna transformed it into a *forza*, a labor. And in the section of the *Treatise* where the Leonardo figure was to be found, "forza" was a central topic.

In any of the abridged versions of the *Treatise*, including the one that originally belonged to Gaddi, Giambologna would have found the image accompanying the chapter that sometimes bore the title "Della forza composta del'huomo et prima si dira delle sue braccia." The chapter read:

> The muscles that move the larger bone of the arm during the extension and retraction of that arm originate one behind the other around the middle of the bone called the "helper." Behind this originates the muscle that extends the arm, and in front of this is the one that bends it.[43]

Although the drawing shows the whole body, the passage focuses attention just on the arm, isolating it from the composition for scrutiny. As a consequence, the flexion of the limb ceases to be a gesture and turns instead into an anatomical

demonstration. Leonardo's text suggests that the depiction did not concern movement per se, but rather the bodily structures that made particular movements possible. This is very close to the way of thinking that Danti, too, would adopt.

Both the body and title of the chapter, referring explicitly to force, pick up on the immediately preceding chapter, "On the Apparatus of the Force in a Man that Generates Great Percussion" ("Dell'apparecchio della forza nel huomo che uol gienerare gran percussione"). If Giambologna, through Gaddi, Giacomini, or someone else, had access not only to the abridged manuscripts but also to their source, he would have known that it was from here that the illustration of the figure with the club originally derived:

> When a man prepares to make a forceful motion, he bends and twists as much as he can in the direction contrary to that where he wishes the blow to fall, and thus he prepares a force as great as is possible for him, which he then brings together and, with a compound motion, launches upon the thing struck.[44]

Like the chapter on the arm and its bones, the broad issue here is the body's might, and whence that derives. Leonardo's idea is that the turned body, like a tautly flexed piece of wood, is in a state of potential. The inclination of such a body is to return to its original form; it is not in motion so much as it is on the verge of movement, and the pose makes legible what is to come. Like Gauricus's "state that seems to precede or follow from a motion," it falls between two conditions, the implications of its stillness bringing added pleasure.

It will not be surprising, in light of all of this, that other Giambologna inventions relate to illustrations from the *Treatise* that concern themselves with "stilled force." A good example is the *Hercules and the Erymanthian Boar* (fig. 4.14), nearly a mirror image of the figure that illustrated Leonardo's chapter on the "ultimo suoltamento che po far l'huomo nel vedersi a dietro" (fig. 4.15):

> The farthest that a man can twist is when he shows the back of his heel and the front of his face at the same time. But this is not done without difficulty, unless the leg is bent and the shoulder lowered as he looks backward. The cause of this twisting will be shown in the books on anatomy, which will discuss which muscles move first and last.[45]

Poses related to this would have a long afterlife in the Giambologna shop. They inform, for example, a *Faun* designed by Adriaen de Vries, a statuette that is important not only because it seems to count among the Dutch artist's earliest works but also because de Vries's own Florentine sojourn, and his time in Giambologna's shop, coincide exactly with the most secure dates assigned to the early manuscripts of the *Trattato*.[46]

4.14. Giambologna, *Hercules and the Erymanthian Boar*. Bronze. Museo Nazionale del Bargello, Florence.

226 L'ultimo suoltamento che può fare l'huomo, sarà nel dimostrar-
ni le calcagna in faccia, et questo non si farà senza difficultà
se non si piega la gamba, et abbassari la spalla che guarda la
nuca, et la causa di tale suoltamento fià dimostrata nella
notomia quali muscoli primi et ultimi si muouono.

4.15. Codex Magliabecchianus 17, 4, fol. 51r. Biblioteca Nazionale Centrale, Florence.

Equilibrium

Giambologna undertook some of his earliest studies of human contortion in the course of designing victory imagery, and figures like the *Philistine* or *Pisa* associate the bending of the human body with enervation, defeat, and even torture. When the *Treatise*'s lines on *svoltamenti* are read in conjunction with those on the *apparecchio della forza*, however, it becomes clear that the twisting of the body could also

have exactly the opposite effect. A figure like the Hercules, bearing an enormous boar on his shoulder, will not appear weakened but rather charged with the fullness of power.

Leonardo considered this state one of *equilibrium*, and John Pope-Hennessy, Rudolph Preimesberger, and others have associated a number of sculptures Giambologna designed in this period (though not the *Hercules* series per se) specifically with problems of balance.[47] In serial works like the *Mercury*, the composition does not provide evidence of any unambiguous direction of motion. The Bologna version, as we have seen, apparently represented an alighting figure. The billowing head beneath the Medici *Mercury*, by contrast, seems to signal a rise. Rather than a movement, Giambologna's *Mercury* continues the exploration of balance that began with the bronze *Bacchus* of the early 1560s, creating a work that directs attention to the figure's axiality, and thus, with Leonardo, to the conditions that allow movement to happen. With works like these, paradoxically, depicted flight offered the ultimate means of achieving sculptural stasis.

The topic of balance interested Giambologna's earliest recorded critics. Baldinucci, for example, admired the fact that Giambologna's large marble *Neptune* stood "on the most narrow support," while Borghini, more generally, offered the following as a kind of ideal:

> Firstly, it is of great importance that you place the head carefully on the shoulders, the chest above the flanks, and the flanks and the shoulders above the feet. When, then, you make a figure with an ordinary pose, you must make the shoulder that corresponds to the resting leg lower than the other shoulder, and if you want the head to look in that direction, you must turn the torso such that the shoulder is raised, otherwise the figure will lack not a little in grace. And when it happens that the torso is carried above a resting leg, be sure not to make the head turn in that direction, for it is very difficult to lend such a figure grace. And if the figure gallantly shows one side, make it in such a manner that the windpipe aligns vertically with the axis running from the neck to the resting foot, and when it departs from this to the inside, but not to the outside, it can still stand: when a figure that rests motionless on its feet goes to throw its arm out in front of its chest, you must throw the same amount of natural or accidental weight behind, and I would say the same thing about every part that projects outward from the whole, beyond what is normal.[48]

Borghini's concern with grace, and with the way the turning of the body creates or undermines grace, places him within a tradition of criticism that dates back at least as far as Cellini and Vasari, and to a much older practice. The more pointed interest in the figure's *axiality*, however, along with the specification that the figure

4.16. Codex Magliabecchianus 17, 4, fol. 59v. Biblioteca Nazionale Centrale, Florence.

should "stand motionless on its feet" (*posa sopra i suoi piedi senza moto*), connects him additionally to the ways of seeing that Leonardo's *Trattato* inculcated.

Leonardo wrote at various places about an imaginary line that ran from the pit of the throat to the feet, in relation to which the figure had to be composed, whether the artist's primary interest was in naturalism or in grace.[49] His chapter "On Equilibrium," for example, began with the statement that "the figure that carries a weight outside of itself and outside its own center of gravity [lit., "outside the central lines of its own quantity"] must throw enough natural or accidental weight in the opposite direction so as to make an equilibrium of weights around that central line." What makes this topic especially relevant to Giambologna is the fact that the *Trattato* illustrated this idea with a single exemplary subject, Hercules (fig. 4.16):

The ponderations or rather balancings of men are divided into two parts, simple and compound. Simple balancing is what a man does on his two motionless feet, above which that man opens his arms at different distances from his mid point, [or what he does while] bending, standing on one or on both feet. In such cases, the center of gravity is always on a perpendicular line [that runs through] the center of that foot on which the weight rests, and if it rests equally on both feet, then the weight of the man will have its perpendicular center [i.e., its center of gravity] in the middle of the line that is coterminous with the space that stretches between the center points of those two feet. Complex balancing should be understood to be what a man who carries a weight upon himself does with his various motions, as [for example, you show when] depicting a Hercules that crushes Antaeus, suspending him away from the ground between his chests and arms. You place his figure back from the central line of Hercules's feet at a distance equal to the distance between Antaeus's center of gravity and those same feet.[50]

In several of the early, abridged versions of the *Trattato*, including the Gaddi manuscript, the passage was even accompanied by a drawing of *Hercules and Antaeus*. Of course, Giambologna hardly needed a second- or third-hand idea from Leonardo to know how the subject of *Hercules and Antaeus* should appear—between the statue that Danti had attempted, the bronze Ammanati successfully completed, the marble in the courtyard of the Pitti Palace, and De' Rossi's fountain sculpture, there was no more familiar sculptural subject in Florence.[51] But if the commission for the Hercules series offered Giambologna a particularly focused opportunity to compete with the antique, with Danti, with de' Rossi, and especially with Ammanati, reading Leonardo would have helped set the terms by which the statues would be judged. The title the *Trattato* gave this particular lesson was, "The Ponderation of Bodies That Do Not Move." To follow the *Trattato*'s terms, the study of equilibrium and the representation of instantaneous motion did not represent alternatives; they were the very antitheses of one another.

In Florence, Giambologna's inventions seem eventually to have come to stand as examples of what Leonardo aimed to teach. While the three early apographs of the *Trattato* Giambologna is most likely to have seen all retain the sketch of *Hercules and Antaeus* in the position Melzi placed it, this was not universally true in the later copies. When, in 1632, Stefano della Bella transcribed the passage "on the ponderations of bodies that do not move," he accompanied it with a figure that does not appear in any known sixteenth-century manuscripts and that evokes the *Mercury* (fig. 4.17). The substitution suggests the importance of the investigations Giambologna undertook with his *Hercules* series to the invention of the exactly contemporaneous Medici fountain (see fig. 2.27). That it was Della Bella,

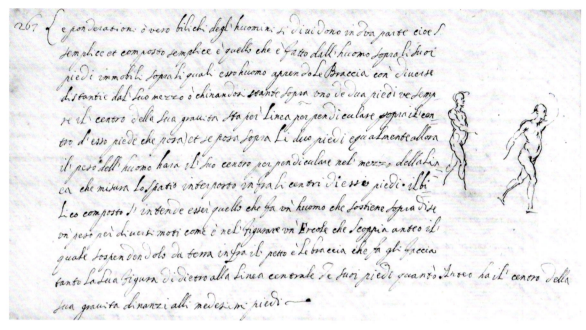

4.17. Codex Riccardianus 2275, fol. 29v. Biblioteca Riccardiana, Florence.

of all copyists, to see the connection is probably no coincidence, since his father, Francesco della Bella, had worked in Giambologna's shop. Nor is it surprising that an earlier seventeenth-century Florentine, looking for examples of modern works conceived around the "linea perpendiculare" representing a figure's center of gravity, would have turned his attention to the *Mercury* in particular. Indeed, one detail of that figure—the upwardly pointed finger of the extended right hand, a finger that, like the caduceus with its coiled snakes, seems to emblematize the theme of the axis around which the figure is balanced—may derive from Leonardo's treatise. The Melzi version of the *Trattato* included a short chapter, "On Bendings," accompanied by an image of two fingers, one bent and the other extended along a vertical line. The abridged Florentine versions of the *Treatise* retained the image, but associated it with a different lesson (fig. 4.18):

When you want to show a man to be the mover of some weight, consider that motions are made along different lines, that is, going from low to high with a simple motion, as does one who, bending over, lifts the weight he would raise by straightening himself, or when one wants to drag something behind, or push it in front, or when you want to pull it down with a rope that passes through a

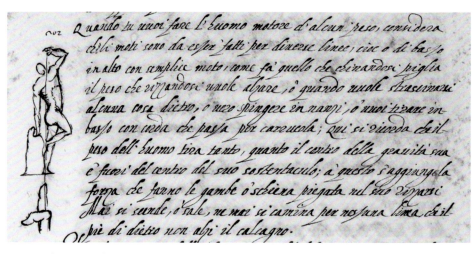

4.18. Codex Riccardianus 2136, fol. 27r. Biblioteca Riccardiana, Florence.

pulley—here we note that the weight of a man pulls as much as his center of gravity is beyond the center of his support, to which is added the force exerted by the legs, and by the bent back as it straightens out. One never descends or climbs or walks along any line without the foot raising the heel in back.[52]

In the abridged *Treatise*, the lesson went under the title "On Human Motion," yet the text is not so much concerned with how people move as with how people move other things. By framing the subject this way, the *Treatise* manages to translate the question of movement into one of force, which, it suggests, is fundamentally linear: the application of force happens along a line, and the body generates force by shifting its relationship to its center of gravity—itself, as we have seen, a notional vertical line, descending from the "fontanella della gola."

There can be little question that Giambologna himself was capable of thinking in just these kinds of terms, which connect subjects as diverse as the flight of Mercury and the labors of Hercules. His investigations may even have figured in his initial architectural interests: in his allegory of *Architecture*, probably invented in the 1560s but extant in several versions (see fig. 5.2), one of the figure's identifying attributes is a plumb line, an instrument used by builders to discover and construct their edifices in relation to a true vertical. At least some of the manuscripts of the *Trattato*, including, as we shall see, one that came out of Giambologna's circle, referred to what Leonardo called the figure's "central line" as its *piombo*, bringing this kind of comparison even closer to hand. And thinking about balance as an *architectural* consideration adds another dimension to the topic, for it reminds us that sculptures, unlike the figures in Leonardo's paintings, are built things that must stand up.

It is this aspect of balance, in fact, to which most writers who have addressed the topic in Giambologna have paid attention. Gramberg's remarks on the Medici *Mercury* are exemplary: "This solution, which draws the characteristic Giambologna problem of the 'reduced base' to its highest fulfillment, wholly removes the figure's weight, letting it 'float' fully free and unbound."[53] Other writers have remarked similarly on, for example, the difficulty of designing a multi-ton bronze horse that stands on only three hoofs, or a marble in which one over-life-size figure suspends another entirely above the ground. This is a significant point of continuity through Giambologna's mature work, from the Medici *Mercury* to the late equestrian monuments. Still, what distinguishes Giambologna's approach to balance from that of at least some contemporaries, and what makes a design such as the *Hercules and Antaeus*—which, unlike Ammanati, he never made on a large enough scale for statics to be an issue—is his simultaneous interest in what we might distinguish as real and depicted balance. The former is a matter of engineering, a technical motivation to make a flamelike composition that narrows at the top so that the unchanging weight of the mass doesn't cause the object to tip; the latter, by contrast, responds to the task of illusionistically portraying motion with motionless means. The two concerns did not have to be aligned: witness Danti's *Executioner* (see fig. 4.7), who, though adopting one of the poses Leonardo associated with equilibrium, could not stand up on its own.

Giambologna, by contrast to Danti, tended to use the real balance required to make the block stand to reinforce the balance of the depicted figure, as if the "architectural" or engineering problems that large objects presented simply extended the anatomical analytics Leonardo had introduced. A work like the *Mercury* gives the impression not of a sculptor balancing a piece of metal so much as of a deity balancing himself. This coincidence of the real and the virtual also helps account for the seemingly contradictory responses viewers have had to Giambologna's figures, sometimes describing them as moving, sometimes as still, sometimes as both at the same time.[54] In fact, the figures are unambiguously still, insistent in their equilibrium. By treating equilibrium, though, not just as an achievement of engineering, permanently distributing weights, but also as the control condition for human movement, Giambologna naturalizes it. Once we read a statue as a figure balancing itself rather than as a balanced figure, it becomes all the easier to see that figure as one capable of motion, one that has just moved or that might move again. Sculptural equilibrium was unavoidable; yet just as Giambologna embraced the stillness that was a necessary condition of his representation, so did he employ equilibrium in a way that depended on a strong sense of its opposite and that ultimately encouraged viewers to think about a movement they couldn't really see.

Heterochronicity and Artifice

As Baldinucci's remarks showed, the drawn arm of the *Hercules* could function as a figure of *émphasis*, encouraging the viewer to imagine how the beast would be struck, or as a figure of *enárgheia*, leading to speculation on how the arm got to be in that position in the first place. To the extent that the ideas in Leonardo's *Treatise* informed a sculptor's thinking about what stillness involved, or even applied to sculptures conceived independently, a similar sort of analysis can be offered for just about every other seemingly "active" statue Giambologna and his contemporaries made. Yet the position at which Baldinucci finally arrived, that the pose of the *Hercules* depended more on the artifice of the sculptor than on any notional movements for which the depicted historical hero himself was responsible, underscores the fact that there are always multiple ways to regard a sculpture's "evidence," to use Gauricus's words, of "what happened earlier."

This, too, turns out to be an issue for the significance Leonardo's *Treatise* held within Giambologna's shop. In 1618, a sculptor named Giovanni Francesco Susini, the thirty-three-year-old nephew of the Antonio Susini who had helped Giambologna with the bronze versions of the *Hercules* series, penned a manuscript that he titled *Drawings and Measures and Rules for the Posing of the Human Body* (*Disegni e misure e regole d'attitudine del chorpo umano*).[55] Brought to light in 1979 by Giovanna Lombardi but still incompletely published, the manuscript is an eclectic compilation. The title suggests the book's catchall conception: its *disegni* include various sketches, some related to paintings, some to architecture; its *misure*, as we shall see in the next chapter, show the measurements of the human body, as represented by canonical sculptures.[56] Most of the book's actual text, on the other hand, consists of *regole*, all of which derive indirectly and without acknowledgment from one of the Florentine versions of the abridged *Trattato* that Giambologna had studied some four decades earlier.

Compared with the other known copies of the *Trattato*, Susini's manuscript has a remarkable form. It is strikingly small in format, reinforcing the impression that it served as a kind of semiprivate notebook. Various considerations suggest that Susini's source was the Gaddi manuscript.[57] Yet unlike other early seventeenth-century artists' apographs of the *Treatise*, Susini's little book does not seem to comprise direct transcriptions of any standard text.

A number of the patrons of early apographs of the *Trattato* proceeded by having a scribe generate a text then handing this off to a painter for illustration.[58] Susini, however, created his notebook in the opposite order. Across the tops of the opening folios of his book he copied the figures he found in the sections of the abridged *Trattato* dedicated to movement, in the order he encountered them.

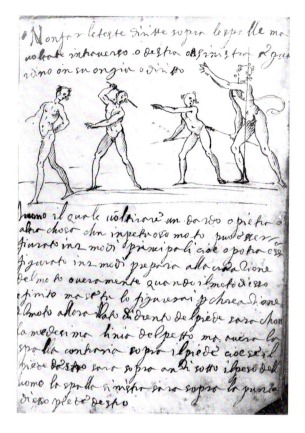

4.19. Gianfrancesco Susini, "Disegni e misure e regole," fol. 13r.

Below and occasionally above these figures, he then excerpted or paraphrased passages from the text of the *Trattato* that seemed to explain what the figures exemplified. This whole approach differentiated his book from the versions of the treatise that earlier literati compiled: while they regarded and sometimes even referred to the *Trattato* as a "discourse" into or onto which visual "demonstrations" could be fit, Susini instead saw it in the first place as a collection of figures, each of which invited commentary. When Susini found unillustrated passages in the abridged *Trattato* he consulted, he simply omitted them.

The result was a book that drew out the relationship between Florentine statues and Leonardo's writings on movement, even while shifting Susini's predecessors' emphasis. Consider folio 13 recto (fig. 4.19), which includes the figure of the now familiar man with the club. As we have seen, other versions of the treatise had used this to accompany either the chapter on the "apparatus of force in the man who wants to generate great percussion" or the one titled "On a man's composite

force, speaking first of his arms." Neither of these passages, however—nor any of the passages associated with the two figures that Susini places to the right of the one at issue—appear in Susini's manuscript, giving the strong impression that he took the illustrations to serve a different function. The passage directly below Susini's figures reads:

> The man who wants to throw a spear or a rock or something else that has impetuous motion can be represented in two principal ways: he can be represented when he is preparing to make the motion or when the motion itself is finished. But if you represent him beginning the motion, the inner side of the outstretched foot must be in line with the chest, and you must bring the opposite shoulder over the foot on which his weight rests. That is: the right foot will be under his weight, and the left shoulder will be above the tip of the right foot.[59]

In any existing illustrated version of the *Treatise*, Susini would have found this statement accompanied by an image of a man holding a spear and striding forward, a relative of the two right-most figures on his own page. Yet the passage fails to make sense of their neighbors on the left.[60]

Susini may have understood these to clarify the (unillustrated) lesson recorded on the previous page, on giving figures graceful poses, a passage that, in all other versions of the *Trattato*, ended with the line "the poses of the head and arms are infinite," but which Susini's text changes from a declarative to an imperative: "let the poses of the head and arms be infinite."[61] Or perhaps he intended one or both to accompany the line directly above them on the page: "Do not make the head straight atop the shoulder but turn it to the left or to the right so that it looks down or up or ahead."[62] This comes from yet another, later section of the *Trattato*, where, even in abridged versions, the sentence is longer: "Do not make the head straight atop the shoulder but turn it to the left or to the right so that it looks down or up or ahead, for it is necessary to make [the figures'] motions such that they show fitting vivacity and not appear asleep."[63] Just as subtle adjustments immediately before had changed a descriptive comment about the wonderment of human motion into a recommendation for contorting forms, so here does the line leave out the end to which the turned head, according to Leonardo, was to be put. In Susini's manuscript, the turning of the figure seems an end in itself.

Susini was not the first copyist to move the illustrations in Leonardo's *Trattato* such that they seem to make a point other than what the treatise's original compiler intended. While some earlier copies of the *Trattato* had omitted occasional words and even whole lines, however, no other text has ever been identified that, like Susini's, freely excerpts and recombines lines from various chapters, composing a sometimes slanted new abridgment of Leonardo's thoughts. The particular

emphasis Susini places on variety and invention, even over and above balance and force, shows that, by the seventeenth century, Leonardo and Giambologna alike could seem to represent two kinds of lessons. While the naturalist might continue to attend to the functions of the human machine, the modeler could dwell on bending of the limbs, focusing his energies on the modification of existing compositions rather than trying to record empirical phenomena. This sheds new light on the understanding at which Baldinucci ultimately arrived. On the one hand, the reaction to Giambologna's *Hercules and Centaur* that he reports—"one will clearly discern that Hercules is in the act not of beating the Centaur, but rather of drawing up his arm to bring it into position to strike"—betrays an impulse to see the statue in terms of natural flexions. If the work is to be evaluated for its naturalism, it will not only be judged by, say, the close attention Giambologna gave to physiognomy, or the anatomical concerns that Ammanati showed in drawing and that Danti advocated in his writing. Viewers will rather notice how aptly the artist characterized an action that, on Leonardo's instructions, consisted of the winding and unwinding of forms. The critic, in this case, avers that the work is a failure, since the hero will obviously miss what he is aiming at; the apologist, in reply, insists that the statue illustrates what Leonardo termed the *disfactione* of the figure, turning its form in such a way as to charge it with potential force. Even as Baldinucci is tempted to accept these criteria for judging the work, however, so does he consider changing the standards of evaluation altogether. *Tornando a maraviglia bene quell'attitudine nel suo modello, per questo fece poi la statua di marmo*—if this, by contrast, is Giambologna's rationale, we are no longer within the logic of the *apparecchio della forza* so much as we are returned to those lines that Susini's text truncates and varies: "let the poses of the head and arms be infinite"; "do not make heads straight on the shoulders, but turn them to the right or left so that they look up, down, or outward." Presented this way, Leonardo's illustrations and all that came out of them begin to look as motionless as anything Giambologna himself ever conceived.

5

SCULPTURE AS ARCHITECTURE

Man with a Compass

On entering the employ of Duke Cosimo in 1554, Vasari turned his attention to the renovation of the Great Council Hall in the Palazzo Vecchio, the former home of the Republican city's government that now served Cosimo as a private residence. By training a painter, Vasari had by this point acquired fairly extensive experience as an architect; what he needed for the project was an expert sculptor. Despising the local eminences, he summoned Ammanati from Rome, "to the end that he might execute the other facade in the above-named Hall, opposite the audience-chamber begun by Baccio [Bandinelli], and a fountain in the center of that facade"; upon his arrival, Vasari added, Ammanati "began straightway to execute the statues that were to go into that work."[1]

The two artists had, since the beginning of the decade, established a good working relationship, one characterized by exchange and not above criticism. At Michelangelo's urging, Vasari had in 1550 taken on Ammanati as a collaborator for the chapel he was constructing in San Pietro in Montorio. Vasari produced a preliminary design for the space but left much of the actual execution in the hands of Ammanati, who departed from Vasari's drawings in significant ways.[2] When he began working on the Villa Giulia, registers referred to him as "Bartolomeo

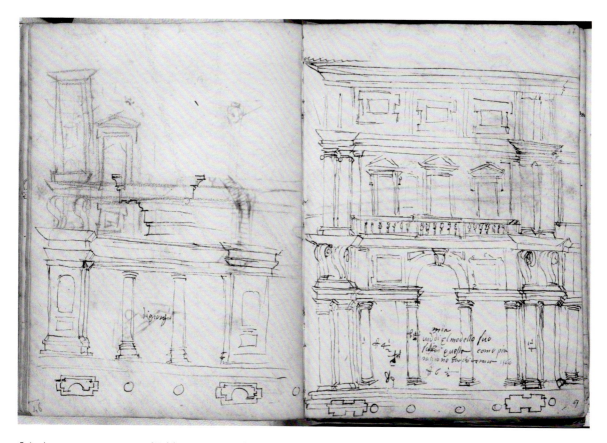

5.1. Ammanati, opening of Biblioteca Riccardiana, Edizioni Rare 120 (fol. 46v–47r), showing Vasari's design for the Uffizi and his own response.

Ammanati, Florentine sculptor, colleague of Giorgio," though he appears to have been responsible for the design of interior facades, windows, and portions of the courtyard, among other features of the building.[3] One useful measure of their rapport in Florence is a 1560 spread from Ammanati's sketchbook in the Riccardiana. On the left-hand page, Ammanati drew an elevation Vasari had conceived for the Uffizi, labeling it "Giorgio's." On the right, he offered a counterproject, writing across the Serliana on which it centered "mine—I saw his model and I drew this, showing more knowledge of architecture" (fig. 5.1).[4] Ammanati rendered his ideas quickly, not working them up in the way one would expect of drawings made for an important audience, but he must have shown them to Vasari, for the architect appropriated the Serliana in the *testata*, the loggia connecting the building's two wings (see fig. 5.4). At the time Ammanati drew his counterproposal, he was himself engaged with the completion of the vestibule to the Laurentian Library, which

Michelangelo had left incomplete upon his departure from Florence in 1534.[5] Though he contributed primarily to the carving of the stairs, following a wooden model Michelangelo had sent him from Rome, Ammanati's counterproposal for the Uffizi takes up a number of the features from Michelangelo's space, including the paired pilasters, the projecting consoles, and the framed areas of plain wall. The execution of the final building in *pietra serena* and white plaster makes it look like a translation of Michelangelo's project into an outdoor public space, and when Danti subsequently added his portrait of Cosimo and recumbent allegories, he shored up the allusion. Ammanati may deserve no less credit than Vasari for this idea.

Vasari was not above minimizing Ammanati's architectural activities, especially when it served his own interests to do so. Of the De Monte Chapel, the *Vite* state that Michelangelo was content that the statues be assigned to Ammanati, "whom Vasari had put forward," but say nothing more.[6] Of the Villa Guilia, the *Vite* report that Vasari made "the design of the courtyard and the fountain, which was then followed by Vignola and Ammanati."[7] Elsewhere, Vasari defines his former "compagno" as "a sculptor of marbles" and as "the Florentine sculptor." The younger artists who had arrived after Ammanati in Florence, however, cannot have failed to notice that by 1568 Ammanati had about as many buildings as sculptural ensembles to his name. Just two years after his arrival in the city, Ammanati started work on the grand Palazzo Grifoni (see fig. 7.2), overlooking the Piazza Santissima Annunziata. By 1561, he had taken charge of the renovations of the Palazzo Pitti.

The catafalque and tomb that the Accademia del Disegno erected for Michelangelo in 1564 presented him as the exemplary sculptor-architect. For the first two decades after Ammanati's arrival in Florence, however, no other artist managed to follow this path. The lament Cellini's "Discourse on Architecture" conveyed in these very same years, insisting on an expertise he had never had an opportunity to show in practice, must have been easy for Ammanati's younger rivals to understand. Danti's father and uncle had both practiced architecture in Perugia, and when offered the opportunity to follow in their footsteps, Danti left Florence for good.[8] Giambologna's first teacher, Jacques Dubroeucq, was likewise an architect no less than a sculptor, and one of the Fleming's earliest small bronzes is an allegory of *Architecture* (fig. 5.2). If Dhanens is correct in placing its invention around 1565, it would be more or less contemporary with Cellini's *Discourse*, Michelangelo's tomb, and Ammanati's work on the Pitti Palace.[9]

As Marietta Cambareri has observed, the instruments that Giambologna's figure holds—a set square, a quadrant, and a compass—point to a version of architecture "strictly dependent on the geometric rules of nature."[10] The instruments themselves approach the qualities of abstracted forms, at once generalizing and disembodying the delicate contours of the nude.[11] Yet for an artist like Giambologna,

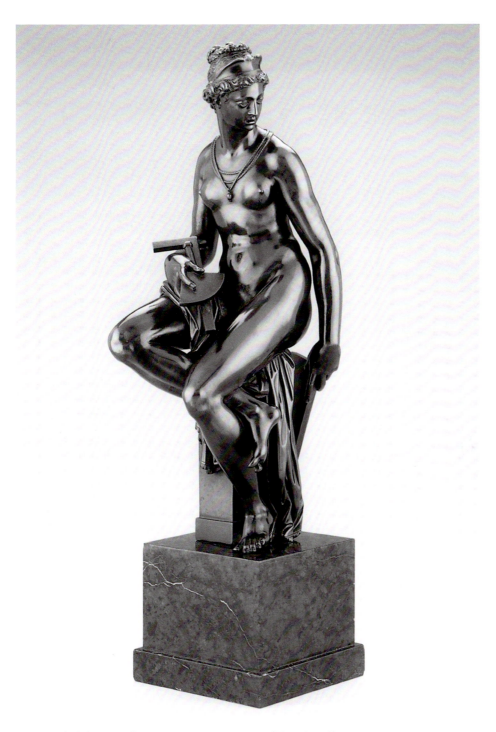

5.2. Giambololgna, *Architecture*. Bronze. Museum of Fine Arts, Boston.

who found himself in an academic milieu that preached the unification of sculpture and architecture in *disegno* even as it restricted the actual practice of architecture to a select few, the instruments take on an additional sense. The tools this *Architecture* holds are instruments of measure: the quadrant helped determine the heights of things (celestial bodies no less than building features) from a fixed point on the ground; the compass divided lines into commensurate parts and regulated distances. Ammanati himself appears to have owned a manuscript, "Discourse on the all the measures that a compass can make," and he may well have intended to include a chapter on a related topic in the treatise he was writing.[12] If the earlier text is any guide, this would have focused on engineering problems, illustrating the ways in which the compass could be of use in tasks that ranged from determining the widths of rivers to calculating the dimensions of towers. What that treatise omitted was any mention of the making or measuring of figures, and in this respect it offers a telling contrast with Borghini's *Riposo*, which remarked how painters

> separated art's difficulty into physical effort and mental effort, and physical effort, being more ignoble, they leave to sculptors, while they claim the effort of the mind for themselves. They say that all sculptors need are the compass and the set square so that they can do the measuring that is their profession, whereas for painters, beyond knowing how to operate these instruments, it is necessary to know perspective, [so that they can construct] buildings, landscapes and a thousand other things.[13]

Giambologna would have been fully aware that the instruments he gave his *Architecture* were instruments outsiders connected to his trade as well. Their application might serve as evidence of the sculptor's merely mechanical approach to the construction of form, his ignorance of the mathematical science that transformed the comparison of lengths and distances into the generation of illusion, but this was a small cost when balanced against the prospect that using a compass would help the sculptor *look like* an architect.

Such perceptions bear on a portrait currently on long-term loan to the National Gallery of Scotland (fig. 5.3). Avery intriguingly identified the picture with one that hung in the bedchamber of the house Giambologna occupied in the Borgo Pinti from 1576 until his death; Alessandro Cecchi has convincingly attributed the majority of it to the sculptor's fellow countryman Pieter de Witte, known in Italy as Pietro Candido.[14] The picture shows Giambologna turning away from a worktable to look at the viewer, a more brightly illuminated space in the background. Though his sleeve is unbuttoned and his garment tied back with a sash, details that emphasize his engagement with his work, the ruff collar and fine

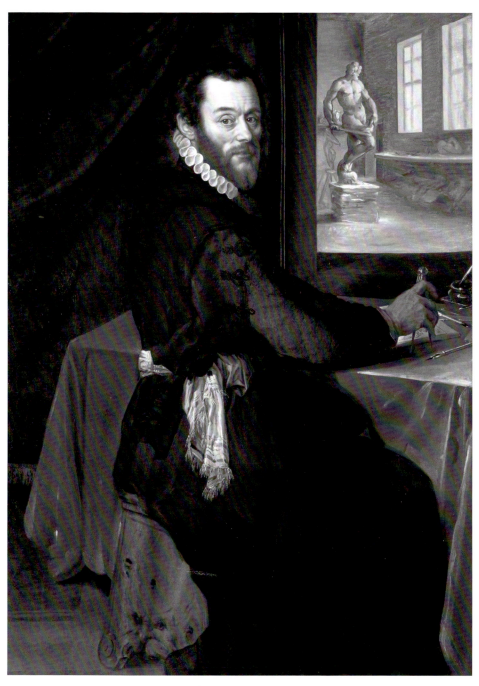

5.3. Pieter de Witte (called "Pietro Candido" in Italy), *Giambologna in His Studio*. Oil on canvas. National Gallery of Scotland.

fabrics equally identify him as a man concerned with status. Giambologna's pose in the painting, with right leg bent and right arm rotated forward, resting the points of the compass on the tablecloth, echoes that of the *Oceanus* in the second room; the repetition suggests an analogy between the god's baton and the architect's instrument, and more generally associates the mastery or control that the sea god holds over the waters with the artist's work. Joining the Neptune is another statue designed by the artist, the figure variously called "Venus" or "Fiorenza," which Giambologna created to top a fountain in the Gardens of the Villa Medici at Petraia. The room, larger and airier than the space where the depicted artist produces his designs, is also furnished with a workbench and a shelf on which various tools and fragmentary models sit; here, the picture announces, is where the sculptures are actually carried out.

Avery has commented that the portrait shows Giambologna "in the role of an architect—always considered in the Renaissance as a more intellectual and gentlemanly pursuit than that of the sculptor," adding that the room in the background containing the two "working models" is the artist's "studio," which is "clearly divided from the more elegant chamber in which he is seated."[15] To be sure, Giambologna's circle included people apt to make fine discriminations between the social value of one kind of artistic labor and another. Still, Avery confuses the matter by referring to the larger space as Giambologna's "studio": the sixteenth-century studio, or study, was a small, private room that ambitious artists kept apart from the main workshop, into which they could withdraw to make models or draw—precisely the kind of thinking space where de Witte's portrait places his sitter.[16] The scene the picture stages seems to be one of an artist absorbed in solitary work—his instrument still in hand—who turns in response to a visitor who has interrupted him.

An inventory drawn up after the sculptor's death in 1608 indicates that Giambologna had separate rooms that functioned as a *studio*, a *scrittoio*, and a larger workspace (as well as a private foundry) after he moved to the Borgo Pinti.[17] If, as is likely, the picture was painted in the late 1570s or early 1580s, it captured rooms with functions like those in which the artist did in fact work.[18] The 1608 inventory specifies that the "studio" contained Giambologna's models, and distinguishes this from the "stanza" in which his staff had carried out full-scale artworks. Independent pictorial conventions must have guided the picture as well, for other late sixteenth-century painters, too, showed themselves in studios. As far as Giambologna's actual practice is concerned, though, the important point is that, when he finally had a chance to structure his environment, he provided himself with a workroom at some remove from the menial activities that could be assigned to assistants.

As Avery realized, at least one of the objects shown in the larger space reflected in the mirror—the "Fiorenza" for the Villa Medici at Petraia—must be a (now lost) model rather than a finished sculpture. The brown color, clearly distinguished from the white *Oceanus* next to it, suggests clay rather than bronze, and the three-legged stool beneath could hardly have supported a metal object that would have weighed thousands of pounds. The portrait's *Oceanus*, too, may be a large stucco model rather than a marble; the stone figure had left Giambologna's *bottega* in 1572, almost certainly before this picture was painted.[19] Models reinforce the picture's more general idea of divided, socially stratified, labor, since they facilitate the assignment of specialized work to groups of helpers. In this respect, the painting bears comparison with Veronese's portrait, from the same decade, of Alessandro Vittoria in his own studio (see fig. 1.3). Given Giambologna's reputation as a modeler, and given the objects in the background, we may be surprised, in fact, that de Witte did not similarly present the Giambologna of the studio with wax or clay before him, but rather with paper. Avery must be right at least in this: that showing Giambologna as a measurer and a draftsman made his status even more immediately legible.

As a matter of history, Giambologna worked in this kind of room and made drawings only after he had turned to architecture, which happened in the very years de Witte must have painted the picture. Nevertheless, the portrait on the whole suppresses evidence of Giambologna's real architectural productions. It does not show any architectural models, and what can be discerned on the paper before the artist on the table look more like doodles than like a coherent project. Just what is the painting saying, then, about the nature of Giambologna's architectural work? Avery implies that the portraitist intended a kind of *paragone* between sculpture and architecture, an idea that would essentially distance the "gentlemanly" activities that most elevate Giambologna in status from the actual objects that had made him famous. More likely, though, is another possibility: the portrait proposes that it was *as an architect* that Giambologna produced his models; the depicted models represent skills that an architect like the one shown at the table might cultivate.[20] The picture raises the possibility that it was precisely the works Giambologna had made in the 1560s that proved his architectural sensibility, a sensibility that Ammanati had compelled him to display. What was it about these works that would have put him in position to make such a claim?

Canons

When Giambologna arrived in Bologna in 1563 to collaborate on the Neptune fountain, he found himself working under Tommaso Laureti, the "architetto"

tasked to deliver "the model for the fountain, including both the figures and the other ornaments belonging to it."[21] The supervisors, as we have seen, expected Giambologna to play the rather limited role of fine tuning the attitudes of the figures, particularly the central *Neptune* (see fig. 2.8). As Richard Tuttle discovered, moreover, the patron had specific ideas about what he wanted the *Neptune* to do, and he took the trouble to spell this out in an unusually precise description of the intended program:

> At the highest summit stands Neptune; his right hand armed with a trident. Under him are the four winds and around them are four children, who handle dolphins, as if playing with them. Under [the children] are four sirens, who likewise sit on dolphins, as if on seahorses, and press water out of their breasts. . . . [Neptune] holds the trident in his right hand, just as if to strike a blow, and he compresses the winds to such an extent that he frees the people who are subject to his sovereignty from fear of any tumult or agitation.[22]

The text goes on to explain the emphasis on play and to justify the inclusion of the sirens, concluding that the whole fountain aimed to demonstrate that "the greatest otium and the most intense zeal for peace are found wherever the sovereign himself undertakes the business of administering his own realm."[23] In addition to the Cesi's commentary, Tuttle also discovered a series of sketches Laureti made of fountains, though none includes all the components named here, and the design of the central figure probably fell to Giambologna, who departed in more subtle ways from Cesi's vision. The left arm of both the small bronze "model" (see fig. 2.9) and the final full-scale work extended in what all would have recognized to be a pacific gesture derived from the "Quos ego" scene in Virgil's *Aeneid*.[24] Giambologna's Neptune calmed the seas, and in doing so it took over the act that Cesi thought to embody in the play of the dolphins. What Cesi had proposed for the central gesture, by contrast, is a god that would "press" or "crush" (*comprimat*) the winds, preventing storms. The gesture of the statuette hardly supports such a reading; characteristically for Giambologna, it emphasizes lightness rather than weight. Neptune's right leg, which falls beneath his chest, head and center of gravity, presses not downward but sideways, into the dolphin it pins against the god's staff.[25]

Then there is the staff itself. In the large sculpture, an added extension transformed this into a trident. (The join is readily visible even from the ground.) Giambologna may have intended the instrument in the small bronze to serve as an abbreviation—a staff that viewers would *imagine* as a trident—but anyone

5.4. Danti, *Equity and Rigor,* with Giambologna, *Cosimo I* (in situ). Marble, Uffizi, Florence

who knew Ammanati's *Neptune* (see fig. 1.9) could easily have mistaken it for another kind of attribute, the baton of rule that had become a basic element in late sixteenth-century colossal sculpture. That motif derived from ancient portraiture, and in the sixteenth century, too, viewers could find it in images of individuated rulers, especially military commanders: Michelangelo's Giuliano de' Medici in the New Sacristy (see figs. I.6, I.7), Bandinelli's two portraits of Giovanni della Bande Nere, and Pierino da Vinci's Duke Cosimo in his relief *Allegory* in Vatican Pinacoteca, among other sculpted portraits, all wield related instruments; the fasces in the hand of Danti's *Cosimo* for the Uffizi (see fig. I.5) offers a variation on the theme, and Giambologna's replacement restored the more standard device (fig. 5.4). Tradition would have sufficed to ensure that when Ammanati made his *Neptune* in Florence and Giambologna his rival statue in Bologna, both evoked the presence of a ruler the sculptors had not quite portrayed—or, put differently, both sculptors had created a kind of portrait that did not depend on resemblance.

In the case of the Ammanati fountain, which drew a specific comparison between the god and the duke through an astrological allusion on the wheels of Neptune's chariot, some modern viewers have perceived the duke's features in Neptune's. Yet Borghini's dialogue, which discusses the fountain at some length, gave no indication that any of its characters recognized such a reference. Across the whole sequence of statues, in fact, the portrait function seems less determinative than the adherence to a generic language, one that was just taking root in the 1560s. As the control of water emerged as a metaphor for the peaceful, bounteous regime, the sculptures that decorated fountains moved the mythological image toward the abstract. The visual translation of the kinds of comparison on which fountains' inscriptions and programmatic descriptions turned required a generalization of form. As the trident or staff became a baton, which historical character the statue showed—Neptune, Oceanus, or even, in the case of Prospero Bresciano's related statue in Rome, Moses—became less important than the figure's embodiment of the political "strongman."[26] When the city of Bologna staged its 1598 triumphal entry for Clement VIII, it had no trouble transforming the *Neptune*, if briefly, into an image of Hercules.[27]

Giambologna illustrated his own sense of the statue's abstraction when, around 1571, he employed nearly identical iconography in a fountain behind the Palazzo Pitti (see fig. 3.1). Although scholars have long debated what name they should give to this monument's marble protagonist, it was close enough in type to the earlier Florentine and Bolognese projects that Baldinucci could call it Neptune; as with the initial design for the fountain in Bologna, this figure holds a long baton—not a trident—in his right hand and places his right foot against a dolphin.[28] The primary difference between Giambologna's two figures is that the later

statue does not extend its right arm, holding a shell against its thigh instead. This change, though, no doubt had less to do with the figure's identity than with two other concerns: concealing the genitals (the statue would rise above the duchess's palace) and keeping in evidence the enormous block from which that statue, like Ammanati's, had been carved.

If, in Ammanati's and Giambologna's Neptunes, the baton relates to the figure's genre and portrait function and the pose to imperatives of medium or decorum, the body itself may come to seem the figure's most significant attribute. The 1546 discovery of the statue that came to be known as the Farnese *Hercules* would have made a massive, upright figure in a state of rest seem archaeologically up to date. Further licensing the translation of such Herculean forms to fountains was the image of the river god. Michelangelo had newly drawn attention to this type when he installed a pair of them on the Capitoline hill—a site where Ammanati had worked—and river gods also counted among the sculptures Ammanati carved at the Villa Giulia in the early 1550s.[29] In antiquity, allegories of waters were always bearded and muscular and restful; a late Renaissance artist like Ammanati, making a colossus in a fountain context, needed to do little more than stand such the figure on its feet.

The rivalry between Ammanati and Giambologna, in other words, resulted paradoxically in an assimilation of forms, an emphasis on type that would eventually contribute to the perception that both artists were indifferent to subject matter. Suppressing attributes and directing attention at the body were lessons artists learned both from Michelangelo and from the antique—if there was a "triumph of the body," to use the title of the 2006 Giambologna exhibition in Vienna, that triumph had happened long before this. What makes colossi of the 1560s and 1570s more of their moment is that where Michelangelo seemed to subordinate all else to a singular image of bodily perfection—adult, male, muscular, flexed—the abstraction that emerged between Giambologna and Ammanati adhered to a different decorum.

In his letter to the Academy, Ammanati wrote of the importance in architecture of "proportion, distribution, discretion and fittingness."[30] These qualities applied equally, though, to sculpture; nowhere did the artist show more of a sense of discrete, differentiated types than in his *Neptune* fountain, where he counterposed a series of lithe bronze sea spirits to his massive, grave centerpiece. The iconography may be opaque—some scholars have attempted to assign names to at least a few of the figures along the rim of the basin, but it is by no means clear that all the bronzes were supposed to have specific identities. The fact that these "ignudi" come as a group, though, and the categorical difference between any member of that group and the giant stone god they surround, lets the marble read all the more

clearly as a distinct type. The difference, as Ammanati indicated, depends to a large extent on proportion. Just ten years before, the sonneteer Alfonso de' Pazzi had lambasted Cellini's *Perseus*, writing "the new Perseus has the body of an old man and the legs of a little girl."[31] The joke was that Cellini did not know how to fit the right parts to the right type of body, though given the forceless figures in which Cellini specialized, Pazzi might also have been suggesting that the artist was simply unable to make the kind of strongmen that had come to be expected in the Piazza. Cellini made much the same charge against what he perceived as Bandinelli's inability to shift types as commissions required when he disparagingly remarked that Bandinelli "only copied *Laocoon*."[32] By the time of its completion in 1575, Ammanati's fountain would have looked like a response to the critical failings of his most successful local elders. Giambologna's statues, too, have the character of a rejoinder.

Venus and the Self-Similar

The rivalry between Giambologna and Ammanati in the 1560s yielded a well-defined sense of one male sculptural type, and much the same happened when the two tackled female subjects. Consider a marble now in a private collection (fig. 5.5), one that Giambologna approached in much the way other sculptors thought through restorations.[33] Though the sculpture as a whole does not look like any other single work, its parts derive from sources that all, in a sense, belong together. The vertical orientation of the figure and the arrangement of its arms inform Michael Bury's observation that "behind the figural invention lies an antique Venus *pudica*." The accessory the figure wears between elbow and shoulder on her left arm, a sort of strap attached to either side of a round central element, updates the ornament worn by numerous ancient Venus figures, including at least one then belonging to the Farnese.[34] A familiar crouching type, which also survived in multiple versions, featured a similarly complicated arrangement of hair, held in place by a simple band but with a single lock draping over the figure's left shoulder.[35]

Closer to hand than these sculptures, though, was a Venus Ammanati had restored for Cosimo I shortly after his arrival in Florence (fig. 5.6). Ercole Ferrata re-restored the statue a century later, so we no longer know exactly what Ammanati produced, though a stucco model now in the Casa Vasari in Arezzo seems to have represented his initial proposal for this.[36] Ammanati's restoration included the legs of the figure, and Giambologna evoked the fragmentary state of the original antiquity by cutting his figure off at the waist and by adding an armband at the

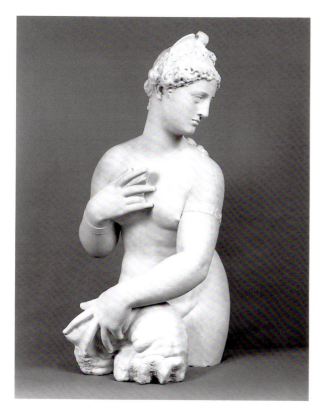

5.5. Giambologna, "Fata Morgana." Marble. Private collection.

place where Ammanati had to hide joins—significantly, a drawing in Giovanni Francesco Susini's notebook (fig. 5.7) shows a statue it identifies as the "beautiful ancient Venus that is in the Gallery." While Giambologna on the whole stayed very close to known prototypes, moreover, he took the most liberties with members he knew to have been added by Ammanati; the *pudica* format, for example, may derive from Ammanati's Venus, but Giambologna turned the head of his figure more sharply and completed the arms in a different manner.

The figure's left hand wraps around a shell, an attribute proper to the goddess born from the sea; the right arm presses something against the figure's breast. Pliny's description of a well-known crouching Venus type as a depiction of "Venus washing herself" had an impact on numerous Renaissance artists, and some writers have inferred that Giambologna's figure, like a Venus at her bath, must be holding a sponge. Bury, however, has appropriately cautioned that whatever the figure once held is now so weathered as to be unidentifiable, and we might go still further and ask whether it is not more useful to view that passage as a document of the

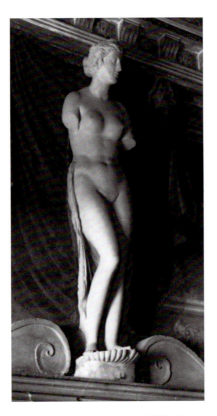

5.6. Ammanati, stucco model for the restoration of an ancient Venus. Casa Vasari, Arrezzo.

5.7. Gianfrancesco Susini, "Disegni e misure e regole," fol. 32v.

sculptor's process than as a specific motif. Giambologna would surely have noticed that one of the most technically impressive features of many ancient statues of Venus was its detached hand and fingers; the young artist, still unsure of his skills as a marble cutter and unwilling to take great risks, may have started the arm with such a vision in mind, then realized that he was not up to the task of finishing it.

Whatever the case, any inventory of the sources from which Giambologna derived his statue would suggest that he thought about its identity largely in reference to depictions of Venus, old and new.[37] And it can only come as something of a surprise, then, to see contemporary indications that the statue's original patron, Bernardo Vecchietti, framed the marble unambiguously as a representation of an entirely different personage: by the early 1570s, visitors to the fountain would have found an inscribed accompanying quatrain that began, "I, reader, am Morgan

5.8. Gianfrancesco Susini, "Disegni e misure e regole," fol. 3r.

5.9. Gianfrancesco Susini, "Disegni e misure e regole," fol. 20r.

Each of the figures comprises a network of line segments that allow comparison of the relative lengths of different body parts and of the distances between them. Between the two sets of Hercules drawings, Susini inserts an elaborate explanation of how he went about constructing these:

We will follow other measures with a new order of measure that seems easier to me. This regulates itself with a part of the body that you will not measure, as follows in the example of Lysippus's Hercules in the Pitti, which was measured by Messer Lodovico Cigoli. You start by taking the whole surface of the face, from the roots of the hair at the top of the forehead to the bottom of the chin. (As for the beard, this will be regulated by comparing it with other parts, such as the shoulder blade, the breasts, and other known and common measures.) You mark this length on a measuring rod and label it with the letter T. You then indicate half of this head-length with another sort of label, maybe this: ℓ. Then you divide the whole in twenty-four parts, giving these the numbers of the abacus in the usual way. You divide each part in half and mark that half with the label $/$. And this final measure [is] the equivalent of one forty-eighth of a part. Since this seems sufficient, and since you want the smallest units, you will divide the

with de Witte's painting of Giambologna in his studio. Both suggest that in making three-dimensional figures, the sculptor might work consciously in the manner of an architect. As Danti wrote "that it is from architecture that most sculptors have taken their model," so does the picture associate Giambologna's operation of the compass with the models he made in the 1560s, before designing his first buildings. More fundamentally, both the treatise and the painting show why, for the ambitious sculptor, the systematic study of sculpture might depend so heavily on measure.

"A New Order of Measure"

Order is also a central topic in Gianfrancesco Susini's notebook. We have already seen how, in the first part of the text, the early seventeenth-century sculptor summarized lessons from Leonardo that had long been central to the Giambologna workshop. The final pages of the manuscript, however, change course from this, giving themselves over to an analysis of actual sculptures. The fact that nearly all the works treated on these folios date to the years before Ammanati's and Giambologna's respective arrivals in Florence suggests that the canon of models at least in this circle had changed little between 1560 and 1620.

We will recall that Susini gave his book the title "Designs and Measures and Rules for the Posing of the Human Body": *misure*, "measurements," first emerge as an interest on the book's third folio (fig. 5.8), on which Susini calculates the height of Florence Cathedral from the ground to the dome (92 braccia) and from the bottom of the dome to the lantern (55 braccia), as well as the height of the bell tower beside it (144 braccia). To do this, he must have relied on instruments like the quadrant and compass Giambologna gave his personification of *Architecture*. The cathedral drawings, moreover, are not the only architectural analyses in the treatise. Folio 35v, for example, provides a diagram inscribed *modo per formare una porta giusta* (manner of forming a proper door). The drawing implies that the sculptor's primary art attuned him to basic architectural choices.

The most significant treatment of measurement, nevertheless, comes in the drawings that begin on folio 18 and continue to folio 35, constituting the largest single section of the manuscript. These include a series of views, from different angles, of the Farnese *Hercules* (fig. 5.9); a longer series, including two profiles of just the head, showing the ancient marble *Hercules* that then stood in the courtyard of the Pitti Palace; two views each of Michelangelo's *Night* (fig. 5.10), *Dawn*, *Dusk*, and *Giuliano de' Medici* (fig. 5.11) from the New Sacristy of San Lorenzo; five views of the above-mentioned Venus (see fig. 5.7; fig. 5.12); and an image of an unidentifiable baby.

architect, using the rules I've just mentioned. This is not true of sculpture and painting, for which no rule has ever been formulated that can truly facilitate their imitation, especially with regard to the human figure, which is obviously so difficult to compose.[55]

To follow Danti's distinction, sculptors tend to think about the task before them as that either of reproducing the way things look (*natura naturata*) or of representing the processes behind what we see (*natura naturans*). Architects, by contrast, take a conventionalized set of elements and assemble them at will. The orders, because they have already been systematized, allow architects to circumvent the first problem that confronts the sculptor, that of deciding what it is that he should take as his material. Architecture, in this sense, has rules, a condition that sculpture has yet to attain. Only by imposing "order" on sculpture will it be possible for the artist who makes figures to graduate from the task of imitation to the higher project of composition. To take the example of Giambologna's *Oceanus* or *Fata Morgana*: each statue is a pastiche, but one that limits itself to drawing on a particular set of motifs that already belong together.

Danti wrote these lines, significantly, in the years he was pushing his own sculpture in the direction of the abstract. His personifications of Equity and Rigor on the *testata* of the Uffizi (see fig. 5.4) maintain the evasiveness of Michelangelo's *Dawn* and *Dusk* in the New Sacristy, and the portrait of Cosimo they flanked pursues the generalization Michelangelo had allegedly remarked in his *Capitani*, saying that rather than following nature, he had given the portraits a "greatness, proportion, and decorum."[56] The assignment itself invited close consideration of just what it might mean to compose figures with proportion and decorum, since Equity's attribute was the compass. Borghini, looking at Danti's allegories with the distance of two decades, remarked that the invisibility of their own attributes made them all but unidentifiable, and the vagueness of the figure between them raised sufficient concern that Duke Francesco later had Giambologna replace the statue.[57] The group must make us ask whether Danti thought sculptors should really "portray" at all, even when making portraits. It is as though the sculptor was trying to make figures no more individualized than the columns behind them.

Francesco's choice of Giambologna to provide the replacement for Danti's duke may indicate that the Fleming limited his abstraction to appropriate spheres. Still, the guidebook editor Giovanni Cinelli could no longer recognize Cosimo even in Giambologna's version only a century later.[58] Numerous works from these years, moreover, suggest a sympathy to Danti's belief that a significant part of the sculptor's art was nonmimetic. And the fact that Danti's *Treatise* characterized the movement of sculpture away from imitation as a move toward architecture, finally, resonates

self-justificatory, since the younger sculptor followed Michelangelo's lead, portraying virtually nothing but bodies. This was characteristic, though, of the sculpture of late sixteenth-century Florence, which, despite the occasional animal subject, remained overwhelmingly anthropocentric.

At the same time, Danti's way of looking at sculpture helps make visible the more radical reduction of repertory that the "Fata Morgana" or "Fiorenza" exemplify, one that went beyond a focus on human figures. When "composing proportionally," one can employ a "rule,"

> and one can take recourse to this, using the compass of the judgment no less than one pursues the endpoint of the architectural orders using the physical compass. And this will be the aim of the perfect proportions.

Danti's treatise conceives sculpture, in other words, on analogy to architecture; both, he emphasizes, rely on proportion so as to reduce compositions to what Danti calls an "order." The sculptor, Danti maintains, should imitate the architect, approaching the design of a figure as one would a building: "one should believe," he writes, "that it is from architecture and from the principle object of architecture that most sculptors have taken their model."[53]

The assertion has an obvious relevance to projects like the *Appenine*, which is really a three-story building in the form of a figure: it would be hard to find a more literal case of an artist thinking of a sculpture as architecture. But Danti's point is that, even in the *Appenine*, the real issue is not the creation of a sculpture with an architectural function, but that the design of such a figure depends on a sense of qualitative and quantitative rightness that is fundamentally architectural in origin and nature. We know little about the architectural projects Danti took on at the end of his life, though Borghini remarks that he reduced his Perugian projects, notably the stairway of the Palazzo de' Signori, with "order and design."[54] This is the same kind of language Danti had used two decades earlier to describe the problem of generating sculptural figures.

The challenge for the artist who would conceive a marble or bronze on analogy to a building is that sculpture and architecture have two different relationships to the task of imitation. Danti writes:

> It is very true that architecture composes things as it pleases—that is, not imitating in the manner that the other arts imitate. For this reason, as is said, architecture appears to be of much greater artifice and perfection [than painting and sculpture]. Today, however, this is no longer true, for architecture has been reduced under so many rules, orders and measures that its execution has become easy. . . . These days anyone who knows how to draw two lines can play

reflects the paucity of information available regarding the dating of even important works; still, the modern Giambologna literature differs strikingly from conventional monographs on other artists in its avoidance of a biographical approach.

The earliest historians to write on the artist dramatized the discontinuity between the types that came out of the studio. Thus, Baldinucci imagined that Giambologna's *Appenine* "damaged" those who worked on it:

> Nor are we to avoid speaking of how, to some of Giambologna's disciples, who were working there on that project, it did considerable damage, they having lost, so to speak, their hands. For in having to work subsequently on statues of ordinary proportion, it seemed to them that they were always working on the muscles of the Appenine. One of them, whom this work greatly harmed, was a certain Antonio Marchissi of Settignano, who so ruined the judgment of his eye that when he returned later to work in Giambologna's studio, he could no longer do anything that was good, and he lost his salary.[50]

The biographer's point is not just that colossal sculpture presented unusual challenges, but also that collaboration with Giambologna required a kind of adaptability to which sculptors might not be accustomed. Working on figures of different sizes required assistants to recalibrate the proportions they used, the relative measurements that distinguished one type from another. Since every sculpture began with a model, his collaborators had to distinguish between "ordinary" and extraordinary proportions even when making figures of the same size. Indeed, it is the small bronzes that put Giambologna's shifts in proportion most pointedly on display.

 Proportion was among the topics on which sculptors in these years tended to dwell in their writings. Ammanati seems to have owned and annotated a copy of Luca Pacioli's *Divina proportione*; his sheets in the Riccardiana include a series of geometrical exercises that Pacioli may have inspired.[51] It is Danti's 1567 *Trattato*, however—a publication that took proportion as its central topic—that sheds the most light on all of this. Early on, the text remarks that Michelangelo painted and sculpted few subjects other than the human figure, indeed that Michelangelo saw "little reason to concern oneself with any other thing that can be portrayed or imitated."[52] The comment responds to one of the more familiar sixteenth-century *paragoni* between sculpture and painting: whereas the painter drew attention to the variety of things he could show, the sculptor stayed with a drastically more limited set of subjects. As Danti saw it, the minimal range of Michelangelo's art was a matter of choice rather than ability; he had willingly forfeited many fields on which painting competed and had reduced his repertory so as to concentrate on a single kind of perfection. Danti's view of Michelangelo may appear

of Michelangelo, came not only to turn out multiples on the Venus theme but also to compete in the central Italian market for overmuscled colossal males. The latter group makes it difficult to characterize Giambologna's art, as Mozzati also does, in terms of an "academic" study of anatomy that privileged the moderated to the well defined.

Nor is it the case that Giambologna approached the nude in terms of some absolute sense of beauty. Assertions to this effect miss the degree to which all of the artist's experiments were contemporary and local, responding in particular to Ammanati. When scholars write of Giambologna's perception of an "ideal," they are getting at something that has as much to do with decorum as with beauty, a discernment of what kinds of things do and don't belong together. This becomes virtually emblematic when the hybrid body of the satyr or centaur appears over and against a beautiful female that almost organically melds motifs derived from well-known sculptures of Venus (see fig. 6.16), and the antithesis conforms to one that Bocchi drew, between the "unity" that characterizes beauty and the ugliness that comes with composing dissimilar parts.[48] Ultimately, such a manner of thinking approaches the sensibility of the architect: it is nothing other than the discernment for which the period's architectural treatises regularly called, a discretion that allowed conformations to type, the practical sensibility that allowed building designers to place the right capital to the right column, the Vitruvian distaste for the chimeric.[49]

Pushing the individual in the direction of the typical required a consideration of iconography and subject as much as style, and a focus on figures that are beautiful as well as on figures that are not; it may be more helpful to suggest that the sculptors were inclined to "categorical," rather than to "idealizing" thinking. When Borghini writes that in the *Sabine*, Giambologna wished, "without intending any *historia*," to show "a fierce youth abducting a most beautiful maiden from a weak old man," he does not mean that Giambologna wanted to show the best possible example of a youth or an old man, but rather that Giambologna's young men and women were *generic*.

The literature on Giambologna already gives the curious impression that the artist thought in terms of types, almost to the point of making chronology inconsequential. Elisabeth Dhanens's classic monograph organized sculptures by subject matter; Charles Avery's important study from the 1980s devoted chapters to "Female Figures in Marble," "Horses and Riders," and so forth. The catalog to the recent Giambologna exhibition in Florence inserted the sculptures into sections on the Wunderkammer and on garden sculpture; the recent exhibition in Vienna placed most of the sculptures featuring female characters on one side of a room and most of the sculptures featuring males on the other. To a certain extent, this

leaving the determination of subject matter to another, though in Florence that determination took place after the work was made, not before. Giambologna also increasingly distinguished the sculptor's work from that of the poet, making statues that were neither illustrations of familiar stories nor quite *poesie* or *historie* themselves. His female figures in particular may ultimately have depended on the culture of restoration exemplified by Ammanati's *Venus*, but they also reversed the process on which those restorations depended, arriving at an incompleteness that stood between different iconographies.

Composing with Things That Are Given

In the case of both the "Fata Morgana" and the "Fiorenza," external devices frame the statues as specific characters, who, absent these supplemental features, become virtually indistinguishable from characters of another name. This might lead us to ask whether similar statues—the "Venus of the Grotticella" or the "Cesarini Venus," or any number of small bronzes—have the secure identities that their conventional names presume, whether these were not just as flexible as their larger-scale predecessors. From another perspective, though, it is the *inflexibility* of the identities Giambologna gave his female figures that is most striking, the insistent regularity, the repetitiveness, of the whole group. The artist, after all, is not just treating arbitrary subjects; he is making statues with a set of more or less homogeneous features, refusing to stray from a narrow range of possibilities even when patrons might like figures with different names.

The scholar who has given the most thought to these issues is Tommaso Mozzati, who suggests that Giambologna "reinvented" the body of the woman "by means of a constant exercise on the theme of Venus," a procedure that distinguished Giambologna's practice from that of Michelangelo.[46] Arguing that Giambologna, concerned as he was with the depiction of the female form, would not have found Michelangelo's figural language useful, Mozzati associates Giambologna's sculpture generally with a broad shift in emphasis from a manner contemporaries associated with Polycleitus, exemplified by Michelangelo, to one associated with Praxiteles, author of the most famous ancient *Venus*.[47] As we shall see further along, this kind of distinction dates back at least as far as the seventeenth century, when Henri Testelin contrasted what he regarded as Giambologna's "effeminate," "Corinthian" manner with, on the one hand, a "strong," "Athenian" style, and on the other, the "tender," "graceful" examples of both Phidias and Praxiteles. Neither of these schemata, nevertheless, proves adequate to the larger picture; they make little room for the fact that Giambologna, in part through a close study

la Fay."[38] *Morgana* was a fitting enough ornament for a grotto (Ariosto's *Orlando Furioso* had identified Morgana as a spirit who lived beneath the sea) but then so was Venus. Duke Ferdinando, in fact, would later have another Giambologna Venus, likewise a fountain, installed in the Grotto Grande of the neighboring Boboli Gardens (see fig. 6.16). Giambologna's *Morgana* seems to be the first Italian representation of the character, and we might ask whether that "invention" was the artist's or whether it came about only upon the patron's "baptism" of the object the sculptor delivered. In the eighteenth century, when the Vecchietti marble was removed from its base, it needed only to be displaced by a few feet to turn it back into a Venus: a 1753 inventory of the contents of the grotto lists "a bust of Venus in marble placed over the earth floor," and a 1755 inventory refers to "a marble Venus, by the hand of Giambologna, which is the same described at the Fountain called the Fata Morgana."[39] It was as a Venus that the statue eventually entered the collection of the English painter and collector Thomas Patch.

The early history of the *Morgana*, in this respect, bears comparison with that behind two other figures. Giambologna's patron seems to have sent the marble now in the Getty as a gift to Duke Wilhelm V of Bavaria, where it remained until King Gustav Adolf plundered it in 1632. Either in Munich or in Sweden, its owners came to call the statue "Bathsheba," but it bears the same attributes that have led scholars to refer to other statues as "Venus."[40] A slightly earlier bronze female nude has traditionally been reproduced under the name "Fiorenza," because it replaced a statue of *Florence* that Tribolo had designed for the fountain on which it stands.[41] No early writer refers to the statue by this name, however, and no other Renaissance evidence supports the modern identification. Baldinucci, apparently the first author to comment on the statue at all, saw only "a woman combing her hair," a misleading description, since the woman holds no comb.[42] As Keutner first suggested, the figure's gesture of wringing water from her hair more readily identifies her as Venus Anadyomene, the goddess who, born from the sea, presses brine from her locks.[43] (Compare Danti's statuette, fig. 2.11.) Though Keutner himself, in the end, also sustained the identification of the figure as "Fiorenza"—largely on the basis of the bronze ring about its socle, which includes emblems of conquered Tuscan cities—the ring is not by Giambologna, who may not even have had it before him when designing the figure.[44] The statue's insertion into a setting with determining attributes provides just one more example of invention (or reinvention) by supplementation, carried out by the patron or collector rather than the artist.[45]

Giambologna's Florentine patrons in this respect operated quite differently from the likes of Cesi, supplying no elaborate description of the work the artist was to make. In both cases, the sculptor kept his role distinct from that of his employer,

5.10. Gianfrancesco Susini, "Disegni e misure e regole," fol. 27v.

5.11. Gianfrancesco Susini, "Disegni e misure e regole," fol. 32r.

other part in thirds, in quarters, and so forth, annotating them with the usual characters of the numbers of the abacus.

This measure divided in twelve parts equals half of the head of the Hercules in the Pitti, which is understood to equal twenty-four parts, though for lack of paper I have not shown the whole thing, but only half of it, that is, twelve parts.

This halfway point of the whole is labeled eleven, thus, in the ancient way, ℓ, and then the others, as you see, are labeled with numbers. Throughout, as has been said, you use the label *T*, [which stands] for the entire head. And if, for example, you want to label something as being one head plus sixteen and a half parts plus two-thirds, you will write *T ℓ 4*: the *T* to signify one head, ℓ for one-half, and from the halfway point, which is twelve parts, until the sixteenth part,

5.12. Gianfrancesco Susini, "Disegni e misure e regole," fol. 33v.

the difference is 4, according to the abacus. And you continue in this way until you arrive at the half-heads, and you label these with this sign— χ —which you see to be one forty-eighth of the entire head, taken from the roots of the hair (A) to the bottom of the chin (B). And because the hair sometimes falls over the forehead, as happens often with ancient women, and because the beard occupies the chin, you take the length of the whole nose and duplicate this three times, as at A ℓ B. This you can understand to represent one head-module, which we divide in twenty-four parts as we did for the measurements above, indicated now with the previously mentioned labels $T \ell 11 \chi$. And if perchance they are more than two of these four parts, you will use the number 2 before the T or more if there were more.[59]

Susini shows most of his measured figures in more than one aspect, not so much to insist that sculptures should have multiple points of view as to illustrate that some of any statue's measurable parts will remain invisible from the front. His decision to start with a work attributed to Lysippus may reflect an awareness of Pliny's assertion that that sculptor "scrupulously preserved the quality of *symmetria*," that is, of commensuration.[60]

Among the most surprising aspects of the sequence is Susini's decision to stand Michelangelo's figures up. This minimized their differences from the

antiquities Susini includes and allowed comparison of the whole group. Late sixteenth-century writers, Borghini among them, had already observed that highly wrought figures defied the kind of measure Susini wanted to take.[61] Danti, for his part, remarked that

> all the major parts vary both in length and in breadth when they move, as anyone can obviously see. Thus, when we need to move [our depictions of] the human body into this pose or that, we cannot—on account of this variation in measurements—use the measurements that are presented to them, and we cannot depend on them.[62]

Anyone who thought through tasks like Susini's would already have seen that the most easily measured figure was a standing one.

Still, Susini's drawings after the modern statues in his series also highlight a broad transformation in imitative sensibilities. Through midcentury, artists and theorists had tended to regard the poses Michelangelo gave his figures *as* his art: the maker of the red wax model after Michelangelo's *Slave* pursued the same ends as the students in Cleve's painting. Susini's drawings, by contrast, reflect a shift pioneered in Danti's *Cosimo as Augustus* and *Honor and Deceit*, which implied that the proper response to a canonical model was a variation, not a quotation. The drawings in the notebook convey no information about costume or hairstyle. They completely eliminate the picturesque in favor of relative quantity. Danti had drawn a distinction between "portrayal" and "imitation." What Susini writes, however, also allows for a different sort of description.

With the word "order," Susini refers to a method, a way of "following other measures," as he puts it, rather than to a collection of rules. Though he presents his order as new, his basic analytical mode is much older, taking up themes from earlier writings on the figural arts—Alberti's *De statua*, for example, much of which was dedicated to what the author called the *dimensio*—but even more than that from the sixteenth-century literature of architecture. Opposite his first drawing of the Farnese *Hercules*, Susini mentions that the measure to which he refers "is the Roman palm, as Serlio writes in his first *Book of Architecture*, which can be divided into twelve 'ounces' and every ounce into four 'minutes.'"[63] The credit betrays an error of memory, since Serlio had introduced the Roman palm in book three, not book one, of his treatise. What remains significant, though, is that Susini brought the terms of modern architectural theory to bear on the figure.

Susini must have known Serlio's publication firsthand, and this itself links him to the earlier generation. When Danti, for example, proposed an oval plan for King Philip II's Escurial, he may have been working from an exercise Serlio did indeed include in his first book.[64] Ammanati was studying Serlio at least as early

5.13. Giambologna, "Bathsheba." Marble. Getty Museum, Los Angeles.

as 1564, when he copied a project from one of the architect's prints.[65] And Giambologna's interest in the text would no doubt have extended from its systems of measure and techniques for generating complex shapes to its application of specific motifs. The Petraia *Venus/Florence* is roughly contemporary with the *Venus of the Grotticella* (see fig. 6.16) and with the nude female in the Getty (fig. 5.13), and all three compositions associate the figures with vases.[66] The Renaissance image of Venus at her bath sometimes included a small jar, a reference to the anointment of the goddess, but vessels of the size Giambologna includes have no place in the traditional iconography. They do, however, feature in Serlio's lessons (fig. 5.14):

> As I was considering the rule I demonstrated on the previous page [i.e., the construction of flattened arcs], the thought came to me to make different forms of vases with this rule, supported by reason and by lines. I shall not make a great effort to describe how to do this because when the intelligent architect sees the figure below he will be able to make use of the rule and create other, different forms.

Serlio regarded the vase as an exemplary architectural product, an illustration of geometrical principles and of the use of the compass. All, he specified, were derived from circles.

Giambologna's vases and the women they accompany belong to a tradition Elizabeth Cropper has studied, within which the vase served as a metaphor for the beautiful female form. Serlio commented that he was offering "a rule and method for forming six types of vase," and the key text Cropper, too, adduced, Agnolo Firenzuola's 1542 *Dialogo delle bellezze delle donne*, presented a diversity of vases, each of which would correspond to one beautiful type. Cropper underscored the fact that the use of vases as pictorial metaphors of beauty pointed to lessons that artists might derive from Vitruvius—on symmetry, eurythmy, and generally, "the analogy between architectural proportions and those of the human figure."[67] In the case of Giambologna, the analogy specifically allowed the artist to stress the difference between sculpture and ornament—Serlio might have indicated that he omitted the beautiful ornaments with which vases could be decorated, "so as to avoid impeding the lines," but the sculptor took this considerably further, eliminating handles, lids, and anything that might even vaguely remind viewers of the work of the goldsmith. Most of all, though, the comparison between figure and vase moved the generation of sculptural form in the direction of architecture.

Pairing figures with vases helped generalize a narrative figure into a visual category. If the varieties of column, to follow Serlio, derived from human form, the vase could abstract the figure in much the same way.[68] Here we should remember that Susini, like Danti, subordinated his exposition of measure to a concept of

5.14. Vases, from Sebastiano Serlio, *I sette libri dell'architettura* (Venice, 1584), fol. 12r.

"order." Consider the nature of the variety in Susini's set of drawings—or rather the lack thereof. Among Susini's measured sculptures are two virtually indistinguishable figures of Hercules, one probably studied in Rome, the other in Florence. From Michelangelo, the book includes only the statues of *Night*, *Dawn*, *Dusk*, and *Giuliano de' Medici*. And whereas the figures on which these were based differed in sex, age, and condition, Susini instead assimilated them: the figure labeled *Cropuscolo* (*Dusk*), for example, removes the beard and gives no indication that the musculature in the original was far more defined than that of the Medici prince. Overall, the notebook gives the impression that the sculptor could get by if he understood the proportions of a Herculean figure, of the svelter statues of Michelangelo in his Florentine years, of a Venus, and of an infant. By 1618, that is, the sculptor's repertoire was, by comparison to Michelangelo's, both simpler and more complex—simpler in the sense that it could elide Michelangelo's differentiations, more complex in that Michelangelo would now represent one among several types. Indeed, the function both of the two Hercules statues and of the ancient *Venus* seems to be that of providing contrast with the sculptural

type one could learn from Michelangelo—but the repertoire did not need to be limitless, either. Susini seems to have presumed that the assignments a sculptor would receive would align themselves with (or perhaps between) these anchoring references.

The reductiveness of Susini's examples goes well beyond Giambologna's earlier practice. The *Florence* crushing Pisa and the *Fata Morgana* may be of a kind, but it is size, as much as type, that determines their proportions. Still, Susini's notebook orients one additional gloss on de Witte's portrait of Giambologna, and especially on its inclusion of the "Fiorenza" for Castello and the "Oceanus" for the Boboli Gardens. As variations on the Venus and Hercules themes, these conform to the essential figures that Susini, too, believed artists should master. And by pairing these two models before a man who operates a compass, the portrait represents the two sculptures as bases and demonstrations of an architectural system.

Measured Drawings

De Witte's portrait suggested that when the sculptor used the dividers, he did so to make drawings rather than three-dimensional models. This, too, moved him into the realm of the architect: the vast majority of Ammanati's works on paper, notably, are studies for buildings, and even sketchy sheets like the Uffizi drawing include measurements. No secure drawings by Danti survive at all, and the drawings that have been persuasively assigned to Giambologna can be counted on one hand; they include a sheet showing an elevation of the Salviati Chapel, in the Uffizi (fig. 5.15); another with the *Oceanus Fountain*, in Oxford (fig. 5.16), one with a Mercury Fountain, in Berlin; and a drawing of a horse, in the Louvre.[69] All feature specific sculptures by Giambologna in more or less finished state; none, that is, seems to have played a role in helping the artist compose a particular figure. And at least with regard to the first three, the drawings key their information to helping the artist imagine or the patron envision the edifice into which an already completed figure would be incorporated. They are designs for installations, not for statues as such.

Through the end of the sixteenth century, sculptors who set out to design figures preferred to work in three dimensions rather than on paper. Giambologna's drawings in particular, however, might allow yet another reading of the de Witte portrait: they complement the image of a sculptor who constructed models according to a sense of measure with an architect who, after completing his figures, turned to the task of conceiving a proper setting for them. Both of the figures shown at the back of the portrait, significantly, belong to fountains, and two of Giambologna's four known drawings are for fountain architecture. In the actual

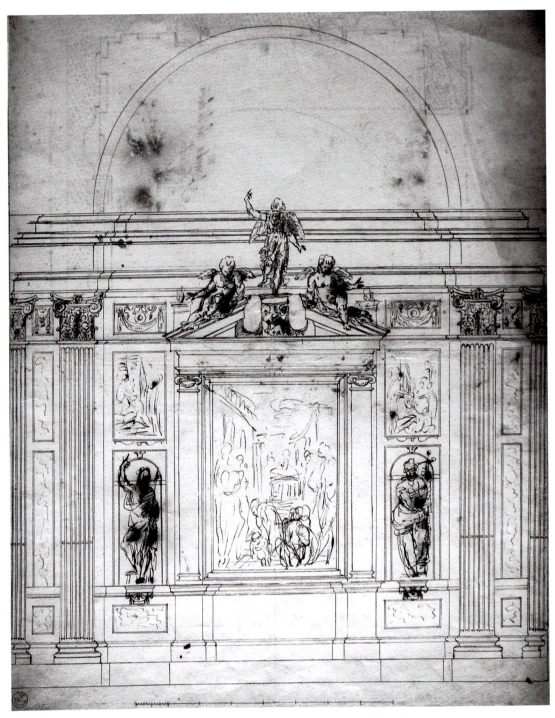

5.15. Giambologna, study for the Salviati Chapel (recto). Ink on paper. Uffizi, Florence.

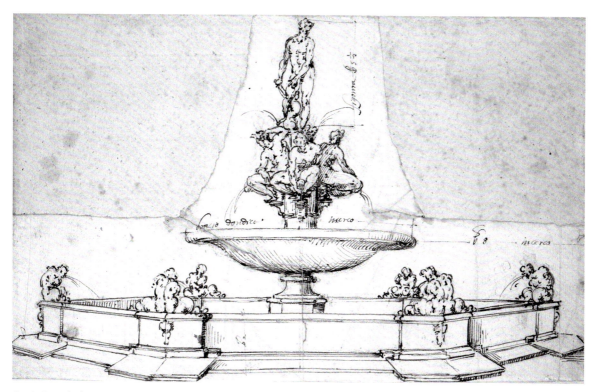

5.16. Giambologna, study for the Oceanus fountain. Ink on paper. Oxford.

drawings he left, moreover, Giambologna harmonized sculpture and architecture by using one to rule the other.

This is true in a rather simple way in the Oceanus drawing, which shows the proportional relation between the marble figure at the center, the basin over which it stands, and the pool with its containing wall at the bottom. More complex is the Salviati Chapel sheet. At the center of the drawing, a light scribble functions as a placeholder for the painting of *Christ in Limbo* that Alessandro Allori would carry out for the space. (It does not really resemble the final painting, which, like those for the other walls, was only completed after much of the rest of the chapel was built—chronologically, at least, the chapel's paintings were secondary to its sculptures.) An aedicule or tabernacle frames the painting, on the top of which lie two putti in positions that, like Danti's Uffizi allegories, imitate those of Michelangelo's *Times of Day*; between them, a large bronze angel perches on one leg. Flanking this ensemble are two niches with their sculptures. These stand on small platforms that project slightly forward from the niche, hence the heavier

inking there. The rectangular fields below each ledge indicate where Giambologna intended to insert marble revetment. Above the niches the draftsman shows the rectangular fields into which he would set bronze reliefs with episodes from the life of St. Antoninus, the saint to whom the chapel was dedicated. At the far sides, finally, are paired pilasters, each separated by three additional pieces of inset marble.

A few details are telling. One is the pair of lines that runs across the back of each niche, marking at once the highest point on each figure's shoulder and the lower limit of the conch. The distance from this line to the floor of the niche is identical to the distance from the base of the pilasters at the sides to the double line that cuts across them about a third of the way up. It is also equal to the distance from the vertical line that runs between the niches and those pilasters to the second of the three lines that divides Allori's painting from the pilasters of its aedicule, as well as to the distance from that same line to the outermost limit of the wall. More correspondences of this sort could be enumerated, but the important point is that a system of proportion governs the various sculptural and architectural forms his chapel included. The same unit of measure that we have been tracking—call it unit x—corresponds not only to the height of the marble sculptures from the base of the foot to the top of the shoulder, but also to the height of the alighting bronze angel, measured from the bottom of the foot to the top of his upwardly pointing hand. In other words, the statues in the chapel are not uniform in size, but they are *made* consistent through their architectural surroundings (in the case of the niche) or through their pose (in the case of the angel). That these measurements are not accidental, finally, is evident from the ruled line at the bottom of the drawing, divided into eight large units, each of which are subdivided in four smaller ones, themselves then broken into thirds. Including a scale measure like this was hardly unusual—they appear frequently, for example, in Ammanati's plans for buildings. Whereas Ammanati tended to use a decimal scale, however, Giambologna's depends on proportional relationships that resemble those of Serlio's Roman palm: Serlio divided his palm by twelve and then divided each of those smaller digits by four; Giambologna divides his large units into four and then his smaller ones into twelve. (Our unit x comprises exactly three of the segments on Giambologna's ruled line.)

Architectural measure in the Renaissance was often human measure. The basic units used by sculptors and architects alike were the "braccio" and the "palmo," literally, the length of the arm and the length or width of the palm. When Ammanati, in his fragmentary treatise, illustrated a technique for determining the depth of a well, he stood a human figure in the top corner of his image (fig. 5.17), divided this into six units, then projected the diagram from the figure's eye, using

5.17. Ammanati, "Modo di misurare una profondita in fossa dun pozzo." Ink on paper. Edizioni rare 120, Biblioteca Riccardiana, Florence, fol. 19r.

its body as the ruling module.[70] He showed that "order," to use Susini's term, could produce figure and architecture together. If Giambologna's allegory of *Architecture*, or for that matter his *Geometry* and *Astrology*, embody an essentially architectural measure, the Salviati Chapel does the same thing on a larger scale, as though the wall and all its figures had been generated in one continuous act.[71]

Epilogue: Testelin's Canon

A century later, the French academician Henri Testelin was no longer able to see the variety of types with which Giambologna worked. As he writes in his *Sentimens*:

> One says, in speaking of the great [Belvedere] *Torso*, that four different manners have been observed among the excellent sculptors. One, strong and hard, was followed by Michelangelo, the Carracci, and the whole Bolognese school, and this manner was attributed to the city of Athens. The second, a bit weak and

effeminate, of which Étienne Delaune, Francavilla, Pilon and even Giambologna were held to be masters, was thought to come from Corinth. The third, full of tenderness and grace, particularly for delicate things, was the one that Apelles, Phidias and Praxiteles were held to follow in their designs; this manner commanded great esteem, and was thought to come from Rhodes. But the fourth, soft and correct, the one that marks great, flowing, natural and easy contours, is that from Sicyon, a city in the Peloponnesus, whence came Herodotus, the author of the Torso, which he completed by choosing and joining together that which was most perfect in each of the other manners.[72]

That Testelin associated Giambologna with what he thought of as a "Corinthian" manner reflects the topicality of the "modes" in the French academy, the organization of styles according to a set of proportional or harmonic scales.[73] Still, Gauricus had made a related idea available already by the early sixteenth century, when he offered advice specifically to "all those sculptors who want to be Corinthian." Both writers point to the possibility that the sculptor, approaching architecture and abstraction, might generate manner from the compass.

6

CHAPELS

On 22 August 1582, Ammanati wrote to his colleagues from the Accademia del Disegno in Florence warning them to avoid falling into the same "error and defect" he had, "making my figures entirely nude and uncovered" just because that was how his predecessors had made theirs.[1] The self-flagellatory letter condemns no one but the author himself, singling out "satyrs, fauns, and similar things" such as he had made on the *Neptune Fountain* just seven years before.[2] Still, anyone who looked to the piazza as the letter directed could not have missed the fact that that space was about to receive its first monumental response to what Ammanati installed there, in the form of Giambologna's *Sabine*. Ammanati had watched the preparations underway in the piazza for over three weeks before sending the letter; the new statue was unveiled six days later.[3]

Ammanati's letter frames Giambologna's statue in terms starkly different from the poets' adulation. If Giambologna aimed, to follow Borghini, at nothing but demonstrating "where all the art of making nudes lay," Ammanati wrote that "in making so many nudes, I derived little honor, and, what is worse, my conscience now weighs heavily upon me."[4] The antithesis echoed one promoted by all of Italy's Counter-Reformation writers, raising the specter that Giambologna subordinated religion to the interests of sculpture. And the artist found the same charge directed against him again, in far less veiled terms, a mere seven years later.

On the fourth of February 1589, the sculptor Michelangelo Naccherino, who had apprenticed for a decade in Giambologna's studio before moving to Naples in the early 1570s, denounced his former teacher to the Inquisition. The sculptor for whom he had worked, Naccherino testified, never went to mass or gave confession. During his years in the studio, Naccherino frequently found himself wishing that "Giambologna was a better man, and that he knew God more than he did."[5] Naccherino asserted that he had seen Giambologna "do some things that Catholics don't do," for example, eating meat on Good Friday. This is perhaps the most suggestive charge, for as Naccherino explained, his master broke the church's dietary rules not because he was sick, but simply because he wished to keep working. As Giambologna's apprentice, Naccherino recalled, he undressed and dressed his teacher, and Giambologna "labored away," failing even to recognize religious holidays.[6] The implication echoes Ammanati's, that Giambologna's continuing commitment to the nude put art before faith. As Naccherino recalled, in fact, the whole matter had come up when he found himself in a conversation with a Flemish painter "about the artistic excellence of Giambologna's sculpture."[7]

The denunciation reports that Giovanni Vincenzo della Porta, hearing Naccherino's accusations, remarked with astonishment that the young man had waited well over a decade before accusing Giambologna formally.[8] And indeed the timing of Naccherino's charge is striking. Just as Ammanati had written at the very moment Giambologna was unveiling the work that would forever upstage him, so did Naccherino attack as the Fleming was putting the finishing touches on his single most impressive multimedia religious ensemble, the Salviati Chapel in the Florentine church of San Marco. Either document, taken alone, might make us wonder whether the attacker was motivated by conscience or envy. The independence and coincidence of the two artists' perceptions, however, ultimately raise questions about just how orthodox Giambologna's negotiation of art and religion during these years really was. As the Salviati Chapel was about to open, Naccherino's confessor reported that he had made inquiries in Florence and had learned "that Giambologna had not emended his ways, and that his deeds gave off a foul odor."[9] And the words of Ammanati and Naccherino alike suggest that Giambologna had an eccentric take on the post-Tridentine apparatus, a position that gave at least the impression of self-interest. Ammanati closed his letter by recalling a comment of Michelangelo's: "good Christians always make good and beautiful figures."[10] And the writer's devotion in his own final years to works that avowed his religious convictions put a new kind of pressure on his contemporaries—especially Giambologna, who may never have gone to mass or said confession but who devoted much of his late career to the design and execution of chapels.

Becoming an Architect

Having sought in the 1560s and 1570s to represent his activities as belonging to the domain of architecture, Giambologna must have been especially pleased by the opportunities that presented themselves at the end of that period. In January 1577, the Opera of the Cathedral of Lucca wrote to Grand Duke Francesco to request the artist's services in the construction of a large marble altar.[11] The duke consented, and Giambologna delivered a model in March of that year, completing the final work early in February 1579 (fig. 6.1). Dhanens reports that the patrons commissioned the altar to commemorate Lucca's 1369 victory over Pisa. Such a function would help explain the monumental architectural framework Giambologna employed, its tripartite scheme evoking the form of a triumphal arch, though a sepulchral quality also pervades the whole composition. The general arrangement resembles Matteo Civitali's 1484 St. Regulus altar (fig. 6.2), a tomb that occupied a position analogous to Giambologna's on the opposite side of the nave; an older tomb also occupied the center of the floor directly in front of Giambologna's monument. The narrow, shallow niche behind Christ recalls the similar excavation behind the portraits in Michelangelo's New Sacristy, and the consoles with recumbent figures, the volutes of which seem to unscroll at the end, derive from the lids of the tombs in the same room. The first triumph that Christ's long, cruciform scepter would have marked is that over death. Giambologna flanked his central figure with two others in more conventional niches, and this, along with the porchlike projection in which Christ stands, characterizes the space behind as more a passage than a wall. It is as though this Christ, rather than emerging from a sarcophagus, has stepped forward from a tomb chamber. The patrons referred to the composition from the beginning as the "altare della libertà," or *Altar of Liberty*: Christ, liberated from mortality, becomes a "liberator" for all, and the altar's inscription promises that he will save those who pray before the work.

This conceit helps explain the novel pose Giambologna lent his figure. Scholars have long compared this to the *Victorious Christ* Michelangelo made for the church of Santa Maria sopra Minerva in Rome, though Giambologna must have had more a mind to the Resurrected Christ that Ammanati had placed at the center of the tomb he produced for Giovanni Buoncampagni in Pisa just three years earlier (fig. 6.3). As Johannes Myssok has argued, Ammanati's novel decision to cover Christ's body with a voluminous drapery moves his sculpture away from the emphasis on the nude that his letter would condemn, relocating the artist's challenge in the rendering of cloth.[12] Giambologna, too, decorously wrapped a drapery about the waist of his own figure, and he used a second cloth that falls from the figure's

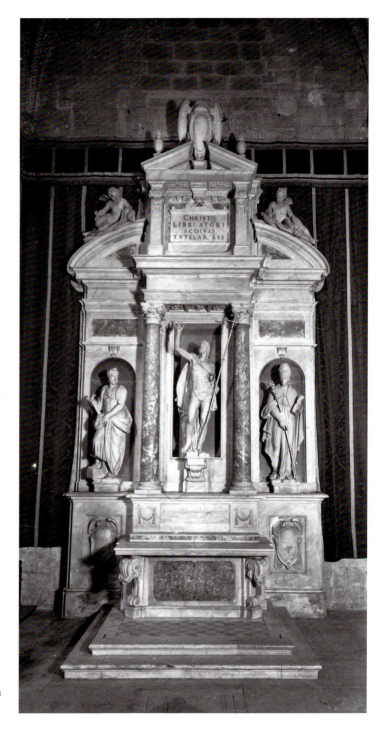

6.1. Giambologna, *Altar of Liberty*. Lucca Cathedral.

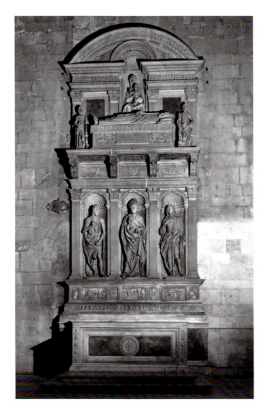

6.2. Matteo Civitali, Altar of St. Regulus. Marble. Lucca Cathedral.

shoulders to the ground as a support. The Lucca composition, nevertheless, rejects the principles behind Ammanati's figure. The Pisa Christ interacts with its drapery, pulling it back to reveal his wound; the drapery in Giambologna's statue, by contrast, provides little more than a backdrop, projecting the nude torso forward almost in the manner of a relief sculpture. The artist used passages like the points of contact between the drapery and the left leg to emphasize the body's contours; the goal, once again, was to negate the sculptural "impediment."

Most remarkable is the figure's right arm. The absence of drapery here draws attention to the arm's complete independence from the broader sheets of marble that prevent other projections from breaking. For much of the sixteenth century, the extension of a marble figure's arm had been a demonstration of virtuosity, and Christ's own gaze seems to encourage study of this limb before all else. Compared to the varieties of compression that had interested Danti (see fig. 3.9), the arm seems not only to pursue a different aesthetic but also to materialize the "liberation" that is the altar's central theme. As Dhanens aptly put it, "Giambologna's

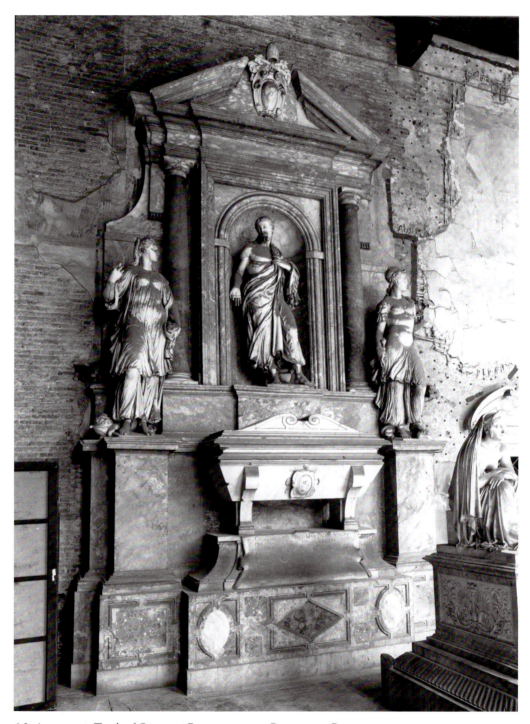

6.3. Ammanati, Tomb of Giovanni Buoncampagni. Campsanto, Pisa.

work comes across as a freeing [of the figure] from the material, a conquest that triumphantly manifests itself."[13] Here again, the sculptor leaves the artifact in evidence; the figure's metaphorical resonance depends on the fact that it is made of stone. A religious commission allowed Giambologna to make a sculptural point.

Dhanens further observed that "for the first time in Italy, the master of freestanding sculpture found himself required to make architecturally bound niche figures."[14] Giambologna himself, nevertheless, might well have seen the commission from the opposite point of view; this was his first chance to produce something that was *largely* architectural, complete with columns and an entablature. If the hollowed-out spaces behind the figures resemble porticos as much as niches, the superimposition of the temple motif on the curved gable gives the whole monument the effect of a facade. It was precisely the kind of project that Ammanati had used to make himself a candidate for architectural commissions, requiring the disposition of multiple three-dimensional figures, the integration of the work into a built space, and the proper use of ornament. It may be, similarly, that Danti's contributions to Florentine tombs paved the way for his 1572 return to Perugia.[15] When, three months after Giambologna completed the Lucca altar, Luca Grimaldi wrote to the Grand Duke, he referred to the artist as "Your Highness's *scultore et architetto*."[16] In that same year, Giambologna started work on two of the three chapels for which he would eventually be responsible, those for Grimaldi in the church of San Francesco di Casteletto in Genoa and the Salviati family chapel in San Marco, Florence. These would occupy him for the next decade.

The drawings considered in the previous chapter suggest that Giambologna's chapel projects represented a kind of extension of his activities as a fountain designer. By contrast to the independent, autonomous figures he was making at the same time, they were what we would now call installations, three-dimensional compositions that centered on sculpture but put the primary emphasis on the conditions of its display. Just how these installations were configured remains speculative in the case of the Grimaldi Chapel, which was largely carried out by others and was destroyed in the nineteenth century.[17] With the Salviati Chapel (figs. 6.4, 6.5), by contrast, the components survive in nearly perfect condition and mostly in their original place, while documentation abounds on the construction history and early reception of the space.[18]

The chapel centered on the sepulcher of the Florentine archbishop Antonino Pierozzi (Saint Antoninus); a bronze effigy topped the ark that contained his remains. Each of the three walls feature a large painting; flanking these were marble figures of saints that had ties to the patrons, the church, and the city, and above each of the marble figures was a corresponding bronze relief showing an episode from Saint Antoninus's life. The images set into the dome filled in further

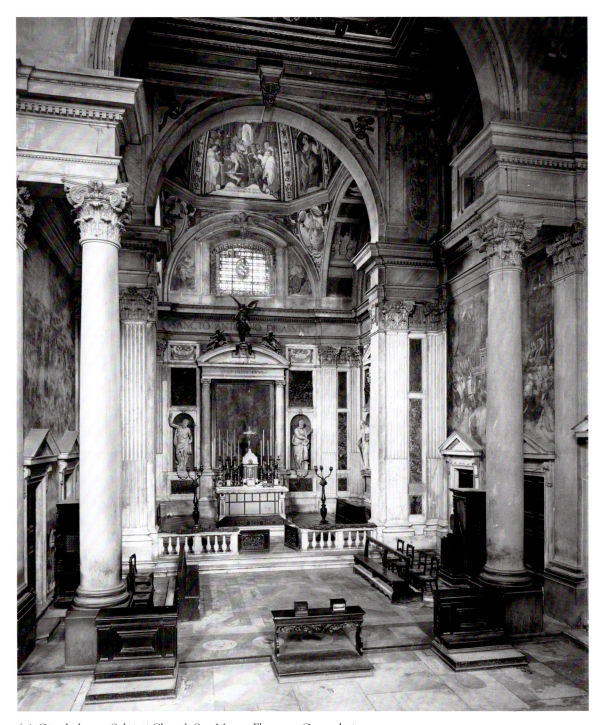

6.4. Giambologna, Salviati Chapel, San Marco, Florence. General view

elements from the bishop's biography, explaining, to quote one contemporary, "why [Antoninus] became a saint and what made him a saint."[19]

Abbot Silvano Razzi's record of the translation of the saint's relics refers to Giambologna as the "architect and master of the statues."[20] And the account books kept for the Salviati offer a still more vivid sense of Giambologna's role, specifying that the artist produced models for some objects, oversaw the execution of others, and coordinated the payments that went to the rest of the artists involved. These books, too, refer to Giambologna as the chapel's "architetore," and the Uffizi drawing appears to confirm that he was responsible for the design not only of the figures but also of the framework that would contain them. Nothing analogous survives for the dome, but the account book does record payment to *legnaioli* for their work on the wood ceiling, "following the design of Giambologna."[21] The upper registers of the chapel involved extensive painting; Giambologna presumably established the general framework, then, in consultation with the patrons, left the designs of individual images to the other artists involved, particularly Alessandro Allori. Benedetto Gondi, who acted as a sort of curator for the project, must have helped coordinate the subject matter: a 1609 inventory of his art collection included twenty-two of Allori's preparatory watercolors, as well as Domenico Passignano's *bozzetti* for the vestibule.[22] Razzi (who had once commissioned a portrait from Danti) remarked that the hiring of Giambologna and Allori illustrated the principle that magnificence requires not just great expense but also the involvement of excellent artists; for at least one monk, that is, the chapel was to be admired not just for inspiring devotion but also for showing off the skills of the man he called "il Fiammingo Buonarroto."[23]

For and Against Savonarola

Naccherino's denunciation of Giambologna seems to have come to naught, probably because of the protection the sculptor enjoyed in Florence. Even so, a non-Florentine might easily have found many things in the audacious decorations of the Salviati Chapel that *dava cattivo odore*. Seminude figure *sforzate*, for example, occupy the foreground of every painting, subordinating story to artfulness. This is precisely the kind of thing that Borghini had decried in his exactly contemporary discussion of sacred imagery, which followed on the heels of Ammanati's letter condemning nudes by only two years. The prominence of these figures demonstrates that there were, despite strong voices that extended beyond the theological ranks, no hard and fast limitations on artistic license in Florence, and that everything depended on the people involved. One key judge in the matter of the chapel

6.5. Giambologna, study for the Salviati Chapel (verso). Ink on paper. Uffizi, Florence.

would have been Tommaso Buoninsegni, a friar at the convent and a professor of theology at Florence's university. Another must have been Alessandro de' Medici, whose elevation to archbishop of the city coincided with the chapel's unveiling. And then there was Francesco I himself, who lived nearly long enough to see the chapel through to its completion. The undertaking required a decade of work from some of the duke's most jealously controlled artists, and this alone signals that it had been carried out under the auspices of the state.

Visually, the chapel aligns itself in various ways with Medici art. The only other monuments in the city with modern bronze reliefs were the sculptures the dukes had commissioned for the Piazza della Signoria, and Giambologna's descending bronze angel, as numerous scholars have remarked, is a sibling of the Mercury that he had sent to the Villa Medici in Rome only a few years before. The paired pilasters in the walls, the inscribed *pietra serena* semicircle that defines the attic story, the symmetrical recumbent figures on their sloped supports, the shallow, narrow niches and the dome, meanwhile, all pay homage to the Medici family chapel in San Lorenzo. The creation of the space continued a series of demolitions that

6.6. Domenico Passignano, *Translation of St. Antoninus*. Fresco. Vestibule, Salviati Chapel, San Marco, Florence.

had already opened up the choir end of the church to the nave, a restructuring that echoed the renovations Marcia Hall has traced in Santa Maria Novella and in Santa Croce, but the likes of which had never previously been undertaken for the sake of a single family's burial site.[24] The now unimpeded view onto the high altar and the coordination of ornament across the nave would have associated the chapel with the new order of sacred space that was being systematically imposed on Florence's religious buildings.

The frescoes Passignano added to the walls of the vestibule followed the completion of the chapel proper (figs. 6.6, 6.7). The first thing the visitor would see framed the chapel not just as a work of architecture but as an *event*, one associated with a transitional moment in the history of the church and of the city. The murals show the 9 May 1589 translation of Antoninus's remains, which had been found in a miraculous state of perfect preservation upon the opening of his tomb

6.7. Domenico Passignano, *Exposition of the Relics of St. Antoninus, with Ugolino Martelli Preaching*. Fresco. Vestibule, Salviati Chapel.

the previous month. These walls give some indication of the memorable piece of civic theater that the procession of the body through the city involved, and they announce unambiguously that the Medici had participated in the inauguration of the space; the consecration of the chapel, in fact, had been timed to coincide with the wedding celebrations of Francesco's successor, Ferdinando I, as if an extension of a ducal ceremony. The Salviati family presence is unmistakable, not least in the large inscription running through the frieze. Still, there are no sculpted portraits here, as there were both in the New Sacristy in San Lorenzo and in the chapel's earlier Quattrocento forerunners; though this chapel was to be a family burial site, there are no conspicuous tombs declaring that purpose. For all of its magnificence, the chapel shied away from anything that could look like the *person* of a patron. The choice accords with Reformation objections to the inclusion of contemporary

portraits in sacred spaces. In this case, however, the impression of selflessness had a political as much as a devotional function.

The Salviati and the Medici families were, by 1580, so intertwined as to be almost indistinguishable. Duke Francesco's grandmother was Maria Salviati, the great aunt of Averardo and Antonio di Filippo Salviati, the chapel's two patrons. Archbishop Alessandro de' Medici was the patrons' cousin, son of their father's brother Ottavio Medici and Francesca Salviati. More importantly, though, the Medici and the Salviati had been jointly tied to the church of San Marco since the early days of Cosimo I's rule.

In August 1545, Cosimo I had expelled the Dominicans from their church. His reason for this, he explained, was the inhabitants' continuing devotion to Savonarola, who had preached against the Medici and supported the family's expulsion in the early 1490s. In accounting for his actions, the duke lamented to Francesco Álverez de Toledo that the Dominicans at San Marco "worship Savonarola as a saint."[25] To intervene in a religious sanctuary, however, Cosimo needed the support of his uncle, Cardinal Giovanni Salviati, the Dominicans' ostensible protector. Giovanni allowed the expulsion to go forward, and by doing so he joined Cosimo in securing the enmity of Pope Paul III, who blamed them jointly for their intrusion into territory over which the pontiff believed that he alone should have jurisdiction.

The conflict brought to the fore one issue that bears on the site, the fact that the Medici considered San Marco, more than most churches in Florence, to be an extension of their family properties. As Cosimo wrote when defending his actions, "San Marco was founded and built by my house and was mine, and I could dispose of it as my own possession and without license from His Holiness or any other person."[26] The Salviati may have been the announced patrons of the chapel, but they were building on Medici turf. Those involved would have remembered the recent conflict, which nearly resulted in Cosimo's excommunication, and this history points up an interpretative question at the center of recent studies of the chapel: just how the legacy of Savonarola matters for what Giambologna and his collaborators made.

Scholars have tended to frame this question by establishing partisanship; they treat the artwork as though it constituted a political rhetoric and advocated a confessional position. The problem is that the same scholars have reached exactly contrary conclusions about which "side" the chapel is on. The first major modern publication on the chapel, Francesca De Luca's 1996 study, demonstrated that Filippo Salviati, the father of the chapel's patrons and the source of their funds, was a supporter of the *piagnoni*, Savonarola's followers; De Luca suggested that Filippo directed his sons to build in San Marco because that had been "the theater of the *frate*'s preaching."[27] In this, De Luca was following Michael Edwin Flack, whose unpublished 1986 doctoral dissertation on the chapel included a chapter on

its "political iconography." Believing the chapel to have come from a family sympathetic to the cult, Flack looked in the chapel for what he described as "Savonarolan themes." In Allori's image of Antoninus blessing the childless wife of Donato Castiglione, which miraculously enabled the couple to continue the family line, Flack saw an oblique reference to the subsequent exile of Bernardo da Castiglione, a monk at San Marco who had printed images of Savonarola. Giambologna's relief of *Antoninus Distributing Alms*, he further suggested, recalled "Cosimo's thwarted attempts to deprive San Marco of charitable gifts."[28]

More recent opinion has gone in the opposite direction. Klaus Pietschman, for example, has argued that both Pope Leo X de' Medici, who initiated Antoninus's canonization, and Pope Clement VII de' Medici, who saw it through, intended the act from the beginning as an affront to the *piagnoni*, "a distraction from the cult of Savonarola."[29] As early as the 1520s, moreover, the popes considered attempting to isolate the Savonarola faction by dedicating a luxurious chapel to Antoninus, an idea that the monks of San Marco opposed.[30] The Salviati project resurrected an earlier, adversarial plan, a fact that adds a further dimension to the argument Nirit Ben-Aryeh Debby has recently advanced: through the chapel the Salviati commissioned, the Medici "were presenting an image of the saint intended to serve and reinforce their absolute rule over Florence." "The Medici and their supporters," Debby writes, aimed to "encourage an alternative cult, trying to steer popular sentiment away from the zealous prophet Savonarola and toward the more agreeable Antoninus."[31]

To be sure, the duke would hardly have allowed his best artists to labor on even the most obliquely anti-Medicean imagery, and any persuasive account of the space must acknowledge the long connection of the two families. Leo X, the sponsor of Antoninus's canonization, was the uncle of Giovanni Salviati, Cosimo I's ally in the confrontation that reemerged in the 1540s. To anyone who knew the politics behind Antoninus's sainthood, Giambologna's chapel would have appeared not so much to institute a new cult as to strengthen one that had been fostered by the Medici and to a certain extent by the Salviati for more than a half century. The artist himself fully understood the interests involved, as Fortuna's 1582 ambassadorial report indicates:

> To the pleasure of their Highnesses, he is making the Chapel of the Salviati in San Marco, where the body of St. Antoninus is going, and the expense of this will exceed 40,000 scudi and by a lot, and Giambologna is hungering for glory in this.[32]

Fortuna confirms what circumstantial evidence itself already implied, that it was the will of Duke Francesco and his wife Bianca Cappella that Giambologna work in the church.

6.8. Giambologna, *Antoninus Pardoning the Magistrato degli Otto*. Bronze. Salviati Chapel.

Still, there is a difference between purging a program of anti-Medicean imagery and aligning it ideologically with the other side. Both Flack and Debby follow Dhanens in taking the relief above the marble representing St. Anthony Abbot to show "Antoninus Pardoning the Florentine Signoria" (fig. 6.8).[33] Elaborating on the historical background, Debby explains that when allies of the Medici attempted to take control of the city council by changing its balloting procedures, Antoninus threatened them with excommunication. Only when the Signoria backed down did the archbishop pardon them. Flack's view was that the relief raised the issue of ecclesiastical jurisdiction; by way of its allusion to the Quattrocento excommunication, it served as "a specific reference to the threat of Paul III to proceed similarly with Cosimo de' Medici."[34] Debby added to this that "Savonarola praised this incident, showing how careful Antonino was in protecting the civic interest."

Now, it would be striking indeed if the chapel included a prominent image of Medici manipulators begging forgiveness before a San Marco prior. But is this really what the sculptor shows?[35] Giambologna has clearly set the scene in front

6.9. Giambologna, *Antoninus Preaching*. Bronze. Salviati Chapel, Florence.

of Florence Cathedral, and in Razzi's 1589 life of the saint—a text published in coordination with the chapel's unveiling—there is exactly one episode that takes place there. The Magistrato degli Otto, having imprisoned two priests, then decided to humiliate them publicly, sending them with trumpeters to Antoninus to deliver the message that they had been given "the penitence that was due to them."[36] Enraged at this affront, Antoninus censured the entire magistracy, requiring it to seek absolution from the pope. The pope, in turn, agreed to forgive the group, but decreed that since its sin had been public, its penitence would have to be public, too. "And thus," writes Razzi, "were the Signori Otto constrained to go . . . humble themselves to the Archbishop, before the portal of the Duomo, asking him to pardon them for their faults, and to receive their penance."[37]

Significantly, this episode serves much the same function as the one involving the Signoria—Razzi's text, in fact, includes a dialogue very much like the one between Antoninus and the Signoria in Vespasiano de Bisticci's earlier *Life*—with

the crucial difference that the confrontation with the Otto involved no conflict with the Medici.[38] The incident put Antoninus in a position that might well have recalled Savonarola's brief rule over the city: the vignette of the dog at the center of the panel underscores the theme of obedience, and more specifically the subordination of civic government to ecclesiastical authority. At the same time, the slight shift in historical register neutralized the political precedent. It cannot be accidental that the conflict between the Medici and the Signoria, which Debby characterizes as "an essential element in later portrayals of Antoninus," goes unmentioned both Razzi's and in Frosino Lapini's biographies.

Another of the reliefs seems even more Savonarolan in theme, placing Antoninus in a pulpit, with listeners gathered about him (fig. 6.9). This aligns the saint, literally and figuratively, with John the Baptist, above whose statue the relief was installed, and Debby speculates that the pulpit from which Antoninus is shown preaching is the same one Savonarola had used. What has not been noticed is that the role given to Antoninus here is one that the creators of the chapel essentially *invented*. Without exception, Antoninus's published biographies suggest that, as bishop, he attended above all to hearing civil and criminal cases, and that these duties prevented him from delivering sermons. In the beginning, Razzi writes, Antoninus appointed two vicars rather than the customary one, and he regularly visited the churches in his parish. Eventually, though,

> experience taught him that it was better for many reasons to have only a single vicar, and, similarly, that it was not possible to attend to preaching himself and at the same time to visit the choir of his church. He held audiences almost without repose, and he performed many duties and undertook many travels in this manner. He resolved not to preach himself but rather to see that the principle churches of the city, at the necessary times, had the benefit of preachers who were worthy and apt for such a duty, both in doctrine and in virtue.[39]

It is possible, of course, that the relief simply breaks the chronological sequence, showing the young Antoninus delivering a sermon rather than emphasizing the ways he ultimately focused his energies. The *difference* in this case between the chapel's sequence and the biography offered in print, though, makes it more likely that the chapel's planners determined to present the saint in an action essential to the image not of Antoninus but of Savonarola, the most famous preacher in the history of the city. In the relief, Antoninus does not wear his miter or ecclesiastical robes; the detail derives from the biographies, which stress that he preferred to conduct his business in simpler Dominican robes, donning more formal garments only for ceremonial occasions, but of course it *also* makes him look more like the Quattrocento friar.

All of this urges a reconsideration of Flack's suggestion that the chapel includes Savonarolan themes. Such themes did not need to indicate Savonarolan sympathies; they could just as readily suggest that the chapel's patrons had Giambologna fashion Antoninus as a "new Savonarola." The reliefs acknowledged the most resonant elements of Savonarola's persona and absorbed them into the Antoninus they presented, rewriting Antoninus's biography as necessary to do just that. A Medici partisan might well have concluded that the chapel acceptably "steer[ed] popular sentiment away from the zealous prophet Savonarola and toward the more agreeable Antoninus."[40] Yet was there anything here that was truly objectionable to those on the other side, who believed that all should learn from Savonarola's example? As executed, the chapel essentially conflated the two Dominican priors, rehabilitating Antoninus's successor by personifying him through the saint. If Filippo Salviati was indeed a *piagnone*, this may well be what he wished all along, instructing his heirs to make Antoninus their focus. He can hardly have been unaware of the politics his sons would have to negotiate.

Both Flack and Debby concentrate exclusively on the narrative images that the chapel contains, offering no comment about the chapel's highly unusual arrangement, centering on the full-scale bronze effigy of the saint, positioned over a casket containing the miraculous relics. The chapel's most important feature, replaced with a new combination of elements in the eighteenth century, looks particularly charged in view of an anxious letter that Archbishop Alessandro wrote in 1583, when the building of the chapel was well underway:

> The case is this: that out of the obstinacy of the Friars of S. Marco the memory of Fra Girolamo Savonarola—which, ten or twelve years ago, was extinct—is resurging, pouring forth and flowering more than it ever has. His insanities are being planted among the Friars, among the Monks, in the laity and the young. They do the most presumptuous things: they hold offices as if he were a martyr, they preserve his relics as if he were a saint, including the irons that held him, the clothes, the habits, the bones which were put to the flames, the ashes, the sack cloth. They preserve wine that was blessed by him, and they give this to the sick, they count miracles, they make images in bronze, in gold, in cameos, in prints.[41]

Flack convincingly uses the letter as evidence of the continuing active presence of Savonarola's followers among the Dominicans of San Marco. Yet what is remarkable about it is that Alessandro's concerns focused less on the idea of the prophet or even on a dangerous reform ideology than on the false cult that had developed around a collection of physical remains and memorabilia. It is precisely this *materialized* Savonarola, the thing Alessandro was most eager to erase, that the producers of the chapel recapitulated. As Savonarola's followers manufactured

illegal bronze portraits, Giambologna's team would produce a full-scale bronze effigy. The offices carried out at the altar above it would replace the subaltern rituals that the *piagnoni* conducted. Most strikingly, the whole chapel would announce the presence of a fifteenth-century Dominican prior as a relic, shaping Antoninus's legacy in the mirror of how Savonarola's followers had transformed his.

It would be reductive to conclude from this that "the Medici family . . . was presenting an image of the saint intended to serve and reinforce their absolute rule over Florence."[42] More useful is to watch how political and religious conflicts opened a space in which the ambitions of multiple actors could play out. These actors included the Salviati brothers, who, in serving the somewhat misaligned interests of the duke, the archbishop, and their own father, found a way to build the most splendid chapel the city had seen. And they included Giambologna and his collaborators, who seem to have been perfectly cognizant of the complex roles the monument had to play. To compete with the subversive mysteries the followers of Savonarola were offering, the artist had to generate a kind of aura around the new cult. "Hungering for glory" and with Ammanati in his sights, he must have realized that this was the greatest architectural opportunity he was ever likely to attain.

Effects

Among the most un-Savonarolan aspects of the chapel was its luxury. With six freestanding marble figures and as many bronze reliefs, it followed two semi-independent local sculptural traditions, descending respectively from Donatello and Ghiberti, but these elements looked newly noble in the company of the colored marbles laid into the walls and pavement. The stones, acquired with help from Giovanni Antonio Dosio in Rome and Tivoli, responded to the newest local fashion; only Dosio's own Gaddi Chapel in Santa Maria Novella, begun in the city's other major Dominican church five years before Giambologna received his commission, anticipated the project.[43] The choice of colors—*mistio giallo*, *mistio verde*, and *africano*—may have been intended to evoke the yellow, green, and red of the Salviati arms, incorporated into the windows. At the same time, the *pietre dure* give the chapel a wider frame of reference, inviting comparison to San Marco in Venice or the Pantheon in Rome, but also to recent secular monuments like Ammanati's *Neptune Fountain*.[44]

Passignano's paintings of the translation ceremonies record the presence not only of the priests of the cathedral, the Salviati family, and Grand Duke Ferdinando but also of a host of foreign dignitaries, among them Cesare d'Este and Vincenzo Gonzaga. To judge from the fresco on the right, locals and their visitors

gathered on that occasion to hear a sermon from Ugolino Martelli. As it happens, Martelli's text survives—the patrons even had it published as part of the apparatus to the event—and it gives some indication both of the chapel's grandeur in the eyes of contemporary churchmen and of the questions it raised. Martelli stemmed from an old Florentine family and as a young man had starred in one of Bronzino's best-known portraits; he was well acquainted with local norms.[45] For the previous seventeen years, however, he had served close to the Calvinist frontier as the bishop of Glandèves. His tenure had coincided with France's decades-long wars of religion, and the starting point for his oration was the possibility that the chapel would provoke controversy.

Martelli began by raising the question of how a patron could justify such an extravagant monument:

> Our Lord and Master Jesus Christ, did he not cry out and did he not, amidst his painful and threatening troubles, bitterly blame the Scribes and Pharisees who built sepulchers for their prophets and who adorned the monuments of the just?[46]

The question, a reference to Matthew 23:29, addressed a concern that Reform-minded clerics had been discussing for decades, with the likes of Lilio Gregorio Gyraldi and Gian Matteo Giberti objecting to nearly all prominent burial monuments in churches.[47] The Salviati had clearly concerned themselves with this, and the fact that they placed their own tombs not in the chapel but in a subterranean chamber acknowledged the 1566 bull of Pope Pius V, which banned "all repositories and deposits or sepulchers of corpses in tombs above ground."[48] Still, Martelli was concerned not just with the resting place of the patrons but with the structure at the center of the space, which returned the tomb and the tomb portrait to the chapel context by transforming the reliquary itself into a kind of imitation of the great Quattrocento cenotaphs that Donatello, Desiderio da Settignano, and others had produced.

Martelli thus turned to the commentaries on Matthew, remarking that saints Hilary, Jerome, John Chrysostom, and Ambrose, along with the Venerable Bede, all took the passage from the Gospels not as a condemnation of grand tombs per se, but as a rebuke to those whose "dishonest deeds" contravened the worship of the saints such tombs ostensibly honored.[49] He followed by citing the example of Moses, who carried the bones of the Patriarch Josephus from Egypt, an act Martelli directly compared to the translation of the saint's bones in San Marco.[50] This way of approaching the new chapel, first citing biblical lessons that could be used to condemn it, then offering theological rebuttals to that position, characterized the rest of the sermon as well. Martelli drew, for example, on the story from Origen that after God built a tomb for Moses, St. Michael hid this from the Israelites,

so that, "not knowing where to find the bones, they would not have a reason to venerate them." The point here, Martelli maintained, was not that honoring the bones of holy forebears was an illicit practice, but rather that cultures susceptible to idolatry needed protection from such temptations; he noted that once the Israelites were "distanced" from idolatry, God permitted various miracles to occur at the tombs of Esaias, Ezekiel, and others.[51]

This thought offered Martelli a segue for treating what post-Tridentine Catholics regarded as a central heresy of the moment, the Protestant rejection of the cult of relics. In the 1580s, Florence was zealously seeking and celebrating the remains of its local saints; that the designers of the Salviati Chapel understood it to participate in a larger movement is suggested by their addition of a pendant statue to Saint Zenobius on the other side of the nave.[52] Martelli's sermon responded to those who would question the very premise of devoting architecture to a set of bodily remains, offering both theological and practical arguments: he noted, for example, that the Second Nicean Council had approved the use of reliquaries, while also reminding his listeners that relics heal with their touch and encourage the imitation of the good lives saints lived.

The chapel justified the veneration of Antoninus, and by association justified the inclusion of the object at its center, by pointing to what Martelli referred to as the archbishop's "effetti santi," the holy and miraculous actions Antoninus had performed or that God had performed through him: rescuing a prisoner from the Turks, for example, or healing the sick. Some of the "effects" Martelli enumerated, significantly, worked through images:

> The same monastery saw sister Chiara di Guido Tolosini abstracted and counterfeited in a such a manner that she seemed not to be in the form of a woman, but rather a lump of deformity. After six or seven years, as her mouth no longer moved away from her knees, she solicited the holy Archbishop (by then already in Heaven) and, placing herself before a small image of him, she lifted herself up with her mind to God, more ardently than usual, but all internally, and outside she felt herself moved, and the holy Archbishop appeared to see her and placed one hand sweetly on her chest and the other on her shoulders, and suddenly from being bent she began to unfold. Nor was her vision empty, because it healed her, and immediately all the other sisters began with marvel to practice the same rites, which likewise made the rest of them healthy and strong.[53]

Following as it does upon his earlier discussion of idolatry and the tomb, Martelli's story raised hopes that those who prayed before the newly displayed images of Antoninus might benefit in similar ways.

Martelli was reluctant to rest his defense on a notion of the "power of images," and throughout the sermon he cautioned those who would connect the chapel too readily with the supernatural. He ended the sermon, nevertheless, with a reminder that the chapel provided a site where one could go for help:

> Because St. Antoninus has been beatified, and because the beatified have to be invoked and supplicated by men, I conclude with an invocation and supplication of how much we all ought to pray and supplicate omnipotent God by means of our Holy Advocate—individuals for themselves and all of us for the sake of the city.[54]

His promotion of Antoninus as a representative, and not just as an exemplar, conforms to the decisions that shaped the space. For the sake both of politics and of piety, filial and otherwise, the Salviati had poured great expense into the chapel's images of advocacy. Giambologna, in turn, designed these in a way that suggests a direct response to the visitor's prayers. The large marble sculptures, showing the men responsible for the room's concentric circles of users—Antonio and Edoardo are the name saints of the patrons, John the Baptist is the protector of the city, and the other three are premier representatives of the order responsible for tending the chapel in perpetuity—project forward from their niches, literally coming out of the walls and into the presence of the prayerful. The large paintings the marbles flank, for their part, draw attention to deliverance as such.

On the back wall (fig. 6.10), a canvas by Allori reworks the conventional imagery of the Harrowing of Hell: Christ crushes a demonic opponent as Moses, John the Baptist, and other prophets look on; in the background, the liberated process upward. The idea for the picture derives in part from the *Christ in Limbo* that Allori's teacher Bronzino painted for Santa Croce in 1552, but the younger painter's scene differs in its unusual inclusion of the Virgin Mary. The belief that Christ's mother had been Assumed directly into Heaven usually discouraged her inclusion in underworld settings, though she does appear among those in Limbo in some older depictions, including Duccio's *Maestà*; the gesture Allori gives Christ, reaching down to take the Virgin's hand, is one of the most common acts he performs in those earlier pictures. What really explains her role, however, is less narrative and more structural. Inscribed in the aedicule above the picture is the phrase ECCE FILIUS TUUS (behold your son), the words Christ said to his mother from the Cross in John 19:26.[55] The phrase reminds its readers that Christ, born of a woman, could be sacrificed, but more importantly it affirms Mary's elect role as the first person to meditate on the crucifixion.[56] The whole arrangement, moreover, would originally have read differently, for anyone positioned before the

6.10. Alessandro Allori, *Christ in Limbo*. Oil on canvas. Salviati Chapel.

altar would have seen the painting and its tabernacle as a kind of backdrop for the bronze crucifix that originally stood above the altar table, behind the tomb. The inscription would have instructed the visitor to follow Mary's example in looking at Christ, and the picture in turn would have promised rescue from an afterlife beneath the earth, in part through Mary's intervention.

On the wall to the left (fig. 6.11) is a painting on the same scale by Francesco Morandini, called "il Poppi," depicting *Christ Healing the Leper*. The subject is as unusual as Allori's, with few if any real precedents. Christ, again at the center, stands before the multitude that followed him after he delivered the Sermon on the Mount. He reaches down to touch the leper whom the Bible says to have "adored" him. The woman at center right with the vase on her head recalls the metaphor used in Matthew 8:2 and 8:3, which describes Christ's act of healing as a kind of cleansing. The recumbent man at the lower right, by contrast, evokes the conclusion of Matthew 7, which narrates how Christ's followers marveled at him, "For he was teaching them as one having power, and not as the scribes and pharisees." The verses on which the image is based mention only a single leper,

6.11. Left wall of Salviaty Chapel.

but Poppi allows the impression that others—particularly the two naked men in the foreground—can expect a similar benefit.

Connecting Poppi's image to Allori's is the circuit of oration and salvation the paintings figure. Above this picture, inscribed in a cartouche, are the words the leper said to Christ, "si vis potes me mundare," "if thou wilt, thou canst make me clean." And the picture itself this time includes a banderole with Christ's response, the performative words that, to follow Matthew 8.3, actually cured the patient: "And Jesus stretching forth his hand, touched him, saying: I will that thou be made clean (*volo mundare*). And forthwith his leprosy was cleansed."[57] The ensemble both models the invocation that the ailing might themselves say within the chapel's space ("make me clean") and promises the repeated effect of Christ's own words.

The corresponding image on the right (fig. 6.12), painted by Giovanni Battista Naldini, shows the *Calling of Matthew*. Before Caravaggio went to work in the church of San Luigi de' Francesi in Rome, this, too, was rare to find as an independent subject in Italy, especially on such a monumental scale. Like his colleagues, Naldini centered the painting on Christ, and on an act of oration. Matthew's pose, with hand on heart, suggests a response, and the earliest writer to comment on the picture took the pose to indicate that Matthew acted under the spell of what Jesus had just said, "immediately obeying."[58] The surrounding figures, a number of which again handle vases, may illustrate Jesus's directly subsequent remark that nobody "puts new wine into old bottles," or they may engage themselves in the preparation of the meal that Jesus ate in the publicans' house. Or perhaps they, too, are proleptic, envisioning salvation as a cleansing. Whatever the case, this painting, like the others, includes an inscription above: "relictis omnibus secutus est eum." The words this time come from Luke's report of the event (5:27–28):

> And after these things, [Jesus] went forth and saw a publican named Levi, sitting at the receipt of custom: and he said to him: Follow me. / And leaving all things, he rose up and followed him (*relictis omnibus surgens secutus est eum*).

The idea of leaving behind one's worldly goods to come closer to Christ must have appealed to the patrons in particular, though the emphasis on the *relictis*, literally the "relics," joins the vases that fill the picture in drawing attention again to the funerary context of the space, and to its primary object.

The Cult Statue

In their format—large, vertically oriented scenes framed as tabernacles and flanked by patron saints—the paintings in the chapel take the traditional place of

6.12. Right wall of Salviaty Chapel.

the altarpiece, and it is as altarpieces that the most recent writers on the chapel have described them.[59] Still, altarpieces they cannot be: they have no altar tables in front of them, and none depicts the figure to whom the chapel is dedicated. In fact, the absence of altars and tombs along the walls is crucial to the chapel's conception, since this reinforces the degree to which, individually and collectively, the paintings refer not to what's below them, but to the center of the space they ornament, the combined altar, crucifix, and miracle-working saintly remains.

Everything in the chapel focuses on that site: the trapezoidal shapes at the angles of the floor work almost like arrows, directing attention toward it, and the centering of the dome marks this as the space's crucial point of honor. Today, the saint's body itself is permanently on view, displayed behind glass under an altar table. This arrangement, however, represents an eighteenth-century reconfiguration of the chapel, which involved the removal of Giambologna's bronze as well as its architectural framework and the crucifix it supported. The original disposition of the elements was recorded in 1728 by Antonio Francesco Gori, who witnessed the transformation:

> on the day of his translation, [Antoninus] had been placed in an honorable sarcophagus of black marble, ornamented above with his true effigy, recumbent and at life-size, cast in bronze by the convert Fra Domenico Portigiani of the same monastery of San Marco, using the so highly praised model of the famous Giovanni Bologna . . . and placed beneath the altar. But displaying such a prodigious deposit, as required by urgent need of the City or the State of Tuscany, turned out to be inconvenient, and so [the relics] were moved into a rich but more comfortable box, where they have stayed until now.

Gori added that Portigiani's bronze (fig. 6.13) was at this point moved into the Sacristy, where it remains today.[60]

Brunelleschi had built a centrally planned sacristy in San Lorenzo, with a great porphyry slab in the middle; Michelangelo, in imitation of this, had originally projected a centrally planned design for the New Sacristy. His tombs, however, eventually went into the wall, as did the *Julius II* monument; Giambologna's scheme, with its central island, must have looked remarkable in its time.[61] Like Stefano Maderno's better-known but later *St. Cecilia* (fig. 6.14), the effigy he conceived both lay over an actual relic, hidden from view, and seemingly recorded the condition in which the saint had been found.[62] The choice to do the statue in bronze brought these two aspects together, and the fact that it represented what Gori called "a true effigy, recumbent and at life size" signaled the miraculous incorruption of the actual body. The integrity of the sculpture, by contrast to the reliquary busts of the earlier Renaissance, documented what had been disinterred.

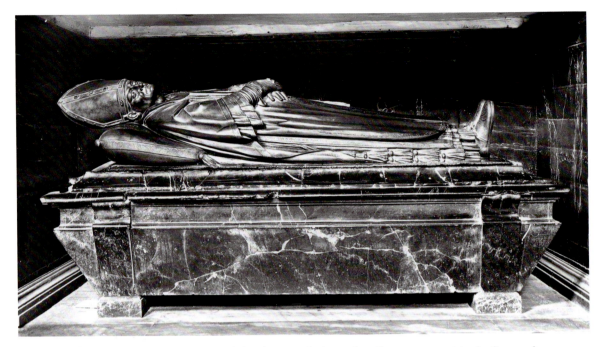

6.13. Giambologna, *St. Antoninus*. Bronze. (The photograph shows the effigy upon its original reliquary, later dismantled.) Sacristy, San Marco, Florence.

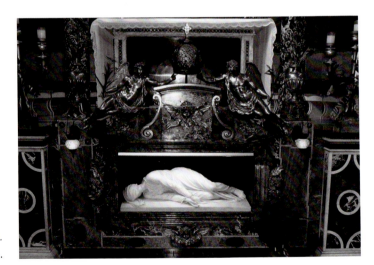

6.14. Stefano Maderno, *St. Cecilia* (in situ). Marble. Santa Cecilia in Trastevere, Rome.

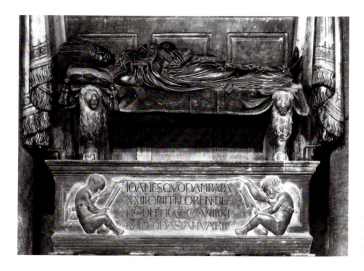

6.15. Donatello, Tomb of Antipope John XXIII (detail of effigy). Bronze. Baptistery, Florence.

In designing a sculpture that followed such Quattrocento models as Rossellino's tomb for the Cardinal of Portugal (begun two years after Antonino's death) and Donatello's tomb for the Antipope John XXIII (fig. 6.15), a Medici commission involving a bronze recumbent portrait), Giambologna was also abandoning the look of more recent sculptural effigies. Unlike the tomb monuments designed by Ammanati (see fig. 1.6) and Francesco da Sangallo, Giambologna's did not attempt to enliven his figure in any way. This may have been an attempt to adopt a style that evoked Antoninus's own period, though the insistent departure of the saint's deflated body and unidealized face from Giambologna's other portraits also suggests the use of a death mask. Here, the impression mattered as much as the reality; if the viewer imagined a bronze shaped by a mold that had touched or had even been formed by the saint himself, the statue would have been sanctified by contact, bridging the difference between the relic and its depiction.[63]

We might go so far as to say that Giambologna conceived his bronze effigy not just as a reliquary but as an "icon." The antithesis it represented to the conspicuously modern manner of the chapel's other sculptural decorations made it—to use a distinction introduced by Hans Belting and applied to early seventeenth-century material by Klaus Krüger—an "image" rather than "art."[64] The jewels set into the framing costume, like the surrounding pavement with its colored marbles, equal the lavish tabernacles used to house icons in their new Counter-Reformation installations. And the removal of the actual relics from display, allowing the visitor to see only the statue, follows the icon's openness

to substitution, the principle that the picture of the thing could be every bit as authentic as the thing it pictures.

Viewed this way, the portrait of Antoninus demonstrates that Giambologna was perfectly capable of making "artless" sacred images, rebutting the kind of criticism Ammanati helped to circulate. At the same time, the tomb-reliquary is truly unusual, and there are reasons why other patrons and sculptors did not go down a similar path. Late sixteenth-century Italians remained generally reluctant to treat three-dimensional images as sacred forms. Borghini's *Riposo*, published while Giambologna was at work on the chapel, suggested at one point that sculpture per se invited idolatry in a way that painting did not.[65] The author seemed particularly troubled, moreover, by sculptures that gave the impression of *hollowness*.[66] In this he was not alone: the Dominican theologian and image theorist Ambrogio Catarino Politi, explaining why the Old Testament had Ezechias smash the brazen serpent that Moses had erected, wrote that the king regarded the statue as a "vessel" and therefore as something unworthy of worship.[67]

Borghini and Catarino had starkly different interests, and their agreement on this point demonstrates that the veneration of a hollow statue could bother commentators of varying stripes. Some would have worried over the idea of the figure's emptiness. Others would have harbored just the opposite concern, fearing the statue's inhabitation. The point is that not every church patron would have been ready to embrace the idea of a statue taking the place of a relic. This further explains the primary structural change made to the chapel in the eighteenth century, the removal of this very element from the space. Gori reports that the bronze-covered box had made it difficult to expose the relics when urgent needs to do so arose.[68] The replacement of an obscure container with a transparent one, however, also addressed one long-standing doubt, expressed both in texts and in decorative conventions, about the proper role that statues, particularly bronze statues, could play.

No other Florentine chapel centered on a single, life-size figure like this one; the closest local parallels to the construction of the space, in fact, are secular. In the years that the chapel was underway, for example, Francesco moved a marble Venus Giambologna had designed a few years earlier to the center of a grotto chamber in the Boboli Gardens (fig. 6.16).[69] This turned the statue into a modern-day version of Praxiteles's Cnidian Venus, which to follow Pliny had constituted the central feature of a shrine.[70] Francesco and Giambologna both seem to have understood the role of centrally planned architectural spaces in pagan practice, their strong association with idolatry.

Perhaps this was all intentional. The insistence on intercession, the way in which the chapel becomes a three-dimensional *sacra conversazione*, reminded

6.16. Fountain of the Grotticella (in situ). Grotta di Buontalenti, Boboli Gardens, Florence.

viewers of the authority that stood between them and the divine; the container attested to the relics but it also kept them from general view. Such strategies of "distancing" were the "major quality" that Walter Benjamin associated with the cult object and its "aura."[71] And in fact, everything about the chapel could well be described as a production of aura. Among the most dramatic (and expensive) features of the decorations was the large bronze angel alighting above the central tabernacle. It is tempting to compare this backlit, elevated motif to the branch seen against the summer sky that Benjamin describes when trying to explain what he means by aura, except that angels were thought in the Renaissance to consist of light itself: this angel *is* the aura.

Giambologna was hardly the first to incorporate angels into the machinery of devotion: two small angels stand at the base of the "statue" in Andrea del Sarto's *Madonna of the Harpies* (fig. 6.17), which seems to have come to life in response to the worship done before it, and in Raphael's Sistine *Madonna*, angels listen to the prayers done before a Virgin identified as an image by the curtains drawn in revelation.[72] These conceits probably owe a debt to Bernard of Clairvaux's commentary on the first line of the Song of Songs, "Let him kiss me with the kisses of his

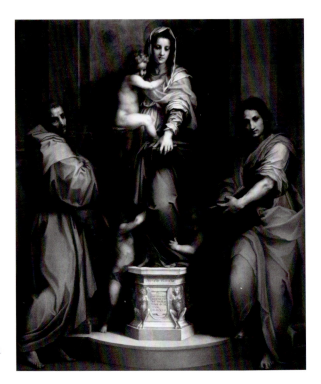

6.17. Andrea del Sarto, *Madonna of the Harpies*. Oil on canvas. Uffizi, Florence.

mouth / For thy love is better than wine" (*osculetur me osculo oris sui quia meliora sunt ubera tua vino*). Starting with the premise that the words are the Bride's (i.e., the Virgin's), Bernard had emphasized the modesty of addressing the Bridegroom (Christ) indirectly, speaking about him in the third person, assuming his absence:

> A sublime favor is petitioned, and hence there is need that the petitioner should be commended by a becoming modesty in the manner of the request. One who seeks access to the interior of the home goes round to the intimate friends or members of the household to attain what he desires. In this present instance who might these people be? In my opinion they are the holy angels who wait on us as we pray, who offer to God the petitions and desires of men, at least of those men whose prayer they recognize to be sincere, free from anger and dissension. We find proof of this in the words of the angel to Tobias: "When you prayed with tears and buried the dead, and left your dinner and hid the dead by day in your house, and buried them by night, I offered your prayer to the Lord."[73]

Bernard's commentary diagrammed intercession: just as the Bride asked angels to deliver prayers on her behalf, so do we ask the Virgin to carry our own

supplications to God. Allori's painting already evokes the Song of Songs; there, Christ takes the hand of the Virgin while angels stand behind. What enlivens the chapel as a whole, though, is the link between the effigy and the angel, the two major bronze figures in the chamber, both positioned on the main axis of the space. As one of the priests at San Marco wrote in 1599, "the word 'angel' refers to the office, not the nature, and in our language it means the same this as 'nuncio' or 'ambassador,' and we call them this because they are . . . messengers from the Great God."[74] Writing of the earlier Christian cult objects, Hans Belting once remarked that it was the burial site that gave images their power.[75] At San Marco, however, the opposite was equally true. The politics of the site, and the stakes for the artists involved, required as much.

Investment and Salvation

Raffaello Borghini, having seen the chapel while it was under construction, compared its inlaid marbles to "jewels in rings," and Baldinucci later celebrated its display of "ornament and richness in every place, such as to render it more worthy of conserving in itself such relics."[76] Remarks like this invited viewers to admire the components of the Salviati Chapel, no less than Giambologna's *Sabine* or *Mercury*, for their materiality. If Giambologna's early sculptures sought to distinguish his labors from the work of goldsmiths, here, by contrast, he took the idea of a precious object's "setting"—an idea that the jewels in the bronze effigy, too, made central—and magnified it to a colossal scale.

Martelli's sermon provides a metaphor for the intended effect, referring to the chapel rather as a "treasury," a place into which the patrons literally and figuratively deposited their wealth.[77] The inlaid stones, like the costly marbles and the precious bronzes, impressed their value upon the visitor. As Flack remarked, the *Calling of St. Matthew* was a subject with which the members of a banking family like the Salviati were particularly apt to identify; the stones, read through Martelli, go still further, suggesting that expenditure itself is part of the chapel's point. Other aspects of the chapel reinforce the notion. The statue of Averardo Salviati's name saint, for example, St. Edward of England, holds a miniature church as an attribute; this makes him, as it were, the patron saint of patronage. For Averardo to commission architecture was to follow Edward's example and merit his protection.

Alexander Nagel has argued that some reform-minded Italians in the 1530s sympathized with the critiques Northern Reformers had launched against lavish expenditure on the arts. They looked for ways to remove Christian art from the

economics upon which it had long depended, devoting attention both to categories of art that required no commission—the finished drawing, for example—and to modes of transmission that involved no monetary exchange. The text that both inspired and captured the spirit of these experiments was Marcantonio Flaminio and Benedetto da Mantova's *Beneficio di Cristo crocifisso*, a widely circulated and later forbidden book that characterized Christ's death and the salvation it brought as an exemplary gift, one given independently of anything its recipient might offer in recompense.[78]

Although Nagel's discussion focuses on 1530s Rome, nowhere did the *Beneficio* have a greater impact than in Florence. Massimo Firpo has suggested that it was this text that guided Pontormo in painting his subsequently destroyed frescoes in San Lorenzo, and Robert Gaston has made similar arguments for paintings by Pontormo's student Bronzino.[79] Bronzino's student Allori, Giambologna's primary collaborator in the Salviati Chapel, would certainly have known of the book and its importance. And as Gaston noted, the central themes of the *Beneficio* survived in the religious outlook of cultural leaders like Benedetto Varchi, who in 1549 wrote a *Sermon to the Cross* and who voiced related ideas in the 1568 dialogue *Della economica cristiana*. The author of that dialogue was Silvano Razzi, the same Razzi tasked to author an official biography of Saint Antoninus the year the chapel was unveiled.[80] If, a quarter century after the conclusion of the Council of Trent, doubts still lingered about the kind of patronage that might exemplify the church's new orthodoxy, few spaces would have presented a more important testing ground than the Salviati Chapel.

Martelli's sermon positions the thinking behind the chapel in terms radically opposed to those of the *Beneficio*. To begin, it treats the investment of money that the chapel involved as a kind of spiritual transaction:

> Are these remunerations not known to be a hundred times greater? And who does not willingly work for a brief moment in order to have a long period of repose? Who does not willingly spend money in order to acquire a great treasure?[81]

He followed this with an extended metaphor from John 12:24–25:

> The farmer who in planting scatters a great part of his family's substance, and who, when someone looks in wonder at this, and perhaps passes judgment on him, says "Wait a little, and you will see the reaping of a greater windfall"—who does not praise folly of this sort? The grain is thrown, this is true, the grain is thrown away and is lost, but wait, and you will see, you will see that "if the grain of wheat falling into the ground die, it bringeth forth much fruit" (*si granum frumenti cadens in terram mortuum fuerit multum fructum affert*).

The comparison of the spending of money to the planting of seed inflects the chapel's image of charity. From a Protestant perspective, this might distressingly recall the principle of the indulgence, the idea that one could buy one's way out of Purgatory—and all the more so given the chapel's central painting. As Martelli saw it, though, the chapel's "expenditure" theme simply honored the example of the saint to whom it was dedicated. Imagining how "the holy Martyrs of God, the confessors in his most holy name," appear in the eyes of those who "throw themselves away and virtually waste away in this mortal life, reaping most abundant fruit in the eternal life," Martelli asked,

> Do we not see that while our little Brother, our Archbishop, our saint, in the opinion of overly sensual men, threw away his life in abstinence, in vigils, in fasts, and in mortifications of the flesh: while he spent his substance in works of charity, and of piety; while he afflicted his spirit with continuous studies, compositions, meditations, lessons, and predications; he did not fall away, no, he did not lose himself, no, but he made himself into seed, and he most prudently mortified himself in order to gather fruit, and such fruit as you see.[82]

And when Martelli turned from this praise of the saint and the life he led to the chapel itself, he suggested that its very beauty and cost allow one to think of the eternal rewards that would come to those the chapel served:

> The tomb is to be praised and honored, but the treasure that exits from it, and that waits to enter back into it, should be honored and esteemed all the more.[83]

The chapel could draw attention to its costliness because investment was a metaphor for the saint's own works, one that underwrote the parallel between the saint and the patrons who now celebrated him. Here was a theological justification for a multimedia extravagance.

The Sign of the Cross

It was not just painters and philosophers who, at midcentury, were attracted to the *Beneficio*'s message: Florentine sculptors, too, had participated inventively in a vigorous Christocentric form of evangelism. Bandinelli responded to Michelangelo's late Roman Pietàs with a pair of multifigure marble sculptures, the *Angel Pietà* now in Santa Croce and the *Christ and Nicodemus* that tops the artist's tomb in the Santissima Annunziata. And by the end of the 1550s, Bandinelli's followers were exploring more triumphal variations on the theme. Giovanni Antonio Montorsoli's last major ensemble, the high altar of Santa Maria dei Servi in Bologna

(1558–61), centered on a freestanding *Risen Christ*. And the Christ at the center of Giambologna's *Altar of Liberty*, as we have seen, emulated Ammanati's Buoncampagni Tomb in Pisa.[84]

Ammanati wrote in his 1582 letter to the Academy of the commission he had been given and of how he thought this through:

> Our Lord Gregory XIII assigned me to make a tomb entirely of marble for one of his cousins in the Camposanto of Pisa. Since he was a most excellent legist, it occurred to me to make a Justice. And because good laws give birth to Peace, I also made a statue of her. And because, in the place where Justice and Peace reside, there is, in the center, our Lord Savior, for this reason I placed in the middle the figure of Jesus Christ, displaying his most holy and healing wounds.[85]

The letter gives the impression that while the chains of association might vary, sculptors could actively look for ways to transform commissions into opportunities to depict Christ. Like the marbles of Michelangelo and Bandinelli, made late in life as expressions of their devotion, the subject reflected the artist's as much as the patron's choice.[86] By the 1570s, as we have seen with Giambologna's *Altar of Liberty*, the attractions could be artful as much as devotional, since the figure of the resurrected Christ allowed virtuoso confrontations with the marble block.

These compositions, all of which date from the 1550s, '60s, and '70s, represent the direct legacy of the *Beneficio*'s by then heretical ideas, even as they avoided controversy by promoting an image of the Church Triumphant. By the 1580s, however, the favored monumental three-dimensional image of Christ had shifted again, from the risen standard bearer to the man on the cross. The Giambologna shop alone seems to have produced more than a dozen of these, many large scale. The crosses went all over Italy and indeed Europe: Loreto, Rome, Genoa, Mantua, Madrid, Munich.[87]

The Salviati account books tell us that on 22 March 1589, Antonio Susini received twenty scudi "to chase the bronze crucifix that is to be placed on the altar" (fig. 6.18).[88] This left the space during the renovation of the central island in the eighteenth century, and a tabernacle now occupies the position on the ledge behind the table where it once stood. The removal of the crucifix obscures not only the connection that originally linked the effigy of the saint both to the image behind and to the angel above but also the coordination between the Allori and Razzi biographies and Giambologna's core design: one of Allori's ceiling paintings shows the saint, while still a child, praying to the cross, while Razzi writes of how the archbishop's followers saw him speak to, embrace, and kiss a crucifix, noting that he was holding a crucifix to his body when he died.[89]

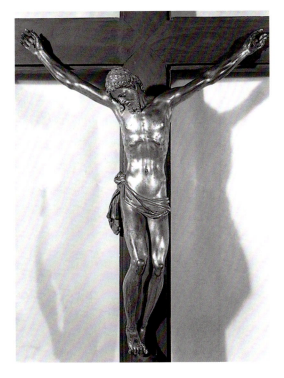

6.18. Antonio Susini, after a design by Giambologna, Crucifix. Bronze. San Marco, Florence.

Ammanati and the Jesuits

The Salviati Chapel was arguably the most impressive sculptural monument unveiled in Florence in the 1580s. It transformed Giambologna's career, breaking down the last fence separating him from the domains in which Danti and especially Ammanati had established themselves.

Stefano Magnanelli has drawn attention to a number of Giambologna's formal architectural debts to Ammanati's buildings, particularly in the late 1570s and 1580s: the bracket supporting the pediment in his altar at San Donato, for example, like the portal he made for the retrochoir in the Santissima Annunziata, comes from Palazzo Grifoni.[90] We might further note that even if Giambologna's decision to center the chapel on an island altar broke with Florentine norms, Ammanati had drawn a series of proposals for chapels and oratories that placed the altar at the center of the space in addition to or instead of along the wall.[91] Some of these drawings may date as early as the late 1550s, when Ammanati was at work on his treatise. The most secure piece of internal evidence, however, suggests that

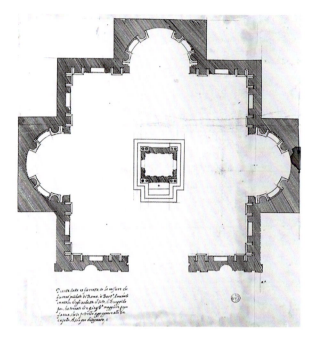

6.19. Ammanati, Project for Santa Maria Maggiore in Rome. Ink on paper. Gabinetto Disegni e Stampe, Galleria degli Uffizi, Florence.

at least one sheet (fig 6.19) was exactly contemporary with Giambologna's project. A note at the bottom states that the plan was "made in Florence, with the measures sent to Bartolomeo Ammanati from Rome, before he saw the site." The site at issue was the family chapel that Cardinal Felice Peretti (soon to be Pope Sixtus V) had commissioned as a kind of transept in Santa Maria Maggiore. Occupying a position analogous to that of the Salviati Chapel in San Marco, it, too, would center on a precious relic, the crib that had held the newborn Christ. Ammanati must have made this drawing, like the others in the series to which it belongs, sometime before his late 1584 trip to Rome. The Peretti renovation, like the Salviati, had been underway since 1581, and it had been clear from that year that the relics would go "in medio dictarum capellarum." This raises the question of whether Giambologna aimed to equal one of the boldest new architectural projects in the papal city, imitating the kind of design that Ammanati was proposing, or whether Ammanati, seeking to secure a plum Roman commission for himself, drew on Giambologna's Salviati Chapel for ideas. Both Giambologna's invention and the one in Ammanati's drawing eliminate tables from the side walls, elevating a single island altar with a set of steps in the center instead. Ammanati's other Peretti proposals, likewise centrally planned, eliminate the exedras in favor of flat walls like the Salviati's.[92]

By the mid-1580s, in any case, Ammanati had set himself on a course quite different from Giambologna's. He had virtually given up sculpture altogether, and he was shifting his architectural focus from domestic to religious structures.[93] While Giambologna was at work in San Marco, Ammanati's primary base of operations was but a few blocks away, in the church dedicated to the child Baptist (see fig. 7.7), right next to the old Medici palace, on the street leading to the cathedral. Here Duke Cosimo and his wife, Eleanora of Toledo, had helped the Jesuits secure a seat, intervening with the canon of San Lorenzo, who controlled the property.[94] In the years following, both Ammanati and his wife, the poet Laura Battiferri, grew increasingly close to the order. From at least the early 1570s, Ammanati had been encouraging the Jesuits to refurbish and expand their building. They engaged him to help with this a decade later.

The plan of the church that Ammanati had underway by 1581 evokes Nanni di Baccio Bigio's initial proposal for the Gesù in Rome: a simple box with a wide nave, suitable for a congregation, with only shallow chapels at the sides.[95] This conformed with the basic principles of the "reformed" Florentine churches in its regularization of the interior and its unobstructed view from the nave to the high altar. If anything, it was intentionally artless, though the church may ultimately be less notable for its purely formal features than for the new role it allowed the architect. After the 1583 purchase of a shop allowed the reinitation of construction that had temporarily come to a halt, a letter from one of the fathers remarked that "we hope that we can [now] finish, having the aid of Messer Bartolomeo Ammanati, our benefactor."[96] The letter characterizes Ammanati less as a designer than as a patron, and other contemporary evidence gives much the same impression. Ammanati offered Jesuits his labors at no charge; beyond this, he and Battiferri helped subsidize construction using funds from their own savings. The general of the order wrote to the duke that Ammanati was showing himself to be "full of love, a benefactor of the college, since he is building it almost at his own expense, and he is dedicating himself to the project with fervor."[97] Baldinucci, who seems to have seen the couple's testament, reported that the pair even named the Collegio as their heir.[98]

Through his labors, Ammanati came to look like a distinctive kind of artist, a *virtuoso*, to use Baldinucci's language, who achieved recognition not by putting craftsmanship on display but by demonstrating "pious liberality."[99] For this, the Jesuits rewarded him: in recognition of the gifts and service Ammanati and Battiferri offered, the order allowed the couple to outfit one of the church's chapels for themselves, using it for their place of burial. During Ammanati's first years in Florence, he would have watched his major Florentine predecessor, Baccio Bandinelli, erect a grand burial monument to himself in the Pazzi family chapel in

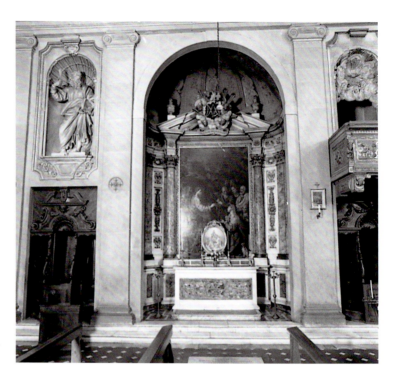

6.20. Ammanati, burial chapel. San Giovannino, Florence.

the church of the Santissima Annunziata.[100] He would also have known that his former teacher Jacopo Sansovino, before his death in 1570, had arranged for burial in a chapel the sculptor-architect had himself designed, featuring a self-portrait.[101] By these standards—let alone those of the Salviati Chapel—Ammanati's own chapel in San Giovannino is rather humble (fig. 6.20). Though it is difficult to imagine the original form behind the subsequent incrustations, it is evident that the space includes no sculpture at all, nor anything else from the artist's own hand. Perhaps Ammanati simply wanted to leave no doubt that he was acting as the client, not the producer. Whatever the case, the design choices he made invited direct comparison with Giambologna's project up the street. Into the floor, he set colored marbles.[102] And when it came time for the altar commission, he went to none other than Giambologna's collaborator, Alessandro Allori, who painted him an image of *Christ and the Samaritan* (fig. 6.21). The subject made explicit the devotion to Christ that had guided Ammanati since at least from the time of his work on the Buoncampagni altar in Pisa. It's theme of reform—the woman of Samaria was an adulteress set right—echoes what Ammanati regarded as his own shift from a sculpture of the body to something more devout. And lest anyone

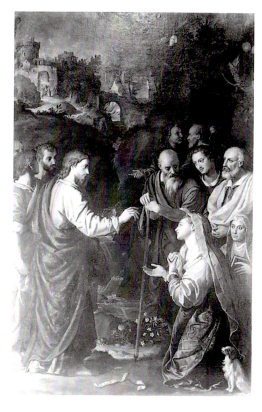

6.21. Alessandro Allori, *Christ and the Samaritan Woman*. Oil on canvas. San Giovannino, Florence.

miss the parallel between the Samaritan's gift and the "denaro in abbondanza" that Ammanati and Battiferri provided to the Jesuits, Allori included the couple as bystanders at the depicted event, looking approvingly upon the offer to Christ.

That Ammanati's work on San Giovannino was pious did not mean it was self-less. He was the city's most experienced architect, and he had been passed over for the Salviati commission. Now, he was doing something no Florentine artist before him had presumed to do, something, indeed, that many in the post-Tridentine church would have found objectionable: building himself a chapel and including an image of himself in its altarpiece. The chapel's nearly exact contemporaneity with the Giambologna project would have intensified comparison between the two artists: while the godless Giambologna was enriching himself, cynically pro-moting the Salviati bankers, the devout Ammanati was giving away his fortune, as Baldinucci later saw it, "for the public good." This goes a long way to explaining what Giambologna did next.

Giambologna's Charity

In 1595, Giambologna secured from the heirs of Dominico de' Dulces the right to a chapel in the church of the Santissima Annunziata, one block away from San Marco. The contract—witnessed by none other than Benedetto Gondi, who had overseen the productions in San Marco—expressly granted the artist license to decorate the space in whatever way he wished, provided he follow the Tridentine guidelines. It also guaranteed that what he made would never be changed.[103] Not even Ammanati had been given such free rein in a sacred space, in this case the chamber right behind the high altar of one of the most revered Florentine churches. The chapel Giambologna completed (figs. 6.22, 6.23) was extraordinary. In choosing the Annunziata as the site for his burial chapel, Giambologna must have known that he was following in a specific sculptural tradition. It was here that Bandinelli was buried, in a chapel marked by his own sculpture of Christ. It was in the same church that Cellini had hoped to install his marble Crucifix, ideally above his own tomb. In addition, the Annunziata housed the chamber that, in many respects, provided the inspiration for all three of Giambologna's: the Cappella di San Luca, the official burial site of the Accademia del Disegno.[104] That chapel, the only one in Florence predating Giambologna's with a sequence of sculptures in niches, was dedicated to the Trinity, the devotional analogue of the central academic idea that the arts could be reduced to the three fields of painting, sculpture, and architecture. Giambologna knew the space well: he had even designed one of its sculptures.[105]

For the walls of his own chapel, Giambologna commissioned paintings of a *Nativity* from Giambattista Paggi, a *Lamentation* from Jacopo Ligozzi, and a *Resurrection* from Domenico Cresti. Each of these was to be flanked by a pair of sculptures on supports that project from shallow niches; below the figures, he installed copies (initially made for the Duke) of the passion reliefs he had designed for the Grimaldi family in Genoa a decade before, works that few in Florence would otherwise have seen. All of the reliefs centered on the figure of Christ (fig. 6.24; see fig. 7.29). In this respect, their design doubled that of the paintings, though it also picked up the primary leitmotif that ran through both Giambologna and Ammanati's work from the mid-1570s on. Although the chapel was dedicated to the Virgin, Christ's status as the space's real protagonist would have been unmistakable at the chapel's unveiling (in still incomplete form) on Christmas Eve, 1598.[106] The marble statues on the back wall, possibly made by Francavilla, show the active and contemplative life. The niches on the side walls appear to have received figures only after Giambologna's death; the decision to do these in stucco rather than stone no doubt saved time and money, but the inclusion of what were essentially full-scale *models*

6.22. Giambologna, Soccorso Chapel. Santissima Annunziata, Florence.

6.23. Giambologna, Soccorso Chapel. Santissima Annunziata, Florence.

also evokes the practice Giambologna had originally made his own. The evangelists in the back niches accord with the chapel's Christocentric theme. The figures closest to the chapel visitor, standing protectively over him, appear to be angels. Their presence recalls the function of the angels in the Salviati Chapel.[107]

The Soccorso project originated with Giambologna's decision to follow Ammanati's example, spending most of the money he had acquired during his years of service to the city's rulers on a final work of architecture. Baldinucci would later marvel at this:

> The cost of this chapel, counting only that which came from Giambologna's own treasury, as we are informed by his previously named disciple, reached the sum of 6000 scudi. When to this is added the cost of the works that he either carried out on his own, or had carried out, to his own advantage, by his *creati*, we can believe that the cost would rise much higher, and this, they say, was part of the reason why a man who had made such great earnings, after the course of a life of 84 years, would die worth only 12000 scudi, and not more.[108]

6.24. Giambologna, *Way to Calvary*. Bronze. Soccorso Chapel, Florence.

The contract that granted Giambologna rights to the space underscored the fact that the artist was undertaking everything at his own expense.[109] The reference to Giambologna's *pia actio* construed his artistic labors as a kind of salvific "work," an idea to which earlier sculptors, too, had gravitated, especially when making images of Christ.[110] Yet the phrase also implies one lesson Giambologna had learned from the city's other recent chapel projects, that financial expenditure could be represented as a demonstration of virtue.

As we have seen, St. Antoninus's biographers had praised him especially for his charity. By donating so conspicuously expensive a work to the church and the city, the Salviati were, in their way, following his example, as the image of St. Edward stressed. Ammanati, for his part, had demonstrated that charity was a virtue that artists no less than patrons might exemplify—the *Samaritan* makes much the same claim about its patron's virtues as the Edward did of the Salviati. It is not surprising, therefore, that when Giambologna came to make his own chapel he associated its production specifically with charity. The space where Giambologna was working stood opposite a doorway he had produced for the Servites in 1578, and the earlier project must have spurred his desire to work in the particular zone

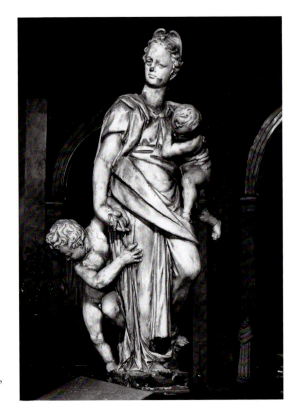

6.25. Giambologna, *Charity*. Stucco. Soccorso Chapel, Santissima Annunziata, Florence.

he negotiated, for he had topped that doorway with a stucco figure of Charity (fig. 6.25). The choice to make the figures in the near niches, like the Charity, in stucco, brings her into the larger ensemble—or rather, it gives the impression that the whole construction had emanated from her.

Dhanens remarked that the Annunziata was already a draw for Flemings, and hypothesized that Giambologna might have frequented the church, especially the Chapel of St. Barbara on the other side of the high altar.[111] An inscription in the Soccorso Chapel specifies that Giambologna "commissioned this chapel to honor God and this burial place for himself and for all Belgians who cultivate the same arts." As Baldinucci realized, the tomb on the back wall elided Giambologna's display of virtue and commitment to art:

Beneath the picture by Ligozzi, Giambologna most gracefully placed his own tomb, upon which he made two statuettes of boys with torches, turned downwards, and, in a sign of his love for art and for his birthplace, he wished that his

tomb be a common one for all of those who, coming from the Fleming nation, exercised in the beautiful departments of sculpture and architecture.[112]

Here again, we may see a difference between Giambologna's priorities and Ammanati's: no inscription in the older artist's chapel made reference to its patron's art, or suggested that other artists should particularly benefit from it.

If Giambologna had access to important relics, the contracts he signed with the Servites do not document this, nor does the chapel itself. What he *was* able to use, however, was a particularly revered painting. The *Madonna del Soccorso* (a.k.a. Our Lady of Help or, in its better-known German form, *Maria-Hilf*) was the second-oldest image of the Virgin in the Annunziata, a church dedicated to her.[113] Commissioned by Forese di Diedi Falconieri "for the remediation of his soul" around 1350, it had remained in the possession of that family until Paolo Falconieri gave it to the sculptor for his use. Baldinucci imagined that the painting was offered "so that Giambologna might adorn it with precious stones and metals"—as he had his icon of St. Antoninus—and that Falconieri "might there continue that holy pledge, to be adored by the faithful with extraordinary frequency and devotion, and not without demonstrating its beneficent effects of continually received graces."[114] In other words, Falconieri saw the gift as a way of honoring the painting, which seemed to be imbued with miraculous powers.[115]

The painting was to this chapel what the reliquary was to its predecessor, and Giambologna followed the example of his earlier patrons in marking the completion of the project with a procession, officially "translating" the icon in 1599 to its new setting. Although on a smaller scale than the earlier one, this procession, like the one the Salviati had orchestrated, passed by the cathedral and gave Archbishop Alessandro de' Medici a prominent role. All of this announced that the creation of the chapel was to serve the public:

> then [the image] was placed in the said chapel with great celebration of sounds, lights, and songs, to the propitious and great contentment of the entire city, [all witnessed] by the immeasurable crowd that came to the said procession, and that thus received infinite daily graces from the said Holy Virgin.[116]

To judge from reports like this, Giambologna wanted the installation of the image in the chapel to take the form not just of an artistic gesture but also of a ritual act. If the Passignano frescoes in San Marco suggest that that chapel perpetuated a ceremonial performance, one that itself aided in the salvation of those present, here again the artwork became an event as much as a thing.

Sailing up above and behind the image of the Virgin, towering over those who entered the space, Giambologna installed a bronze image of the crucified

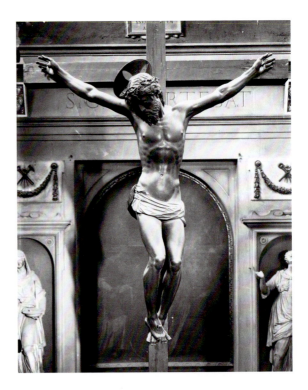

6.26. Giambologna, *Crucifix*. Bronze. Soccorso Chapel, Santissima Annunziata, Florence.

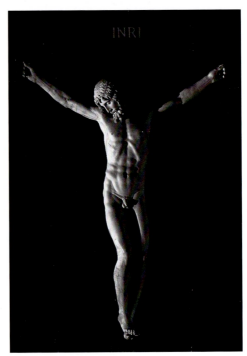

6.27. Benvenuto Cellini, *Crucifix*. Mixed marbles. Marble. Escorial.

Christ (fig. 6.26).[117] Given the small amount of space he had to work with, the artist might just as easily have repeated his earlier design for the Grimaldi Chapel and installed the crucifix above the sarcophagus in the central wall.[118] Instead, he pulled it forward, making the cross the chapel's most important feature. The documentary record shows that, already in the 1580s, Giambologna regarded the subject of the crucifix as an opportunity for competition. He knew, for example, that Benvenuto Cellini's last major work had been a life-size marble crucifix (fig. 6.27). Although Cellini had failed in his attempts to find a visible home for it in a publicly accessible church (Cosimo I had kept it in the Pitti Palace, and Francesco sent it to Spain in 1576), it had elicited encomiastic poems, including two by Danti.[119] When the Duke of Urbino requested that Giambologna interrupt his work on the chapel to make "a marble figure of the crucified Christ, without the cross, two palms in size and carved from a single piece of marble," Giambologna replied with disdain.[120] He showed the Duke's ambassador all the works he had underway at the moment, including the Cesarini Venus and portraits of the Grand Duke, the Duchess, and Cardinal Francesco, then remarked that "even if he were completely out of work, he would not waste his energy making such a small marble work." Yet if the duke would like a metal crucifix, Giambologna would,

> notwithstanding his many duties, see to making one secretly and would try to satisfy you, displaying the great desire to serve you and I believe it, because he never lets anything out of hand that it not finished with the greatest diligence, aspiring to glory, and he wants his works to rival those of Michelangelo. He says as well that he would also be willing do one life-size in marble, like Benvenuto's, which was sent to the King of Spain.

The report suggests that Giambologna, like Ammanati, made depictions of Christ in part because he simply wished to—offering even to accept the commission behind the duke's back. But whereas Ammanati seems to have been motivated largely by faith, Giambologna openly admitted that he thought through such assignments in relation to his rivalries.

That said, Giambologna must also have known that the "sign" the cross represented bore a charge that other Christocentric formats did not.[121] When Giambologna visited the Holy City in 1587, he may have seen that his former collaborator Tommaso Laureti had added a monumental image of a Crucifix towering over a broken sculpture to the center of the ceiling of the Hall of Constantine in the Vatican (fig. 6.28)—a painting that would have made an impression on an artist with Giambologna's priorities. He certainly could not have missed the biggest public "sculptures" that had gone up in that city's squares over the previous two years, the obelisks, topped by crosses (fig. 6.29), that Pope Sixtus had erected in front of

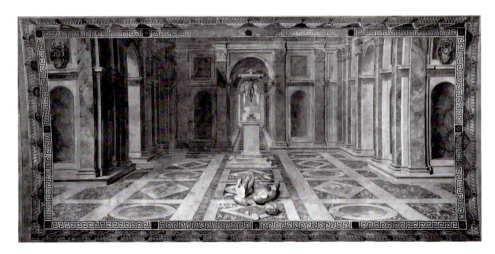

6.28. Tommaso Laureti, *Crucifix Raised over Broken Idol*. Fresco. Sala di Costantino, Vatican.

6.29. Natale Bonifacio de Sebenico, *The Vatican Obelisk*. Engraving. Houghton Library, Harvard.

St. Peter's (1586) and Santa Maria Maggiore (1587)—the church for which Ammanati had hoped to design a chapel to rival Giambologna's. Encomiastic poems, Roman analogues to those written in response to the later sixteenth-century public statues of Florence, treated the gilded bronze cross on the Vatican obelisk as an instrument that could deliver health and salvation.

The Salviati Chapel, as we have seen, had already featured a crucifix on its island altar. Now, though, Giambologna expanded this to life size, dwarfing the icon below. If Laureti's painting suggested that the sign of the cross was somehow at odds with sculpture, this bronze insisted with its very monumentality that sculpture belonged in the Reformed church. Here was a Crucifix that matched Cellini's, and in the very church the late sculptor had vainly hoped his own would go. The prominence of the crucifix pointed to an idea to which Florentine sculptors from the time of Giambologna's youth had repeatedly returned: that of transforming their final artistic efforts into a labor of love, focused on the body of Christ. Its place in the ensemble, though, situated Giambologna's labor within a larger act of patronage, transforming the image of the artist that the chapel left to posterity. Ammanati, in his late years, had grown suspicious of sculpture: to commit himself to drawing was to shift to the artistic practice that was perhaps furthest from it. Giambologna used architecture to make sculpture the very object of devotion.

7

SCULPTURE IN THE CITY

What They Saw in Rome

The obelisks that Pope Sixtus had Domenico Fontana erect around Rome and the colossal bronze statues of saints Peter and Paul that he had the same engineer place on the columns of Trajan and Marcus Aurelius together amounted to one of the most extraordinary urbanistic projects in the history of the city.[1] A feat of engineering, the relocation of the stones and the addition of the bronzes also picked up on an idea that Gregory XIII's fountains had introduced a few years before, moving monuments from the fringes to the center of the city's squares and joining those squares into a network. Cardinal Ferdinando de' Medici, who was living in Rome in these years, would have understood immediately why later writers on urbanism have so frequently regarded the obelisks in particular as friendly monuments, helpfully establishing terminals for Gregory's and Sixtus's new long, straight streets, orienting pilgrims traveling between the city's major basilicas. Still, no resident of the city, and no one with access to the papal court, could have missed the fact that the objects also operated in more adversarial ways.

The inscription Sixtus placed on the outward face of the Vatican monument— "behold the cross of the Lord, flee, you enemy forces"—reiterated the operative words from the exorcism performed upon the completion of work. Those approaching the monument, however, and seeing the new church rising behind, might well have concluded that the message was no longer directed to the stone

itself, but to *them*. It was the obelisk, after all, that now held the cross: look at this cross, the inscription seemed to say, and foes be gone. The 1586 poems written in praise of Fontana's work refer to the Vatican obelisk as a "standard" (*stendardo*), a "banner" (*vessillo*), comparing it directly to the insignia that led armies. The cross was not just triumphal, it was belligerent.

Ferdinando witnessed all of this, probably even playing a more active role: Suzanne Butters has argued that he was the one who put the idea for the columns and obelisks in Sixtus's head in the first place.[2] And in 1587, with all of these works underway, Cardinal Ferdinando murdered his brother, renounced his office, and acceded to the throne of the Grand Duchy of Tuscany, moving to Florence, where he suddenly had his own city and his own team of artists to work with.

Rome in Tuscany

When Giambologna, under Ferdinando's patronage, began to undertake equestrian monuments for the first time (fig. 7.1), he seems to have been less concerned to take credit for the design than to lay claim to the sort of engineering expertise for which Ammanati had been especially renowned. For the actual design of the animal, Giambologna simply turned to two painters, Gregorio Pagani and Ludovico Cigoli, for drawings. For its casting, by contrast, he determined to take matters back into his own hands. Cosimo I's son Giovanni reports Giambologna poured the first horse in one piece, commanding a team of some seventeen assistants.[3] A practical task or not, there were bragging rights to be had in pouring something bigger than anyone in Florence had previously attempted.[4] Moving and installing the monument would have constituted feats in their own right, requiring the artist to balance twelve tons of metal on a high, narrow platform. The monuments might seem a return to the equestrian prototypes of Donatello and Verrocchio, or of Michelangelo's Capitoline square, but they followed more directly on the heels of Fontana's projects.

Giambologna would certainly have known of Ammanati's entry in the competition to move the Vatican obelisk, and there is an unmistakably Roman orientation to his work for Ferdinando.[5] This did not stop at technological ambition, moreover, but extended to the use of the piazza. In designing the Palazzo Grifoni (fig. 7.2), Ammanati had completely ignored the most iconic neighboring structure, Brunelleschi's Ospedale degli Innocenti and had abandoned traditional local building materials in favor of a quite un-Florentine brick structure with sculpted friezes. His model was, unmistakably, the Palazzo Farnese in Rome (fig. 7.3), and Ammanati went so far as to recreate the decorative patterns in its walls (fig. 7.4).

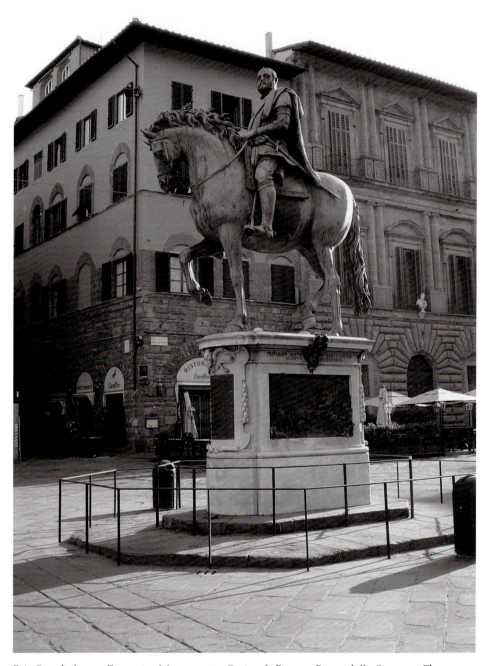

7.1. Giambologna, *Equestrian Monument to Cosimo I*. Bronze. Piazza della Signoria, Florence.

7.2. Ammanati, Palazzo Grifoni (seen from the north). Florence.

7.3. Antonio da Sangallo, Palazzo Farnese, Rome.

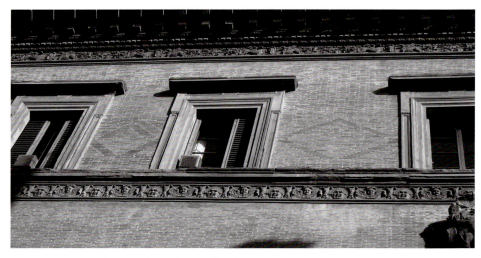

7.4. Ammanati, Palazzo Grifoni, detail of brickwork.

The Grifoni family could hardly claim a status like that of the Farnese, but they were fortunate enough to occupy property that faced directly onto the large, open space. In Ammanati's design, the piazza became a framing element, and more importantly, the palace, especially its forcefully rusticated corner, a way of commanding that. Before the Annunziata had the great porch it does today, the question of the piazza's orientation could still have seemed undecided. Ammanati's palace proposed that it might be an area one looked across from the north side, toward the cathedral, with the palace itself as a principle object.

Much the same thinking guided the installation of Ammanati's Neptune fountain. The early sources tell us that Cosimo wanted a waterwork in the piazza, and they comment on the impressively large stone that would become its centerpiece. The same sources are largely silent on the thinking behind the fountain's position, though the planners must have considered this carefully. Bandinelli, the first artist to work on the stone, no doubt appreciated the opportunity the commission would present to place a new statue in the company of Michelangelo's *David* and Cellini's *Perseus*; here the much-maligned artist would have a shot at redemption. The site of the new work, though, had considerably more urbanistic charge than any of those already occupied. Brunelleschi's famous perspective panel had supposed the northwest entrance to the piazza to constitute the principle view on the Palazzo Vecchio, and processions conventionally entered the space from Via de' Cerchi.[6] And a drawing now in the Louvre (fig. 7.5) demonstrates that contemporaries contemplated such issues.

7.5. Study for the Neptune fountain. Chalk and Ink on paper. Louvre, Paris.

The sheet, which shows an early design for the fountain at its center, must predate Ammanati's decision for how to use the large central block of marble. Not only does the pose of the *Neptune* differ significantly from the one at which Ammanati finally arrived, but a lightly sketched enclosure seems to indicate the original contour of the block. The author, if not a sculptor, must have been attuned to problems of the carving that the assignment presented. If we take Ammanati's 1561 letter to Michelangelo, as Virginia Bush did, to indicate that he was "feverishly at work," the drawing would have to stem from an earlier moment.[7] Ammanati uses no such words, however, and his remark about trying to remove as little marble as possible from the block could suggest just the opposite.[8] Whatever the case, the drawing must date to before May of 1564, by which point hippocamps had replaced the more humanoid vase-bearers that it shows.[9] Most significant in the present context is the sketch that appears in the upper right, showing the platform ("ringhiera") that once ran along the Palazzo Vecchio, the position of the flanking river gods (the Arno and the Tiber) that the draftsman imagines below, and a hexagonal basin. An inscription below draws attention to the shape: "in this way I believe it would turn out rather well, that is, making the said additions with six faces and not with eight: it would be better with respect to the *vedute*."[10] A surviving medal by Pietro Paolo Galeotti similarly places the central figure on a hexagonal structure, suggesting that this may originally have been the official plan.[11] Ammanati's basin, however, is octagonal, meaning that he changed his mind, or—more likely—that the drawing pre-dates Ammanati's involvement with the fountain. The hand of the inscription bears no comparison with that on the sheets generally attributed to Ammanati, and there is virtually no decorative feature of the proposed fountain that appears in the structure as executed.

Even if this is the case, though, the drawing demonstrates that designers were apt to think of a project like this in plan and not just in elevation. As maps, too, would later indicate, the fountain differed from the earlier works of Michelangelo and Cellini in that it was a structure, and not just a figure. Rather than simply using the building as a backdrop, the centrally planned composition would become a new corner, occupying a space that history had made a focus of attention. And an artist designing that structure would take account, right from outset, of what that structure would *face*. Ammanati's ultimate octagonal structure offered two advantages over the rejected hexagonal alternative: the side opposite the building's corner would rotate slightly more to the west, confronting those approaching from the Via Calzaiuoli more directly, and the adjacent side to the north would meet those entering the piazza along the traditional processional route.

In 1568, during a hiatus between the temporary installation of his octagonal fountain and the completion of its last permanent features, Ammanati began work

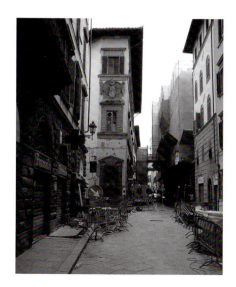

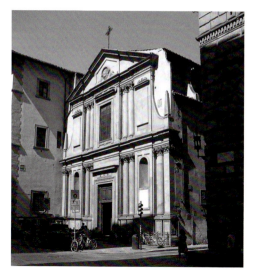

7.6. Ammanati, Palazzo Mondragone. Florence.

7.7. San Giovannino, Florence.

on a palace for Don Fabio Arazzola, the Marchese of Mondragone (fig. 7.6).[12] Here, the "theme" of the corner returned; in fact, it determined the form of the entire building, which was made to be seen from across the small square over which it looks.[13] The church of San Giovannino (fig. 7.7) provided a bigger challenge, since the Jesuits lacked space and money and had to acquire the land for their complex parcel by parcel, with Ammanati sometimes advocating personally on their behalf.[14] Even with these constraints, however, Ammanati proposed a plan sufficiently modest to allow for a small piazza in front, a reminder that the church descended from the Gesù in Rome.[15] A small house that still stood between the church and the street prevented Ammanati from seeing the square realized before his death. Only in the late seventeenth century would it be evident that Ammanati had attempted a trifecta: the Piazza Colonna, the Piazza Farnese, and the Piazza del Gesù were three of the most prominent modern piazzas in the papal city, and Ammanati had sought to import versions of each into Florence.

This makes any evocation of the Campidoglio (fig. 7.8) look all the more pointed, lending particular significance to a report like the one we read from the Florentine diarist Francesco Settimani in 1608, on Giambologna's second equestrian monument, in the Piazza Santissima Annunziata (fig. 7.9):

there was erected on our piazza the statue of the serene and glorious Prince Don Ferdinando Medici, Grand Duke of Tuscany, etc., a work by the most excellent

7.8. Étienne Dupérac, Piazza Campidoglio. Engraving. Graphische Sammlung, Albertina, Vienna.

sculptor Giovanni Bologna of Belgium. While the base of the said statue was being made, the people whispered uneasily about it, believing that it was Giambologna who had persuaded His Serene Highness to choose this particular site for the statue. But once the base and the statue were seen in their proper place, these murmurs turned into benedictions, with many affirming that the site of the statue was a success, and that it brought ornament and beauty to the theater that the piazza of the Santissima Annunziata is.[16]

To follow Settimani, the artist was first mocked and then praised not for his design per se, but for his considerations on where the statue was to be placed. The impression on the Florentine street was that Giambologna's responsibilities went beyond the invention of figures and the handling of materials to include urbanism. At the very end of his career, the equestrian monuments offered Giambologna an opportunity to challenge Ammanati on a new front.

Settimani also indicates that there were questions about whether the artist, then in his eightieth year, was up to the job. Yet it is difficult to imagine who in the city would have been better equipped to make these kinds of decisions. From

7.9. Giambologna, *Equestrian Monument to Ferdinando I* (seen from the south). Bronze. Piazza Santissima Annunziata, Florence.

his completion of Laureti's fountain in Bologna to his numerous works for gardens and grottoes, site had long been an important consideration for Giambologna. He seems to have been thinking about the environment of his sculptures as early as 1583, when his advocate Vecchietti pressed to changed the assigned material of the Orsanmichele St. Luke from marble to metal: "since the other two niches of the façade have figures of bronze," Vecchietti wrote, "let this one, too, be in bronze, so that it unites with the other two."[17] If there was a new challenge in the equestrian projects, it could hardly have been their demand for reflection on how a sculpture should relate to the things around it.

Ferdinando's interests, moreover, only reinforced Giambologna's.[18] From the time of his arrival in Florence, the Campidoglio (fig. 7.8) in particular seems to have been much on his mind. In 1594, as Giambologna's equestrian monument in the Piazza della Signoria was nearing completion, Ferdinando had Giambologna's occasional assistant Pietro Francavilla carve a portrait statue for the Piazza de' Cavalieri in Pisa (fig. 7.10).[19] This had been the site of the city's ancient forum and into the Early Renaissance its seat of government. In an act that had as much to do with internal Tuscan relations as it did with the Turkish menace he was ostensibly aiming to fight, Ferdinando's father, Duke Cosimo I, had installed the Order of St. Stephen here; the statue was just one of a series of previously planned transformations that Ferdinando carried through, to an extent following a project that Cosimo's master architect Vasari had left.[20]

7.10. Vasari et al., Palazzo degi Anziani.Piazza de' Cavalieri, Pisa.

A tower that had been the former seat of the Capitano di Giustizia, the so-called Torre dei Gualandi or "Tower of the Moulters" in reference to the constant changing of feathers that an elected government sees, was truncated. Masons united it with the tower to its right (called the Torre de Fame, in reference to Conte Ugolino), using the stones the came from its upper stories to build stables. Painters then decorated the humbled horizontal block with frescoes celebrating Medici virtues.[21] The church of San Sebastiano dei Fabbri, which had been restructured and rededicated to St. Steven when the order moved in, received a new facade beginning in 1594.[22] The Canoninca or "canonry" along the south side of the piazza, a Vasarian fusion of miscellaneous medieval houses, received its own new facade in the same years.[23] Simultaneously, a university building, the Palazzo del Collegio Puteano, began to go up, helping to create a closed environment in which everything was similar in height and largely consistent in period style. Another older building, finally, was enlarged and reornamented between 1596 and 1603 to serve as the new Palazzo del Consiglio.[24] This structure, to which Francavilla's Ferdinando seems to look, provided a seat for the new city council, while the building that had formerly housed the magistracy—the Palazzo degli Anziani—was not only transformed into the order's headquarters but also expanded into the

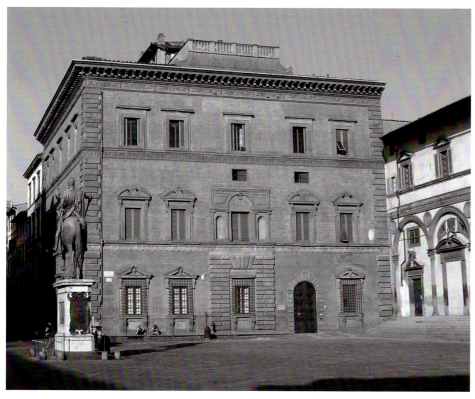

7.11. Piazza Santissima Annunziata, with Giambologna's *Ferdinando I* and Ammanati's Palazzo Grifoni (seen from the northeast).

dominant structure on the square. Its symmetrical staircase lent the whole space a strong axiality, focused on it, and the statue only reinforced this.[25] If the combination of elements evokes the site where the Roman senator presided, we should not forget that it did this precisely by destroying Pisa's closest analogue to the city halls of Florence and Siena.[26]

The Florentine context added another level of antagonism, for in nearly every space that Giambologna worked, Ammanati had ensured that the theme of the Roman piazza was already in place. What Giambologna installed, as a consequence, acquired territorial pretensions. Consider the Annunziata statue, the one that, according to Settimani, the Fleming took such care to place. Rising on a particularly tall base, the bronze blocks much of the ground-level view of Ammanati's palace from the points in the piazza where it would have shown best (fig. 7.11). The baton of rule the duke holds extends over just the part of the space on which Ammanati's

building might seem to have had the most claim. Beyond this, though, the statue decisively reorients the piazza as a space one should see from south to north (see fig. 7.9), looking not toward Palazzo Grifoni but toward the new facade Ferdinando added to the Annunziata. With Giambologna's horse in place, this piazza resembled the Campidoglio more closely than any other in Florence, but the conversion also demoted what Ammanati had done just a few decades before.

Unity and the Republic Past

A constant in Ferdinando's urban patronage was the possibility that public sculptures would sustain an antagonistic relationship with their surroundings. The Pisa commissions belonged to a systematic unification, or even "colonization," through statuary, of the duke's Tuscan domain. In the same year that the marble Ferdinando went up in the Piazza dei Cavalieri, Giambologna and Francavilla made another portrait monument for the same city, now showing the duke as the city's restitutor, ostensibly lifting Pisa to its feet.[27] One year later, the duke had Francavilla make yet another portrait for the square in front of the cathedral of Arezzo (fig. 7.12), and four years after that, he commissioned Giovanni Bandini to carve a portrait for the Piazza Micheli in Livorno, the monument to which Giambologna's student and heir Pietro Tacca added his enchained bronze *Slaves* in 1626.[28]

Giambologna's public sculptures in Florence confronted that city's Republican past as well. This was a history at odds with the very principle of the monument to an individual ruler, as most public portraits of the Medici acknowledged. Coins might replace the traditional images of the fleur-de-lis and John the Baptist with ruler portraits, but when Michelangelo carved his Capitani, he made them so vague as to render impossible secure identification; Vincenzo Danti's statue of Cosimo I (see fig. I.5) likewise shows a completely unrecognizable figure. Only after Cosimo's death did Ferdinando replace this with a real likeness. The fact that Ferdinando, too, initially declined to commission images of himself suggests that he recognized the issue.

Then he changed his mind. Perhaps his days in Rome had simply left Ferdinando with fewer qualms than his predecessors about taking up imperious imagery. Or perhaps he decided that his models should be the other European rulers who were his contemporaries, rather than the Florentine dukes who had preceded him. Whatever the case, Ferdinando's son still seems to have been uncomfortable with the aggressiveness of his father's choices. As Dietrich Erben observed, in the best study of the equestrian monuments' manufacture and imagery, Ferdinando's son added a dedicatory plaque to the statue in the Piazza of the Annunziata in 1640,

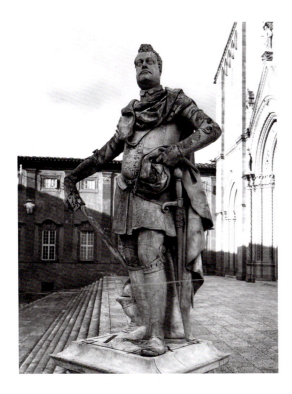

7.12. Francavilla, *Ferdinando I*. Marble. Cathedral Square, Arezzo.

disguising the actual circumstances of the commission and giving the impression that he had been the patron, just as Ferdinando had commissioned the original monument for his father. The political delicacy of Ferdinando's choices, furthermore, may help explain one rumor that circulated, suggesting that it was not he but his artists who were pushing for these commissions. On 21 December 1587, two months after Francesco's murder, Gian Vittorio Soderini wrote of speaking with Giambologna,

> who explained the intense desire he has always had to cast a horse, greater than that in Rome by a third of a braccio in every direction, which would be placed in the Piazza della Dogana, opposite the fountain. Asked how much it would take to start work on this, he responded fearfully, and with a fearful and pusillanimous heart, that 600 scudi would do.[29]

It is not hard to believe that, for all the opportunities he had had under Francesco, the artist regarded the regicide as an event that could open a new professional world to him. The idea of trying to rival the Marcus Aurelius had probably

been in his head for some two decades, from the time Danti had contributed an ephemeral statue of Cosimo on horseback to the decorations for Francesco's 1565 wedding.[30]

Ammanati died in 1592; Giambologna completed his last and in many ways his most impressive public statues for a city in which he no longer had living rivals. Still, these works appear almost systematically to engage what Ammanati had left. They also depended on a particular set of political interests, which gave the sculptor a kind of opportunity he had never had previously. The patron's and artist's hostilities came into alignment, as both attempted at once to shape and respond to local memories.

Site and Address

A political reading of Giambologna's late works will do well to distance itself from two other ways of looking at public sculpture: as commemorations, and as manifestations of a ruler's personal iconography. To see this, it is helpful to turn to one of the better-documented Florentine monuments of the late sixteenth century, the column Ammanati erected in the piazza before the church of Santa Trinita (fig. 7.13). The granite shaft—considerably taller than any other column in the city—had come from the Baths of Caracalla, and it was in place by July of 1565. In November of that year it was supporting a terra-cotta statue of Justice, and in 1581 Francesco installed the porphyry and bronze replacement Ammanati had produced in collaboration with Francesco Ferrucci sixteen years later.[31] (Appropriately enough, Ferrucci carved the figure and Ammanati gave it extra bronze clothing.) The most common anecdote that circulates about the column is that it marked a site of personal significance to Cosimo. The Touring Club Italiano guide to Florence puts this concisely, recapitulating an idea accepted by authorities from Leonardo Ginori to Virginia Bush: "[the column] was donated in 1560 by Pius IV to Cosimo I, who wanted to erect it in memory of the victory of Marciano (2 August 1554) against the Sienese, at the place where he had heard the news [of this]."[32] Several things here are odd, however. To begin, neither Cosimo nor Francesco provided any visible public indication that this was the function of the column: there is no inscription or relief that makes any reference whatsoever to a battle. The only real clues, if that's what they are, that this would be the column's purpose, are the figure-on-column format, which some by the 1560s might have understood as the recreation of an ancient triumphal type, and the addition of a capital and base that rendered the stone as an example of the "Tuscan" order. Pietro Paolo Galeotti placed the column on the verso of a 1569 portrait medal,

7.13. Ammanati and Francesco Ferrucci, *Justice* column. Piazza Santa Trinita, Florence.

surrounded with the inscription IVSTITIA VICTRIX, but the passerby would be forgiven for inferring that "justice" was more a domestic concern than a cause for or result of foreign military action.

Still more difficult to believe is the additional assertion that the delivery of news to the duke really determined the position of the column itself. It rises at

7.14. Francesco Magnelli and Cosimo Zocchi, 1783 map of Florence (detail, oriented with south at the top). Engraving. Museo di Firenze com'era, Florence. Ammanati's column is the black square in Piazza Santa Trinita, just right of center. Giambologna's Centaur is the black rectangle at the intersecting trident of streets at the lower center. Magnelli and Zocchi also indicate the locations of Ammanatti's Neptune fountain and Giambologna's first equestrian monument in the Piazza della Signora, upper left.

7.15. Ammanati's *Justice* column, as seen from Via delle Terme.

the exact meeting point of Via delle Terme, Borgo Santissimi Apostoli, and Via Tournabuoni (figs. 7.14, 7.15). While not impeding traffic on what was then one of the chief north–south thoroughfares in the city, it was also visible from Ponte Trinita, Ammanati's much admired 1567 bridge; for anyone entering the city by that route, it would have come into view in much the same way that the Column of Marcus Aurelius did when one walked or rode south along the Corso. Here again, Ammanati may have been drawing on his knowledge of Roman squares, in this case thinking about the experience of encountering Piazza Colonna, though with the difference that Ammanati's column, unlike its Roman counterpart, also marked a key nodal point, much as Fontana's obelisks would some two decades later. The Justice column was not unique in this. When Cosimo laid the base for a column he intended to erect in front of the church of San Marco (fig. 7.16), he did not center it on the facade of the church or place it in the middle of the square, but instead located it so as to intercept anyone approaching the space from Via degli Arrazini, Via Battisti, or Via Cavour. The specific place of the column commemorates nothing; there is no sense that the column's installation designated the historical importance of one spot.[33]

7.16. Stefano Bonsignori, 1584 plan of Florence (detail). Engraving. Museo di Firenze com'era, Florence. Cosimo I's column for the statue of *Religion* appears in its projected location in Piazza San Marco in the upper left-hand corner.

The statue dedicated to Cosimo I was the first made for the Piazza della Signoria to be separated from a building and placed out in the square, yet it was not centered against a backdrop to create the effect of a symmetrical space—by contrast to what he would do at the Annunziata in the following decade—Giambologna did not really try to transform *this* space, Soderini's "Piazza della Dogana," into a Florentine Campidoglio. Instead, the monument's position eyed the same entry points that Ammanati had with his fountain three decades earlier (fig. 7.17). When the procession occasioned by Ferdinando's 1589 marriage to Christina of Lorraine entered the piazza, it did not, as Francesco's had in 1565, enter the space by way of Via de' Gondi, but rather turned east at Via de' Cimatori then approached the Palazzo Vecchio from the north. After 1594, those following the same route would have found Giambologna's bronze standing between them and the building—or rather, between them and Ammanati's fountain. The statue is not truly aligned with the Hercules, the David, and the Neptune, edging rather toward the opening of the street. The monument's subtle counterclockwise rotation and its proximity to the wall of buildings to the north aligns the work additionally with Via

7.17. Giacomo Papini, plan of Florence (detail). Engraving. Museo di Firenze com'era, Florence. Ammanati's *Neptune Fountain* is the circle at 106; Giambologna's equestrian monument is the rectangle directly above. Significantly, the map does not indicate the presence of Bandinelli's *Hercules and Cacus* or of Michelangelo's *David*. Its maker gives the impression that the equestrian monument was not aligned with these, but with the street openings to the north and west.

Calimaruzza to the east. Giambologna positioned the monument for maximum visibility, even beyond the piazza; it commands much more space than its immediate periphery.

I have been referring to both the Justice column and the Cosimo as "monuments." But regarding them as documents of particular historical events, the politics of which are contained in their iconography, makes it easy to overlook the way they actually address the city, the way they direct themselves at viewers located at predictable points in space. This issue becomes still more insistent with the Centaur, which was moved in 1842 from its original site, the Canto de' Carnesecchi, to the Loggia dei Lanzi. Hidden there, in the shadow of Giambologna's earlier and more famous *Sabine* (see fig. 3.2), it can come across as a museum piece, and a relatively dull one at that, just one more large sculpture with a victory theme that follows in the sequence running from Michelangelo to Bandinelli to Cellini to Ammanati.

The location also makes it easiest both to see and to photograph the statue from one side, so most of the pictures of it reproduced in books look like figure 7.18. One of the most recent monographs on Giambologna goes so far as to say

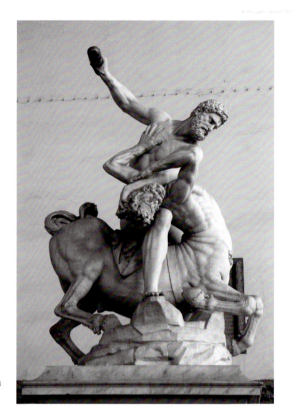

7.18. Giambologna, *Hercules and the Centaur*. Marble. Loggia de' Lanzi, Florence.

that "Giambologna, abandoning for once the principle of 'multi-visuality,' seems here to suggest a privileged point of view, probably determined by the placement of the group at the so-called Canto dei Carnesecchi."[34] The actual site, however, makes it difficult to share such a conclusion. And the early sources suggest just the opposite: Giovanni Cinelli reports in 1677 that Duke Cosimo II "used to drive around the statue repeatedly in his carriage so that he could enjoy its beauty" (*molte volte passeggiava con la carrozza intorno di essa per goder di sua bellezza*).[35] Maps indicating the sculpture, similarly, deny that it was framed by a single approach, as does Giuseppe Zocchi's 1744 *veduta* of the corner (fig. 7.19). Artist and patron alike must have been perfectly cognizant of the fact that it would have be seen from a distance as well as from close up, and from angles that the Loggia block. Surely they considered its relation to the street as carefully as they considered that of every other public monument going up in the city.

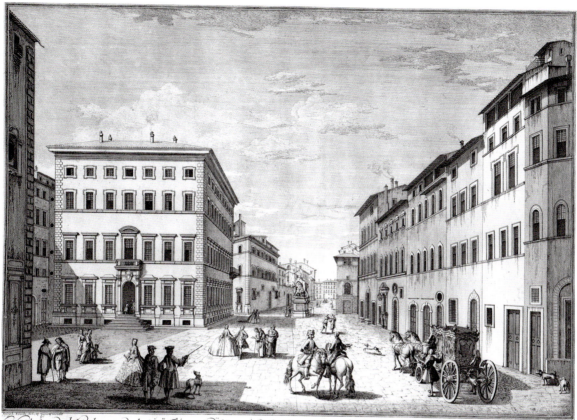

Veduta del Palazzo del Sig.r March.e Strozzi, del Centauro, e della Strada, che conduce a S. M.a Nouella
T. X

7.19. Giuseppe Zocchi, Canto dei Carnesecchi. Etching and engraving. Metropolitan Museum of Art, New York. The large building in the middleground left is the Palazzo dei Cento Finestri, and in fact the inscription identifies the print as a view of that Strozzi residence. The building to the right with the bust above the door is the Palazzo Carnesecchi. The open space in the distance, beyond Giambologna's *Centaur,* is the piazza on the east side of Santa Maria Novella.

Politics and Neighborhood

In addition to seeing the monuments of Grand Ducal Florence in terms of commemoration, scholars have sometimes been tempted to describe them as part of a system of emblems that run across every visual medium in which the dukes showed an interest. This approach is perhaps best represented by Paul Richelson and Detlef Heikamp, who made sense of the Trinita column by placing it within

what Heikamp called a *Gesamtkonzeption* that should have included a statue of Religion on a column in front of San Marco and one of Peace on a column in front of San Felice.[36] Heikamp's fundamental article on the columns is structured as the story of how this plan failed, the San Felice column never having received its statue, and the San Marco column having never gone up at all. What is lost by focusing on the pieces of an ideal program that were considered but never realized, though, is the remarkable success of the Santa Trinita column. Francesco had overseen the placement of two different statues here before he ordered even one for either of the other columns. He preferred, moreover, to have his laborers prepare an extraordinary figure of porphyry and bronze to having the San Marco monument go up in any form.[37] This looks like a statement of priorities: Cosimo and Francesco were both willing to sacrifice much of whatever original total plan they had in mind, but for one of the works, they spared no man hours or expense.

Heikamp also emphasizes the duke's ostensible desire to spread the columns as far from one another as possible.[38] Yet when Ferdinando inherited a city with one fully finished column and two others in various states of incompletion, he set his best artist to work not on either of those, but on the Centaur, a statue he intended to install just a few blocks away. This suggests that, whatever the duke's broader vision for the city, we should approach works like these, following the lead of historians like Dale Kent and Nicholas Eckstein, in relation to more local environments.[39] To say that the placement of the column depended on the organization of the streets around it and of the experience of going through them, after all, is to say that it was conceived in relation to a neighborhood.

One good example of a neighborhood perspective also happens to be the primary text that has shaped scholars' understanding of the Santa Trinita column, a contemporary journal kept by the priest Agostino Lapini. Lapini's family lived near Santa Maria Novella, so he was in a position to observe what was going on, and his comment deserves to be quoted in extenso:

> On the second of August 1554, on Thursday, at 10:30 pm, three couriers arrived here in Florence, one after the other, with garlands on their heads and olive branches in hand, who produced for Duke Cosimo . . . the most happy news of the great rout of the whole Piero Strozzi camp. And this great rout happened at Marciano, in a place and in a camp called Scannagalli. And this proved to be a defeat in every sense of the word, for there were many dead Gauls there, that is, Frenchmen. As soon as Duke Cosimo had heard this excellent news, he went to the Annunziata, and to his own chapel there. He kneeled down with great devotion, and he remained like that for close to half an hour, as the friars around him sang the Te Deum laudamus. . . . And the Duke received the good

news mentioned above at the place where he erected the column of S. Trinita, for eternal memory.[4]

A few things here are worth noting. Lapini's specification that the couriers arrived in the city at 10:30 p.m. makes it all the more surprising that the column marked the site where Cosimo heard the news. Would Cosimo, the same duke who would have Vasari build him a private passageway to take him between his palaces, really be out on a street corner at this hour of the night? The most plausible scenario, perhaps, is that he had been alerted that the couriers were on their way, and had gone to meet them at the piazza in Santa Trinita—the location where he heard the news, that is, was one he had selected in advance. This, of course, would change everything, raising the question of why he chose just that location for such a major event. Finally, and most importantly, Lapini's long account does not actually mention the Sienese at all. What he writes is that the battle of Marciano marked Cosimo's decisive defeat of an enemy that might have looked as domestic as foreign: the Florentine Republican Piero Strozzi, who was in fact the commander of the French soldiers Lapini mentions. This, more than anything, seems impossible to disregard when considering the site at issue, for the piazza in front of Santa Trinita was a stone's throw from the palace where Piero was born (fig. 7.20), in the precinct most closely identified with the exiled family.[41]

Piero Strozzi in fact had Medici blood in him: his mother was Clarice de' Medici, the niece of Leo X and the granddaughter of Lorenzo the Magnificent. After Clarice's death, however, and after Alessandro de' Medici was installed as the first Duke of Florence in 1532, Piero's father, Filippo, had turned against the ruling family, and both men left the city. What followed was brutal: Piero would have seen his sister Luisa poisoned and all the family's Florentine property confiscated. His father's forces were crushed by Cosimo's at the Battle of Montemurlo, where Filippo was captured; he then either killed himself or was murdered in prison. Piero and his younger brother Leone both continued the fight, and in the months leading up to Marciano they had captured Pescia, Monte Carlo, and Monte Catino. Leone, though, with whom Piero seems to have been particularly close, was fatally shot at Scarlino. Piero, who made it out of Marciano alive, met the same fate four years later.[42]

Other members of the Strozzi family remained loyal to the Medici and continued to live in the neighborhood around Cosimo's column. The house that is now Via Tournabuoni 5 (fig. 7.21), was occupied in the 1590s by the poet Giovan Battista Strozzi (the arms that still decorate the facade were carved by Antonio Novelli in the early seventeenth century), and there were also Strozzi properties at the corner for which Giambologna made his statue—the Palazzo delle Cento

7.20. Ammanati's *Justice* column, as seen from Palazzo Strozzi.

Finestre (see figs. 7.19, 7.24), an eighteenth-century Strozzi palace whose northern facade looked onto the Centaur, incorporated houses that had belonged in the family since their purchase by Carlo Strozzi in the fifteenth century.[43] The first chapel one encountered on entering the church of Santa Trinita, before which the column stood, belonged to the Strozzi, and Bocchi identified a Baldovinetti portrait of Filippo Strozzi il Vecchio in the tribuna of the church.

Still, no one could have walked through that neighborhood in the later sixteenth century without being aware of the fortunes of those who had built it. This must have been most apparent in the grand palace that to this day remains one of the city's major landmarks: at the time Giambologna made his Centaur, the building belonged to Leone di Roberto Strozzi, but Leone lived in Rome, and half of the palace was empty, a ghost looming over the neighborhood.[44] Farther down the street, at no. 16, in a Michelozzo palace that was radically transformed in the nineteenth century, lived Alessandro de' Medici, archbishop of the city. He had purchased the property from Cardinal Marco Altemps, who had himself bought

7.21. Via Tournabuoni 5.

it in 1571 from Lorenzo Ridolfi, Filippo Strozzi's son-in-law, who had committed suicide in a Medici prison.[45]

Some residents of the street seem to have felt compelled to demonstrate their loyalty. In 1575, for example, Simone Corsi placed a bust of Cosimo on the facade of his house (fig. 7.22). Seventeenth-century writers believed that Giambologna had carved it, but it is no doubt a workshop production; nevertheless, it doubly documents Corsi's affiliations, for by 1575, Giambologna would never have been permitted to take a private commission of this sort without explicit permission.[46] The duke appears to look across the street to a palace, today outfitted with Medici arms, that the Altoviti family had taken over from the Strozzi (fig. 7.23).

This activity all dates to about a decade after the erection of Ammanati's column, which makes Cosimo's intervention in the neighborhood look like a model that others were invited to follow. And what activated Giambologna's Centaur, in turn, was not a program of personal imagery but a series of renovations, undertaken by various patrons, that combined to coordinated effect. The street that ran

7.22. Palazzo Corsi, with bust of Cosimo I.

7.23. Palazzo Altoviti, with Medici arms, as seen from the portal of Palazzo Corsi.

7.24. The Canto de' Carnesecchi (viewed from the west, looking toward the Cathedral). The large building behind the square to the right is the Palazzo delle Cento Finestre.

south from the square where he worked was one of the widest in Florence—this is a primary reason why the Strozzi had built there in the first place. The Canto de' Carnesecchi marked the street's northern terminus, the point at which the northern and western walls of the old Roman city had intersected, and it constituted a significant interchange: Via de' Banchi led from there to the Strozzi family chapels in Santa Maria Novella (see fig. 7.19), and Via de' Cerretani (fig. 7.24) to the cathedral and, just beyond that, to another Strozzi palace. The Centaur was positioned, in other words, in the heart of the Strozzi precinct, and, what's more, in a space haunted by its own conflicts. Ammanati's Palazzo Mondragone, just beyond the piazza to the west, takes its name from Don Fabio Arazzola, the Marchese of Mondragone, a one-time favorite of Francesco's. In 1575, however, the same year Simone Corsi added the bust over his door, Arazzola was implicated in a conspiracy against the duke; he was banished and compelled to sell his property to Zanobi Carnesecchi for a paltry sum. The Carnesecchi, after whom the corner (formerly Canto a Panzano) was eventually renamed, also owned the palace at number ten (see fig. 7.19), and they later placed a bust above that door

7.25. Giambologna, *Equestrian Monument to Cosimo I* (detail of armor).

with an inscription from Horace's Odes (1.2.49–50): "HIC AMES DICI / PATER / ATQUE PRINCEPS," or "Here take our homage, Chief and Sire," from a couplet that continues "Here wreathe with bay thy conquering brow."[47] The Carnesecchi may well have been self-conscious about their own history, since Cosimo had turned over Piero Carnesecchi, the family's most illustrious member, to the Roman Inquisition. Under torture, he confessed to heresy, and he was decapitated at the Ponte Sant'Angelo in 1567.

If the columns and statues belonged to a citywide system of imagery, if they contributed to a new urban consolidation, they did so in opposition to independently defined and sometimes feuding enclaves that had constituted the historical city. The politics emerge wherever the links between the monuments become most explicit: the Trinita column commemorated the same event as the Piazza della Signoria equestrian statue, namely, the victory over the Sienese—which is to say, over the Strozzi. To the extent that it is possible to say the duke is riding in a direction, that direction is toward the column (see fig. 7.14). Cosimo's armor (fig. 7.25) is decorated with an image of Hercules Slaying the Centaur, a preview of the marble to which Giambologna was just setting his hand to make when the

bronze statue was unveiled.[48] And the Centaur itself might be viewed as a sadistic reworking of the equestrian type, a release of the violence implied in its more self-contained image of the mastered animal.

The Artist's Fixation

The monumental marble itself—carved, like the Pisa portrait, with extensive help from Francavilla—seems to have occupied Giambologna like no other. In March of 1596, the court *provveditore* and engineer Girolamo Seriacopo wrote to Ferdinando that the artist was not making progress on some reliefs expected from him:

> It does not appear that Messer Giovanni Bologna will make the reliefs in his own hand, but is its believable that most or perhaps all will be as good as autograph for, apart from the fact that they must be completed to his satisfaction, he cannot help but finish the works, since he has two of his students involved with them. And if there were another way to assign the responsibility for these, Giambologna would not in the end make them at all, because he is too fixated on the carving of a centaur.[49]

A week later, Seriacopo wrote again:

> Giovanni Bologna persists in his determination of not wanting to get his hands into the things [that others in his studio are doing], especially since he has nothing on his mind except the centaur. Everything else has little place.[50]

In May, Seriacopo wrote to the representatives of the Cathedral of Orvieto, who were expecting a marble St. Matthew from Giambologna, that they would have to wait, since the artist was "too enamored and inspired" by his centaur.[51] The ugly Matthew that the cathedral eventually received (fig. 7.26)—Francavilla's marble reproduces the model Giambologna was using for his St. Luke in Florence—may in the end have been the centaur's most evident material casualty.[52] In February of the following year, Seriacopo wrote to Piero Usimbardi, Ferdinando's secretary of state, that "the Centaur is proceeding apace, since M. Giambologna has nothing else before his eyes."[53] The whole correspondence, which lasts for about a year, suggests an artist obsessed with his work. In a way, this is not surprising, since the composition derives from an earlier design to which Giambologna was particularly attached (see figs. 4.9, 4.11). When commissioned to make a series of Hercules' labors in the 1570s, as we have seen, the battle with the centaur was the first Giambologna produced, and in the 1580s he designed a related image for the verso of a medal by his collaborator Michele Mazzafirri. The small bronze illustrated at figure 4.9 may

7.26. Francavilla, after a model by Giambologna,
St. Matthew. Marble. Orvieto.

date as early as 1590 or as late as the 1600s; it is an open question whether that is a
reduction of the marble or the marble an expansion of the earlier bronze.

The Spectacle of the Piazza

When Ferdinando and Christine's wedding procession turned at the Canto de'
Carnesecchi in 1589, it passed through a triumphal gateway. This was an ephem-
eral construction, and no trace of it remained by the time the *Centaur* was in
place. Still, the relief Giambologna eventually added to the side of the *Equestrian
Monument to Cosimo I* (fig. 7.27) underscored the importance of gateways to the
idea of the *entrata*, the procession that established the advent of a new ruler.

From his earliest days in Florence, Giambologna's relief sculptures had shown
his attraction to urban settings. The relief *Allegory* (see fig. I.8), as we have seen,
features a figure derived from the Michelangelo portraits in the New Sacristy; if
Giambologna's point was to use Michelangelo's image of princely death in order
to show Medici rebirth, however, he introduced a particularly curious change in
setting, placing his figures in a space that has nothing to do with Michelangelo's
interior. Now the key event will transpire before what looks like the portico of
Vasari and Ammanati's Uffizi, newly underway at the time. Mercury leads the
young prince across a piazza.

Other reliefs by the artist evoke more specific Florentine squares: in the Sal-
viati Chapel, for example, we see Antoninus both in the Piazza del Duomo (see
fig. 6.8) and in the Piazza della Signoria (fig. 7.28). Most surprising, though, is

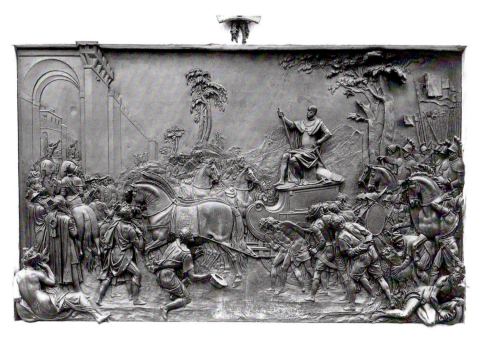

7.27. Giambologna, *Cosimo I's Triumphal Entry into Siena.* Bronze relief from the *Equestrian Monument to Cosimo I.*

7.28. Giambologna, *St. Antoninus's Ceremonial Entry into the Piazza della Signoria.* Bronze. Salviati Chapel, San Marco, Florence.

7.29. Giambologna, *Pilate Washing His Hands*. Bronze. Soccorso Chapel, Santissima Annunziata, Florence.

7.30. Albrecht Dürer, *Pilate Washing His Hands*. Woodcut.

the artist's tendency to set scenes in piazzas even when the subjects don't call for this. In the reliefs he installed in the Grimaldi Chapel in Genoa and in his own burial chapel, nearly the entirety of Christ's Passion takes place out of doors. The scene of *Pilate Washing His Hands* (fig. 7.29), for example, quotes Dürer (fig. 7.30), but nevertheless dispenses with the walled-in, roofed room in which the German

artist placed the tyrant, setting him instead in front of what looks like a freestanding niche.[54] The grid pattern on the ground repeats the device Giambologna used in the *Allegory*. And both the *Pilate Washing His Hands* and the preceding relief showing Christ before Pilate take place before what appear to be the tall, blank, fenestrated exteriors of city buildings. A number of the scenes in the series also feature archways, equally generic, though a few include more coherent structures: the form in the middle-ground distance of the *Ecce Homo*, for example, resembles a triumphal arch.

These reliefs do not represent actual places but rather stage events in a manner consistent with contemporary set design. Mary Weizel Gibbons has aptly compared the Passion sequences to mystery plays, though Giambologna could just as well have found all he needed in Serlio.[55] The generic neutrality of the environments in which he places his characters denies any close connection between narrative and place. In the reliefs for the Cosimo showing citizens rendering obeisance to the duke (fig. 7.31), for example, the enthroned figure sits over the same kind of gridded pavement as did Giambologna's Pilate. Whether this is to be read as a room is indeterminable, for no space with such grand vaults existed in the building where the ritual really took place, and the tiny bust over the door in the background, which seems to turn approvingly to witness the event, evokes nothing so much as those that private citizens were newly placing above the main entrance portals of their residences, indicating their loyalty to the duke.

Giambologna's approach to the relief set him sharply apart from his recent predecessors. Borghini remarked that Michelangelo never concerned himself with "perspectives," and the same kind of criticism could be directed, in its way, at Bandinelli, Cellini, and Danti as well, all of whom thought in terms of figures rather than spaces (cf. fig. 2.10).[56] From a stylistic point of view, Giambologna's different way of working would have demonstrated his ability to do something that his rivals had chosen not to, even something of which they were incapable. Taken not just as generic perspectively rendered spaces but more particularly as depictions of urban piazzas, however, the reliefs also read as responses to the real piazzas to which Ammanati had begun drawing attention. In this respect, the reliefs anticipate the urbanistic undertakings to which Giambologna would dedicate the last years of his life. Their staged quality resonates with Settimani's comment that Giambologna's equestrian monument to Ferdinando "brought ornament and beauty to the beautiful theater that the piazza of the Santissima Annunziata is," as well as with the history of ephemeral decorations. It comes as no surprise to find that several of his most important reliefs appear on the bases of statues made for piazzas.

This is not to say that Giambologna's perspectival constructions always work terribly well. As often as not, the figures he carves in the round compete with

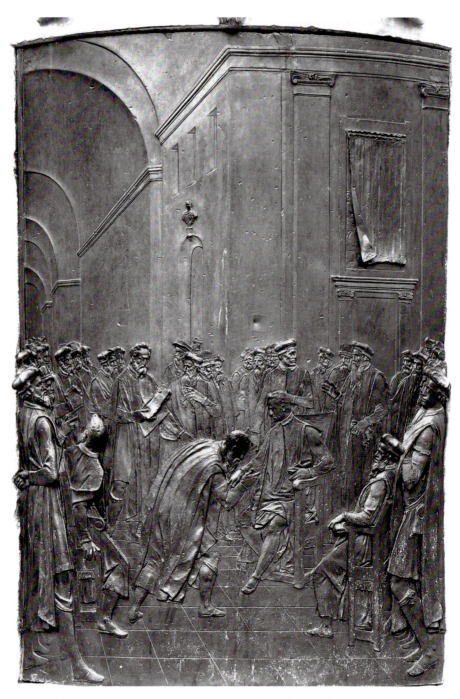

7.31. Giambologna, *Florence Rending Obeisance to Duke Cosimo*. Bronze relief from the base of the *Equestrian Monument to Cosimo I*.

7.32. Giambologna, *Coronation of Cosimo I*, photographed from the side. Bronze relief from the *Equestrian Monument to Cosimo I*.

rather than occupying whatever illusionistic space he employs. As Gibbons observed, the figures in Giambologna's reliefs are objects that work from, even require, multiple points of view. Mise en abyme, the typical Giambologna composition includes a crowd of onlookers that both establishes and calls for multiple points of view. One consequence of the way that Giambologna represents these crowds, with flattened but still three-dimensional (as opposed to incised or drawn) figures that overlap one another, is that the figures he shows often seem to be able to see out around those who are standing in front of them (fig. 7.32). A scene may have dozens of represented perspectives on it; onlookers peek from behind curtains, and even statues seem to turn their heads. Giambologna's image of the spectacle, at least, was one of a central event observed in multiple ways. To think of his sculptures for piazzas in similar terms would be to approach them as monuments that expect and include the people who encounter them.

Vielansichtigkeit or Multiple Address?

The fascination with the piazza betrayed by Giambologna's reliefs, the imagery on Cosimo's armor, the reports of contemporaries about the sculptor's priorities in this period—all of these things suggest that the Centaur, which Giambologna must have known would be the last monumental sculpture in marble that he was likely to make in Florence, was the kind of assignment that aligned precisely with what he identified as his "art." Central was the goal of *Vielansichtigkeit*, the creation of a sculpture with multiple views.[57] In the 1590s, though, Giambologna seems to have attempted a concerted accommodation of the idea of the sculpture with multiple aspects to a set of urbanistic concerns that centered on conflicted streets and intersections. One way of characterizing the result would be to say that Giambologna reversed the expected relationship between object and spectator. Marvin Trachtenberg has taught us what a key concern perspective could be even for piazzas without sculpture, but the difference between a statue and an empty square is that while both can be approached and viewed from different sides, the statue, unlike the piazza, can also address those who move toward it.[58] This is a key issue in Rome—witness again the Vatican obelisk, with its imperative to "behold the cross"—but it bears on the Florentine scene as well.

If the Sabine has traditionally been regarded as the paradigm of the sculpture designed to work from multiple points of view, its installation in the Loggia, as we have seen, nevertheless made it impossible as a practical matter to circumambulate the figures. In this regard, the relief Giambologna added to the front may in part have been meant to be compensatory, replaying the dramatic abduction from angles that were now occluded above. Sixtus V's new Roman model would have discouraged such a limiting placement for future sculptures. Yet while the pope positioned his obelisks so as to have multiple points of view, the form of the obelisk did not guarantee that those perspectives would all be interesting. When Giambologna designed his first equestrian monument, by contrast, he would have known that the sculpture had to acknowledge multiple significant openings onto the piazza, coming dramatically into view however one entered the space. By contrast even to the Marcus Aurelius, positioned such that the building behind it became a kind of symmetrical *scenae frons* for those who approached (as the stairway required) from the front, the Florentine equestrian monument had to present itself to the entire surrounding space.

Ammanati's *Neptune Fountain* already showed that sculptors in Florence concerned themselves with address, with what it was that their works would face. The document recording the installation of Danti's Beheading group, similarly, states that it was to go "above the door of S. Giovanni that looks toward the

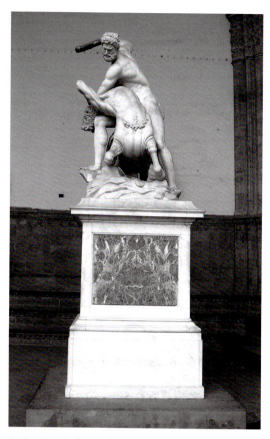

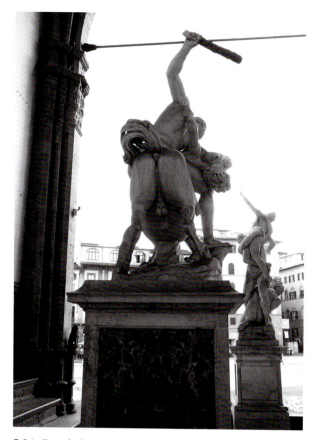

7.33. Giambologna, *Hercules and the Centaur*.
View from the front.

7.34. Giambologna, *Hercules and the Centaur*. View from
the back.

Misericordia."[59] Not only, that is, was Danti making a kind of *titulus*, identifying
the saint to whom the building was dedicated, he was also engaging the site oppo-
site, the home of the confraternity that tended to prisoners who were about to be
executed. What Ferdinando and Giambologna may really have imported to Flor-
ence from the Rome of Gregory XIII and especially Sixtus V was the recognition
that monuments could do this in coordination. Moving through the city, seeing
these monuments in succession, the memory of one would shape the experience
of the next.

The question for Giambologna's Centaur, then, was not just whether the com-
position resolved pleasingly when seen from various angles, but what it did to
those who came upon it from different sides. Those approaching from what is now
Via Tournabuoni (see fig. 7.18), an approach that Florentine processional patterns

had defined as the primary one, would have seen the breaking of the monstrous rebel. This was the statue's most theatrical display, and Giambologna made it into an extreme version of the inventive form that viewers of his marbles had admired from the beginning. His retrenchment in the hallmarks of his youthful manner looks like a willful stand against the new decorum imposed by the Council of Trent, and it is difficult to imagine that a sculpture of this sort, with colossal nudes and twisted poses that went beyond anything the artist had previously done, would have been possible in many Italian cities by 1595.[60] The art here, though, also had another edge to it as well, and its violence would have brought back memories of Florence's recent struggles, especially for those who had just passed by the Justice column, the Corsi portrait, and the Strozzi Palace.

Approaching the sculpture from Via Cerretani or Via de' Banchi, by contrast, would have been a different experience. The walls that had once met at the intersection were gone, but the Centaur now refortified the corner. It cannot have been indeliberate that Giambologna positioned the statue such that Hercules prevented the Centaur's movement toward the city center, literally turning it back (fig. 7.33). Nor it is conceivable that the statue could just as easily have been reversed, with the other side (fig. 7.34) facing the cathedral. Still, something in the militant use of sculpture here has changed. Charles Seymour once observed that the idea of placing prophets on the north tribunes of Florence Cathedral occurred to the Florentines during the city's war with Milan.[61] These were statues that faced in a particular direction. To place a statue in a key intersection, though, was to do something different. Ferrucci's porphyry *Justice* is oriented such that there is no place one can comfortably stand and see the statue from the front. And Giambologna's *Hercules*, similarly, does not exactly face anything at all. It is not surprising that it originates from a fountain designer, and if it is like any other monumental marble in Florence, it is arguably closest to Ammanati's *Neptune*, guarding its corner, guaranteeing the safety of the frolicking creatures that encircle it.

CONCLUSION

Florence and Europe

Giambologna differs from most artists active in early modern Italy in that his significance has been most visible from a distance. Nearly all of the major twentieth-century monographs on the sculptor were written in languages other than Italian by foreigners who presented his importance in international terms. Werner Gramberg, focusing on Giambologna's *Wanderjahre*, made him into a *Wanderkünstler*, an artist without a single defining base of operations. Elisabeth Dhanens, a specialist in Flemish art who also wrote major studies of the van Eycks, of Hugo van der Goes, and of Rogier van der Weyden, characterized Giambologna's work in a way that lent it a strongly northern European aspect: the principle that crystallized his artistic drive, she went so far as to write, was "to portray from nature and imitate the manner of no one." Realism, she thought, was in his blood.[1] Charles Avery gave us something of an English Giambologna when he opened the final chapter of his monograph with a full-page photo of the collector Sir Brinsley Ford.[2] Now it seemed less important that the artist came from Douai than that his works went back abroad (though Avery, too, compared Giambologna to Breugel). The single largest Giambologna exhibition ever mounted, the 1978 show in Vienna, took as its title "Giambologna: A Turning Point in European Sculpture"; it was not just the sculptor himself but his continental following that mattered.[3] The more recent catalog from the 2006 exhibition in Florence, in the same spirit, included chapters on "Giambologna in Germany," "Giambologna in England and America," and "Giambologna and France." Beatrice Paolozzi Strozzi's preface to

the volume, which she coedited with yet another foreigner, noted that it was the first exhibition *ever* devoted to Giambologna in Italy.[4]

To an extent, this historiography mirrors Giambologna's unusually international presence, with major works in many countries. It has the advantage, moreover, of casting light on the artist's workshop, which served as an entrepôt for artists coming from and eventually going to numerous other lands. It frames issues, finally, that a narrower perspective would fail to register: the present study, it, too, written by a foreigner, has itself attempted at points to sharpen distinctions by taking stock of what visitors made of Florentine sculpture and of what students, followers, collaborators, and mere lookers-on took away.

Still, just as this book's introduction resisted the notion that late sixteenth- and early seventeenth-century sculpture amounted primarily to a lesser or belated imitation of Michelangelo, so have its last chapters shown the trade-offs that come with a widened lens. Giambologna might seem to lend himself particularly well to the new global history of art, yet such a presumption can also orient us against approaches whose value has not yet been exhausted: symbolic anthropology, with its "thick description" of social behavior; new historicism, with its attention to conflict and the dynamics of power; microhistory and its individuation of semi-literate actors. At worst, the international frame works against the recognition of an immigrant simply as a member of the community in which he lived and worked, a betrayal not only of the political sympathies that motivated the international turn in the first place but also of the facts. Giambologna spent nearly his entire documentable career in one town, serving a single family of patrons. Compared to a near contemporary like Tetrode or to younger artists like Adriaen de Vries, he traveled rather little, and then for the most part only when representing his employer. Circumstantially, at least, there is every reason to regard him as a "Florentine" rather than as a "European" artist.

This, in turn, ties him into a different network of relationships, putting his own decisions and pursuits in a new light but also recalibrating our sense of the urban scene. Michelangelo, who did not set foot in Florence during the years this book concerns and who died before most of the works it considers were initiated, fades in importance, his art requiring a familiar nod but holding less explanatory force. Ammanati, a sculptor with little to no presence in textbooks or in the university classroom, comes to matter much more than expected. It was to Ammanati's ideas, goals, strategies, and calculations, we find, that Giambologna and others responded. Danti, similarly, looks less peculiar than he otherwise might. Once characterized as an epigone who imitated Michelangelo better than most, he now appears rather like a successor who recast Michelangelo's legacy in the shared terms of the day. From Danti's choice of materials and formats to his fascination

with the paradoxes of sculptural movement to his overall career path—even to his theoretical excursis on birds—he belongs to a late sixteenth-century world, not to the earlier moment of Michelangelo. If the twentieth-century historiography made Giambologna look like an alien, it rendered Danti an anachronism; both shared place and moment of Ammanati, however, thinking competitively but also collectively about Florence as their site.

Focusing on the local before the continental does not just change our cast of characters, it also expands our understanding of sculptural function. With few exceptions, patrons, not artists, initiated the major sculptural and architectural projects in this period, and the chief patrons in Florence were sovereigns. Commissions targeted a specific, relatively knowable audience. Occasionally, the Medici used sculpture to shape relationships with powerful figures in distant places, but far more often they concerned themselves with the response at home. When we emphasize portable objects over monuments, the ties we bring to life are ambassadorial, governed by protocols of exchange. An account of local, or localized, objects, by contrast, places weight not just on diplomacy but also on politics. Giambologna's sculptures traveled more than most of his predecessors' and more than did those of Ammanati, Danti, and his other rivals. The comments of ambassadors, moreover, provide a particularly rich written record documenting the ways in which those sculptures were viewed; we do not have such sources for all artists. Still, foreign audiences were not the only witnesses to the qualities and interests of a given piece, nor always the best ones.

T. J. Clark taught many in my generation to see the politics in pictures; historians of early modern Italian art, however, barely took this up.[5] One way of following his lead would have been to think of media in a more integrated way, turning to the city, attending in particular to the ways that the disempowered would have lived the transformations of the urban fabric. The present book's final chapters, which depend, perhaps belatedly, on Clark's example, have asked something slightly different: How is it that a set of shared ambitions led sculptors to become political actors? What incidental agendas—the erasure of Savonarola or the Strozzi, the colonization of once free cities—followed the path from the production of autonomous gallery sculptures to the installation of site-specific works? How did a patron's political goals enable artists who may well have had quite different aims, and what dividends did "narrowly" artistic goals pay for patrons?

Pursuing these questions has led me at once to ask what concerns were specific to sculptors and to work against the modernist idea that individual media pursue their own constitutive conditions and goals. As this book has shown, the preeminent sculptors of the late Renaissance aspired to be—and were recognized to be—architects as well. Not all Renaissance cities attracted the artists or provided

the opportunities that Florence did, and few generated comparably critical literary cultures around the arts. One might ask how different the answers to the questions this book has posed would look had it taken a different city as its subject; one might equally ask, however, whether other cities would even allow these questions. Still, the basic patterns the book has tracked are not limited to the half century it concerns or to a single place. Renaissance artists as a rule thought between architecture and the other arts. Indeed, the number of significant architects who did not come to that practice from another of the fields Vasari grouped under the rubric of "disegno" can be counted on one hand.

For all of that, few historians of early modern art have thought systematically about the relationship between figuration and architecture, or about the urban conditions of painting and sculpture. In part, this may reflect the limitations of the print publication, its restricted ability to let authors convey and readers grasp the nature of real spaces. In part, this may be an effect of the museum and its isolation of paintings and sculptures from the sites for which they were made. But the situation has only been exacerbated by the adoption of a global framework, with its emphasis on movement and on objects that became collectibles.

The artists this book concerns were working at the moment that the gallery was just beginning to take shape, the moment when it was just beginning to be possible for an artist to think of his or her paintings and sculptures as autonomous things. Not accidentally, it was also the moment when "Italian" art was becoming truly European, as the impact of travelers from abroad became unavoidable and as Italy's products began in numbers to find homes well beyond the peninsula's shores. It is a moment that suits our own, our identification of the modern with the cosmopolitan. Yet what we lose with our comparative, macroscopic gaze is the experience of a place.

PHOTO CREDITS

3.16 Photograph © Fitzwilliam Museum, University of Cambridge

3.17 Soprintendenza Speciale per il Patrimonio Storico, Artistico ed Etno-antropologico e per il Polo Museale della città di Firenze

3.18 Kunsthistorisches Institut, Florence

3.19 Foto Marburg / Art Resource, NY

4.1 Kunsthistorisches Institut, Florence

4.2 Kunsthistorisches Institut, Florence

4.3 Kunsthistorisches Institut, Florence

4.4 Photograph courtesy Beinecke Rare Book & Manuscript Library, Yale University

4.5 Soprintendenza Speciale per il Patrimonio Storico, Artistico ed Etno-antropologico e per il Polo Museale della città di Firenze

4.6 Nimatallah / Art resource

4.7 Alinari / Art Resource, NY

4.8 CED-Liège

4.9 © 2009 Kunsthistorisches Museum, Vienna

4.10 © 2009 Kunsthistorisches Museum, Vienna

4.11 Photograph courtesy of Huntington Library, Art Collections, and Botanical Gardens, San Marino, California

4.12 © 2009 Kunsthistorisches Museum, Vienna

4.13 Photo courtesy of the Ministero per i Beni Culturali della Repubblica Italiano / Biblioteca Nazionale Centrale di Firenze

4.14 Soprintendenza Speciale per il Patrimonio Storico, Artistico ed Etno-antropologico e per il Polo Museale della città di Firenze

4.15 Photo courtesy of the Ministero per i Beni Culturali della Repubblica Italiano / Biblioteca Nazionale Centrale di Firenze; further reproduction or duplication prohibited

4.16 Photo courtesy of the Ministero per i Beni Culturali della Repubblica Italiano / Biblioteca Nazionale Centrale di Firenze; further reproduction or duplication prohibited

4.17 Photograph by Donato Pineider. Permission to publish courtesy of the Biblioteca Riccardiana, Florence; further reproduction prohibited

4.18 Photograph by Donato Pineider. Permission to publish courtesy of the Biblioteca Riccardiana, Florence; further reproduction prohibited

4.19 Photo courtesy of the Ministero per i Beni Culturali della Repubblica Italiano / Biblioteca Nazionale Centrale di Firenze; further reproduction or duplication prohibited

5.1 Photograph by Donato Pineider. Permission to publish courtesy of the Biblioteca Riccardiana, Florence; further reproduction prohibited

5.2 Photograph @ 2010 Museum of Fine Arts, Boston

5.3 National Gallery of Scotland

5.4 Michael Cole

5.5 Photograph courtesy Patricia Wengraf

5.6 Ralph Lieberman photograph, courtesy of Special Collections, Fine Arts Library, Harvard College Library

5.7 Photo courtesy of the Ministero per i Beni Culturali della Repubblica Italiano / Biblioteca Nazionale Centrale di Firenze; further reproduction or duplication prohibited

5.8 Photo courtesy of the Ministero per i Beni Culturali della Repubblica

Italiano / Biblioteca Nazionale
Centrale di Firenze; further reproduc-
tion or duplication prohibited

5.9 Photo courtesy of the Ministero per
i Beni Culturali della Repubblica
Italiano / Biblioteca Nazionale Cen-
trale di Firenze; further reproduction
or duplication prohibited

5.10 Photo courtesy of the Ministero per
i Beni Culturali della Repubblica
Italiano / Biblioteca Nazionale Cen-
trale di Firenze; further reproduction
or duplication prohibited

5.11 Photo courtesy of the Ministero per
i Beni Culturali della Repubblica
Italiano / Biblioteca Nazionale Cen-
trale di Firenze; further reproduction
or duplication prohibited

5.12 Photo courtesy of the Ministero per
i Beni Culturali della Repubblica
Italiano / Biblioteca Nazionale Cen-
trale di Firenze; further reproduction
or duplication prohibited

5.13 The J. Paul Getty Museum, Los
Angeles, California

5.14 Anne and Jerome Fisher Fine Arts
Library, University of Pennsylvania

5.15 Michael Cole

5.16 © Copyright University of Oxford,
Ashmolean Museum

5.17 Photograph by Donato Pineider.
Permission to publish courtesy of the
Biblioteca Riccardiana, Florence

6.1 Archivio Fotografico Lucchese del
Comune di Lucca — Fondo Ettore
Cortopassi

6.2 Foto Marburg / Art Resource, NY

6.3 Ministero per i Beni e le Attività
Culturali / Soprintendenza Pisa

6.4 Alinari / Art Resource, NY

6.5 Michael Cole

6.6 Michael Cole

6.7 Michael Cole

6.8 Soprintendenza Speciale per il
Patrimonio Storico, Artistico ed Etno-
antropologico e per il Polo Museale
della città di Firenze

6.9 Soprintendenza Speciale per il
Patrimonio Storico, Artistico ed Etno-
antropologico e per il Polo Museale
della città di Firenze

6.10 Alinari / Art Resource, NY

6.11 Soprintendenza Speciale per il
Patrimonio Storico, Artistico ed Etno-
antropologico e per il Polo Museale
della città di Firenze

6.12 Soprintendenza Speciale per il
Patrimonio Storico, Artistico ed Etno-
antropologico e per il Polo Museale
della città di Firenze

6.13 Alinari / Art Resource, NY

6.14 Michael Cole

6.15 Alinari / Art Resource, NY

6.16 Ralph Lieberman photograph, cour-
tesy of Special Collections, Fine Arts
Library, Harvard College Library

6.17 Scala / Art Resource, NY

6.18 Soprintendenza Speciale per il
Patrimonio Storico, Artistico ed Etno-
antropologico e per il Polo Museale
della città di Firenze

6.19 Soprintendenza Speciale per il
Patrimonio Storico, Artistico ed Etno-
antropologico e per il Polo Museale
della città di Firenze

6.20 Soprintendenza Speciale per il
Patrimonio Storico, Artistico ed Etno-
antropologico e per il Polo Museale
della città di Firenze

6.21 Soprintendenza Speciale per il
Patrimonio Storico, Artistico ed Etno-
antropologico e per il Polo Museale
della città di Firenze

NOTES

I submitted the manuscript for this book in the fall of 2008. Although I have made some revisions in the interim, references to scholarship that appeared after that date may be incomplete.

INTRODUCTION

1. Paola Barocchi and Giovanna Gaeta Bertelà, eds. *Collezionismo mediceo Cosimo I, Francesco I e il Cardinale Ferdinando* (Modena: Franco Cosimo Panini, 1993), 181: "Egli è poi la migliore personcina che si possa trovar mai, non punto avaro, come dimostra l'esser egli poverissimo e in tutto e per tutto volto alla gloria, avendo una ambizione estrema d'arrivare Michelangelo et a molti giudiziosi par già che l'abbi arrivato e vivendo sii per avanzarlo e tale opinione ha il Gran Duca ancora."

2. For the history of the model, see the fundamental discussion in Eike D. Schmidt, "Die Überlieferung von Michelangelos verlorenem Samson-Modell," *Mitteilungen des Kunsthistorischen Institutes in Florenz* 40 (1996): 78–147.

3. Their passing left the twenty-one-year-old Francesco as Cosimo's oldest living male child, and it was with Francesco that Giambologna would cultivate his crucial relationship. My reading differs from that of Avery, who thought that the relief might date as early as 1560. See Charles Avery, *Giambologna: The Complete Sculpture* (Oxford: Phaidon, 1987), 178.

4. Tietze-Conrat discovered that the relief originally went under the title "Il parto di Cibele," or "Cybele's child." This would imply that the Medici figure is Jupiter, whom Cybele protected from Saturn. Elisabeth Dhanens hypothesized that the relief referred to a line of Medici lost to time (without specifying which Medici she had in mind), and described the central event thus: "Mercury, who unites within himself all understanding of all arts, leads the child of Cybele to his bride, while Cupid shoots an arrow at him." See Elisabeth

Dhanens, *Jean Boulogne / Giovanni Bologna Fiammingo: Douai 1529–Florence 1608. Bijdrage tot de studie van de kunstbetrekkingen tussen het graafschap Vlaanderen en Italie* (Brussels: Koninklijke Vlaamse Academie voor Wetenschappen, Letteren en Schone Kunsten van Belgie, 1956), 138.

5. Joachim Poeschke's extremely useful 1996 survey, *Michelangelo and His World: Sculpture of the Italian Renaissance* (New York: Abrams), includes Ammanati and Danti but not Giambologna. The editors of the Pelican History of Art series divided the art of sixteenth-century Italy—unlike that of France, Spain, or even seventeenth-century Italy—by medium, and the sculpture volume was the single one never to appear.

6. John Pope-Hennessy, *Italian High Renaissance and Baroque Sculpture* (Oxford: Phaidon, 1986), 46.

7. Ibid., 86.

8. Ibid., 49.

9. Ibid.

10. Ibid., 74.

11. Ibid., 61.

12. Ibid., 71.

13. Ibid., 64 ("The strain of journalism in his temperament caused him difficulty in the Cappella dei Principi") and 96 ("Tacca, had he curbed a journalistic tendency to overstatement, might have become a major portrait sculptor").

14. Ibid., 51 and 53. The idea of a Florentine "school of Michelangelo" dates at least as far back as Aurelio Gotti, who wrote in 1877 on the statues in the Palazzo Vecchio (including De' Rossi's Hercules series, Bandinelli's Adam and Eve, and Danti's *Honor and Deceit*): "Di quelle statue alcune veramente sono grandi opere di arte, come quelle che uscirono dalle mani di Michelangelo e di Giambologna, le altre che in verità sono in maggior numero, servono alla storia della scuola Michelangiolesca perché fatte appunto da scolari di Michelangelo e da artisti che pretesero tener dietro a quel Grande nella via da lui aperta e che egli solo però seppe correre senza cadere." See Detlef Heikamp, "Scultura e politica: Le statue della Sala Grande di Palazzo Vecchio," in *Le arti del principato mediceo* (Florence: Studio per Edizioni Scelte, 1980), 201–54, especially 227 and 242.

15. On the topic in general, see Martin Warnke, *Hofkünstler: Zur Vorgeschichte des modernen Künstlers* (Cologne: DuMont, 1996) and Stephen Campbell, *Artists at Court: Image-Making and Identity, 1300–1550* (Boston: Isabella Stewart Gardner Museum; distributed by University of Chicago Press, 2004).

16. Dhanens, *Jean Boulogne*, 356: "quando pur vedo parecchi miei servitori e scolari che, partiti da me, con quel che da me hanno appreso, et con li miei modelli, si sono fatti richissimi et honorati, et mi pare che di me si ridano, che per voler pure stare al servitio di S.A.S., ho rifiutato partiti larghisssimi si in Spagna con quel re, come in Germania con limperatore."

17. For Catherine de' Medici's failed attempts to employ Giambologna, see especially Malcolm Campbell and Gino Corti, "A Comment on Prince Francesco de'Medici's Refusal to Loan Giovanni Bologna to the Queen of France," *The Burlington Magazine* 115 (1973): 507–12.

18. Archivio di Stato Fiorentino, Archivio Mediceo del Principato, Relazioni con stati italiani ed esteri, filza 5080, fol. 1257v. See also below, chapter 1, note 45.

19. Filippo Baldinucci, *Notizie dei professori del disegno da Cimabue in qua: Per le quali si dimostra come, e per chi le belle arti di pittura, scultura e architettura, lasciata la rozzezza delle maniere greca e gotica, si siano in questi secoli ridotte all'antica loro perfezione / opera di Filippo Baldinucci* (Florence: SPES, 1974–75), II, 348: "qui accolto dalla benignità del duca Cosimo I, trovò egli le sue fortune, e spazioso campo eziandio in cui potesse fare mostra delle virtù sue."

20. I am thinking in particular of Michael Fried, *Art and Objecthood: Essays and Reviews* (Chicago: University of Chicago Press, 1998).

21. Paolo Barocchi, ed. *Trattati del arte del Cinquecento: Fra manierismo e controriforma* (Bari: Gius. Laterza and Figli, 1960), III, 121: "E pur sappiamo, che il più degli uomini, che ci fa operare, non dà invenzione alcuna; ma si rimette al nostro giudizio, diecendone: qui vorrei un giardino, una fonte, un vivaio, e simili."

22. See Dhanens, *Jean Boulogne*, 351: "Per ciò se V.A.S. si degnerà soggiugnere ad una mia breve lettera che li scrive, pur una delle sue sante parole, veggo colorito ogni suo e mio buon disegno." Also ibid., 368: "non vogliamo impedire al Francavilla i disegni et la fortuna sua."

23. Michael Cole, *Cellini and the Principles of Sculpture* (Cambridge: Cambridge University Press, 2002), 133–34.

24. See Hans-Ulrich Kessler, *Pietro Bernini (1562–1629)* (Munich: Hirmer. 2005), 427: "Diciendomi detto maestro Lionetto come le S. V. vanno continuando fare sculpire le statue delli sanctissimi apostoli e per che dette opere le più belle che sia possibile sieno le vanno dispensando â vari maestri dove intendo che eccellenti sieno opera cierto molto laudabile diligentia squisita donde ne nascie che resta servita meglio la venerabile chiesa. E si vede la varietà delle maniere il valore delli artefici e la emulatione e stimolo per chi viene dopo e così ognuno desideroso portarne la palma si inigegna superare gli altri. E così discorrendo noi qua di detto opera mi acciesi di desiderio attale impresa come che scorgo essere malagievole l'aquistarsi quella bona fama che dalli più si sole desiderare se non per mezzo delle opere degne come stimo essere ognuna di detti colossi."

25. See Rona Goffen, *Renaissance Rivals: Michelangelo, Leonardo, Raphael, Titian* (New Haven, CT: Yale University Press, 2002); Beth Holman, "For 'honor and profit': Benvenuto Cellini's Medal of Clement VII and His Competition with Giovanni Bernardi," *Renaissance Quarterly* 58 (2005): 512–75; and the excellent anthology edited by Hannah Baader, Ulrike Müller-Hofstede, Kristine Patz, and Nicola Suthor, *Im Agon der Künste: Paragonales Denken, ästhetische Praxis und die Diversität der Sinne* (Munich: Fink, 2007).

26. Dhanens, *Jean Boulogne*, 341: "harebbela tirata, secondo che dice, molto più innanzi, se non havessi tenuto glihuomini a lavorare sopra la figura a sedere che fece Vincentio Perugino, la quale è a bonissimo termine."

27. Ibid., 337: "havendosi a fare cavare il marmo a Seravezza per la fiorense del salone, ho pensato, quando piaccia a V. E. I., che si potrà dare questa cura a maestro Vincentio Perusino . . . et così io potrò avanzare spesa et molto tempo, quale meterò nela fine di questo ucelli."

28. Another example of this emerges in the documents relating to the Salviati Chapel, which reveal that Giambologna had the architect and antiquarian Giovanni Antonio Dosio acquire marbles for him in Rome. See Ewa Karwacka Codini and Milletta Sbrilli, eds., *Il quaderno della fabbrica della cappella di Sant'Antonino in San Marco a Firenze: Manoscritto sulla costruzione di un'opera del Giambologna* (Pisa: Scuola Normale Superiore di Pisa, 1996), 25, and chapter 6 below.

29. Dhanens, *Jean Boulogne*, 342: "Vi si scrisse già che voi facessi opera per via di cotesto capitano che si ritrovassi che havea guasto et dannificato le cave de' marmi et arnesi desse, et li delinquenti pagassino il danno conforme alla stima fattane, et anche si castigassero per giustizia per dare exemplo a gli altri, acciò non savezzino haversi poco rispetto alle cose di S. A. Ser. Hora ci vien detto che li rapresentanti il comune della Cappella hanno dato per dannatori Vincenzo de' Rossi, G. Bologna, maestro Raffaello Carli et altri ministri di dette cave."

30. For Ammanati's treatise, see Bartolomeo Ammannati, *La Città: Appunti per un Trattato*, ed. Mazzino Fossi (Rome: Officina Edizioni, 1970).

31. See Alina Payne's comments on Palladio in *The Architectural Treatise in the Italian Renaissance: Architectural Invention, Ornament, and Literary Culture* (New York: Cambridge University Press, 1999), 197, as well as her broader discussion of "architecture as sculpture"; also David Summers, "Michelangelo on Architecture," *Art Bulletin* 54 (1972): 146–57.

32. See Bruce Boucher, *The Sculpture of Jacopo Sansovino* (New Haven, CT: Yale University Press, 1991); Deborah Howard, *Jacopo Sansovino: Architecture and Patronage in Renaissance Venice* (New Haven, CT: Yale University Press, 1987); and Deborah Howard, "Alla ricerca del Sansovino architetto," in *Studi in onore di Renato Cevese*, ed. Guido Beltramini (Vicenza: Centro internazionale di studi di architettura Andrea Palladio, 2000): 313–29.

33. See the excellent discussion in Michael Kiene, *Bartolomeo Ammannati* (Milan: Electa, 2002), with further references.

34. See Francesco Bocchi and Giovanni Cinelli, *Le bellezze della città di Firenze dove a pieno di pittura, di scultura, di sacri templi, di palazzi, i più notabili artifizi, e più preziosi si contengono. Scritte già da M. Francesco Bocchi, ed ora da M. Giovanni Cinelli, ampliate, ed accresciute* (Bologna: Forni, 2004 [Facsimile of 1677 edition]), 409–10, and Dhanens, *Jean Boulogne*, 93.

35. See, most recently, Emanuela Ferretti, "La casa-studio di Giambologna in Borgo Pinti," in *Giambologna: Gli dei, gli eroi*, ed. Beatrice Paolozzi Strozzi and Dimitrios Zikos (Florence: Giunti, 2006), 315–20, and idem, "Giambologna architetto: Le esperienze architettoniche e la fortuna critica," ibid., 321–26, with the recent bibliography, as well as the discussion and documents in Dhanens, *Jean Boulogne*.

36. Dhanens, *Jean Boulogne*, 342.

37. See Bernd Evers, ed., *Architekturmodelle der Renaissance: Die Harmonie des Bauens von Alberti bis Michelangelo* (Munich: Prestel, 1995).

38. See, for example, the historiographical review in Charles Avery's "Ein halbes Jahrhundert Giambolognaforshung," in *Giambologna: Triumph des Körpers*, ed. Siepel, 234–47, which engages most of the exhibition catalogs published since 1985 but none of the major literature on the equestrian monuments, the *Sabine*, or the fountains.

39. See Peter Kinney, *The Early Sculpture of Bartolomeo Ammanati* (New York: Garland, 1976) and Kiene, *Bartolomeo Ammannati*.

40. Examples include Kinney, *The Early Sculpture of Bartolomeo Ammanati*, and Dimitrios Zikos, "Le belle forme della Maniera: La prassi e l'ideale nella scultura di Giambologna," in Paolozzi Strozzi and Zikos, eds., *Giambologna*, 20–43.

41. Dhanens, *Jean Boulogne*, 243–45: "Et ipsa omnia laboreria statuarum tabularum angelorum et aliorum predictorum facere de illa pulchriori qualitate aeris coloris aurei et illiusmet qualitatis cujus est statua aenea raptus mulieri Sabine quam dictus D. Joannis trasmissit Sereniss. Duci Parme et Placentie et omnia quidem expolita et diligenter quam fieri possunt et in ipsis adhibere omnem ejus scientiam artem curam studium et diligentiam et ea facere finire et perficere intra annos quinque proxime venturos."

42. See ibid., 141 and 239.

43. The description of Danti's marble is Beatrice Paolozzi Strozzi's. See Paolozzi Strozzi, "Il percorso di Vincenzo Danti. Qualche appunto preliminare," in Charles Davis and Beatrice Paolozzi Strozzi, eds., *I grandi bronzi del battistero: L'arte di Vincenzo Danti, discepolo di Michelangelo* (Florence: Giunti, 2008), 17–23, at 20.

CHAPTER 1

1. Even Michelangelo, the iconic solitary artist, oversaw a team of assistants when making his most famous Florentine works; see especially William Wallace, *Michelangelo at San Lorenzo: The Genius as Entrepreneur* (Cambridge: Cambridge University Press, 1994). Two spurs for much of the literature on this topic were Jennifer Montagu's classic essay, "Bernini Sculptures Not by Bernini," in *Gianlorenzo Bernini: New Aspects of His Art and Thought*, ed. Irving Lavin (University Park: Penn State University Press, 1985), 25–61; and the still earlier anthology edited by John Paoletti and Wendy Stedman Sheard, *Collaboration in Italian Renaissance Art* (New Haven, CT: Yale University Press, 1978).

2. It might be added that with a number of late sixteenth-century sculptures, even major ones, these attributions themselves remain a matter of debate. See, for example, Louis A. Waldman's comments in "The Recent Vincenzo Danti Exhibition in Florence," *The Burlington Magazine* 1267 (2008): 680–86. A wax *Neptune* in the Victoria and Albert Museum has shifted in attribution between Ammanati and Giambologna, a marble *Leda* in the same collection between Danti, Ammanati, and Battista Lorenzi.

3. See the description of the palace in Bocchi and Cinelli, *Le Bellezze*, 410, as well as Baldinucci's remarks in the *Notizie* at II, 568, 572, and 573. For Tacca, see especially Katherine Watson, *Pietro Tacca: Successor to Giovanni Bologna* (New York: Garland, 1983); and Franca Falletti, ed., *Pietro Tacca: Carrara, la Toscana, le grandi corti europee* (Florence: Mandragora, 2007).

4. In his "Capitolo contro l'Alchimia del q[ua]le ogni terzo verso è del Petrarca," Danti writes, "Più Legne, e piu Carbon' io arsi in vano, / che in Etna non ne tien' cotanti accesi / l'antichissima Fabro Siciliano (more wood and more coals did I burn in vain than

that most ancient Sicilian smith fired in Aetna).” See David Summers, *The Sculpture of Vincenzo Danti: A Study in the Influence of Michelangelo and the Ideals of the Maniera* (New York: Garland, 1979), 505–12, for the poem, and the discussion in Michael Cole, “Under the Sign of Vulcan: The Early Modern Bronze between Peace and War,” in *Bronze: The Power of Life and Death*, ed. Martina Droth (Leeds: Henry Moore Institute, 2005), 36–52.

5. For discussion of the relief, see especially Frits Scholten, *Adriaen de Vries: Imperial Sculptor* (Los Angeles: Getty Museum, 1998), 187–89, and Frits Scholten, “Bronze, The Mythology of a Metal,” in Droth, ed., *Bronze*, 20–35.

6. See the discussion in David Rosand, *Drawing Acts: Studies in Graphic Expression and Representation* (Cambridge: Cambridge University Press, 2001).

7. The standard study of Renaissance sculptors’ models remains Johannes Myssok, *Bildhauerische Konzeption und plastisches Modell in der Renaissance* (Münster: Rhema, 1999), though that largely concerns an earlier period than the one treated here.

8. Baldinucci, *Notizie*, II, 354: fecene un piccolo modello di cera, secondo quel che credeva di potersi cavar la staua di quel marmo stato tanto assottigliato, e con esso fece anche un legno, che a proporzione mostrava la lunghezze, larghezza, grossezza e lo sbieco dell’istello marmo, e l’uno e l’altro mandò a Roma a mostrare al Buonarroti, acciochè piacendoli, l’aiutasse appresso al duca, siccome seguì; il perchè fece il duca serrare un arco della medesima loggia di piazza, e ordinò all’Ammannato il far della sua figura un modello grande quanto doveva esser l’opera.

9. Avery, *Giambologna*, 274–77, catalogs some thirty-three Giambologna models he considers autograph. The most persuasive attempt to attribute two models to Ammanati is Myssok, *Bildhauerische Konzeption*, 264–67.

10. On the appearance of these *mensole*, see Charles Avery, “Pietro Francavilla’s Drawings of Giambologna’s Models,” *Apollo* 152 (September 2000): 22–26.

11. See the letter of 24 July 1568, cited in Dhanens, *Jean Boulogne*, 338: “Io hebbi il cavallo del Fiamingo et poi un altro minore et li fo gittar di bronzo per mio humore.”

12. Raffaello Borghini, *Il riposo* (Florence: Marescotti, 1584 [Facsimile Hildesheim: Olms, 1969]), 14: “La prima stanza è tutta intorniata di modelli di Giambologna, e di statue d’altri maestri, e di pitture, e di disegni.” See also Baldinucci, *Notizie*, V, 122, as well as the discussion in Walter Holzhausen, “Die Bronzen der Kurfüstlich sachsischen Kunstkammer zu Dresden,” *Jahrbuch der Königlich-Preußischen Kunstsammlungen* 54 (1933): 45–88, at 46–47, and Dhanens, *Jean Boulogne*, 54.

13. Baldinucci, *Notizie*, II, 337.

14. Ibid., 346: se n’andò a Roma, dove di gran proposito attese a fare studi dall’antiche architetture; onde potè poi, come diremo, con suo modello condurre molte maravigliose fabbriche.”

15. On Danti in Rome, see Alessandro Nova, “La statua di Giulio III a Perugia: Stile, committenza e politica,” in Davis and Paolozzi Strozzi, eds., *I grandi bronzi del battistero*, 61–75, as well as the discussion in Summers, *The Sculpture of Vincenzo Danti*.

16. See especially the discussion in Nicole Dacos and B. W. Meijer, eds., *Fiamminghi a Roma: 1508–1608. Artistes des Pays-Bas et de la principaute de Liège à Rome à la Renaissance* (Brussels: Société des Expositions du Palais des Beaux-Arts, 1995).

17. Borghini, *Il riposo*, 585: "disideroso di veder le cose d'Italia si trasferi à Roma, doue stette due anni."

18. Scorel seems to have found a patron in Pope Adrian VI, and Heemskerck appears to have carried out significant paintings while in Italy, but they are the exceptions rather than the rule. See A. L. de Meyere, *Jan van Scorel, 1495–1562: Schilder voor Prinsen en Prelaten* (Utrecht: Centraal Museum, 1981); Ilja M. Veldman, "Maarten van Heemskerck en Italie," in *Nederland—Italie: Relaties in de beeldende kunst van de Nederlanden en Italie*, ed. Jan de Jong (Zwolle: Waanders Uitgevers, 1993); and Ilja M. Velman, "Maarten van Heemskerck und die römische Kunst," in *Kunst und Kultur im Rom der Päpste*, ed. Petra Kruse (Ostfildern-Ruit: Hatje, 1998), 417–20.

19. See especially Walter S. Melion, "Hendrick Goltzius's Project of Reproductive Engraving," *Art History* 13 (1990): 458–87; and Walter S. Melion, *Shaping the Netherlandish Canon: Karel van Mander's "Schilder-boeck"* (Chicago: University of Chicago Press, 1991).

20. Olga Kotková, *The National Gallery in Prague: Netherlandish Painting, 1480–1600, Illustrated Summary Catalogue* (Prague: National Gallery in Prague, 1999), 45, with further references.

21. I owe thanks to Matt Kaveler for helpful discussion of this point.

22. Borghini, *Il riposo*, 585: "disideroso di veder le cose d'Italia si trasferì à Roma, doue sette due anni, e quiui fece grandissimo studio, ritraendo di terra, e di cera tutte le figure lodate, che vi sono." A May 1556 report places Giambologna in the city, where he was sending some busts to Paolo Giordano Orsini. Zikos, "Le belle forme della Maniera," 23, speculated that these busts were by Giambologna. More likely, though, is that Giambologna was simply acting as an agent, brokering a deal. For now, in any case, the letter is the best indication we have of which "two years" Giambologna was in Rome. The text is in Michael Brunner, "Die Kunstförderung der Orsini di Bracciano in Rom und Latium (1550–1650)," in *Die Kreise der Nepoten*, ed. Daniel Büchtel (Bern: Peter Lang, 2001), 179–202.

23. Baldinucci, *Notizie*, II, 556 (emphasis mine): "Partitosi dunque da Dovai, se ne venne a Roma, dove in due anni ch'e' vi dimorò, modellò quanto di bello gli potè mai venir sotto l'occhio."

24. See Frits Scholten, *Willem van Tetrode, Sculptor (c. 1525–1580)—Guglielmo Fiammingo scultore* (Zwolle: Waanders, 2003), especially 117–28.

25. Borghini, *Il riposo*, 585, writes that Vecchietti, seeing the studies (*studi*) Giambologna had made in Rome, "e conoscendo che egli era per riuscire valenthuomo, il consigliò à non tornarsene così tosto alla patria; ma fermarsi in Firenze, e studiare ancora qualche anno." The introduction to Michelagnolo Sermartelli's *Alcune composizioni di diversi autori in lode del ritratto della Sabina, scolpito in marmo dall'Eccellentissimo M. Giovanni da Bologna* (Florence: Sermartelli, 1583), remarks that "mediante la liberalità di S. A. S. ha per lo spazio di circa XXX anni, che è stato qui fermo potuto studiare, & apprendere." Given the notice of Giambologna's presence in Rome in 1556, we should probably place emphasis on the "circa"; still, the comment may suggest that 1556 was the end, rather than the beginning, of his two-year stay there, and that he arrived in Florence shortly thereafter. For Vecchietti's patronage of Giambolonga, see especially Michael Bury, "Bernardo Vecchietti: Patron of Giambologna." *I Tatti studies* 1 (1985): 13–56; and Francesca Carrara, "Il magnifico

Bernardo Vecchietti, cortigiano e committente in un inedito epistolario privato," in Paolozzi Strozzi and Zikos, eds., *Giambologna*, 302–14.

26. Borghini's description of Vecchietti's villa notes that the room adjacent to the one "lined with models by Giambologna" contained a forge. Suzanne Butters has plausibly suggested that the artist may have experimented there. See Borghini, *Il riposo*, 14; and Suzanne B. Butters, *The Triumph of Vulcan: Sculptor's Tools, Porphyry, and the Prince in Ducal Florence* (Florence: Olschki, 1996), I, 282.

27. Avery, *Giambologna: The Complete Sculpture*, 270, asserts of the *Allegory* now in the Prado that "This relief, Giambologna's earliest," was "in a material he was familiar with from his Flemish training." Avery was the first to attribute another early work to Giambologna as well, a limewood Julius Caesar now in a private collection; subsequent scholars have largely avoided discussing the figure. If it is what Avery believes, it reinforces the impression both of Giambologna's early activities in Rome—it apparently reproduces a model made after a statue in the Mattei collection—and of his early preference for softer materials. There are reasons for doubt, nevertheless, chief among them the medium, which has no comparison in Giambologna's ouevre. It is unlikely that scholars would even have connected the object with Giambologna were it not for an inscription on the base, but the base does not quite match the work, and the inscription itself, among other curious features, includes the date 1549, one well before Giambologna's arrival in Italy. See Charles Avery's entry in Charles Avery and Anthony Radcliffe, eds., *Giambologna 1529–1608: Sculptor to the Medici* (London: Arts Council of Great Britain, 1978), 216, which appears to mistranscribe the date on the base (rendering it MDLI), perhaps to make the attribution more plausible.

28. See especially Dhanens, *Jean Boulogne*, 103–4. It is conceivable that Borghini meant to describe the alabaster *Allegory*, a much-copied work clearly made with Francesco as its intended audience that otherwise goes unmentioned in Borghini's text. Anyone could have inferred that the nude woman with Cupid flying above was Venus, and Borghini might well have misremembered the material of the relief, which had left Florence years earlier. This would mean that the episode took place not before the 1559 Neptune fountain competition, as Borghini suggests, but several years after. For other suggestions, see Avery, *Giambologna: The Complete Sculpture*, 97.

29. Borghini, *Il riposo*, II, 353: "dovessero fare un modello, ed a quelli che meglio operato avesse si dovesse dare quest'occasione."

30. Baldinucci, *Notizie*, II, 557.

31. Dhanens, *Jean Boulogne*, 329, cites the relevant text from the letter.

32. For the career of Francavilla, see Robert de Francqueville, *Pierre de Francqueville, sculpteur des Médicis et du roi Henri IV (1548–1615)* (Paris: Picard, 1968); for his collaboration with Giambologna in Genoa in particular, Stella Seitun, "Giambologna e Pietro Francavilla a Genova," in *Genova e l'Europa atlantica: Opere, artisti, committenti, collezionisti*, ed. Piero Boccardo and Clario Di Fabio (Milan: Silvana Editoriale, 2006), 133–51.

33. Cited in Dhanens, *Jean Boulogne*, 355: "Ne Donatello, nè quei della Robbia, tanto famosi scultori, sono men chiari per non saper cuocere senza i fornaciai l'opere loro; a

Giambologna, per non dir di tutt'altri, si toglie adunque il pregio della eccellenza, poichè non egli, ma un frate di S. Marco getta tutte le sue figure e bassirilievi?"

34. Werner Gramberg, *Giovanni Bologna: Eine Untersuchung über die Werke seiner Wanderjahre (bis 1567)* (Libau: Meyer, 1936), ix: "In seiner Werkstatt und Giesshütte drängt sich noch nicht jene unübersehbare Schar der Schüler 'von diesseits und jenseits der Alpen,' deren epigonenkunst das eigenhändige Werk des Meisters so sehr überrankt hat, dass der Name 'Bologna' heute nur zu oft Sammelbegriff für die Produktion einer ganzen Werkstattgemeinschaft geworden ist."

35. Benedetto Varchi, *Due lezzioni di M. Benedetto Varchi, nella prima delle quali si dichiara un sonetto d. M. Michelagnolo Buonarotti, nella seconda si disputa quale sia più nobile arte la scultura, o la pittura, con una lettera d'esso Michelagnolo* (Florence: Torrentino, 1549).

36. For most of the twentieth century, scholars unanimously regarded a terra-cotta *Honor and Deceit* in the Bargello as a preliminary study for Danti's marble. Responding to a spur from Carlo del Bravo, however, Claudio Pizzorusso's entry in the catalog to the 2008 Danti exhibition convincingly disattributed the work. Though opinion remains divided about its authorship, no one who saw the sculptures that the exhibition assembled can continue believing it is by Danti. This removes from the artist's oeuvre the single object that would have testified to his skills as a modeler, though as Francesco Federico Mancini reminds us in the same catalog, we can hardly doubt the skills themselves.

37. Baldinucci, *Notizie*, II, 556: "soleva poi in vecchiaia raccontare a' suoi famigliare, che avendo un giorno fatto un modello di propria invenzione, il quale aveva finito, come noi usiamo di dire, coll'alito, l'andò a mostrare al gran Michelagnolo; il quale presolo inmano, tutto glie lo guastò, secondo però quello che parve a lui, attitudinandolo di nuovo, e risolvendolo con meraviliosa bravura tutto al contrario di quello che il giovanetto aveva fatto, e sì gli disse: or va prima ad imparare a bozzare e poi a finire."

38. Borghini, *Il riposo*, 108: "onde Batista, che hauea già accomodata la sua figura per darle luogo in su quel canto, doue hoggi si vede, non potendo metterla nel mezo, bisognò che la sua statua, che per la scultura hauea fatto insino all'hora, tramutasse nella pittura, e questo fece con farle quei contrasegni, che à piedi sele veggono; ne volle leuarle il modello della mano, del che hebber ragione, per non dare disgratia alla sua figura, la quel hauea già quasi fornita in quell'attitudine." (Thus Battista, who had already composed his figure with the idea of placing it on the corner where it is now seen—not being able to put it in the center of the tomb—had to transform his statue, which had depicted sculpture, into an image of painting. He did this by making those attributes that you see at the figure's feet, though he did not want to remove the model from its hand, and in this he was right, for he did not want to remove the grace from his figure, having already established its pose.)

39. Giovan Battista Aremenini, *De' Veri Precetti della Pittura*, ed. Marina Gorreri (Turin: Einaudi, 1988), 118: "Ma chi è che ancora non sapia che di una o di due figure di tondo rilievo, solamente col voltarle, nel modo che sono per diverse vie, non se ne cavino molte in pittura e tutte tra sé diverse? Poiché ciò pure si vede, da chi punto considera nel Giudizio dipinto da Michelangelo, lui essersi servito nel termine ch'io dico. Né ci sono mancati c'hanno detto quivi, ch'egli n'aveva alcune fatte di cera di man sua e che li torcea le

membra a modo suo, immollandole prima le giunture nell'acqua calda, acciò quelle a rimorbidir si venisse."

40. See Charles De Tolnay *Michelangelo: The Tomb of Julius II* (Princeton, NJ: Princeton University Press, 1954), III, 155–56.

41. John Pope-Hennessy, *Catalogue of Italian Sculpture in the Victoria and Albert Museum* (London: Her Majestry's Stationery Office, 1964), II, 422, and Johannes Myssok, *Bildhauerische Konzeption*, 260–87 and 354–55, provide the strongest case for Michelangelo's authorship; De Tolnay, *Michelangelo*, IV, 157, the most direct argument against, though Jean-René Gaborit, *Michel-Ange: les esclaves* (Paris: Réunion des Musées Nationaux, 2004), 43, demonstrates that the question remains open. See also the discussion in Peta Evelyn [Motture], "'Broken and Repaired': Michelangelo's Wax Slave in the Victoria and Albert Museum," *The Burlington Magazine* 138 (1996): 809–12. I myself originally agreed with Pope-Hennessy, and I published the work as an autograph Michelangelo in an earlier article, though I have come to take the opposite view.

42. See Friedrich Kriegbaum, "Zur Florentiner Plastik des Cinquecento: Michelangelo und die Antike; der Bildhauer Giovanni Bologna," in *Münchner Jahrbuch der bildenden Kunst 3–4* (1953), 10–66.

43. The most important recent contribution to the discussion is an essay by Volker Krahn, who notably cast doubt on the authorship of a wax *Florence and Pisa* in the Victoria and Albert Museum, a model long used as a touchstone for making sense of Giambologna's design process. The elongation of the standing figure in particular, Krahn maintained, bears no comparison to anything else in the artist's "figurative typology," and the face of the lower figure is too highly finished for the work to have been a true sketch model. Rather than a study for the marble, Krahn argued, the wax must be a "pseudo-bozzetto executed by an epigone, who used Giambologna's examples for study purposes." Comparison with an autograph wax like Cellini's for the *Perseus*, nevertheless, shows that such designs could be more attenuated than the marbles and bronzes that followed and could have highly finished faces. Krahn's stylistic analysis is acute, though this only raises new questions about the object's origins and purpose. The wax *Florence* is not really a copy after a finished Giambologna statue. Nor is Krahn's idea of the "pseudo-bozzetto," with its connotations of the spurious and the counterfeit, particularly helpful, since there is no evidence that anyone ever tried to pass off the sculpture for anything other than what it is.

Surviving drawings by Pietro Francavilla show that Giambologna at least permitted and probably encouraged followers to draw after his models, studying these alongside or in lieu of his finished works. If the wax is after rather than by Giambologna, this would suggest that the compositional training the sculptor's shop provided consisted not only of copying but also of rehearsing the method by which Giambologna had generated his models in the first place. The maker of the wax, in the scenario, ignored the proportions and contours of the original, devoting his energies instead to a replication of the process by which the poses came about, folding the extensions of the body back against themselves. The modeler turned the torso gently in the opposite direction of the head; he assured that her arm, too long at the top, nevertheless operated fully in every joint; and he pulled her right leg

up even more severely than Giambologna had in his marble. Similarly, the modeler forced the man's head even closer to the ground; removing the woman's leg from his back made it easier to observe the contortions to which he has been subjected.

For Krahn's important, eye-opening argument, see "I bozzetti del Giambologna," in Paolozzi Strozzi and Zikos, eds., *Giambologna*, 44–61. On the Francavilla drawings, see Avery, "Pietro Francavilla's Drawings." See also Gramberg, *Giovanni Bologna*, 84, who already recognized the problems with this piece, but who accounted for its lack of integration by suggesting that its artist (Giambologna, he believed) had conceived the two figures independently, not yet concerning himself with the problem of uniting them.

44. Dhanens, *Jean Boulogne*, 152.
45. See Matteo Inghiarmi's 11 August 1569 letter to Francesco, in Giovanni Gaye, *Carteggio inedito d'artisti dei secoli XIV, XV, XVI* (Florence: Giuseppe Molini, 1839–40), III, 227; and the discussion in Gramberg, *Giovanni Bologna*, 87. Bertha Harris Wiles, *The Fountains of Florentine Sculptors and Their Followers from Donatello to Bernini* (Cambridge, MA: Harvard University Press. 1933), 64–66, located the basin in the garden of Aranguez.
46. Abel Desjardins, *La vie et l'oeuvre de Jean Bologne: D'après les manuscrits inédits recueillis par M. Foucques de Vagnonville* (Paris: A. Quantin, 1883), Wiles, *Fountains of the Florentine Sculptures*, and Gramberg, *Giovanni Bologna* had all identified the monkeys in the Giardino de' Cavalieri at the top of the Boboli gardens as coming from this fountain, though Pope-Hennessy, *Catalogue of Italian Sculpture*, and Dhanens, *Jean Boulogne,* more plausibly suggest that the only surviving Giambologna monkey is the one now in the Victoria and Albert Museum.
47. Archivio di Stato Fiorentino, Archivio Mediceo del Principato, Relazioni con stati italiani ed esteri, filza 5080, fol. 1257v (document discovered by the participants in the Medici Archive Project): "et quanto ad'un'altra fonte per il Giardino del sudetto Signor Duca, che il suo Architetto ui ha detto, che hauesse ordinato di farne comprare una simile, se si fusse potuta trouare, noi habbiamo ardire di dirui, che senza dubbio non se ne trouerà una come quella fatta per mano del Cau. Gio. Bologna, che è hoggi il migliore scultore che sia nel Mondo, et però l'abbiamo fatto chiamare, et ci ha detto che è pronto à fare un'altra statua della medesima misura, et belleza di quella, in un'anno, ma uorrebbe ben mutare inuentione per non parere d'hauere imitata quella, et rappresenterà nella statua quello che costà gusterà più al S. Duca." Giambologna never made the new statue, but in 1611, Ferdinando II de' Medici sent the original to the Duke of Lerma as a diplomatic gift. The Duke of Buckingham acquired it in Spain twelve years later, and by the second quarter of the seventeenth century, it was in England, where it remains today. See Gramberg, *Giovanni Bologna*, 85.
48. See the document published by Gramberg, *Giovanni Bologna*, 110, dated 6 November 1566: "Addi affar Debitor il palazzodi fiorenza e creditor giambologna fiammingho scultor che sono la stima fatta per due figure insieme fatta per pisa di terra messi nel salone grande dipinto per ornamento di essa."
49. Francavilla completed the *Florence and Pisa* after his arrival in Florence in 1572; see Dhanens, *Jean Boulogne*, 150, and Detlef Heikamp, Letter to the editor, *The Burlington Magazine* 115 (1973): 42–40.

50. Baldinucci, *Notizie*, II, 337–38: "[Ammanati] fece il sepolcro di marmo, che doveva esser osto nella chiesa della Santissima Nunziata per Mario Nari romano, che combattè con Francesco Mufi. Aveva egli figurata la Vittoria, che sotto di sè teneva un prigione, e ancora aveva scolpito due fanciulli, e la statua di esso Mario sopra la cassa, ma fra 'l non sapersi di certo da qual parte fosse stata la vittoria, e 'l poco servizio che il povero Ammannato ricevè dal Bandinello, quell'opera non si scoperse mai, onde essendone poi state levate le statue, fu quella della vittoria collocata in una delle testate nel secondo cortile di quel convento, dalla parte della chiesa, presso alla cappella degli accademici del disegno."

51. Werner Gramberg aptly described the difference from Michelangelo's composition in this way: "Während also der Michelangelo-Sieger den fast freiwillig seinem Schicksal sich ergebenden Unterjochten in den Wirbel seiner aufsteigenden Bewegung mitreisst, fristet der Gefangene der Fiorenza sein zerbrochenes Dasein unter der freien Bewegung der Frau." See Gramberg, *Giovanni Bologna*, 83

52. Cited in Dhanens, *Jean Boulogne*, 148: "Ein Weib vil mehr dan lebensgros uff einem man, der wunderbarlich zusammengeboen knieht oder steht, bede nakhend, von Jan de Balone ganz künstlich gemacht."

53. Malcolm Campbell, "Observations on Ammannati's *Neptune Fountain*: 1565 and 1575," in *Renaissance Studies in Honor of Craig Hugh Smyth*, ed. Andrew Morrough et al. (Florence: Giunti Barbèra, 1985), vol. 2, 113–36, especially 123.

54. The diarist Agostino Lapini reports that the stuccos "erano tutte come sono al presente," suggesting that the bronzes derived from the same models. See Agostino Lapini, *Diario fiorentino di Agostino Lapini: Dal 252 al 1596, ora per la prima volta pubblicato da Giuseppe Odoardo Corazzini* (Florence: G. C. Sansoni, 1900), 128, as well as Campbell, "Observations," n. 14.

55. Borghini. *Il riposo*. 82: "Ma perche di questo ne ha scritto largamente Giouanandrea Gilio da Fabriano in quel suo dialogo degli errori de' pittori sopra il Giudicio di Michelagnolo, voglio che mi basti l'hauerne detto questo poco per mostrare quanto longano dal vero habbia dipinto il Puntormo, il quale come sapete, ha fatto vn gran monte di corpacci, sporca cosa à vedere, doue alcuni mostrano di risuscitare, altri sono risuscitati, & alri morti in dishonesti attitudini si giacciano; e di sopra ha fatto alcuni bambocci con gesti molti sforzati, che suonano le trombe, e credo che egli voglia, che si conoscano per Agnoli."

56. Ibid., 117: "Ma quando pur fosse conceduto che la concettione si hauesse a dipignere, credo che molte consideratione bisognerebbe hauere, che in cotesta tauola non veggo: e non so perche Adamo, & Eua habbiano à fare si sforzate, e poco honeste attitudini, e non piu tosto stare in atto humile, e modesto dimostrando ò speranza d'hauere à esser liberati dalle catene del peccato per la Concettione, ò vero rendendo gratie alla Genitrice del sommo bene."

57. Ibid., 179–80: "Ma passando all'attitudini dico, che quelle deon essere in tutto conformi all'historia, & alla persona, che dimostrano; perciò che dipignendosi historie sacre si deon fare l'attitudini de' Patriarchi, de' Profeti, de' Santi, de' Martiri, del Saluador del mondo, della Reina de' Cieli, e degli Agnoli graui, modeste, e diuote, non fiere, e non isforzate; ma quelle de' Tiranni, e de' ministri loro sarà molto conueneuole far le fiere, e crudeli; ma non dishoneste, e lasciue, per non iscemare la diuotione, che s'ha nel rimirare i Santi che

à quelli sono appresso. Quando si dipingono guerre, e contese all'hora si può scherzare con attitudini sforzate, gagliarde, e terribili, si come figurando cose amorose fa di mestiero far l'attitudini molli, dilicate, e gratiose."

58. Ibid., 202–3: "Il Christo in forma d'Ortolano apparito alla Maddalena del Bronzino, soggiunse il Sirigatto, è lauorato con molta diliganza, e con bellissimi colori. Digratia non dite piu, replictosto il Michelozzo, che l'attitudini son tanto sforzate, e senza diuotione, che ogn'altra cosa, che mi lodaste da quelle rimarebbe oscurata."

59. Ibid., 199–200: "La Resurretione del nostro Signore, che quiui appresso si vede, seguito il Sirigatto, è pur del Vasari fatta con bella dispositione, e buoni color, e particolarmente assai mi piace quell'Agnolo, che fra lo splendore apparisce con molta gratia. Mi piace tutto quel che voi dite, rispose il Michelozzo, ma l'attitudine del Christo mi pare alquanto sforzata, e Santo Andrea, e San Damiano secondo che si dice à rispetto del piano, doue posano i due Santi, che sono innanzi, non sembrano ne dritti, ne inginocchioni, perche essendo dritti su quel piano sarebbono corti di gambe, & essendo ginocchioni apparirebbono troppo alti."

60. Ibid., 202: "Poichi noi siamo spediti di Santa Maria Nouella, disse il Vecchietto, possiamo andarcene in ogni Santi. Io no vo mai in cotesta Chiesa, replicò il Michelozzo, ch'io non perda il gusto della pittura; perche vi è vna tauola di Carlo da Loro, che può seruire per esempio, in cui si veggano tutte le parti di quella dette da noi mal osseruate; percioche oltre all'hauer mal disposte tutte le figure ha messo innanzi vna gran feminaccia ignuda, che mostra tutte le parti di dietro, & occupa piu di meza la tauola, e poi le ha fatto sopra la Madonna, che pare se le posi sopra le spalle, l'altre figure fanno attitudini sforzate, e disconueneuoli, e sono di membra mal composte, e senza disegno alcuno." The painting is no longer to be seen on the altar, having been removed by a seventeenth-century sacristan who found the work equally distasteful.

<p style="text-align:center">CHAPTER 2</p>

1. Giorgio Vasari, *Le vite de' piu eccellenti pittori, scultori ed architettori*, ed. Gaetano Milanesi (Florence: Sansoni, 1880), VII, 631: "fece un modello di cera bellissimo, magior del vivo, d'un Ercole che fa scoppiare Anteo, per farne una figura di bronzo da dovere essere posta sopra la fonte principale del giardino di Castello, villa del detto signor duca; ma fatta la fora addosso al detto modello, nel volere gettarla in bronzo, non venne fatta ancoraché due volte si rimettessi, o per mala fortuna o perché il metallo fusse abbruciato, o altra cagione." The reading of the evidence in Summers, *The Sculpture of Vincenzo Danti*, 64–67 remains persuasive, despite the recent skepticism expressed in Claudio Pizzorusso, "Indagine su uno scultore al di sopra di ogni sospetto," in Davis and Paolozzi Strozzi, eds., *I grandi bronzi del battistero*, 149–63.

2. Mazzino Fossi (Ammannati, *La città*, 21–22, n. 18) makes the case for Ammanati's ownership (rather than authorship) of the manuscript. Folio 183 has two studies for the courtyard Ammanati designed in the early 1560s for the Pitti Palace.

3. When, in 1585, Ammanati submitted a proposal for the transportation of the Vatican obelisk in Rome, the judges agreed unanimously that the commission should go to him, "as the person with the most experience in such works." In the event, the pope overruled the committee and awarded the project to Domenico Fontana, his house architect. See Cesare D'Onofrio, *Gli obelischi di Roma: Storia e urbanistica di una città dall'età antica al XX secolo* (Rome: Romana Società Ed., 1992), 152.

4. On the dating of this material, see Fossi's introductory discussion in Ammannati, *La città*, especially 22–24. Riccardiana 120, fol. 85r, includes one of several strong clues: "Hanno giudicato che i baluardi delle cittadelle siano anplj e larghje di muraglia prosisima e gagliarda; anzi, per il modo delle batterie d'oggi giorno 1559, si faccino di sorta che muraglia nessuna non resista, e perche alle cittadelle non u'e spatio di ritirata, bisogna farle fortisime e che le habino a difendere da ogni batteria."

5. Fols. 55v and 59v indicate that Ammanati had learned about ballistics in part by studying the writings of Nicolò Fontana (called "Tartaglia") and Giambattista Belluzzi (called "Sanmarino"), both of whom were interested in technology more generally. In his introduction to Ammannati, *La città*, 20, Fossi speculates plausibly that Ammanati also knew the writings of Francesco di Giorgio.

6. Riccardiana 120 includes, for example, "un parere, secondo me, che faccia utile ai fiumi" (53r) and a disputation regarding the use of wells (57v).

7. See Detlef Heikamp's entry in Luchinat et al., *Magnificenza alla corte dei Medici*, 28.

8. Borghini, *Il Riposo*, 594. On the aqueducts installed for the fountain, see Detlef Heikamp, "La fontana del Nettuno in Piazza della Signoria e le sue acque," in *Bartolomeo Ammannati: Scultore e architetto, 1511–1592*, ed. Niccolò Rosselli del Turco (Florence: Alinea, 1995), 19–30.

9. Baldinucci, *Notizie*, II, 352, on Ponte Santa Trinita: "fece gli archi di figura ovata, acciocchè anco ne' fianchi de' medesimi fosse l'apertura capacissima e del tutto vôta; e con tale bellissima invenzione non solamente fece apparire in quella fabbrica una leggiadria e sveltezza incoparabile, ma eziandio un'invincibile robustezza."

10. Francesco Federico Mancini, "Vincenzo Perugino," in Davis and Paolozzi Strozzi, eds., *I grandi bronzi del battistero*, 37–59, at 51.

11. Marco Campigli, "'Anima e forza' nella scultura di Vincenzo Danti: La decollazione del battista per il Battistero," in Davis and Paolozzi Strozzi, eds., *I grandi bronzi del battistero*, 205–19.

12. On this initial project, see Birgit Laschke, "Un ritratto di Giovanni Bologna e la Fontana di Oceano nel Giardino di Boboli," in *Giambologna tra Firenze e l'Europa*, ed. Sabine Eiche (Florence: Centro Di, 2000), 65–86, especially 72. His ultimate composition appropriated an idea Ammanati had earlier discarded, including personified rivers below his main figure (see fig. 2.5).

13. See Herbert Keutner, *Giambologna: Il Mercurio volante e altre opere giovanili* (Florence: SPES, 1984), 139. Zikos, "Le belle forme della Maniera," proposes a significantly later dating, with no new evidence.

14. Several scholars, beginning with Kriegbaum, have also compared the lowered head and outstretched arm of the *Bacchus* to the pose of Cellini's *Perseus*. Dhanens, *Jean Boulogne*, 99,

puts this comparison particularly well: "Ongetwijfeld roept het beeld de herinnering op aan Cellini's Perseus (in 1554 onhuld), zowel naar het anatomisch canon als naar de komposite, in omgekeerde richting." The point is especially relevant since, at least as late as 1560, Vincenzo de' Rossi still considered Cellini the most competent bronzist in Florence. See Gaye, *Carteggio*, III, 24: "se lopera avesi a esere di bronzo, parlerei di Benvenuto," also the discussion in Francesco Vossilla, "Storia d'una fontana: Il Bacco del Giambologna in Borgo San Jacopo," *Mitteilungen des Kunsthistorischen Institutes in Florenz* 38 (1994): 130–46.

15. The chronology of the Neptune fountain is carefully reconstructed in Gramberg, *Giovanni Bologna*, 15–43, though the real authority on both the work and the site was Tuttle. See Richard J. Tuttle, "La fontana del Nettuno," in *La Piazza Maggiore di Bologna: Storia, arte, costume*, ed. Giancarlo Roversi (Bologna: Aniballi, 1984), 143–97; idem, "Bononia Resurgens: A Medallic History by Pier Donato Cesi," in *Italian Medals*, ed. John Graham Pollard (Washington, DC: National Gallery of Art, 1987), 215–46; idem, *Piazza Maggiore: Studi su Bologna nel Cinquecento* (Venice: Marsilio, 2001); and idem, "Giambologna e il mecenatismo di Pier Donato Cesi a Bologna (1563–1567)," in Paolozzi Strozzi and Zikos, eds., *Giambologna*, 327–31, all with references to his other studies.

16. Gramberg, *Giovanni Bologna*, 96.

17. Ibid., 104: "i quali mi disano con chi io avevo quistione, chi m'era nimico. Risposi non avere quistione, nemici. Mi disiano chi era mio compagnio: risposi m.o Janni fiamingo, e cosi ordinorono si mandasi per lui, e cosi venuto, dise, che aueua sodisfato a una opera dove lui era mio compagnio, e che io lo voleuo ritenere contro a lauoglia del S. Principe, la quale mostrai non essere vero. e mostrai la conuentione fatta fra monsinore di Narni e noi: quel che Vostre S. mi feciano copiare: e così vedutta, fui lizenziatto dal Magistratto de gli Otto; e lui non (so) che cosa che lui volesi per che uoleua quelo che non era di ragone, e qua si fa iustizia con ragione a tutti i magistrati, che cosi è la uoglia del S. Duca e del S. Principe, quale Dio salui e mantenga." See also the letter published by I. B. Supino, "Una lettera inedita di Giovanni Bologna," *Rivista d'arte* 1 (1903): 140. Gramberg, *Giovanni Bologna*, 23, reads Portigiani's "che io lo voleo ritenere contro a la uoglia del S. Principe" to indicate that Francesco's summoning of the artists back to Florence was the cause for the fight, though the earlier inferences of Abel Désjardins, *La vie et l'oeuvre de Jean Bologne: D'après les manuscrits inédits recueillis par M. Foucques de Vagnonville* (Paris: A. Quantin, 1883) and Patrizio Patrizi, *Il Giambologna* (Milan: Cogliati, 1905), 74–75—that the fight was the cause of Giambologna's departure—may be correct.

18. Richard Tuttle, "I contratti per la fontana del Nettuno," in *Il Nettuno del Giambologna: Storia e restauro*, ed. Giulio Bizzarri et al. (Milan: Electa, 1989), 44, puts it this way: "Giambologna sembra aver tracciato una distinzione tra il proprio ruolo di scultore creativo e quello del Portigiani di fonditore esecutivo."

19. See Cardinal Crassi's report to the duke from May 1565, in Sabine Eiche, "Giambologna's Neptune Fountain in Bologna: Newly Discovered Letters from 1565," *Mitteilungen des Kunsthistorischen Institutes in Florenz* 38 (1994): 428–29: "Il Fiammingo, come scrissi pochi giorni sono à V. Ecc.a, partì di quì senza farmi motto, et se ne venne à Fiorenza."

20. Gramberg, *Giovanni Bologna*, 102.

21. Cole, *Cellini*, 47.

22. Tuttle, "Giambologna e il mecenatismo di Pier Donato Cesi," 329.

23. Domenico Mellini's description of the entry of Giovanni of Austria on 16 December 1565 refers to Giambologna as "eccellentissimo nella scultura & nel gettar di bronzo maraviglioso," indicating that he already had an established reputation as a caster before he cast the Bologna *Neptune*. See Dhanens, *Jean Boulogne*, 132.

24. See the letter published by Campbell and Corti, "A Comment," 512.

25. The one major exception was the bronze crucifix that was to mark the center of the chapel; this Giambologna assigned to Antonio Susini, the artist chiefly responsible for the execution of the small bronzes the Giambologna workshop continued to turn out in the same period.

26. Hans Weihrauch, *Europäische Bronzestatuetten: 15.-18. Jahrhundert* (Braunschweig: Klinkhardt and Biermann, 1967), 177: "Die beträchtliche Zahl von Bronzereduktionen nach der Antike und nach den Hauptwerken Michelangelos verdeckt etwas die Tatsache, daß die Bronzestatuette als selbständiges Kunstwerk, die doch in Florenz entstanden ist, in eben dieser Stadt für fast ein halbes Jahrhundert aus dem Programm der Bildhauer verschwindet."

27. A wax figure in the Louvre, showing a seated woman, makes just this point: remarkably, the figure was gilded. It plays the part of a bronze, such that we can no longer properly call it a "model" at all. Charles Avery, the only scholar to have given the work close attention, suggests that a member of Giambologna's studio had made the work as a loose reproduction of the master's *Architecture*. See Avery, *Giambologna: The Complete Sculpture*, 104.

28. In the early 1560s, for example, Cellini claimed to have said to Duchess Eleanora "that the world, and all of Italy, knew very well that I was a good goldsmith, but that Italy had not yet seen works of sculpture from my hand. And among the artists, certain angry sculptors, laughing at me, called me 'the new sculptor.' I hope to show them that I am an 'old sculptor,' if God grants me the grace of allowing me to exhibit, finished, my *Perseus*." The line resonates with Vasari's report that it seemed strange to Bandinelli "how Cellini had gone so quickly from being a goldsmith to being a sculptor; nor could he understand how Cellini, who was accustomed to making medals and small figures, could now make colossi and giants." See *Opere di Benvenuto Cellini*, ed. Giuseppe Guido Ferrero (Turin: UTET, 1980), 501, and the discussions in Angela Biancofiore, *Benvenuto Cellini artiste-écrivain: L'homme à l'oeuvre* (Paris: L'Harmattan, 1998), 128, and Michael Cole, "Universality, Professionalism, and the Workshop: Cellini in Florence, 1545–62," in *Benvenuto Cellini 1500–1571: Sculptor, Goldsmith, and Writer*, ed. Margaret Gallucci and Paolo Rossi (New York: Cambridge University Press, 2004), 115–47, as well as Vasari, *Le vite*, VI, 183.

29. Dhanens, *Jean Boulogne*, 344: "Nel getto egli non s'è molto esercitato, havendola per cosa assai facile, non di meno mi ha fatte vedere una statuetta di bronzo che fece à concorrenza di molti altri nello studiolo del Gran Duca, la quale è tenuta molto bella."

30. For Bandini's late career, see especially Charles Avery, "Giovanni Bandini (1540–1599) Reconsidered," in *La scultura: Studi in onore di Andrew S. Ciechanowiecki*, ed. Gianna Marini (Turin: Allemandi, 1994), 16–27.

31. Borghini, *Il Riposo*: "alcuni termini d'oro fati a concorrenza da Benvenuto Cellini, da Bartòlommeo Ammanati, da Giambologna, Da Vincentio Danti, da Lorenzo della Nera, e da Vincentio de' Rossi."

32. Dhanens, *Jean Boulogne*, 186, documents this beginning in the mid-1570s.

33. Among the earlier figures in the format of Giambologna were those in his Hercules series, discussed in chapter 4 below. For these he turned to Giorgio d'Antonio Rancetti and Michele Mazzafirri, and Rancetti was certainly capable of making bronzes as well; it was he who, on 9 April 1575, was paid for cleaning Giambologna's *Apollo* for Francesco's studiolo. See Ettore Allegri and Alessandro Cecchi, *Palazzo Vecchio e i Medici: Guida storica* (Florence: SPES, 1980), 347.

34. For this and the following, see especially Marco Collareta, "L'historien et la technique: Sur le rôle de l'orfèvrerie dans les Vite de Vasari," in *Histoire de l'histoire de l'art*, ed. Édouard Pommier (Paris: Klincksieck, 1995), 163–76.

35. See the document published by H. W. Frey in *Neue Briefe von Giorgio Vasari* (Burg-sur-le-Main: 1940), 209. The *Bacchus* is now in the Metropolitan Museum of Art in New York. Among the few substantial discussions of Poggini as a sculptor is Eike D. Schmidt, "Die Signatur und Datierung von Domenico Pogginis 'Lex antiqua,'" *Mitteilungen des Kunsthistorischen Institutes in Florenz* 41 (1997 [1998]): 206–11.

36. In a letter of 18 July 1564, Giambologna wrote to Francesco that he had had to stop working on the two figurines commissioned from him because the wax, which he had chosen on account of its suitability for casting, did not handle as expected. "I ask," he added, "che si degni di havermi per iscusato acetando la prontezza dell animo mio, et imputando il difetto di esse all' arte et non alla naturale inclinatione mia di servirla, e tanto più che simile materie son più tosto opere da orefici che da scultori o da un mio pari che ho già avvezze le mani a figure più grandi." See Dhanens, *Jean Boulogne*, 330.

37. Probably referring to the "duoi Termini" that Vecchietti delivered to Francesco on July 26, Giambologna wrote "et quando particularmente in questo negocio occorrerà altro circa il gittare et rinettarli, non si mancherà del debito con ogni prontezza et diligentia a compimento dell'opra . . . e se in questo mentre che sta in Bologna a finire quell'opra, V. E. si degnerà farli favore di comandarli altre cose, massime modelli et operette adatte, haverà tempo a servirla presto, et lo farà volentieri. Dicemi ancora che se V. E. I. volesse un orefice, che li in Bologna vi è residente un Fiamingo, che è stato in Italia 10 o 12 anni, persona da bene, valente ed conosciuta, che volentieri verrebbe a servirla, et dice che pensa sene satisfarìa." Francesco replied on July 29: "I duoi termini che ha fatto Gian Bologna, si son visti et ci satisfanno a pieno; se ci occorerà che faccia altro intorno aciò, ve lo faremo intendere, et parimente dello orefice che egli offerisce, aggradendo noi la diligentia vostra, così nel invierle ben conditionate, come nell'haver le sollecitate più volte." See ibid., 331.

38. Barocchi and Bertelà, eds., *Collezionismo mediceo*, 181: "modelli di cera o di terra, che si fan presto, di sua mano, darà nel medesimo tempo a far le forme, il getto et a ripulirle poi agli orefici che tiene apposta per Sua Altezza, per la quale ha fatto ultimamente le XII forze di

Ercole." Fortuna was probably referring to Giorgio d'Antonio Rancetti and Michele Mazzafirri, both of whom he understood to be Giambologna's employees.

39. Collareta, "L'historien et la technique." Collareta has expanded on aspects of this topic in several other essays, most recently "Vincenzo Danti e l'oreficeria," in Davis and Paolozzi Strozzi, eds., *I grandi bronzi del battistero*, 77–85. His arguments also influenced a number of the other authors of that volume, in which the topic of "finish" and the importance of Danti's training as a goldsmith become leitmotifs.

40. Cf. Zikos, "Limina incerta: Filosofia e tecnica del 'non finito' nell'opera di Vincenzo Danti," in Davis and Paolozzi Strozzi, eds., *I grandi bronzi del battistero*, 272–97.

41. Eugène Plon, *Benvenuto Cellini, orfévre, medailleur, sculpteur: Recherches sur sa vie, sur son oeuvre et sur les pièces qui lui sont attribuées* (Paris: Plon, 1883), 236.

42. Dhanens, *Jean Boulogne*, 344: "Le quali se non saranno di quella perfetzione che merita la grandezza, et cortesia dell'Ecc. mo Animo suo, saranno non di meno, quali ha saputo condurli il debile saper mio, condito certo di maggiore studio nel farle et di piu diligenza che ho saputo (massime nel rinettarle) accio che (come spesso adviene) se nulla di buono vi fosse stato, il rinettatore non l'havesse poi, o stravolto o con la lima portato via." Zikos, "Le belle forme della Maniera," 39, comments: "Rileggendo la lettera inviata dallo scultore a Ottavio Farnese, si potrebbe anche concludere che Giambologna non avesse mai cesellato personalmente i suoi bronzi, poiché non avrebbe avuto bisogno altrimenti di esprimere la speranza che il rinettatore non avesse gustato le linee della composizione. Anche alcuni casi documentati sembrano del resto testimoniare in questo senso; infatti, non solo la fusione veniva eseguita al di fuori della bottega di Giovanni, ma anche la cesellatura." ("Rereading the letter sent by the sculptor to Ottavio Farnese, one could also conclude that Giambologna had never personally chased his bronzes, since he would not otherwise have needed to express his hope that the chaser not ruin the lines of his composition.") This directly contradicts the inference of Charles Avery, "Adriaen de Vries and Giambologna: The Model Becomes the Statue," *Sculpture Journal* 6 (2001): 30–35, who interpolates the key passage to read (p. 31): "they have been made with the greatest concentration and diligence that I know how to apply (especially in [personally] cleaning up the cast)."

43. Avery, "Adriaen de Vries and Giambologna," 31, by contrast, uses the passage to support the view that Giambologna "clearly experienced a tension between the freshness of a modelled piece of sculpture and the sometimes frozen inertness of a meticulously finished one."

44. See Bocchi, in Paola Barrocchi, ed., *Trattati del arte del Cinquecento: Fra manierismo e controriforma* (Bari: Gius. Laterza and Figli, 1960): "Nessuna cosa è meno al nostro appetite sodisfacci, come la troppa diligenza et i troppo isquisiti ornamenti."

45. Borghini, *Il Riposo*, 273, makes much the same point, remarking on how Apelles criticized Protogenes "che egli non sapea mai leuare la mano della pittura, volendo dimostrare che la souerchia diligenza nuoce il piu delle volte."

46. Dhanens, *Jean Boulogne*, dated it to ca. 1565; James Holderbaum, *The Sculptor Giovanni Bologna* (New York: Garland. 1983); Keutner, *Giambologna: Il Mercurio volante*; and Anthony Radcliffe, "Giambologna's 'Venus' for Giangiorgio Cesarini: A Recantation," in *La scultura* (Turin: Allemandi, 1994–96), 60–72 placed it still earlier. See also Karla Langedijk, "Ein

unbekanntes Dokument zu Giambologna: Die badende Venus in Wien," *Mitteilungen des Kunsthistorischen Institutes in Florenz* 39 (1995 [1996]): 426–27.

47. The earliest plausible reference to the figure, a 1588 inventory of the Villa Medici in Rome, mentions a "Venere fuori del bagno"; a Florentine inventory from the following year, by contrast, refers more generically to a "figura di bronzo chinata." See Zikos's entry in Paolozzi Strozzi and Zikos, eds., *Giambologna*, 199.

48. On the work's peregrinations, see ibid., 136.

49. See Claudia Kryza-Gersch's (2006) helpful entry in Wilfried Seipel, ed., *Giambologna: Triumph des Körpers* (Milan: Skira, 2006), 281–83.

50. Cited by Davide Gasparotto, "Cavalli e cavalieri: Il monumento equestre da Giambologna a Foggini," in Paolozzi Strozzi and Zikos, eds., *Giambologna,* 88–105, at 93: "Si doleva Giovanni Bologna, che havendolo Iddio creato a far con la scoltura colossi, e machine grandi, il Gran Duca Francesco per occorrenze, che così portavano, del continuo l'avesse adoperato in far uccellini, pesciolini, ramarri, et altri animali minuti; della qual noia l'ha liberato il Gran duca Ferdinando occupandolo in far la nobilissima statua equestre del nobilissimo principe Gran Duca Cosimo padre suo."

51. Zikos, "Le belle forme della Maniera," 39: "Anche se continuerà a fornire modelli per piccole sculture al suo principale mecenate, è chiaro, come testimonia anche l'Ammirato in un passo spesso citato, che non sono queste le sue priorità."

52. The entry on the relief in Davis and Paolozzi Strozzi, eds., *I grandi bronzi del battistero,* 360–61, includes a technical report from the National Gallery on the frame.

53. See, most recently, ibid., 137–47, with references to the earlier literature.

54. Summers, *The Sculpture of Vincenzo Danti,* 364.

55. Borghini, *Il Riposo,* 43: "la seconda prouano per la comodità, mostrando la pittura potersi fare in libri, in tele, in cuoi, & in altre cose facilissime à portare, e da poter comodamente mandarle per tutto il mondo, si come si vede tuttogiorno auuenire de ritratti de Principi, e di donne belle, e de' paesi de' pittori di Fiandra, laqualcosa non adiuiene, e non può adiuenire à gli scultori."

56. See *The Moment of Caravaggio,* forthcoming from Princeton University Press.

57. See the letter of 27 October 1580 in Barocchi and Bertelà, eds., *Collezionismo mediceo,* 180–82: "le statue piccolo di marmo non compariscono, sono pericolose di rompersi, non che altro dal portarsi e trasmutarsi da luogo a luogo e da ogni minimo disastro e accidente e non può l'uomo assicurarsi di far capricci fuori dell'ordinario, come egli ha fantasia, acciò le cose sue siano differenti dagli altri e vogliono grandissimo tempo."

58. Dhanens, *Jean Boulogne,* 343–44: "che possono inferire il rapto d'Elena e forse di Proserina [sic] o, d'una delle Sabine: eletto per dar campo alla sagezza et studio dell'arte." See the discussion in Fabio Burrini and Loretta Dolcini, "Un bronzetto del Giambologna del museo di Capodimonte," *OPD restauro* 6 (1994): 81–87.

59. These "others" included artists: Massimiliano Soldani Benzi, for example, placed a severed head in the hand of his version of the Giambologna figure that usually goes under the name "Mars"; Adriaen de Vries attached a male voyeur to a recumbent female that Giambologna seems to have invented previously as an independent work; and another

seventeenth-century artist, perhaps Pietro Tacca, added a lion to a variant on the rearing horse that Giambologna may first have modeled when designing his late equestrian monuments. See Sybille Ebert-Schifferer, "Giambolognas 'Venus und Satyr': Ein erotisches Staatsgeschenk aus Italien," *Dresdener Kunstblätter* 48 (2004): 232–36; idem, "Schlafende Venus und Satyr," in *Giambologna in Dresden: Die Geschenke der Medici* (Munich: Deutscher Kunstverlag, 2006), 18–25; and idem, "Giambolognas 'Venus und Satyr' in Dresden: Ein durchdachtes Geschenk für einen Florenz-Bewunderer," in *Docta Manus: Studien zur italienischen Skulptur für Joachim Poeschke*, ed. Johannes Myssok (Münster: Rhema-Verlag, 2007), 301–12; as well as Charles Avery, "Giambologna's Horses: Questions and Hypothesis," in *Giambologna tra Firenze e l'Europa: Atti del convegno internazionale,* ed. Sabine Eiche et al. (Florence: Centro Di, 2000), 11–28; and Charles Avery, *Jean Bologne: La Belle endormie* (Paris: Galérie Gerald Piltzer, 2000).

60. Giovanni Andrea Gilio da Fabriano, *Due Dialogi* (Florence: SPES, 1986), 69v.

CHAPTER 3

1. Leon Battista Alberti, *On Painting and on Sculpture: The Latin Texts of De pictura and De statua*, ed. with trans., intro., and notes by Cecil Grayson (London: Phaidon, 1972), 1.

2. Pomponius Gauricus, *De sculptura (1504)*, ed. André Chastel and Robert Klein (Geneva: Droz, 1969), 51.

3. *Physics* 2.7 (199a15–19). Cf. Thomas DaCosta Kaufmann, *Court, Cloister, and City: The Art and Culture of Central Europe, 1450–1800* (London: Weidenfeld and Nicolson, 1995), 176–77.

4. Since the publication of Marcello Fagiolo's important 1979 anthology *Natura e artificio: L'ordine rustico, le fontane, gli automi nella cultura del Manierismo europeo* (Rome: Officina), the literature on this topic has grown too large to survey here. Touchstones, though, include Oliver Impey and Arthur MacGregor, *The Origins of Museums: The Cabinet of Curiosities in Sixteenth- and Seventeenth-Century Europe* (Oxford: Clarendon Press, 1985) and Giuseppe Olmi, *L'inventario del mondo: Catalogazione della natura e luoghi del sapere nella prima età moderna* (Bologna: Il Mulino.1992).

5. See the slightly inconsistent accounts in Vasari, *Le vite*, I, 119 and VI, 186, as well as the discussion in Virginia Bush, *Colossal Sculpture of the Cinquecento* (New York: Garland, 1976), 144.

6. For the relevant documents, see Dhanens, *Jean Boulogne*, 167–73. Tribolo quarried the granite in 1550; it arrived in Florence in 1567, and in that year Giambologna prepared a model for the figures. Cosimo's engineers (among them, presumably, Ammanati), completed the hydraulics in 1576, allowing the fountain to be installed in the space that is now the amphitheater behind the palace. It was moved to its current location in 1618.

7. Baldinucci, *Notizie*, II, 557: "Io ho fatto cavar questo sasso, come tu vedi, per fare una bella fonte per lo giardino; sia dunque tuo pensiero il fare essa fonte in modo, che la tazza faccia onore a te, e l'opere tue alla tazza."

8. Paolo Barocchi, ed. *Trattati del arte del Cinquecento: Fra manierismo e controriforma*, 3 vols. (Bari: Gius. Laterza and Figli, 1960), III, 118: "e prima, per dar grazia ad una statua di marmo, quant'arte e giudizio ci voglia, acciò che i grandi e fini marmi, che con gran fatica, tempo e spesa non picciola si son cavati e condotti, per poca pratica e mancamento d'arte non si guastino e non si storpino; et appresso, come si debba svolgere dolcemente una figura, acciò che i non paia di molti pezzi e mal divisata, come putroppo spesso adiviene a chi non è da qualche maestro fedelmente avvertito e corretto."

9. The different versions of the story are collected in Paola Barocchi, *La vita di Michelangelo: Nelle redazioni del 1550 e del 1568* (Milan: Ricciardi, 1962), I, 34, and II, 395.

10. Borghini, *Il riposo*, 72.

11. Dhanens, *Jean Boulogne*, 236.

12. Borghini, *Il riposo*, 72: "punto dallo sprone della virtù, si dispose di mostrare al mondo, che egli non solo sapea fare le statue di marmo ordinarie, ma etiandio molte insieme, e le piu difficili, che far si potessero, e doue tutta l'arte in far figure ignude (dimostrando la mancheuole vecchiezza, la robusta giouentù, e la delicatezza feminile) si conoscesse; e così finse, solo per mostrar l'eccellenza dell'arte, e senza proporsi alcuna historia, vn giouane fiero, che bellissima fanciulla à debil vecchio rapisse." Major recent studies that comment both on the statue and on Borghini's text include Margaret D. Carroll, "The Erotics of Absolutism: Rubens and the Mystification of Sexual Violence," *Representations* 25 (1989): 3–30; Geraldine A. Johnson, "Idol or Ideal? The Power and Potency of Female Public Sculpture," in *Picturing Women in Renaissance and Baroque Italy*, ed. Geraldine A. Johnson and Sara F. Matthews Grieco (New York: Cambridge University Press, 1997), 222–45; Diane Wolfthal, *Images of Rape: The "Heroic" Tradition and Its Alternatives* (New York: Cambridge University Press, 1999); and Gerald Schröder, "Versteinernder Blick und entflammte Begierde: Giambolognas 'Raub der Sabinerin' im Spannungsfeld poetisch reflektierter Wirkungsästhetik und narrativer Semantik," *Marburger Jahrbuch für Kunstwissenschaft* 31 (2004): 175–203.

13. Neither of the views represented by the woodcut illustrations in Sermartelli's book of poetry are possible in situ, since one is blocked by a pier and the other by a wall.

14. See Joseph Leo Koerner, *Caspar David Friedrich and the Subject of Landscape* (London: Reaktion Books, 1990) and Michael Fried's equally relevant discussion in *Courbet's Realism* (Chicago: University of Chicago Press, 1990).

15. Sermartelli, *Alcune composizioni*, 19.

16. Ibid., 4.

17. See the discussion in John Shearman, *Only Connect . . . Art and the Spectator in the Italian Renaissance* (Princeton, NJ: Princeton University Press, 1992), 44–58.

18. Sermartelli, *Alcune composizioni*, 10.

19. Ibid., 21.

20. See, for example, the version of Bernardo Davanzati's poem in ibid., 7.

21. Ibid., 13.

22. Ibid., 23–35.

23. For the sculpture *ex uno lapide*, V. B. Mockler, "Colossal Sculpture of the Cinquecento from Michelangelo to Giovanni Bologna," unpublished PhD dissertation, Columbia University,

1967; Irving Lavin, "The Sculptor's 'Last Will and Testament,'" *Allen Memorial Art Museum Bulletin* 35 (1977): 4–39; Heikamp, "La fontana del Nettuno"; and Irving Lavin, "*Ex Uno Lapide*: The Renaissance Sculptor's *Tour de Force*," in *Il cortile delle statue. Der Statuenhof des Belvedere im Vatikan*, ed. Matthias Winner et al. (Mainz: Philipp von Zabern, 1998), 191–210.

24. Borghini, *Il riposo*, 75: "E' finta adunque la fanciulla rapita per la detta Sabina, & il Rapitore rappresenta Talassio, il quale se bene non la rapì in publico egli istesso, la rapitono i suoi per lui, & egli la rapì in priuato togliendole la verginità, & il vecchio sottoposto dimostra il padre di lei, dicendo, come ho detto, la historia, che le rubarono di braccio a' padri."

25. Ibid., 72: "& hauendo condotta quasi à fine questa opera marauigliosa, fù veduta dal Serenissimo Francesco Medici Gran Duca nostro, & ammirata la sua bellezza, deliberò che in questo luogo, doue hor si vede, si collocasse."

26. Sermartelli, *Alcune composizioni*, 23–40.

27. For the history of the quarry, see Emanuele Repetti, "L'escavazione del marmo a Seravezza," in *Toscana granducale*, ed. Ludovica Sebregondi (Rome: Editalia-Edizioni d'Italia, 1996), 232–35.

28. Bernini's *Pluto and Proserpina* was commissioned by Scipione Borghese, who subsequently offered it as a gift to Ludovico Ludovisi. It was transferred from the Villa Ludovisi back to the Villa Borghese only in 1908. See Matthias Winner's discussion in Anna Coliva and Sebastian Schütze, eds., *Bernini scultore: La nascita del barocco in Casa Borghese* (Rome: De Luca, 1998), 180–203, with further references.

29. Louis Waldman, *Baccio Bandinelli and Art at the Medici Court: A Corpus of Early Modern Sources* (Philadelphia: American Philosophical Society, 2004), 67. See also the receipt Waldman transcribes in his document 137.

30. Dhanens, *Jean Boulogne*, 338–39.

31. Kessler, *Pietro Bernini*, 422: "A Donno Pietro antonio di Napoli di Marano ducati sessanta. et per lui a mastro Pietro Bernino statuario fiorentino habitante in Napoli disse se li pagano per caparro et in parte di ducati duecento venti per fattura di due statue di marmo gentile di Carrara, una di Santo Pietro apostolo con chiavi et libro in mano et l'altra di Santo Paolo apostolo con spada et libro: quali saranno di palmi 7 d'altezza e 2 1/2 di larghezza, tutte tonde con li debiti pannamenti ben transforate et lavorate dove se richiede a dette Statue et anco siano ben transforate et staccate mani et braccia et tutte le statue bene impomiciate et renettate et fatte di tutta perfettione."

32. Borghini, *Il riposo*, 473, and for Pontormo's letter, Paola Barocchi, ed., *Scritti del Arte del Cinquecento* (Milan and Naples: Riccardo Ricciardi, 1973), I, 504.

33. Karl Frey, *Sammlung ausgewählter Briefe an Michelangelo Buonarroti* (Berlin: Karl Siegismund, 1899), 381: "col nome di Dio cominciai a lauorare sul marmo del Nettuno, doue sento piu la pasione d'auere a leuare poco marmo, che non mi da fatica a leuarne asai." Cited in Bush, *Colossal Sculpture*, 148.

34. Compare Baldinucci's comments (themselves a topos) on Giambologna's *Appenine*, *Notizie*, II, 566: "E questi un gran gigante in atto di sedere . . . e basti il dire, che se quest'afigura fosse in piedi, alzerebbe cinquanta braccia."

35. Vasari, *Le vite*, VI, 126.

36. Anticipating these interests to a certain extent were the Quattrocento "spiritelli" that, as Charles Dempsey and Ulrich Pfisterer have demonstrated, gave form to intangibles like the intoxicating powers of wine or the movements of fear. See Charles Dempsey, *Inventing the Renaissance Putto* (Chapel Hill: University of North Carolina Press, 2001) and Ulrich Pfisterer, *Donatello und die Entdeckung der Stile, 1430–1445* (Munich: Hirmer, 2002).

37. Baldinucci, *Notizie*, II, 559.

38. Keutner, "Note intorno all'Appennino del Giambologna," in *L'Appennino del Giambologna: Anatomia e identità del gigante*, ed. Alessandro Vezzosi (Florence: Alinea, 1990), 18–27. See also Dhanens, *Jean Boulogne*, 228, who suggests that the London river god was actually a *bozzetto* (sketch-model) for the *Appenine*.

39. On the changing iconography of the mountain over time, see Eike D. Schmidt, "Symbol und Kulisse: Bergdarstellungen in der Kunst des Mittelalters und der Renaissance," in *Der Berg*, ed. Hans Gercke (Heidelberg: Kehrer, 2002), 42–57.

40. Baldinucci, *Notizie*, II, 348: "Fu ancor opera del suo scarpello la statua gigantesca figurata per lo monte Appennino quasi tremante di freddo, che si vede in mezzo al vivaio nella sommità del bosco di essa villa, e scaturisce dal suo capo gran vena d'acqua."

41. To an extent, this impression is the result of a posthumous demolition; a 1742 etching still records a structure that originally rose up behind the figure, such that much of its body occupied an interior; this appears to have been destroyed in 1877. See Dhanens, *Jean Boulogne*, 228, as well as Avery, "Giambologna's Horses." On grottoes, see especially Philippe Morel, *Les grottes maniéristes en Italie au XVIe siècle: Théâtre et alchimie de la nature* (Paris: Macula, 1998).

42. The figure might, in this way, be seen as an analogue to what H. W. Janson referred to almost five decades ago as the "image made by chance." See Janson, "The 'Image Made by Chance' in Renaissance Thought," in *De artibus opuscula XL: Essays in Honor of Erwin Panofsky*, ed. Millard Meiss (New York: New York University Press, 1961), I, 254–66. Claudia Lazzaro suggestively compared the *Appenine* to Virgil's description of Atlas: "fallen snow mantles his shoulders, while rivers plunge down the aged chin and his rough beard is stiff with ice." Claudia Lazzaro, *The Italian Renaissance Garden: From the Conventions of Planting, Design, and Ornament to the Grand Gardens of Sixteenth Century Central Italy* (New Haven, CT: Yale University Press, 1990), 148, n. 98.

43. I follow Regine Schallert's persuasive arguments for a revised dating of the *Triton* in "Ein Triton-Brunnen von Giambologna?" *Mitteilungen des Kunsthistorischen Institutes in Florenz* 45 (2001 [2002]): 503–19. Her further inference, 508, seems less conclusive: "Im Gegensatz zum Triton-Brunnen fällt beim Samson-Brunnen die ikonographische Differenz auf, die zwischen dem Ornamentwerk der Brunnenschale sowie ihres Postaments und der bekrönenden Gruppe besteht. . . . Giambologna dürfte den *Samson un Philister* ursprünglich nicht als Brunnenfigur sondern als Freistatue geplant haben."

44. See especially the discussion in Irving Lavin, "'Bologna è una grande intrecciatura di eresie': Il nettuno di Giambologna al crocevia," in *Il luogo ed il ruolo della città di Bologna tra Europa continentale e mediterranea: atti del colloquio C.I.H.A.*, ed. Giovanna Perini (Bologna: Nuova Alfa, 1990), 7–44, and n. 18, elaborating on the discussion in Richard J.

Tuttle, "Il palazzo dell'Archiginnasio in una relazione inedita di Pier Donato Cesi al cardinale Carlo Borromeo," in *L'Archiginnasio: Il palazzo, l'università, la biblioteca*, ed. Giancarlo Roversi (Bologna: Credito Romagnolo, 1988), I, 65–85.

45. The best overview of the development of Giambologna's Mercury design is now Dirk Syndram, "Merkur," in *Giambologna in Dresden: Die Geschenke der Medici*, ed. Martina Minning et al. (Munich: Deutscher Kunstverlag, 2006), 10–17, with further references. Vasari writes that Giambologna made a *Mercury* "in atto di uolare, molto ingegnoso, reggendosi tutto sopra vna gamba & in punta di pie" for Emperor Maximilian II around 1564. Neither Vasari nor Borghini (who describes the same work) mention the presence of the "wind" beneath this earlier Mercury's foot. I will proceed with the assumption that the Bargello *Mercury*, completed by 1580, is the earliest version of the *Mercury* to have included a wind. This roughly follows the chronology proposed by Anthony Radcliffe, dating the *Mercury* in Vienna to 1565, that in Naples to 1579, that in the Bargello to 1580, and all others to later. A drawing of uncertain date shows another Mercury atop a fountain with fishing boys on the sides. The boys initially belonged to the early fountain Giambologna helped produce for the Casino of San Marco, but this did not include a Mercury. Baldinucci also writes that Giambologna "made a life-sized Mercury for the garden of the Acciaiuoli," a fountain that does not appear to have survived; it is possible, as Donatello Pegazzano, "Un collezionista in giardino: Buontalenti e Giambologna per Alessandro Acciaiuoli," *Paragone/Arte* 57 (2006): 88–118, first proposed, that the drawing relates to this.

46. Gramberg, *Giovanni Bologna*, 74, writes on how this figure ended up in Florence.

47. See Dhanens, *Jean Boulogne*, 133: "de linker voet wordt gedragen door de gematerialiseerde ademtocht, die door een windkop wordt uitgeblazen. Deze ademtocht vervulde tevens de funktie van fontein: enkele gaatjes lieten dunne waterstraaltjes ontsnappen."

48. The most persistent explanation of Giambologna's addition is that the head is a "wind": Renaissance winds were conventionally represented as detached heads with puffing cheeks, and a 1598 reference to the statue calls it "a bronze Mercury atop a head of a wind, which in turn surmounts a multi-colored pile of gravel, making a fountain." The documentary reference, though, can hardly be regarded as an authoritative guide either to Giambologna's intentions or to the idea behind the commission, since it postdates the work by eighteen years, well after artist and patron alike had left the city. And the 1565 edition of Aristotle was only stating the obvious when it had the philosopher assure readers that winds do not blow vertically; see Francesco Vicomercati, *Inquatuor libros Aristotelis meteorologicorum commentarii: Et eorundem liborum e Greco in Latinum per eundem conversio* (Venice: Hieronymum Scotum, 1565), 95r: "Eorum autem motio obliqua est."

49. See Ovid. *Fasti*, trans. James George Frazer (Cambridge, MA: Harvard University Press, 1989), 5, 673–92; and Giovanni Manente, *Il Segreto de Segreti, le Moralita, & la Phisionomia d'Aristotile, Dove si trattano e' mirabili ammaestramenti ch'egli scrisse al Magno Alessandro si per il reggimento de l'Imperio, come per la conservatione de la sanita, & per conoscere le persone à che siano inclinate, ad esempio & giovamento d'ogn'uno accomodatissimi* (Venice: Zuan Tacuino da Trino, 1538), 36r: "Adunque conciosia che quella cosa che vince i pianeti sia l'acqua, & non si distende se non per spargimento, & conciosia che l'operatore dello spargimento

dell'acque sia perpetuale operando senza fine nel suo cielo, cioe' Mercurio, pero' universal-mente, vero è che ciascuno pianeto regge & dispone quello che si conviene, & s'assimiglia alla sua natura piglia l'esempio; Saturno tiene la terra, Mercurio l'acqua, Giove l'aere, il Sole il fuoco, & non si truova questa convenienza nelli corpi de pianet, ma nell'operationi."

50. For more period sources on "exhalations," see Michael Cole, "The Medici *Mercury* and the Breath of Bronze," in *Studies in the History of Art: Large Bronzes of the Renaissance*, ed. Peta Motture (Washington, DC: National Gallery of Art, 2003), 128–53.

51. Vicomercati, *Inquatuor libros Aristotelis meteorologicorum commentarii*, 91r–v: "Inest uerò & in terra multus ignis, multusque calor, ac Sol, non eum solùm humorem, qui in superficie terrae est, trahit, sed terram quoque calefaciendo exiccat. Cùm autem duplex sit (ut dic-tum est) exhalatio, una quae uaporis plena est, altera fumida, utranque fieri necesse est. Harum uerò exhalatio ea, quae maiorem humoris copiam obtinet, aquae pluuiae, ut antea diximus, principium est: sicca autem uentorum omnium principium & natura."

52. Ibid., 95r–96v.

53. Camillo Agrippa, *Dialogo . . . sopra la generatione de Venti, Baleni, Tuoni, Fulgori, Fiumi, Laghi, Valli & Montagne* (Rome: Bartholomeo Bonfadino and Tito Diani, 1584), 19–20.

54. Camillo Agrippa, *La virtu: Dialogo . . . sopra la dichiaratione de la causa de' Moti, tolti da le parole scritte nel dialogo de' venti* (Rome: Stefano Paolini, 1598), 10–11.

55. On the fountain, see Alessandro Rinaldi, "La ricerca della 'terza natura': Artificialia e naturalia nel giardino toscano del '500,'" in Fagiolo, ed., *Natura e artificio* 167; and Detlef Heikamp, "Bartolomeo Ammannati's Marble Fountain for the Sala Grande of the Palazzo Vecchio," in *Fons sapientiae: Renaissance Garden Fountains*, ed. Elisabeth Blair MacDougall (Washington, DC: Dumbarton Oaks, 1978), 115–73. My quote comes from the descrip-tion by Tanai de' Medici, discussed in both.

56. Borghini, *Il riposo*, 592: "e perciò fece l'Ammannato sei statue di marmo molto maggiori del naturale, che significauano il generar dell'acqua."

57. See G. H. Bode, ed., *Scriptores rerum mythicarum latini tres romae nuper reperti* (Cellis: Schultz, 1834), 48: "Mercurrius quasi *medius currens* dicitur appellatus, quod sermo *currat* inter homines *medius*; unde et velox et errans inducitur. Alae ejus in capite et in pedibus significant, volucrem ferri per aera sermonem Muntium dicunt, quoniam per semonem omnia cogitata nuntiantur." Adriaen de Vries's Lambach *Mercury* shows how little it took to make Giambologna's figure into a sprinter. On this figure type, see especially Lars Olaf Larsson, "Zwei Frühwerke von Adrian de Fries," in *Netherlandish Mannerism: Papers Given at a Symposium in Nationalmuseum Stockholm*, ed. Görel Cavalli-Björkman (Stockholm: Nationalmuseum, 1985), 117–26, and Scholten, *Adriaen de Vries*, 198–200.

58. Cellini, *Opere di Benvenuto Cellini*, ed. Giuseppe Guido Ferrero (Turin: UTET, 1980), 779. Bernard Palissy, for example, remarks that "all species of stones, metals and minerals are formed of liquid matter." Antonio Allegretti writes that "water is the first material [of met-als], that from which they were created and made." Francesco Vieri remarks that "metals are substances composed of humid vapors, and are by nature made of water." See Bernard Palissy, *Oeuvres complètes*, ed. Keith Cameron (Mont-de-Marsan: Editions InterUniversi-taires, 1996), I, 376; Antonio Allegretti, *De la trasmutatione de metalli*, ed. Mino Gabriele

(Rome: Ediz. Mediterranee, 1981), 85–86; Francesco de' Vieri, *Trattato di m. Francesco de' Vieri, cognominato il Verino secondo cittadino fiorentino, nel quale si contengono i tre primi libri delle metheore. Nuouamente ristampati, & da lui ricorretti con l'aggiunta del quarto libro* (Florence: Giorgio Marescotti, 1581), 148. The idea of metals as waters derives ultimately from Plato and Aristotle; see Cole, *Cellini*, 51.

59. See the introductory essay and entries in Scholten, *Adriaen de Vries*, and Francesca G. Bewer, "'Kunststück von gegossenem Metall': Adriaen de Vries's Bronze Technique," in ibid., 64–77.

60. For the term *vento*, see Giorgio Vasari, *Le Vite de' Più Eccelenti Architetti, Pittori, et Scultori Italiani, da Cimabue insino a' Tempi Nostri* (1550), ed. Luciani Bellosi and Lorenzo Torrentino (Turin: Einaudi, 1986), 52: "Usasi fare certe cannelle fra l'anima e la cappa, le quali si dimandano venti, che sfiatano a la in su, e si mettono verbigrazia da un ginocchio a un braccio che alzi; perché questi danno la via al metallo di soccorrere quello che per qualche impedimento non venisse." (It is usual to make certain channels between the core and the outer mold; these are called *venti*, and they exhale upward. They are run, for example, from a knee to a raised arm, and their purpose is to move the metal which, given an impediment, would not flow.) Such a terminology extends the corporeal language Renaissance writers used to describe casting molds, which comprised a "soul," a "skeleton," "clothes," and a "mouth."

61. On this work generally, see Dorothea Diemer, *Hubert Gerhard und Carlo di Cesare del Palagio: Bronzeplastiker der Spätrenaissance* (Berlin: Deutscher Verlag für Kunstwissenschaft, 2004), with further references.

62. Vicomercati, *Inquatuor libros Aristotelis meteorologicorum commentarii*, 120: "At quaecunque metallica sunt, & aut fusilia sunt, aut ductilia, ut ferrum, aes, aurum ad uapidum pertinent exhalationem. Vapida autem exhalatio, cùm in terra includitur, & in lapidibus potissimum ob eorum siccitatem constringitur in arctius, densescitque roris, aut pruinae modò cùm excernitur." On the breath of mines, see also Lucretius, *De Rerum Natura*, trans. W.H.D. Rouse (Cambridge, MA: Harvard University Press, 1982), 6, 803–39: "But when a burning fever is in possession of a man's limbs, then the odor of wine has the effect of a deadly blow. Do you not see also that sulphur is produced in the earth itself, and asphalt grows together in lumps with its filthy smell? Again, when they follow veins of silver and gold, rummaging with their tools the innermost secret places of the earth, what smells Scaptensula exhales [*expiret*] from below! Or what mischief do gold mines breathe out [*quidve mali fit ut exhalent aurata metalla?*], what do they make men look like, what colours! Do you not see or hear in how short a time they are accustomed to perish, how their vital force fails, who are held fast in such work as this by the great constraint of necessity? All these streams therefore the earth streams out and breathes forth into the open and ready space of the sky."

CHAPTER 4

1. Dhanens, *Jean Boulogne*, 316. See also ibid., 99, on the Bacchus: "Het is niet de wiegende onbepaalde beweging van de maniëristen (bijv. de Adam van B. Bandinelli), maar een kordate ondubbelzinnige stap; zoal wij bij de Samson de sprong zullen zien en bij de Mercurius

de vlucht in de ruimte." Also ibid., 220, on the *Christ* for Giambologna's *Altar of Liberty*: "het statische van Michelangelo's christus is hier vervangen door een illusie van beweging, die werkelijk reeds als barok aandoet."

2. See Claudia Kryza-Gersch's entry in Paolozzi Strozzi and Zikos, eds., *Giambologna*, 180: "l'eroe è raffigurato in azione . . . colto mentre sta ancora eseguendo il suo compito."

3. Detlef Heikamp, "Uccelli di bronzo," in Paolozzi Strozzi and Zikos, eds., *Giambologna*, 249–52, at 251: "coglie l'animale mentre è in movimento, o per meglio dire coglie la singola fase di un atto transitorio che si svolge con la velocità di una frazione di secondo. Questa operazione è facilitata, nei tempi moderni, dalla tecnica dalla fotografia e dalla cinematografia, così che alcuni riflessi del moto si possono fissare con agio: quando ad esempio il piccione sta preparandosi per il volo e distende le ali, anche solo minimamente, la coda per riflesso si apre a ventaglio e punta verso il basso. Giambologna, che conosceva bene le dinamiche del concatenarsi dei movimenti grazie alla sua consuetudine con la rappresentazione di cavalli e di altri grossi animali in corsa, ora è messo nelle condizioni di estendere le sue competenze anche agli uccelli."

4. Ibid., 252: "Se non sapessimo nulla della storia dell Grotta e dei suoi bronzei pennuti, potremmo pensare che essi siano stati creati nell'Ottocento positivista."

5. Cole, *Cellini*, 144–45.

6. Barocchi, *Trattati*, I, 254: "oltre all'essere il loro composto fatto di più parti e tra loro differenti, ha di più il muoversi, il qual movimento di più parti d'un corpo accresce artifizio e difficoltà, perche non solamente bisogna ben comporre le parti d'uno animale sensitivo o intellettivo, che corrispondano al loro tutto, ma ancora dare a quelle parti movenza et attitudine, secondo che sarà necessario."

7. Ibid., 254: "Perocché non bisogna solamente saper comporre le membra con proporzione, verbigrazia d'un cavallo, ma saperle fare in atto di camminare, correre, saltare o altro simile, secondo che occorre."

8. Ibid., 257: "ma non già sono così le parte che sono fra loro differenti, perché nel comporsi un tutto di parti differenti l'una dall'altra, in modo che esso tutto sia atto a conseguire il suo fine, si ha difficoltà, come ciascuno per sé stesso può imaginarsi e comprendere." ("But this is not the case with the parts that are different from one another, for in composing a whole out of parts that are different from one another in such a way that the whole is suited to follow its end, one encounters difficulty, as anyone can see and imagine.") Also ibid., 259: "Sono dunque gli uccelli composti di membri atti all'operazione del senso, et atti similmente al volare; e questi ha voluto la natura vestire di penne e piume, affine che, volando, si possano con brevità trasferire da luogo a luogo, essendo che infinite specie di loro di regione in regione ciascun anno si tramutano per fuggire il troppo caldo o il troppo freddo e per schivare ancora ogni altro accidente che mostra la natura esser loro nocivo e contrario: e questo è il loro fine universalmente." ("Thus, birds are composed of members that are suited to the operation of particular senses and suited similarly to flying; and nature wanted to clothe these in feathers and down, such that, flying, they could move themselves quickly from place to place, it being the case that an infinite number of species move from region to region each year, fleeing excessive heat or cold and additionally

evading every other accident that nature shows to be harmful or contrary to them: this is their universal end.")

9. Ibid., 255: "E così, avendo considerare questa varietà sì grande in tutte le parti che compongono il tutto di ciascuno animale (della quale varietà si parlerà a lungo nel libro delle cause delle figure), resta, come dissi poco fa, che veggiamo la varietà che fanno tutte le parti (oltre queste naturali) accidentalmente nel moversi e fare varie attitudini."

10. Ibid., 259–60: "essendo l'uccello animale sensitivo et il suo composto atto al muoversi, questo effetto del moto ha bisogno di veder le cause di esso moto, come dicemmo ne' quadrupedi, e per questo fare è necessaria la notomia, la qual cosa come ho detto, Dio concedente, prometto non solo degli uccelli, ma degli altri due generi parimente. E se bene questa forse degli uccelli può parere impertinente, per essere essi coperti di penne che non lasciano vedersi i muscoli, non avverrà così quando di essi vedremo l'effetto; perciocché, se bene agli uccelli non si veggiono i muscoli, rispetto all'occupazione delle penne, non è però che non si veggia la bella o brutta composizione del tutto della figura loro. E però, ricercando le cause di qualcuno degli uccelli col mezzo della notomia, saremo capaci non solamente delle sue proporzioni in particolare, ma ancora ci aremo qualche poco di lume e notizia in tutte le specie degli altri uccelli in universale."

11. Ibid., 257: "Il fine del composto sensitivo di qual figura d'animale si voglia è di servire sufficientemente a tutte le operazioni de' suoi sensi, et il fine di detti sensi è di governare esso composto; perché per lo mezzo del senso il corpo si soministra il vitto. Di maniera che un fine e l'altro scambievolmente s'aiutano, et unitamente ancor essi hanno provocano la generazione e la conseguiscono, il che è quello che in loro disidera la natura finalmente."

12. Michel de Montaigne, *Journal de voyage*, ed. Fausta Garavini (Paris: Gallimard, 1983), 182: "rendant qui par bec, qui par l'aile, qui par l'ongle ou l'oreille ou le naseau, l'eau de ces fontaines."

13. On Renaissance taxidermy, see Karl Schulze-Hagen, Frank Steinheimer, Ragnar Kinzelbach, and Christoph Gasser, "Avian Taxidermy in Europe from the Middle Ages to the Renaissance," *Journal of Ornithology* 144 (2003): 459–78.

14. Baldinucci, *Notizie*, II, 573–74: "Questa per certo fu una delle più maetrevoli opere, che formasse mai lo scarpello di Gio. Bologna; ed io risponderei a chi scrisse, per sentenza di non so qual maestro di scherma, che se quell'Ercole scaricasse il colpo, non sarebbe a tiro di colpire il centauro, che, se bene si considera, conoscerassi chiaramente che l'Ercole non istà in atto di percuotere il centauro, ma di ritirare il braccio per metterlo a tiro del colpo; se poi tale mia risposta non piacesse, seguiterei a dire, che forse Gio. Bologna di ciò s'avvidde ancor esso, ma tornando a maraviglia bene quell'attitudine nel suo modello, per questo fece poi la statua di marmo, cioè per assicurarsi, che ella non avesse mai con sua vergogna a scaricar quel colpo a vôto, e così non avesse a dar materia che altri s'avesse a far beffe di lui."

15. Alberti, *De pictura,* 2.43.

16. See Detlef Heikamp's entry on the work in *Magnificenza alla corte dei Medici: Arte a Firenze alla fine del Cinquecento*, ed. Cristina Acidini Luchinat et al. (Electa: Milan, 1997), 48, as well as, more recently, the same author's entry in Paolozzi Strozzi and Zikos, eds., *Giambologna*, 155–57.

17. See below, chapter 5.

18. Gotthold Ephraim Lessing, *Laokoon* (Berlin: C. F. Voss, 1766), 19.

19. Ibid., 20.

20. Frank Fehrenbach, *Licht und Wasser: Zur Dynamik naturphilosophischer Leitbilder im Werk Leonardo da Vincis* (Tübingen: Ernst Wasmuth, 1997).

21. Gauricus, *De sculptura*, 4.6.

22. Giovanni Battista Passeri, *Die Künstlerbiographien*, ed. Jacob Hess (Worms am Rhein: Werner, 1995), 133–34: "[Urbano] ordinò che se gli desse da fare una delle statue grandi d'altezza di 23 palmi l'una, che sono collocate nelle quattro nicchie maggiori ne' pilastroni di S. Pietro che sostengono la cupola. Fu data a lui quella della Veronica la quale è una figura di tutto spirito, e maestria. La rappresentò in atto di moto, e d'un moto violento non solo di camminare, ma di correre, e qui mancò (e sia detto con sua pace) della sua propria essenza, perche se la parola denominativa di statua deriva dal moto latino *sto stas*, che significa esser fermo, stabile in piedi, quella figura non è più statua permanente, ed immobile come esser deve per formare un simulacro da esser goduto, ed ammirato da' riguardanti, ma un personaggio che passa, e non rimane."

23. For an introduction to the topic, see David Summers, *Michelangelo and the Language of Art* (Princeton, NJ: Princeton University Press, 1981), 71–96 and 406–17; Ulrich Pfisterer and Anja Zimmermann, eds., *Animationen, Transgressionen: Das Kunstwerk als Lebewesen* (Berlin: Akademie-Verlag, 2005); and Fredrika Herman Jacobs, *The Living Image in the Renaissance* (Cambridge: Cambridge University Press, 2005), with further references.

24. Kenneth Gross, *The Dream of the Moving Statue* (Ithaca, NY: Cornell University Press, 1992).

25. See, for example, Bernardo Segni, *L'Ethica d'Aristotile tradotta in lingua vulgare fiorentina et comentata* (Florence: Lorenzo Torrentino, 1550), 17.

26. Barocchi, *Trattati*, I, 262: "E se bene questo genere, che io propongo, del fare, sotto il quale sono tutte le movenze, non rimane dopo l'effetto suo in corpo od in materiale; e tutte le cose che non hanno corpo o material visibile, come sono gli affetti, non si possono ritrarre: con tutto ciò, l'arte della pittura e della scultura di questo, circa le movenze, si serve, e le dimostra in opera per lo mezzo de' membri che esse movenze producono e mettono in moto. Verbigrazia, l'arte nostra può mostrare gli affetti d'un volto adirato con il moto delle ciglia o altre movenze a quello appropriate."

27. Borghini, *Il riposo*, 521: "E dalla parte destra la crudeltà mescolata con horrore d'Erodiana, che con vn baccino sotto il braccio aspetta di portare il dimandato dono all'iniqua madre."

28. Dhanens, *Jean Boulogne*, 215–16.

29. See Nicole Dacos's entry in Dacos and Meijer, eds., *Fiamminghi a Roma*, 248–49.

30. Bocchi (Cinelli), *Le Bellezze*: "oltre le statue di bronzo di incredibile artifizio campeggiano in sul palchetto riccamente sopra certi archietti alcune figure di argento effigiate per le fatiche d'Hercole di mano di Giambologna: le quali & per soma industria & per nobile invenzione, & per isquisita bellezza sono senza pari."

31. The *Hercules and Antaeus* group now in the Pitti Palace courtyard has only been there since 1860, though as Dhanens notes, other ancient copies of the work were known. See Dhanens, *Jean Boulogne*, 193–94.

32. Gaye, *Carteggio*, III, 24: "per sapere io che la eccellenza vostra vole far fare uno Gigante di marmo, e desideroso di esere anche io nel numero di quelli che la servano, la prego che la si voglia degnare, poichè di mio nonè opere in firenze."

33. For a helpful register of documents and an overview of De' Rossi's late career, see Allegri and Cecchi, *Palazzo Vecchio*, 381–85; also Detlef Heikamp, "Die Laokoongruppe des Vincenzo de' Rossi," *Mitteilungen des Kunsthistorischen Institutes in Florenz* 34 (1990): 343–78; and Detlef Heikamp, "Sulla scultura fiorentina fra Maniera e Controriforma," in Sframeli, ed., *Magnificenza alla corte dei Medici*, 346–69.

34. Borghini, *Il riposo*, 597.

35. See Detlef Heikamp, "Hercules Slaying the Hydra of Lerna: A Forgotten Statue by Giovanni Bandini, detto Giovanni dell'Opera," in *Essays Presented to Myron P. Gilmore*, ed. Sergio Bertelli (Florence: La Nuova Italia Editrice, 1978), 239–44.

36. Borghini reported that of the five labors merely "abbozzate" by De' Rossi, some were in Livorno, some at the Ponte à Signa. Baldinucci's 1681 *Life of De' Rossi* specifies that two remained at Livorno, three at the Ponte al Signa, "e trovasi fra le memorie e ricordi del capitan gio. Batista Cresci provveditore delle fortezze nel 1599 essere stato ordinato dal ganduca, che si levassero d'Arno al ponte a signa più marmi, e fra gli altri numero tre figure di marmo bianco di Seravezza abbozzate per forze d'Ercole, e si conducessero in Firenze in bottega di m. Giov. Bologna." See Allegri and Cecchi, *Palazzo Vecchio*, 385. Dhanens, *Jean Boulogne*, 368, documents Giambologna's letter to the duke from 16 February 1600: "abiamo per mano ona di quele forcia di Ercola di marmi de Vincense, di queso che il proveditore condousi oultimamente nola vostro certo." On this, see also Alessandro Cecchi, "Documenti inediti sul San Luca del Giambologna," in Eiche, ed., *Giambologna tra Firenze e l'Europa*, 29–45, at 37.

37. For this and what follows, see Dhanens, *Jean Boulogne*, 190–94.

38. On Gaddi and his collections, see Carolyn Valone, "A Note on the Collection of Niccolò Gaddi," *Critica d'arte* 42 (1977): 205–7; Cristina Acidini, "Niccolò Gaddi collezionista e dilettante del Cinquecento," *Paragone* 31 (1980): 141–75; and Cristina De Benedictis, "Devozione-collezione: Sulle committenza fiorentina nell'età della Controriforma," in *Altari e committenza* (Florence: Pontecorboli, 1996), 6–17.

39. James Saslow discusses this role in Saslow, *The Medici Wedding of 1589: Florentine Festival as Theatrum Mundi* (New Haven, CT: Yale Univesity Press, 1996).

40. Barocchi and Bertelà, eds., *Collezionismo mediceo*, 182.

41. See Claire Farago's discussion in the introduction to Farago, ed., *Re-Reading Leonardo: The Treatise on Painting across Europe, 1550–1900* (Burlington, VT: Ashgate, 2009.

42. Cf. Gasparotto's discussion in Paolozzi Strozzi and Zikos, eds., *Giambologna*, as well as Bury, "Bernardo Vecchietti," on Vecchietti's protection of Gregorio Pagani.

43. Magliabechiano 372 (hereafter BNCF) 17, 18, fol. 55: "Li musculi che muouono il maggior' fucile del' braccio nella stensione, et retratione del braccio nascono circa al mezo dell'osso detto aiutorio l'uno di dietro al'altro, dietro è nato quello che estende il braccio, et dinanzi quello che lo piega."

44. Leonardo da Vinci, *Treatise on Painting (Codex Urbinas Latinus 1270)*, trans. A. Philip McMahon (Princeton, NJ: Princeton University Press, Leonardo, Treatise), II: "Quando l'huomo si dispone alla creatione del moto co' la forza esso si piegha ci si storce quanto puo nel moto contrario a quallo doue uole gienerare la percusione, e quiui s'aparecchia nella forza ch'a'lui e' possibile la quale puoi congiongie e' lascia sopra dela cosa da lui percossa con moto decomposto."

45. BNCF 17, 18, fol. 54v. Cf. Leonardo, *Treatise*, II, fol. 119v: "L'ultimo suoltamento che puo fare l'huomo, sarà nel dimostrarsi le calcagna in faccia, et questo non si farà senza difficulta se non si piega la gamba, et abbassasi la spalla che guarda la nuca, et la causa di tale suoltamento fia dimostrata nella notomia quali muscoli primi et ultimi si muouono."

46. Volker Krahn's insightful article in the German edition of the 2000 Adriaen de Vries catalog was the first to propose a connection between Leonardo's *Trattato* and De Vries's figure. Krahn refers to the Melzi and Poussin versions of the treatise, to which De Vries would likely not have had access, though the figure and text that are crucial to his argument appear in all the Florence abridgments as well. Krahn suggests that the *Nymph* paired with de Vries's *Faun* in some versions of the statue is indebted to a figure by Giambologna, though he did not recognize Giambologna's likely role in bringing de Vries's attention to the Leonardo treatise. See Volker Krahn, "*Von der äussersten Umdrehung, die der Mensch ausführen kann.* Bemerkungen zur Faun-Nymphe-Gruppe von Adriaen de Vries," in *Adriaen de Vries, 1556–1626: Augsburgs Glanz—Europas Ruhm*, ed. Björn R. Kommer (Augsburg: Städtische Kunstsammlungen, 2000), 59–65.

47. The recent literature on the topic includes Rudolf Preimesberger's entry on *Aeneas and Anchises* in Coliva and Schütze, eds., *Bernini sculture*, 110–23; Rudolf Preimesberger, "Themes from Art Theory in the Early Work of Bernini," in *Gian Lorenzo Bernini: New Aspects of His Art and Thought*, ed. Irving Lavin (University Park: Penn State University Press, 1985), 1–24; Schröder, "Versteinernder Blick," esp. 186; and Zikos, "Le belle forme della Maniera," 28–30.

48. Borghini, *Il riposo*, 152–53: "Primieramente è di grande importanza situar bene la testa sopra le spalle, il busto sopra i fianchi, & i fianchi, e le spalle sopra i piedi: quando poi si fa vna figura d'attitudine ordinario si dee far la spalla della gamba, che posa piu bassa che l'altra spalla, & volendo che la testa guardi verso quella parte, bisogna far girare il torso, accioche la spalla s'alzi, altramente la figura harebbe non poca disgratia: e quando adiuiene che il torso si carichi sopra la gamba, che posa auertiscasi di non far volgere la testa da quella banda, perche à darle gratia è cosa molto difficile: e se la figura mostrasse il fianco gagliardo all'hora fa di mestiero che la fontanella della gola batta à piombo con la fontanella del collo del pide, che posa, e quando vscisse al quanto per l'indentro, ma non in fuore, ancora potrebbe stare: quando à vna figura, che posa sopra i suoi piedi senza moto si fa gittare vn braccio innanzi verso il petto, si dee altretanto peso naturale, ó accidentale farle gittare indietro, e cosi dico di ciascuna parte, che sporta in fuore del suo tutto, oltre all'ordinario."

49. Compare, for example, Leonardo, *Treatise*, II, 51r–v: "et se tu uuoi far' figura che dimostri in se leggiadria, debbi fare membra gentili et distese, senza dimostratione di troppi

muscoli, et que' pochi che al proposito farai dimostrare, fagli dolci; cioe di poca euiden-
tia, con ombre non tinte, et le membra et massimamente le braccia disnodate, cioe che
nissuno membro non stia in linea diritta, col membro che si aggiunge seco, et se il fiaco
polo dell'huomo si troua per lo posare fatto, che il destro sia più alto che il sinistro, farai
la giuntura della spalla superiore piouere per linea perpendiculare sopra il piu eminente
oggietto del fianco, et sia essa spalla destra più basso che la sinistra, et la fontanella stia
sempre superiore al mezo della giuntura del piede di sopra che posa, la gamba che non
posa, habbi il suo ginocchio più basso che l'altro, et presso all'altra gamba." (If you want
to make a figure that demonstrates loveliness in itself, you have to make the limbs soft and
relaxed, without too much demonstration of muscles, and those few that are appropriate
for you to show make them sweet, that is, little in evidence, with shadows that are not
deep and the limbs and especially the arms relaxed, that is, such that no limb stands in
a direct line with what adjoins it, and if the side poles [i.e., the hips] of the human figure
are placed such that the right hip is higher than the left, you will make the joint of the
higher shoulder fall on the perpendicular line that runs to the outermost point of the fig-
ure's side. And let the right shoulder be lower than the left, and the throat should always
be above the middle of the ankle of the foot on which the weight rests. The knee of the
leg on which the weight does not rest should be lower than the other and should be near
the other leg.)

50. Ibid., 128v: "Le ponderationi ò vero bilichi degl'huomini si diuidono in dua parte cioe
semplice et composto semplice è quello che è fatto dall'huomo sopra li suoi piedi immobili
sopra li quali esso huomo aprendo le Braccia con diuerso distantie dal' suo mezo ò chinan-
dosi stante sopra uno de dua piedi che sempre il centro della sua grauita sta per linea per-
pendiculare propria il centro d'esso piede che posa et se posa sopra li duo piedi equalmente
allora il peso dell'huomo hara il suo centro perpendiculare ne' mezo della linea che misura
lo spatio interposto in fra li centri di esso piedi il bilico composto s'intende esser' quello
che fa un' huomo che sostiene sopra di se un peso per diuersi moti come è nel figurare un'
Ercole che scoppia anteo il' quale sospendendolo da terra in fra il' petto e' le braccia che
tu gli faccia tanto la sua figura di dietro alla linea centrale de suoi piedi quanto anteo ha il'
centro della sua grauita dinanzi alli medisimi piedi"

51. Leopold D. Ettlinger, "Hercules Florentinus." *Mitteilungen des Kunsthistorischen Institutes in
Florenz* 16 (1972): 119–42, at 119.

52. BNCF 17, 18, 50–51: "Quando tu uuoi fare l'huomo motore d'alcun peso, considera ch' li
moti sono da esser' fatti per diuerse linee, cioe ò di basso in alto con semplice moto, come
fa quello che chinandosi piglia il peso che rizandosi uuole alzare, ò quando uuole strascin-
arti alcuna cosa dietro, ò uero spingere innanzi, ò uuoi tirare in basso con corda che passa
per carucola; Qui si ricorda che il peso dell'huomo tira tanto, quanto il centro della grauità
sua è fuori del centro del suo sostentaculo; à questo s'aggiunge la forza che fanno le gambe
ò schiena piegata nel suo rizzarsi. Mai si scende, ò sale, ne mai si camina per nessuna linea,
che il piè di dietro non alzi il calcagno."

53. Gramberg, *Giovanni Bologna*, 76: "Diese Lösung, die das für giambologna charakteristische
Problem der 'verringerten Basis' jetzt in höchster vollendung zeigt, nimmt der Figur nun

vollends jede Schwere, lässt die Gestalt völlig frei und ungehemmt 'schweben.'" Gramberg also compares Giambologna's *Mercury* to the Mercury from Cellini's *sockel*. Ibid., 78.

54. Zikos, "Le belle forme della maniera," 43, n. 81, credits the perception to Jennifer Montagu, "The Bronze Groups Made for the Electress Palatine," in *Kunst des Barock in der Toskana: Studien zur Kunst under den letzten Medici* (Munich: Bruckmann, 1976), 126–36, at 130: "for all its movement, it is a static image, implying no development in space or time."

55. Giovanna Lombardi, "Giovan Francesco Susini," *Annali della scuola normale superiore di Pisa* 3 (1979): 759–90.

56. The present discussion concerns only the first part of the manuscript. The annotations beginning on fol. 40v are in a different hand, and the drawings there do not appear to be by Susini.

57. Carlo Pedretti, *The Literary Works of Leonardo da Vinci: Commentary* (Berkeley: University of California Press, 1977), 12–47, argues that at least four copies of the abridged *Trattato* can be placed in late sixteenth-century Florence: Riccardiano 2136 (hereafter BRF 2136), Riccardiano 3208 (hereafter BRF 3208), Magliabechiano 372 (BNCF 17, 18, following its current collocation), and Belt 35, first owned by Lorenzo Giacomini, Carlo Concini, Niccolò Gaddi, and Giovanni Berti respectively. BRF 2136 cannot have been Susini's source, as the figures he drew on fol. 10v wear capes, while those on BRF 2136 fol. 23v, where the chapter these accompanied appears, do not. The corresponding figures in BRF 3208, fol. 47—which are so badly drawn as to raise doubts as to whether the draftsman was a trained artist—similarly lack capes. BNCF 17, 18 is the only Cinquecento manuscript still in Florence to pass the "cape test." If Pedretti is correct in concluding that BNCF 17, 18 was derived from BRF 2136, and that Belt 35 was in turn derived from it, we can infer that the capes were introduced by its draftsman; BNCF 17, 18 must thus be Susini's direct or indirect source.

58. Francesco Furini's 1632 copy of the *Trattato* includes a memo that indicates it was prepared in just this way; see the text and translation in Pedretti, *Literary Works: Commentary*, I, 15, as well as the recent discussion in Tristan Weddigen, "Leonardismo seicentesco: Furini e il 'Trattato della pittura,'" in *Un'altra bellezza: Francesco Furini*, ed. Mina Gregori (Florence: Mandragora, 2007), 121–27.

59. BNCF 17, 4, fol. 13: "Luomo il quale vol tirare un dardo o pietra o altra chosa cha impetuoso moto puo esser figurato in 2 modi principali cioe o potra esser figurato in 2 modi prepara alla creazione del moto o veramente quando il moto di esso e finito ma se tu lo figurerai per chreazione del moto allora illato di drento del piede sara chon la medesima linia del petto ma avera la spalla contraria sopra il piede cioe se il piede destro sara sopra anzi sotto il peso dell uomo la spalla sinistra sara sopra la punto di esso piede destro."

60. See Leonardo, *Treatise*, II, fol. 128, and compare fol. 59v in BNCF 17, 18. That the passage in Susini's text is simply transcribed from elsewhere is evident in its garbled fourth line, where the distracted writer repeats the words "in 2 modi" from the line above, producing a phrase without sense.

61. On fol. 12–12v, Susini writes: "Fa che nessun membro non sia in linea diritta chon il membro che si agiunge seco e se il fianco polo dellomo si trova per lo posare fatto che l

destro sia piu alto che l sinistro farai la giuntura della spalla superiore piovere per la linia perpendicolare sopra il piu eminente ogetto del fianco et sia essa spalla destra piu bassa che la sinistra et la fontanella stia sempre superiore al mezzo della giuntura del piede di sopra che posa la gamba che non posa abia il suo ginochio piu basso che laltro et presso a laltra gamba lattitudine della testa e braccia si sieno infinite. / Quando tu fai uno che si volti indietro o per chanto non far voltare e piedi e le ginochia dove volta la testa e se poserai sula gamba destra farai il ginochio della sinistra piegare indentro e il suo piede sia sollevato di for e la spalla sinistra sia piu bassa della destra et la nuca si scontrà a quel luogo dove e volta la noce di fuori del pie sinistro e la spalla sinistra sara alla punto del pie destro perpendiculatre linia e sempre usa che dove le figure volta non la testa non sia volto il petto." Compare BNCF 17, 18, fol. 51 and Leonardo, *Treatise*, II, fol. 114 and 114v.

62. BNCF 17, 4, fol. 13.

63. BNCF 17, 18, 56v; cf. Leonardo, *Treatise*, II, fol. 122: "Non farai mai le teste diritte sopra le spalle, ma uoltate intrauerso à destra, ò à sinistra, ancor che elle guardino in su ò in giù ò, diritto perche egli è necessario fare i loro moti, che mostrino uiuacità desta et non addormentata. [. . .]."

CHAPTER 5

1. Vasari, ed. Milanesi, *Le vite*, VI, 185.

2. Scholars have reached different conclusions about the extent of Ammanati's ultimate role in the project. Poeschke, whose book *Michelangelo and His World* allows comparison of the drawing and the chapel as it now looks, writes (p. 200) that "Ammannati's contribution to the chapel consisted primarily of the two monuments erected on either side of the altar. . . . The overall design of the chapel and its tombs was supplied by Vasari." Kiene, *Bartolomeo Ammannati*, by contrast, concludes (p. 12) that "Vasari si occupò infatti solo della pala dell'altare, lasciando a Ammannati di progettare il resto, senza pore vincoli per i dettagli."

3. For the register, see Tilman Falk, "Studien zur Topographie und Geschichte der Villa Giulia," *Römisches Jahrbuch für Kunstgeschichte* 134 (1971): 101–78. Kiene, *Bartolomeo Ammannati*, cites this, p. 50, in introducing his excellent discussion of Ammanati's role in the building.

4. See the discussions in Leon Satkowski, *Giorgio Vasari: Architect and Courtier* (Princeton, NJ: Princeton University Press, 1993), 36–37, and Kiene, *Bartolomeo Ammannati*, 21–23.

5. The best account of Ammanati's role in the ricetta is Paola Barocchi, ed., *La Vita di Michelangelo nelle redazioni del 1550 e del 1568* (Milan: Riccardo Ricciardi, 1960–62), III, 884–87, with further references. Michelangelo mentions in 1558 that Ammanati had sought advice from him about the stairs; he sent Ammanati a wooden model in July of 1559, and Ammanati had begun work by 1560, when he offered his counterproposal for the Uffizi. See also Wallace, *Michelangelo at San Lorenzo*, 137 and 180.

6. Vasari, ed. Milanesi, *Le vite*, VII, 227.

7. Ibid., VII, 81.

8. For the architectural background of Danti's father, see Summers, *The Sculpture of Vincenzo Danti*, 2.

9. See Dhanens, *Jean Boulogne*, 163–65; the piece is undocumented. Dhanens regarded the Paris version of the work as the earliest, and the similar statues in Berlin, in Boston, in the Wallace Collection, and in the Louvre versions as later, student works. Current consensus, by contrast, accepts only the version in the Museum of Fine Arts in Boston as a statue modeled by Giambologna.

10. Cambereri in Paolozzi Strozzi and Zikos, eds., *Giambologna*, 218.

11. Compare the account of Michelangelo's *Risen Christ* in Summers, *Michelangelo and the Language of Art*, 395, which observes that the reed Christ holds "is divided into almost precisely even sections, numbering nine altogether." "If the topmost section," he adds, "is taken as a module, and five of these units are measured off (as they are in fact marked off on the reed), then the fifth mark coincides with the center of the body, the seventh with the knee, as they should according to a Vitruvian canon." See also Summers, "Michelangelo on Architecture," which is relevant to this whole chapter.

12. See Fossi's Ammannati, *La città*, 21, on the connection to Ammanati, and 441–79 for the text.

13. Borghini, *Il riposo*, 32–33: "alla sesta rispondono diuidendo la difficultà in fatica di corpo, e in fatica d'animo, e la fatica del corpo come più ignobile lasciano à gli scultori, prendendosi per lor quella dell'animo; dicendo che à quelli bastano le seste, e le squadre per tutte le misure, che lor fanno di mestiero; doue al pittore è necessario oltre al sapero adoperare i detti strumenti, hauer cognitione di prospettiua per i casamenti, e per i paesi, e pcr mille altre cose, e gli bisogna hauer più giudicio perla quantità delle figure, che in vna historia occorrono, doue molti più errori che in vna statua sola nascer possono; e che allo scultore basta hauer notitia delle vere forme, e delle fattezze de corpi solidi, e palpabili, & al pittore è necessario non sola mente conoscere le forme di tutti i corpi retti; ma di tutti i trasparenti, & impalpabili, e di tutti i color ad essi diceuoli; soggiugnendo che se la maggiori fatiche, & i più gan pericoli maggior nobiltà inducessero; l'arte del cauar le pietre delle caue de monti per i pesanti strumenti, che si adoperano, e per la difficultà, di nobiltà la scultura auanzerebbe; & il fabro dell'orefice, il muratore dell'architettore, e lo spetiale del medico sarebbe più nobile."

14. Alessandro Cecchi, "La casa e bottega del Giambologna in Pinti," in *Case di artisti in Toscana*, ed. Roberto Paolo Ciardi (Milan: Pizzi, 1998), 139–43, especially 142, n. 18. Although I am persuaded by Cecchi's proposal, other scholars have proposed different possibilities: Gramberg, *Giovanni Bologna*, assigned it to Francavilla; Avery, *Giambologna: The Complete Sculpture*, to Hans van Aachen; Laschke, "Un ritratto di Giovanni Bologna," and Krahn, "Die Entworfsmodelle Giambolognas," to Bartolomeo Passerotti.

15. Avery, *Giambologna: The Complete Sculpture*, 27. The present chapter accepts this basic part of Avery's reading, though see also the discussion in Erna Fiorentini, *Ikonographie eines Wandels: Form und Intention von Selbstbildnis und Porträt des Bildhauers im Italien des 16. Jahrhunderts* (Berlin: TENEA, 1999), 92–98, which places the picture in a more

general academic context and notes that Ripa gave his emblem of *disegno* a compass as an attribute.

16. Fiorentini, *Ikonographie eines Wandels*, 94, writes of the "deutliche Trennung der Raumebenem zwischen Werkstatt und Studienzimmer." See also Michael Cole and Mary Pardo, "Origins of the Studio," in *Inventions of the Studio, Renaissance to Romanticism*, ed. Michael Cole and Mary Pardo (Chapel Hill: University of North Carolina Press, 2004), 1–35, esp. 17–19.

17. Gino Corti, "Two Early Seventeenth-Century Inventories Involving Giambologna," *The Burlington Magazine* 118 (1976): 629–34, published the important document.

18. On the places where Giambologna worked, see Cecchi, "La casa e bottega del Giambologna in Pinti"; Dimitrios Zikos, "Giambologna's Land, House, and Workshops in Florence," *Mitteilungen des Kunsthistorischen Institutes in Florenz* 46 (2002 [2004]): 357–408; and Emanuela Ferretti, "La casa-studio di Giambologna in Borgo Pinti," in Paolozzi Strozzi and Zikos, eds., *Giambologna*, 315–20.

19. This would make it more difficult to follow Laschke's proposal that the portrait's inclusion of the *Oceanus* is "un'ovvia dichiarazione dell'orgoglio professionale del Giambologna, che documenta proprio con questa scultura le sue grandi capacità nel lavorare il marmo, anche in dimensioni monumentali, pietra di paragone ormai obbligatoria per uno scultore attivo a Firenze." See Laschke, "Un ritratto di Giovanni Bologna." Fiorentini, *Ikonographie eines Wandels*, too, takes the statue in the background to be the marble work.

20. Cf. Dhanens, *Jean Boulogne*, 306: "Heel zeker, er is ook spraak van de verhoudingen van het menselijk lichaam, van de 'misure delle membre,' maar die verhoudingsleer, trouwens vol relativiteiten, komt aldus in heel ander licht te staan."

21. Document in Gramberg, *Giovanni Bologna*, 93.

22. Tuttle, *Piazza Maggiore*, 183.

23. Ibid., 184.

24. See Laschke, "Un ritratto di Giovanni Bologna," 82.

25. Friedrich Kriegbaum, "Ein verschollenes Brunnenwerk des Bartolomeo Ammanati," *Mitteilungen des Kunsthistorischen Institutes in Florenz* 3 (1928): 71–103, suggested (p. 71) that Giambologna took the motif of sirens squeezing breasts from Ammanati.

26. For the *Moses,* see Steven Ostrow, "The Discourse of Failure in Seventeenth-Century Rome," *Art Bulletin* 88 (2006): 267–91. Slightly later, Giambologna made a statuette that, in the absence of any defining attributes, has conventionally gone under the name "Mars." Moritz Woelk, "Mars," in *Giambologna in Dresden: Die Geschenke der Medici*, ed. Martina Minning et al. (Munich: Deutscher Kunstverlag, 2006), 34–41, aptly compares its physical type to that of the *Neptune* fountain, and writes: "Möglicherweise stellt der *Mars* nicht allein ein allegorisch auf jeden Herrscher übertragbares Ideal dar, was am warhscheinlichsten ist, sondern darüber hinaus ein Idealbild des Francesco I. de' Medici."

27. See the account of the event in Vittorio Benacci, *Descrittione de gli apparati fatti in Bologna per la venvta di N.S. Papa Clemente VIII* (Bologna: Vittorio Benacci, 1598). I owe thanks to T. Barton Thurber for this reference.

28. Malcolm Campbell and John Pinto both identify the figure as Neptune; see John A. Pinto, *The Trevi Fountain* (New Haven, CT: Yale University Press, 1986), 232.

29. See Dhanens, *Jean Boulogne*, 170.

30. Ammanati in Barocchi, *Trattati*, III, 118: "oltre ciò sapete tutti, eccellenti Accademici, quant'io pregassi, che delle proporzioni, distibuzioni, discrezioni e comodità dell'architettura si ragionasse e discorresse."

31. Discussions in Detlef Heikamp, "Rapporti fra accademici ed artisti nella Firenze del '500," *Il Vasari* 1 (1957): 139–63; Michel Plaisance, "Culture et politique à Florence de 1542 à 1551: Lasca et les Humidieux prises avec l'Académie Florentine," in *Les écrivains et le pouvoir en Italie à l'époque de la Renaissance*, ed. André Rochon (Paris: Presses Sorbonne Nouvelle, 1974), 149–242, esp. 421; and Cole, *Cellini*, 110.

32. Cf. Cole, *Cellini*, 102.

33. See especially the discussion in Michael Bury, "Giambologna's *Fata Morgana* Rediscovered," *Apollo* 131 (1990): 96–100; also Maria Teresa Colomo, "La grotta di Fattucchia e la statua della *Fata Morgana* di Giambologna," in Sframeli, *Magnificenza alla corte dei Medici*, 426–29, and Detlef Heikamp's entry in Paolozzi Strozzi and Zikos, eds., *Giambologna*.

34. The most famous "Medici Venus" only came to light long after Giambologna's death, but a similar work that has not survived was known in the Renaissance: Pisanello, Jacopo Bellini, Gentile Bellini, Amico Aspertini, and Francisco de Hollanda all made drawings of it. See Bernhard Degenhart and Annegrit Schmitt, "Gentile da Fabriano in Rom und die Anfänge des Antikenstudiums," *Münchner Jahrbuch der bildenden Kunst* 11 (1960): 59–151, illustrations 65–68.

35. Phyllis Pray Bober and Ruth Rubinstein, *Renaissance Artists and Antique Sculpture: A Handbook of Sources* (London: Harvey Miller, 1987), 63.

36. See Herbert Keutner's important article, "Die Bronzevenus des Bartolommeo Ammannati," *Münchner Jahrbuch der bildenden Kunst* 14 (1963): 79–92. The fullest account of the marble's history is Arnold Nesselrath, "The Venus Belvedere: An Episode in Restoration," *Journal of the Warburg and Courtauld Institutes* 50 (1987): 205–14. Margarita M. Estella, "Adiciones y rectificaciones a noticias sobre esculturas italianas en España," *Archivio español de arte* 81 (2008): 17–30, challenges Keutner's conclusion that a bronze now in Spain records Ammanati's restoration.

37. Compare also the engraving after Penni adduced as a source in Anthea Brook, "A Graphic Source for Giambologna's *Fata Morgana*," in Eiche, ed., *Giambologna tra Firenze e l'Europa*, 47–64, especially 56.

38. The relevant texts are collected in Dhanens, *Jean Boulogne*, and Bury, "Giambologna's *Fata Morgana* Rediscovered."

39. Bury, "Giambologna's *Fata Morgana* Rediscovered," 97, n. 13: ("Un Busto di Venere di Marmo posta sopra il pavimento della Terra esistente dentro all stanza della fonte della Sammaritana"), and n. 14: ("Una Venere di marmo, di mano di Giovan Bologna, che è l'istessa descritta alla Fonte della Fata Morgana").

40. See the discussion in Herbert Keutner, "Die Bathseba des Giovanni Bologna," *The J. Paul Getty Museum Journal* 15 (1987): 139–50.

41. Vasari, ed. Milanesi, *Le vite*, VI, 79. As Antonia Boström argued, Tribolo's model had in fact been cast, well before Giambologna's time, by Zanobi Lastricati. Lastricati's bronze

currently stands in the gardens at Aranjuez in Spain. See Antonia Boström, "A New Addition to Zaobi Lastricati: *Fiorenza* or the Venus Anadyomene, the Fluidity of Iconography," *Sculpture Journal* 1 (1997): 1–6.

42. Baldinucci, *Notizie*, IV, 568: "Gettò dipoi a Firenze una femmina in atto di pettinarsi le chiome, per l'altre volte nominata villa di Castello."

43. Avery and Radcliffe, eds., *Giambologna: Sculptor to the Medici*, 80.

44. See Boström, "A New Addition to Zaobi Lastricati," and the entry in *L'ombra del genio: Michelangelo e l'arte a Firenze, 1537–1631*, ed. Marco Chiarini et al. (Milan: Skira, 2002). The attributes on Lastricati's figure that most clearly identify it as "Florence"—a diadem with Medici *palle* and a fleur-de-lis—are absent from Giambologna's.

45. If the earlier figure already represented Florence as Venus, or if Giambologna transformed Lastricati's figure of Florence into Venus, the height and distance at which the work was originally displayed would further have reduced its legibility. The work's original viewers, moreover, may even have appreciated the conflation of the two figures; with the fountain's fertile waters pouring from her hair, the statue could suggest Venus's role as *genetrix*, or even as *dea hortorum*, governing the garden and its liquids, presiding over the flowers that gave Florence its name. The point is that the kind of work Giambologna made shifted this whole decision from a matter for artists—a concern to include attributes that would clarify the identity of the figure—to one for collectors, the often erudite villa owners who could show their own mastery of ancient and modern poetry by using the vague form the sculptor delivered as an opportunity for their own invention. On the Venus Genetrix as the goddess of flowers, and more generally on the Venus Hortorum, protectress of gardens, see Charles Dempsey, *The Portrayal of Love: Botticelli's Primavera and Humanist Culture at the Time of Lorenzo the Magnificent* (Princeton, NJ: Princeton University Press, 1992), 41–49.

46. Mozzati, "Il tempio di Cnido: il nudo e il suo linguaggio nell'età di Giambologna," in Paolozzi Strozzi and Zikos, eds., *Giambologna*, 66–87, at 71.

47. Ibid., 77.

48. Bocchi in Barocchi, *Trattati*, III, 170.

49. On this enormous subject, see especially Payne, *The Architectural Treatise in the Italian Renaissance*. Among other topics, she discusses the importance of body types within Renaissance theories of decorum, 66, and the "gendering" of proportion, 166.

50. Baldinucci, *Notizie*, II, 566: "ne è tacersi, come ad alcuni de' discepoli di Gio. Bologan, che eransi adoperati in quel lavoro, ella fu di notabil danno, mercè l'aver eglino, per così dire, persa la mano; dovendo poi lavorare in sulle statue d'ordinaria proporzione, parea lor sempre di lavorare sopra muscoli dell'Appennino. Uno di coloro, a cui ella nocque molto, fu un certo Antonio Marchissi da Settignano, il quale si guastò tanto il giudizio dell'occhio, che quando tornò poi ad operare nella stanza di Gio. Bologna, perchè e' non faceva più cosa che buona fosse, gli fu scemata la provvisione."

51. See Ammannati, *La città* especially 16.

52. Danti in Barocchi, *Trattati*, I, 212: "E che ciò sia vero, da niuna altra cagione fu spinto il divino Michelagnolo a porre quasi tutto il suo studio e diligenza intorno al corpo umano, che dalla cognizione della perfetta et in tutte le parti compiuta et artifiziosa figura di quello;

apertamente veggendo che ogni altra imitazione et ogni altro composto è a esso corpo umano per sì fatta guisa inferiore, che è poco da curarsi di qual si voglia altra cosa che ritrarre si possa od imitare."

53. Ibid., 236: "Anzi è da credere che dall'architettura, come da loro principale obietto, la maggior parte dell'altre abbiano preso esempio." Barocchi's commentary on the passage, 60, notes precedents in Varchi and Vasari.

54. Borghini, *Il riposo*, 521–22: "Fu quest'huomo vniuersale quasi in tutte le virtù, intese molto di fabricare, e di fortificare; laonde fu fatto in Perugia sopra le forificationi di quella Città: e con suo ordine, e disegno si ridusse à quella buona forma, che hoggi si vede il palagio de' Signori, e particolarmente vi rifece le scale"

55. Danti in Barocchi, *Trattati*, I, 237: "Ma è ben vero che l'architettura, perché compone le cose da sua posta, cioé non imita nella maniera che fanno l'altre due, sì come è ditto, pare che sia di molto maggior artifizio e perfezzione; ma non già oggi, che sotto tante regole, ordini e misure è stata ridotta, le quale la rendono facilissima nelle sue esecuzioni. Quegli antichi primi ritrovatori di tanti begli ordini, con tanti begli ornamenti e comodità, furono quelli i quali si può dire che fussero in ciò di grandissimo ingegno e giudizio, e che allora essa architettura per i suoi esecutori fusse nobilissima e molto artifiziosa. Ma, come ho ditto, in questi tempi quasi ognuno che cappia tirare due line può fare l'architettore, rispetto alle regole di sopra dette. Ma non così interviene alla scultura et alla pittura, alle quale non è mai stata formata regola niuna che possa facilitare veramente questa loro imitazione; e massimamente dintorno all figura dell'uomo, il quale di tanta difficultà di composto si vede."

56. See Niccolo Martelli's well-known comment in his 28 July 1544 letter, reprinted in Pope-Hennessy, *Italian High Renaissance and Baroque Sculpture*, 336: "non tolse dal Duca Lorenzo, ne dal Sig. Giuliano il modello apunto come la natura gli avea effigiati e composti, ma diede loro una grandezza, una proportione, un decoro . . . qual gli parea che piu lodi loro arrecassero, dicendo che di qui a mille anni nessuno non ne potea dar cognitione che fossero altrimenti."

57. Dhanens, *Jean Boulogne*, 231, quotes the diarist Settimani to establish 11 February 1585, as the date of installation and 23 March as the date the work was unveiled: "fu collocata la statua e ritratto di marmo in testa alla strada de nuovi Uffici e Magistrati di verso Arno, che rappresenta l'effigie del granduca Cosimo di Giovanni de' Medici, quale fu opera di Maestro Giam Bologna fiammingo scultore e pittore raro, il quale la lavorò nel convento di S. Maria Novella . . . fu scoperta la statua di marmo del Granduca Cosimo ritto in piedi collo scettro dorato in mano in atto di comandare, posta in testa della fabbrica de nuovi Magistrati e scolpito di mano di Gian Bologna scultore eccellente."

58. Bocchi (Cinelli), *Le bellezze*, 65–66. See also Heikamp, "Scultura e politica," 214.

59. BNCF, 17, 4, 23–24: "Seguiremo altre misure chon nuouo ordine di misura il quale mi pare piu facile e questo s'e lordine il regolarsi da una parte del chorpo che non misurerete come per chaso sege lerchole de pitti di lisippo misurato dal s.o lodouico cigoli si presume tutto lo schudo del uiso cio è dalla radice de capelli ideste la somitta della fronte a tutto il mento e quanto alla barba e' regola chon ilrischontrarlo chon laltre chome le chiauicole le poppe e

altra misura nota e chomune et quella si notera in sur un regolo e si chontra segniera chon
la letera ·T· et la meta di essa testa con altra sorte di chontra segnio e per chaso chonquesto
·e· poi si diuidera il tutto in parte 24 e questi si noteranno chon li numeri dabbaco alsolito
ciaschuna parte si diuidera per meta la quale meta si notera chon questo chontrasegnio
⁒ e detta misura la 48esima parte siche pare sia basteuole e uolendo la piu strito laltra si
diuidera interzi inquarti e simili notando li chon li soliti charatteri di numeri diabbaco.

Con questa misura diuisa in dodici parte e la meta della testa dello erchole de pitti la
quale intesa sara parte 24 ma per manchamento del foglio non se fatta intera ma la meta
che sono parte 12.

Alla quale meta del tutto sie contrasegniato un dieci così alla ntica ·e· poi laltre come si
uede di numeri et ntutto come s'e detto si contrasegnia con un T per lintera testa in però
questi perchaso per chontrasegnio di una testa et parte 16 ½ e 2 terzi si fara T·e·4·⁒ il T per
significare una testa ·e· per una mezza e dalla meta che e dodici parte fino insedici che sono
~~alla mezza testa~~ di resto parte 4 in 4 à lusanza diabbaco e chosi segue fino che non ariva alla
mezza testa che sono et quella mezza ~~testa~~ parte con questo contrasegnio ⁒ che la uisione
della 48esima parte di tutta la testa inteso dalla radice dei capelli ·A· a tutto l mento B e
perche taluolta i capelli caschano sopra la fronte come ochorre le più uolte nelle femine
degli antici o la barba ochupa lmento percio si piglia tutta la lungezza del naso e duplicato
tre uolte come lo ·A· 'e' ·B· sintende per una testa modulo che lo diuideremo inparte 24
come per la misura di sopra si accenna per sopra detti chontrasegni T ·e· 11⁒ e se fusse per
chaso piu di 2 deste 4 parte si segnierebbe il n° 2 inanzi al ·T· o piu se piu fussero."

60. Pliny, *Nat. Hist.* 34.19.65.

61. Borghini, *Il riposo,* 136: "conciosiacosa che spesso si facciano figure in atto di chinarsi,
d'alzarsi, e di volgersi, nelle cui attitudini hora si distendono, & hora si raccolgono le
braccia di maniera che à voler dar gratia alle figure bisogna in qualche parte allungare, &
in qualche altra parte ristringere le misure. Laqual cosa non si può insegnare; ma bisogna
che l'artefice con giudicio dal naturale la imprenda." See also the discussion in Summers,
Michelangelo, 381.

62. Danti in Barocchi, *Trattati,* I, 238: "dato ch'ella desse a tutte le membra una assegnata mi-
sura, a ciasuno per se et insieme al tutto di loro (il che ancora si può negare), dirò che tutt'i
membri principali variano e di lunghezza e di grossezza nel moversi, come apertamente
ciascuno per sé può vedere; di maniera che, avendo noi bisogno, quando in una attitudine
e quando in un'altra, di adoperare il corpo umano, non può per questa varietà questa cotale
misura attuale servirci, come dependente dalla quantità."

63. BNCF, 17, 4: "Questa misura si e il palmo romano chome schriue il serlio nel primo della
sua a[r]chitettura nel quale si diuide in dodici oncie e ugni oncia in quattro minuti."

64. Borghini, *Il riposo,* 522.

65. Kiene, *Bartolomeo Ammannati,* 198.

66. The vase in the Getty statue is a late eighteenth- or early nineteenth-century restoration;
it replaces the smaller vase the figure originally held with one copied from a bronze by
Adriaen de Vries—itself inspired by this group of works. See Keutner, "Die Bathseba des
Giovanni Bologna," 149–50.

67. Elizabeth Cropper, "On Beautiful Women: Parmigianino, Petrarchismo, and the Vernacular Style," *Art Bulletin* 58 (1976): 374–94, esp. 382. Mozzati, "Il tempio di Cnido," likewise connects the vases to Firenzuola, though he seems unaware of Cropper's fundamental discussion.

68. Sebastiano Serlio, *I sette libri dell'architettura* (Bologna: Arnaldo Forni, 1987 [Facsimile of 1584 ed.]), v: "Gli antichi dedicarono gli edifici à i Dei; accommodandosi à quelli secondo la lor natura robusta, o dilicata: come l'opera Dorica à Gioue, a Marte, & ad hercole. Queste si fatte forme Doriche da l'huomo togliendo & la Ionica à Diana, ad Appolline, & a Bacco, l'opera togliendo da la forma matronale; che participa del robusto, & del dilicato."

69. The most comprehensive discussion of Danti and drawing is Davis, "*Disegno. Lo scultore all'opera: Delineare, inquadrare, progettare,*" in Davis and Paolozzi Strozzi, eds., *I grandi bronzi del battistero*, 221–71; Davis accepts one drawing on the basis of a somewhat thin stylistic comparison and of a later collector's inscription. No one has closely studied Giambologna's drawings, though see the comments in Avery and Radcliffe, eds., *Giambologna: Sculptor to the Medici*, 199–208, and in Avery, *Giambologna: The Complete Sculpture*, 273–74, nos. 167–70.

70. In his edition of Ammannati, *La città*, 18, Fossi remarks that the problems Ammanati proposed for measuring the depth of a well, the height of a tower, or the dimensions of a parcel of land can be found in earlier writings by Leonardo, Fibonacci, Alberti, and Filippo Calandri.

71. This relieves the space of the tensions that characterize one its primary models, Michelangelo's New Sacristy, tensions that came about in part because of the way that chapel was designed through freehand chalk drawings of individual elements then harnessed together into service.

72. Alain Mérot, ed., *Les Conférences de l'Académie royale de peinture et de sculpture au XVIIe siècle* (Paris: École nationale supérieure des Beaux-Arts, 1996), 334: "On dit, en parlant sur le grand *Torse*, qu'on avait remarqué entre les excellents sculpteurs quatre manières différentes; l'une que l'on nomma forte et ressentie, laquelle a été suivie de Michel-Ange, de Carrache et de toute l'école de Bologne, et que cette manière avait été attribuée à la ville d'Athènes. La seconde, un peu faible et efféminée, qu'ont tenue maître Étienne Delaune, Franqueville, Pilon et même Jean de Bologne, laquelle avait été estimée venire de Corinthe. La troisième, pleine de tendresse et de grâce, particulièrement pour les choses délicates, que l'on tenait qu'Apelle, Phidias, et Praxitèle ont suivie pour le dessin. Cette manière avait été fort estimée, et l'on tenait qu'elle venait de Rhodes. Mais la quatrième est douce et correcte, qui marque les contours grands, coulants, naturels et faciles, qu'elle était de Sicyone, ville du Péloponèse, d'où était Hérodote, auteur de ce *Torse*, lequel s'est perfectionné en choisissant et joignant ensemble ce qu'il y avait de plus parfait en chacune de toutes ces manières."

73. Testelin would have known Giambologna's work from the king's extensive collection of bronzes, on which see especially Amaury Lefébure, "Une collection dominée par l'art de Jean Bologne," in *Les bronzes de la couronne* (Paris: Réunion des Musées Nationaux, 1999), 37–42.

1. Barocchi, *Trattati*, III, 119: "che siano avvertiti e si guardino, per l'amor di Dio e per quanto hanno cara la lor salute, di non incorrere e cadere nell'errore e difetto, nel quale io nel mio operare son incorso e caduto, facendo molte mie figure del tutto ignude e scoperte, per aver seguitato in ciò più l'uso, anzi abuso, che la ragione di coloro i quali innanzi a me in tal modo hanno fatto le loro e non hanno considerato che molto maggiore onore è dimostrarsi onesto e costumato uomo, che vano e lascivo, ancorché bene et eccellentemente operando."

2. Ibid. See also 121: "E pur sappiamo che il più degli uomini che ci fa operare non dà invenzione alcuna, ma si rimette al nostro giudizio, dicendone: Qui vorrei un giardino, una fonte, un vivaio, e simili."

3. Preparations for the installation of the *Sabine* began on 30 July 1582; the installation was complete by 28 August. Ammanati's letter is dated 22 August. See Dhanens, *Jean Boulogne*, for the documentation. Mozzati, "Il tempio di Cnido," 68, also recognized the connection between the letter and the statue.

4. Barocchi, *Trattati*, III, 121–22: "E se bene io feci il Colosso che è in Padova e 'l Gigante, col resto della fonte, che è su la Piazza di Firenze, con tanti ignudi manco onore assai ne ritrassi e, quel ch'è peggio, me ne trovo la coscienza fuor di modo gravata, come dirittamente mi si conviene; onde del continua acerbissimo dolore e pentimento ne sento all'animo."

5. Luigi Amabile, *Due artisti ed uno scienziato: Gian Bologna, Jacomo Svanenburch e Marco Aurelio Severino nel S.to Officio Napoletano* (Naples: Tip. della Regia Università, 1890), 55: "io disse al detto vincenzo che vorria che detto Gio.ne mio maestro fusse piu huomo dabene, et cognoscesse piu Dio de quel che fa."

6. Ibid., 56: "esso magnava carne di ogni tempo di venerdi di sabato di vigilia di quatragesima, non stanno matalo ma lavorando, et io lo spogliava et vesteva, et lui faticava."

7. Ibid., 55: "Sapera V. S. como havera da tre mesi in circa che io parlando con Vincenzo Goperger flamengo pictore, nel mio oratorio, et parlassimo del'opera et eccelentia nell'arte della scoltura di Gio.ne Bologna flamingo che habita in fiorenza."

8. Ibid., 56: "Il che inteso me disse maravigliandosi, come era stato tanto tempo ad denuntiarlo."

9. Ibid.: "il pred. P. lorenzo mio confessore me disse, che havevano havuto risposta da fiorenza che detto Gio: bologna non era emendato, et che dava cattivo odore de fatti soi."

10. Barocchi, *Trattati*, III, 123: "sovvendomi d'una parola che già mi disse Michelagnolo Buonarruoti, et è: che i buoni cristiani sempre facevano le buone e belle figure."

11. For the documents on the project and discussion, see Dhanens, *Jean Boulogne*, 219–21.

12. The best study of the Ammanati monument is Johannes Myssok, "Bartolomeo Ammanati: Das Boncompagni-Grabmal im Camposanto zu Pisa," in *Praemium Virtutis: Grabmonumente und Begräbniszeremoniell im Zeichen des Humanismus*, ed. Joachim Poeschke, Britta Kusch, and Thomas Weigel (Münster: Rhema, 2002), 125–45.

13. Dhanens, *Jean Boulogne*, 324: "Tegenover Michelangelo's dramatisch onopgeloste komposities en zign innerlijke gespletenheid doet het werk van J. Boulogne aan als een bevrijding uit de materie, een overwinning di zich trimfantelijk manifesteert."

14. Ibid., 220.

15. The question is whether Danti participated in the design of the tombs or exclusively followed drawings by Vasari or others. See the discussion in Charles Davis, "La 'Madonna del Monasterio degli Angeli': Danti e l'ambiente intorno a Benedetto Varchi, tra la quiete fraterna e la stanza dei 'Sonetti Spirituali,'" in Davis and Paolozzi Strozzi, eds., *I grandi bronzi del battistero*, 165–203.

16. Dhanens, *Jean Boulogne*, 342: "Si bisognerìa in questa citta dell'industria et della presenza di Gio. Bologna scultore et architetto di Vostra Altezza per qualche pochi giorni."

17. The basic references for Giambologna's late sculpture for chapels, and of the Grimaldi Chapel sculptures in particular, are Michael Bury, "The Grimaldi Chapel of Giambologna in San Francesco di Castelletto, Genoa," *Mitteilungen des Kunsthistorischen Institutes in Florenz* 26 (1982), 86–127, and Mary Weitzel Gibbons, *Giambologna: Narrator of the Catholic Reformation* (Berkeley: University of California Press, 1995).

18. See the good overview by Ewa Karwacka Codini, "The Plans and the Work-Site of Sant'Antonino's Chapel in St. Mark's in Florence—The Work of Giambologna—in a Manuscript in the Salviati Archives," in *Proceedings of the First International Congress on Construction History*, ed. Santiago Huerta (Madrid: 2003), 1215–23.

19. Ugolino Martelli, *Sermone sopra la traslazione del corpo di S. Antonino arcivescovo di Firenze: Fatto nella chiesa di S. Marco, mentre che la solenne Processione passaua* (Florence: Sermartelli, 1589), 14.

20. Silvano Razzi, *Vita, miracoli, e traslazione di S. Antonino Arcivescovo di Firenze* (Florence: Sermartelli, 1589), 109–10: "elessero per Architettore, e maestro dell statue di bronzo, e di marmo l'eccellentissimo veramente e, non mai a bastanza lodato, giouanni Bologna fiammingo (ò piu tosto il Fiammingo Buonarroto) scultore del Serenissimo Gran Duca di Toscana."

21. Karwacka Codini and Sbrilli, *Il quaderno della fabbrica*, 135: "fatta con 15 sfondati e spartimenti con intagli e fusaiole secondo il desegno di m. Gio. Bolognia."

22. Corti, "Two Early Seventeenth-Century Inventories," 634.

23. Razzi, *Vita, miracoli, e traslazione di S. Antonino*, 110: "e percio che non le grandi, e reali spese solamente; sono quelle, che fanno ragguardeuoli, e magnifici gli edificii, & i Tempii, ma ancora gli eccellenti Maestri." For Razzi and Danti, see Davis, "La 'Madonna del Monasterio degli Angeli,'" especially 169.

24. For the comparative context, see Marcia B. Hall, *Renovation and Counter-Reformation: Vasari and Duke Cosimo in S.ta Maria Novella and S.ta Croce, 1565–1577* (Oxford: Clarendon Press, 1979); for the transformation of Santa Croce, Hans Teubner, "San Marco in Florenz: Umbauten vor 1500; ein Beitrag zu Werk des Michelozzo," *Mitteilungen des Kunsthistorischen Institutes in Florenz* 23 (1979): 239–72; Monica Bietti, "La pittura nella chiesa di San Marco," in *La Chiesa e il Convento di San Marco a Firenze* (Florence: Cassa di Risparmio, 1990), II, 213–46; and Francesca De Luca, "La Cappella Salviati e gli altari laterali nella chiesa di San Marco a Firenze," in *Altari e committenza*, ed. Cristina De Benedictis (Florence: Pontecorboli, 1996), 114–35, who notes, p. 131, that "a differenza di Santa Croce, San Marco non presenta un progetto iconografico omogeneo."

25. Archivio di Stato di Firenze, Archivio Mediceo del Principato, Minute di Lettere e Registri, filza 6, fol. 316 (document discovered through the Medici Archive Project): "et se bene hanno dato nome di pazzo a un frate che haveva ultimamente suscitate et scritte le medesime conclusionj, li altrj frati però l'hanno sempre dette et publicate di bocca a tutti e loro confidenti et seguacj, che in Firenze sono gran numero e tutti adorano fra Girolamo per santo."

26. Ibid.: "il monasterio di San Marco era stato fondato et hedificato dalla casa mia et era mio et che potevo disporne come di cosa propria, et senza licentia di S. S.tà o d'altra persona."

27. De Luca, "La Cappella Salviati," 116.

28. Michael Edwin Flack, "Giambologna's Cappella di Sant'Antonino for the Salviati Family: An Ensemble of Architecture, Sculpture and Painting," unpublished doctoral dissertation, Columbia University, 1986, 165.

29. Klaus Pietschmann, *Kanonisationspolitik im augehenden Mittelalter: Die Heiligsprechung des Antoninus von Florenz im Jahre 1523*, unpublished master's thesis, Wesfälischee Wilhelms-Universität zu Münster, 1996, 111.

30. Ibid., 113, 129.

31. Nirit Ben-Aryeh Debby, "Giambologna's Salviati Reliefs of St. Antoninus of Florence: Saintly Images and Political Manipulation," *Renaissance Studies* 22 (2008): 197–220, at 198.

32. Barocchi and Bertelà, eds., *Collezionismo mediceo*, 181.

33. Dhanens, *Jean Boulogne*, 259, gives the following list of scenes: "De Jonge Sint antoninus ontvangt het Dominikaanse kleed. Sint Antoninus als bisschop deelt aalmoezen uit. Sint antoninus predikt voor het volk. Intrede van Sint antoninus te Florence, voorgesteld op de piazza della signoria. Sint Antoninus verzoent zich met de Florentijnse Signoria en heft de censuur op, die haar getroffen had om de rechten van de Kerk te hebben geschonden. De opwekking van de dood van een kind, voorgesteld in een kamerruinte vóór talrijke aanwezigen."

34. Flack, "Giambologna's Cappella di Sant'Antonino," 165.

35. Debby, "Giambologna's Salviati Reliefs," who gives the most recent and complete account of the relief cycle, writes that there are three main sources for the life of Antonino, the biographies of Domenico Baldovini, Francesco Castiglione, and Vespasiano da Bisticci. What she does not note is that none of these had been published by the end of the sixteenth century. She appears to be unaware of the biography written by Frosino Lapini and published by the Sermartelli press in 1569, one decade before work started on the chapel. More curiously, she also ignores a key source on which Flack drew, the Silvano Razzi biography published in 1589 on the occasion of the chapel's unveiling.

36. Razzi, *Vita, miracoli, e traslazione di S. Antonino*, 73: "Essendo vna notte da i sergenti della corte stati presi due preti, e messi nelle prigioni de' Signori Otto di Balìa, Magistrato di grande autorità sopra le cose criminali; i detti Signori, che in quel tempo risedeuano, per ischerno di bel mezzo giorno, che da tutto il popolo fossero veduti, gli mandarono all'Arciuescouado con le trombe innanzi, facendo intendere a Monsignore che haueuano essi data i detti preti quella penitenza, che loro era paruta: e che se egli giudicaua che piu ne meritassero, la desse loro."

37. Ibid., 74: "E cosi furono costretti qe' Signori Otto andare publicamente con la coreggia al collo a humiliarsi all'Arciuescouo, dauanti alla porta del Duomo, chiedergli perdono del loro fallo, è riceuere la penitenza."

38. Compare the episode described in Vespasiano da Bisticci, *Renaissance Princes, Popes, and Prelates: The Vespasiano Memoirs: Lives of Illustrious Men of the XVth Century*, trans. William George and Emily Waters (New York: Harper and Row, 1963), 161.

39. Razzi, *Vita, miracoli, e traslazione di S. Antonino*, 40: "Ma finalmente facendogli l'esperienza conoscere, che per molte cagioni era meglio tenere vn solo vicario: e che parimente non era possibile, che egli attendesse alle predicationi, & insieme frequentasse il coro della sua chiesa; desse senza quasi mai restare vdienza, e facesse altri molti si fatti vfficii, e speditioni; si risoluette a non predicare per se stesso, ma si bene a procurare, che nelle chiese principali della città a' debiti tempi, e dauantaggio si hauessino predicatori del verbo di dio, per dottrina, e bontà degni & atti a tanto vfficio."

40. Debby, "Giambologna's Salviati Reliefs," 198.

41. Flack, "Giambologna's Cappella di Sant'Antonino," cites the letter, 189: "Il caso e questo che per l'ostinazione dei Frati di S. Marco la memoria di Fra Girolamo Savonarola che era dieci o dodeci anni fa estinta, risorge, pullula, ed e più in fiore che mai stata sia. Si semina le sue pazzie tra i Frati, fra le Monache, fra i Secolari e nella gioventù. Fanno cose presuntuosissime, gli fanno l'offizio come a Martire, conservano le sue reliquie come se Santo fosse insino a quello stilo dove fu appiccato, i ferri che lo sostengnono, gli abiti, i cappucci, le ossa che avanzarono al fuoco, le ceneri, il cilicio, conservano vino benedetto da lui, lo danno agli infermi, ne contano miracoli, le sue imagini fanno in bronzo, in oro, in cammei, in stampe, e quello che e peggio li fanno iscrizioni di Martire, Profeta, Vergine e Dottore."

42. Debby, "Giambologna's Salviati Reliefs," 198.

43. The documents do not make Dosio's role in the chapel entirely clear, but it is plausible that he inspired or even suggested the use of the colored stones. Also comparable is the use of colored stone in the Nicolini Chapel in Santa Croce, begun in 1584. For an introduction to Florentine chapels in this period, see Rosamaria Martellacci, "Cappelle gentilizie fiorentine in epoca di Controriforma," in *Architetture di altari e spazio ecclesiale*, ed. Carlo Cresti (Florence: Pontecorboli, 1995), 74–111.

44. For Rome, see Steven F. Ostrow, "Marble Revetment in Late Sixteenth-Century Roman Chapels," In *IL 60: Essays Honoring Irving Lavin on His Sixtieth Birthday* (New York: Italica Press, 1990), 253–66; for San Marco in Venice, and for the history of colored marbles more broadly, Fabio Barry, "Walking on Water: Cosmic Floors in Antiquity and the Middle Ages," *Art Bulletin* 89 (2007): 627–56. Campbell, "Observations on Ammannati's *Neptune Fountain*," speculates that the 1564 discovery of quarries for *marmo mischio* near Pietrasanta led to a change in plans for what the fountain would include, placing new emphasis on its flecked purple-red basin.

45. See the discussion in Elizabeth Cropper, "Prolegomena to a New Interpretation of Bronzino's Florentine Portraits," in *Renaissance Studies in Honor of Craig Hugh Smyth*, ed. Andrew Morrogh et al. (Florence: Giunti Barbèra, 1985), II, 149–62.

46. Martelli, *Sermone sopra la traslazione del corpo di S. Antonino*, 7: "Il Signor Nostro, & Maestro Iesu christo, non isgridò egli, & fra quei dolorosa guai molto, & molto minacciosi, non biasimò egli agramente gli Scribi, & Farisei che edificauano i sepolchri de Profeti, & ornauano i Monumenti de giusti?"

47. See the excellent discussion in Kathryn B. Hiesinger, "The Fregoso Monument: A Study in Sixteenth-Century Tomb Monuments and Catholic Reform," *The Burlington Magazine* 118 (1976): 283–93.

48. Martelli, *Sermone sopra la traslazione del corpo di S. Antonino*, 284.

49. Ibid., 7: "'l Signore in cotali parole riprese i guide, non per fabbricare, ò abbellire i sepolchri de' Profeti, ma per non imitare, anzi con i fatti disonesti contrauenire alle sante, & giuste opera di quelli, a chi si dirizzauano, & ornauano le splture."

50. Ibid., 7, drawing on Exodus 13:19 and Joshua 24:32: "Il gran Mosè gand'amico di dio, hauendo a partirsi dell'Egitto con tutto 'l popolo d'Israelle per gire in Palestina lasciar non volle l'ossa del santo Patriarca Iosepho neglette, anzi molto honoreuolmente seco le portò, & translatò nella terra di promissione; Eccoci l'origine della traslazione de corpi santi, eccoci come l'offizio santo, & pio della Città."

51. Ibid., 8: "Leggasi l'vltimo capitolo dell'Esodo, & vedrassi che venendo Moisè alla fine de suoi giorni, iddio stesso gli fece la sepoltura, & benche ciò si facesse all'hora, perche i guide non sappiendo ritouarne l'ossa, cagione non hauessero d'adorarle; pur si conoscono di sepoltura esser state da dio honorate, & in quell tempo con la Giudea fieramente era inuolta nell'Ethnica Idolatria, a ragione furono dalla bontà di Dio celate: La doue appresso la prigionia Babillonica essendosi meglio rauueduto il popolo, & dal sospetto dell'idolatria lontanato si come Dio permesse molti miracoli farsi alli sepolchri d'Esaia, d'ezecchielle, di Hieremia, d'Eliseo, d'Abida, & d'altri [4. Reg. 3], cosi molto credibile apparisce che 'l sepolcro di Moisè s'è sarebbe senza tal sospizione stato honorato, & di miracoli illustrato se toccando solamente vn morto la sepoltura d'Eliseo, nella subitana resurrezione del morto, si manifesto la Gloria di Dio, come non sono l'ossa de i santi di Dio gregiate, & honorate da Dio?"

52. On the phenomenon, see especially Giovanni Leoncini, "Il culto ai santi fiorentini dopo il concilio di Trento," *Vivens Homo* 7 (1996): 129–50.

53. Martelli, *Sermone sopra la traslazione del corpo di S. Antonino*, 16: "Il medesimo Monastero vide suor chiara di guido Tolosini di modo attratta, & contrafatta, che non forma di donna, ma bozza di sconciatura piu tosto rassembraua, doppo sei, ò sette anni, che la sua bocca non si scostaua molto dale ginocchia, al santo Arciuescouo (gia salito al Cielo) raccomandandosi, & dinanzi vna piccolo immaginetta di lui piu ardentemente dell'vsato in DIO con la mente leuandosi, tutta dentro, & di fuori sentì commuouersi, & l'Arciuescouo santo veder le parue vna mano porle dolcemente al petto, & l'altra alle spalle, & di subito cosi strorta, cominciarsi a distendere, ne in vano le fu la sua visione, perche sana, & dritta immantenente cominciò con marauiglia di tutte le suore a maneggiarsi ne medesimi seruigi, che l'altre sane, & robuste faceuano."

54. Ibid., 3: "Perche Santo Antonino è Beato, & i beati deuono essere inuocati, & supplicati da gl'huomini, si conchiude tutto nella inuocazione, & supplicazione di quanto altri per

se, & tutti per lo commune dobbiamo pregare, & supplicare per mezzo del Santo Auuocato nostro, Dio l'mnipotente."

55. De Luca, "La Cappella Salviati," 117 and n. 32, draws attention to the picture's unusual inclusion of the Virgin, but understands the subject differently.

56. See Amy Neff, "The Pain of *Compassio*: Mary's Labor at the Foot of the Cross," *Art Bulletin* 80 (1998): 254–73.

57. De Luca, "La Cappella Salviati," 121, writes that "Martelli nel suo sermone contro le critiche eretiche nei confronti del culto della Chiesa per le reliquie si appella proprio alle guarigioni miracolose avvenute solo baciando la veste di Cristo, proprio come Francesco Poppi illustra nel suo dipinto." One might read the "adoration" Poppi depicts as an act of kissing, though the painting seems to suggest that it is Christ's words, rather than his garment, that effects the healing.

58. Gori, *Descrizione della cappella di S. Antonino arcivescovo di Firenze dell'ordine de' predicatori* (Florence: Bernardo Paperini, 1728), xxxv: "A gara col Poppi dipinse Batista Naldini l'altra bellissima Tavola, collocate a mano destra entrando, cioè dall parte dell'Epistola; nella quale con vago colorito, con vivacità, ed ottima disposizione delle figure, rappresentò la chiamata di S. MATTEO all'Apostolato, fatta dal REDENTORE, alla quale incontanente obbedì."

59. See, e.g., De Luca, "La Cappella Salviati," passim, and Karwacka Codini and Sbrilli, *Il quaderno della fabbrica*, vi. Gibbons, *Giambologna*, intriguingly compares the arrangement to that of Ammanati's Del Monte chapel in Rome.

60. Gori, *Descrizione della cappella di S. Antonino*, xxvi–xxvii: "Era Egli prima, cioè nel giorno della sua TRASLAZIONE, stato collocate in un'onorevol Deposito di marmo nero Orientale, ornato di sopra della sua vera Effigie giacente, ed al naturale, gettata in bronzo da Fra Domenico Portigiani Converso nel medesimo convento di San Marco, col modello tanto stimato del celebre Giovanni Bologna, mostrato nella Tavola VIII, e posto sotto l'Altare; ma riuscendo questo d'incomodo nell'esporre per qualche urgente bisogno della Città, e dello Stato di Toscana, sì prodigioso PEGNO, fu dipoi riposto in una ricca Cassa più comoda, nella quale onorevolmente finora riposa; ed è quella pur'ora mostrata nella Tavola I. serbandosi presentemente il vecchio descritto Deposito quì delineato, in un decente luogo nella Sagrestia."

61. Fossi, in Ammannati, *La città*, refers to Ammanati's proposed structures as "tempietti." Many, unlike Giambologna's chapel, contain altars along the walls as well as in the center. The format Giambologna introduced, one promoted by Carlo Borromeo for the high altars of churches, was also being newly invigorated in contemporary Roman chapels. See especially Steven Ostrow's discussion of the Sistine Chapel in Santa Maria Maggiore, Rome, in *Art and Spirituality in Counter-Reformation Rome: The Sistine and Pauline Chapels in S. Maria Maggiore* (Cambridge: Cambridge University Press, 1996). Like Giambologna's chapel, the burial chapel for Sixtus V in Santa Maria Maggiore essentially centered on a monumental reliquary; the use of bronze, gold, and precious stones justified by that purpose.

62. Flack, "Giambologna's Cappella di Sant'Antonino," 70, points out that the effigy was *not* based on the actual relics, which were disinterred only in 1589, too late for Giambologna to use as a model.

63. For this mentality, compare the suggestive discussion in Peter Parshall, "*Imago contrafacta*: Images and Facts in the Northern Renaissance," *Art History* 16 (1993): 554–79.

64. See Klaus Krüger, *Das Bild all Schleier des Unsichtbaren: Ästhetische Illusion in der Kunst der frühen Neuzeit in Italien* (Munich: Wilhelm Fink Verlag, 2001), especially 146.

65. Borghini, *Il riposo*, 37–38: "gli statuari dicono che gli Idoli antichi diedero le loro risposte nelle statue, e non nelle pitture; rispondono, che la nobiltà essendo cosa che nasce, e deriua da chiarezza di fatti, e da veri, e virtuosi gesti, & essendo la cosa degli Idoli oscura, fallace, e bugiarda, non può quello che in se stessa non ha per alcuna via porgere altrui; e soggiungono che gli Idoli rispondeuano nelle statue piu che nelle pitture, non perche giudicassero piu nobili le statue; ma per hauere maggior comodità col mezo di quelle di persuadere alle genti la loro falsità, & i loro inganni; laonde si può dire che in questo la scultura sia stata ministra del diauolo, econ questo danno fine alle loro risposte i pittori."

66. Ibid., 39: "percioche hauendo i lor Idoli di bronzo, ò d'altre materie cauati dentro gli accomodauano si fattamente sopra gli altari, che senza poter esser veduti da alcuno per di dietro entrauano in quelli, e dauano le risposte, il che nelle pitture non harebbon potuto fare, laonde quando Lucifero volea rispondere egli istesso n'ol facea se non nelle statue, per mantener la credenza, e la riputatione de suoi bugiardi Sacerdoti."

67. Ambrogio Catarino, *De cultu and adoratione imaginum* (Rome: Antonius Bladus, 1552), 126. See also the discussion in Cole, "Perpetual Exorcism in Sistine Rome," in *The Idol in the Age of Art: Objects, Devotions, and the Early Modern World*, ed. Michael Cole and Rebecca Zorach (Aldershot: Ashgate, 2009), 57–76. Moses himself is present in Allori's painting, and as we have seen, Martelli used his example in the sermon he gave. The nearly contemporary Nicolini Chapel in Santa Croce included large statues of Moses and Aaron, and Giambologna must also have known Danti's *Brazen Serpent* relief.

68. Gori, *Descrizione della cappella di S. Antonino*, xxvii: "ma riuscendo questo d'incomodo nell'esporre per qualche urgente bisogno della Città, e dello Stato di Toscana, sì prodigioso PEGNO, fu dipoi riposto in una ricca Cassa più comoda, nella quale onorevolmente finora riposa; ed è quella pur'ora mostrata nella Tavola I. serbandosi presentemente il vecchio descritto Deposito quì delineato, in un decente luogo nella Sagrestia."

69. The work is undocumented, but Dhanens, *Jean Boulogne*, dates the statue to 1572–73. It was installed in the grotto between 1583 and 1587.

70. The leering satyrs on the grotto fountain especially evoke Pliny's remark, 36.4, that the ancient Venus was "equally admirable from every angle"; the fictive pergola painted on the surrounding walls recall the Cnidian shrine, "entirely open so as to allow the image of the goddess to be viewed from every side." Borghini, *Il riposo*, 263, writes on Praxiteles's Venus and its centering in the temple.

71. Walter Benjamin, "The Work of Art in the Age of Mechanical Reproduction," in *Illuminations*, ed. Hannah Arendt, trans. Harry Zohn (New York: Schocken Books, 1969), 217–51.

72. Compare Shearman, *Only Connect*, 60.

73. Bernard, Commentary on the *Song of Songs* 7.4: "Verecunde tamen non ad ipsum sponsum sermonem dirigit, sed ad alios, tanquam de absente: Osculetur me, inquiens, osculo oris sui. Grandis quippe res petitur, et opus est verecundia comitari precem, commendari

petentem. Itaque per domesticos et intimos, accessus ad intima quaeritur, ambitur ad desideratum. Quinam illi? Credimus angelos sanctos astare orantibus, offerre Deo preces et vota hominum: ubi tamen sine ira et disceptatione levari puras manus perspexerint. Probat hoc angelus ita loquens ad Tobiam: *Quando orabas cum lacrymis, et sepeliebas mortuos, et derelinquebas prandium, et mortuos abscondebas per diem in domo tua, et nocte sepeliebas; ego obtuli orationem tuam Domino.*"

74. The writer is Serafino Razzi, Silvano's younger brother. See *Della Corona angelica, libro primo, in cui si parla della sostanza degli Angeli, assolutamente, e per comparazione à i corpi, al luogo, & al Moto, e si dichiarano quattro quistioni, dell'Angelico San Tommaso di Aquino, fatica di F. Serafino Razzi, Dottore Teologo Domenicano, e professo del Convento di San Marco, di Firenze* (Lucca: Vencentium Busdrag, 1599), 7: "Angelo nome è di officio, e non di natura, e nella lingua nostra è l'istesso che Nunzio, ò vero Ambasciadore, e sono cosi chiamati quei beati spriti, peroche, i più ordini di quelli, sono Nunzij, e messaggieri di Dio Ottimo, e grandissimo, mandati (come dicea San Paolo) per cagione di coloro che la salute conseguiscono eterna."

75. Hans Belting, *Likeness and Presence: A History of the Image before the Era of Art*, trans. Edmund Jephcott (Chicago: University of Chicago Press, 1994), 60.

76. Cf. also Borghini's comments on Dosio's Niccolini Chapel in Santa Croce, *Il riposo*, 602: "in essa con gran disegno saran compartiti dodici pilastri di marmo bianco fra' vani de' quali si vedranno quasi gioie legate in oro, molte pietre fine orientali."

77. Martelli, *Sermone sopra la traslazione del corpo di S. Antonino*, 4, 6.

78. See Alexander Nagel, "Gifts for Michelangelo and Vittoria Colonna," *Art Bulletin* 79 (1997): 647–68, and, more broadly, Alexander Nagel, *Michelangelo and the Reform of Art* (Cambridge: Cambridge University Press, 2000), especially 145–46, 169–79.

79. Robert W. Gaston, "Iconography and Portraiture in Bronzino's *Christ in Limbo.*" *Mitteilungen des Kunsthistorischen Institutes in Florenz* 27 (1983): 41–72, and Massimo Firpo, *Artisti, gioiellieri, eretici: Il mondo di Lorenzo Lotto tra Riforma e Controriforma* (Rome: Laterza, 2001).

80. Silvano Razzi, *Della economica cristiana, e ciuile di don Siluano Razzi i due primi libri: Ne i quali da vna nobile brigata di donne, & huomini si ragiona della cura, e gouerno famigliare: secondo la legge christiana, e vita ciuile* (Florence: Sermartelli, 1568).

81. Martelli, *Sermone sopra la traslazione del corpo di S. Antonino*, 4: "Non si conoscono esser queste remunerazioni à cento volte cento doppi? Et chi non volentieri fatica piccolo momento per hauer posa lunghissimo tratto di tempo? Chi non volentieri spendemenomo danaio per acquistar' ampio Tesoro?"

82. Ibid., 4–5: "l'Agricoltore sparge seminando gran parte della sostanza di sua famigliuola, & chi piu oltre non rimirasse stolto, e forsennato lo giudicarebbe, Aspetta vn poco, & lo vedrai mieter frutto larghissimo: chi non loda follia cosi fatta? il grano si getta, questo è vero; il grano si getta via, & si perde, hor questo nò, aspetta, & vedrai, vedrai che *si granum frumenti cadens in terram mortuum fuerit multum fructum affert.* [Ioa. 12] La semenza sparsa, & marcita rende gran frutto. I santi Martiri di dio, i Confessori del santissimo nome suo, mentre che ne gl'occhi del volgo gettarono via se stessi, & quasi si marcirono in questa vita mortale, abbondantissimo frutto mieterono nella vita immortale. Oh che frutto? Ma per

non dire de gl'altri testè; non veggiamo noi che mentre il nostro Fraticello, il nostro Arci-uescouo, il nostro santo, nel concetto de gl'huomini troppo sensuali, gettaua via la sua vita nelle astinenze, nelle vigilie, nelle macerazioni, & mortificazioni della carne: mentre che egli spendeua le sue sostanze in opera di carità, & di pieta, mentre ch'egli affligeua lo spirito suo in continui studii, componimenti, meditazioni, lezzioni, & predicazioni, egli non si fet-taua via, nò, non si perdeua, nò, ma si seminaua, & prudentissimamente si mortificaua per coglierne frutto, & frutto tale, che voi vedete. Venne pioggia dal cielo della diuina grazia, surse, & raggiò il sole sopra la mortificata semenza, ò sole, ò almo sole, ò Christo Giesu vero nostro sole, tu della carne, tu dello spirito, tu delle facultà del saggio & santo agricoltore Sant'antonino, ne gl'occhi de gl'insensati, gettate via, dissipate, & marcite, spiga ne cau-asti, & à lui coglierla donasti, la piu vaga, & la piu ricca, frutto ne traesti. "

83. Ibid., 6: "L'arca si pregi, & s'honori; ma'l Tesoro che n'vscìo, & pur di rientrarui aspetta, s'honori, & si stimi viè maggiormente."

84. For the Reform context of this sequence of monuments, see Hiesinger, "The Fregoso Monument."

85. Barocchi, *Trattati*, III, 122: "E soggiungerò ancora, con buona grazia vostra, a maggior tes-timonianza di quanto vi ho pur testé detto, quello che m'è occorso in questi ultimi anni di mia vecchiaia. Fummi imposto dall Santità di N. S. Papa Gregorio XIII ch'io dovessi fare una sepoltura tutta di marmi per un suo cugino in Camposanto di Pisa; il quale per essere stato eccellentissimo legista, mi parve di fare una Giustizia; e perché le buone leggi partoriscono la pace, feci anco la statua di lei, e [perché] dove dimora la Giustizia e la Pace v'è nel mezzo il Signore Salvator nostro, però posi nel mezzo la figura di Gesù Cristo che mostra le santissime e salutari sue piaghe."

86. For the Christs of Michelangelo, Cellini, and Bandinelli, see Lavin, "The Sculptor's 'Last Will and Testament.'"

87. Dhanens, *Jean Boulogne*, 204–9, assembles the following list: the crucifix Vasari presented to Pius V in 1572; the silver crucifix that had arrived in Loreto by the spring of 1573; the "crocifisso di metallo con crocie d'ebano" presented to Cardinal Ferdinando de' Medici in 1578; the crucifix given to Ginori, which Dhanens dates to 1579/82; the replica now in Douai of a crucifix that belonged to Bernardo Vecchietti; the bronzes that stood on the altars of the Grimaldi Chapel in Genoa and, ca. 1591, of Santa Maria Nuova; the bronze sent to Wilhelm V, Duke of Bavaria, in 1594; the replicas of this given to the Archbishop of Pisa in March 1597 and installed in the Soccorso Chapel in the Santissima Annunziata in Florence; the gold crucifixes given to Cardinal Salviati, Cardinal Aldobrandini, and Pope Clement VIII in 1595; the diplomatic gifts offered to the King of Spain and the Duke of Mantua; and the three crucifixes owned by Paul van Praun.

88. Karwacka Codini and Sbrilli, *Il quaderno della fabbrica*, 93: "A statue scudi 20 pagati li Salviati per rinettura del crocifisso di bronzo per mettere in sull'altare."

89. Razzi, *Vita, miracoli, e traslazione di S. Antonino*, 39 and 89–90.

90. Stefano Magnanelli, "L'altare di San Donato de Vecchietti: Un'ipotesi di ricostruzione," in De Benedictis, *Altari e committenza*, 136–45, especially 138–40.

91. See Ammannati, *La città*, 198–205.

92. The fundamental discussion of Ammanati's proposal for Santa Maria Maggiore is Klaus Schwager, "Zur Bautätigkeit Sixtus' V. an S. Maria Maggiore in Rom," in *Miscellanea Bibliothecae Hertzianae zu Ehren von Leo Bruhns, Franz Graf, Wolff Metternich, Ludwig Schudt* (Munich: Anton Schroll, 1961), 324–54, especially 335–41. For the broader history of the chapel, see especially Ostrow, *Art and Spirituality*.

93. Ammanati's *Ops* of ca. 1572 for Francesco's *studiolo* and his figures for the Giovanni Buoncampagni monument in Pisa, commissioned in 1574, appear to be the artist's last works in marble or bronze.

94. The essential discussions are Pietro Pirri, "L'architetto Bartolomeo Ammannati e i Gesuiti," *Archivum Historicum S. J.* 12 (1943): 5–57; Mazzino Fossi, *Bartolomeo Ammannati, Architetto* (Florence: Morano, 1968); Fossi, *Bartolomeo Ammannati*, 127–40; and Merlijn Hurx, "Bartolomeo Ammannati's San Giovannino te Florence: Een verbouwingsgeschiedenis in het licht van de religieuze hervormingen in de zestiende eeuw," *Incontri* 20 (2005): 151–71, which gives further references.

95. See, recently, Giovanni Sale, "Il progetto del 'Gesù' di Roma: Breve storia di una difficile collaborazione tra committente e fruitore d'opera," in *Ignazio e l'arte dei Gesuiti*, ed. Giovanni Sale (Milan: Jaca Book, 2003), 47–64, as well as James Ackerman's classic essay "The Gesù in the Light of Contemporary Church Design," in *Baroque Art: The Jesuit Contribution*, ed. Rudolf Wittkower (New York: Fordham University Press, 1972), 15–28.

96. Fossi, *Bartolomeo Ammannati*, 131.

97. Hurx, "Bartolomeo Ammannati's San Giovannino te Florence," 158: "essendo Ms. Bartolomeo Amannati tanto intellibente della sua professione, che perciò anche coteste Altezze nelle loro principali fabriche si sono servite di esso, et essendo tanto amorevole et benefattore del collegio, poiché quasi a sue spese vuol fabricare, et vi si impeiga con tanto fervore ci pare di rimetterci alla sua prudenza, che ben haverà riguardo alle comodità del collegio."

98. Baldinucci, *Notizie*, II, 366: "Determinarono inoltre Bartolommeo e la sua consorte, non solo di far parte in vita di loro facultà a' medesimi padri per aggrandimento di quelle fabbriche, ma vollero ancora con testamento dopo una reciproca vocazione di loro stessi alla propria eredità, fare erede il collegio per lo medesimo fine, il che tutti due effettuarono il dì 25 di marzo 1587, facendo ancora molti caritativi legati." Compare also Cinelli's description, in Bocchi (Cinelli), *Le Bellezze*, 22: "Questa chiesa col disegno e co' danari altresì di Bartolommeo Ammanati raro scultore e architetto, e con assidua industria nobilmente è stata fatta, adorna e condotta a somma bellezza, come si vede."

99. Baldinucci, *Notizie*, II, 366: "Ma giacchè il dar notizia della pia liberalità di questo virtuoso ne ha portato a parlare del collegio della compagnia di Gesù, edificatosi in Firenze fino dai fondamenti ne' tempi dell'Ammannato e della chiesa rifabbricatasi in grande e nobilissima forma, ne' quali edifizi egli, a pubblico benefizio, ebbe tanta parte non solo per lo disegno e contina assistenza di sua persona in tutto 'l tempo che e'visse, ma ancora per le copiose limosine ch'egli somministrò, e per lo ricco patrimonio che tanto esso, che la donna sua gli lasciarono."

100. Zygmunt Waźbiński, *L'Accademia Medicea del Disegno a Firenze nel Cinquecento: Idea e istituzione* (Florence: Olschki, 1987), I, 53–54, and Francesco Vossilla, "Da scalpellino a

cavaliere: L'altare-sepolcro di Baccio Bandinelli all'Annunziata," in De Benedictis, *Altari e committenza*, 68–79.

101. See Vasari's 1570 supplement to his *Life of Sansovino* in *Le vite de' più eccellenti pittori, scultori e architetti,* ed. Paola della Pergola, Luigi Grassi, and Giovanni Previtali (Novara: Edizioni per il Club del Libro, 1965), VII, 409, as well as Boucher, *The Sculpture of Jacopo Sansovino*, 323.

102. Myssok, "Bartolomeo Ammannati," remarks on Ammanati's frequent use of colored marbles, 132, and gives further bibliography.

103. Gibbons, *Giambologna*, 167, transcribes the contract, which permitted Giambologna "cum facultate et potestate quatenus ei videatur dictum Altare et Cappellaniam intus, foris et circum circa, amovendi et in aliam formam etiam ampliorem versus conventum et monasterium dictorum fratrum eius arbitrio reducendi, cum figures eneis, marmoreis et sculptis in forma tamen licita, eamdemque Aram et Cappellaniam circum circa, intus et foris ornandi et decorandi nunc et in futurum et quandocunque edidem domino Ioanni Bononie viedebitur et placebit, eiusdem domini Ioannis Bononie sumptibus et expensis, et etiam apponendi arma et insignia dicti domini Ioannis Bononie, cum inscriptione nominis et aliis licitis et honesties."

104. Discussion in Waźbiński, *L'Accademia Medicea del Disegno*, I, 111–54.

105. See Eugenio M. Casalini, "Due opere del Giambologna all'Annunziata di Firenze," *Studi storici dell'Ordine dei Servi di Maria* 14 (1964): 261–76, and Summers, *The Sculpture of Vincenzo Danti*, 248 and n. 110.

106. For the unveiling, Dhanens, *Jean Boulogne*, 296.

107. For the stuccos, see especially the discussion in Watson, *Pietro Tacca,* 338–52. The crucifix is a replica of one sent to Wilhelm V of Bavaria a few years before; see Avery, *Giambologna: The Complete Sculpture*, 202.

108. Baldinucci, *Notizie*, II, 576.

109. Gibbons, *Giambologna*, 166: "de suis proriis pecuniis decorandi et in alium statum meliorem reducendi et alia in predictis necessaria faciendi prout similis pia actio requirit."

110. Michael Cole, "Cellinis Grabmal—Poetik und Publikum," in Poeschke et al, eds., *Praemium Virtutis*, 175–90.

111. Dhanens, *Jean Boulogne*, 295.

112. Baldinucci, *Notizie*, II, 575.

113. On the history of the painting, see especially Eugenio Casalini, "La miracolosissima Vergine del Soccorso," in *Nuove Prospettive della Mariologia: L'immagine' della Madre di Dio*, ed. L. Crociani, o.s.m. (Florence: SS. Annunziata, 1993), 209–12.

114. Baldinucci, *Notizie*, II, 575.

115. Casalini, "La miracolosissima Vergine del Soccorso," 211. Even before Giambologna reframed it, its setting signaled the benefits the image distributed: it had its own tabernacle, a complex framework that seems to have involved some kind of lockable door.

116. Ibid., 212: "dipoi si pose nella detta Cappella con grande allegrezza di suoni, lumi, canti, con fausto et contento grande della città tutta, et di un popolo infinito che era venuto alla detta pricisione, ricevendosi giornalmente gratie infinite dalla detta Vergine Santissima."

117. This, like the reliefs showing Christ's Passion, reproduced an earlier work. See the discussion in Dhanens, *Jean Boulogne*.

118. The contract published by Gibbons, *Giambologna*, 166, specifies that Giambologna had been conceded the "Altare seu Aram sub tituolo et imagine sacratissime Virginis Marie Succursus."

119. The poems are published in Adolfo Mabellini, *Delle rime di Benvenuto Cellini* (Turin: G. B. Paravia e comp, 1885), 326–27. Here I take up the argument I first made in a short conference paper some years ago, that although the secondary literature sometimes gives the impression that Cellini's *Crucifix* was a private work, made solely out of devotion, it in fact had a public, as evidenced by the poems his contemporaries wrote about it. My earlier paper ("Cellinis Grabmal—Poetik und Publikum") focused on new archival discoveries, though Charles Davis aptly notes Danti's well-known sonnets to Cellini as another example of this response. Here as elsewhere, Davis provides the most complete bibliography on Danti, though his characterization earlier scholars' contributions to the topic is unreliable. The only substantial discussion of Danti as a poet is Summers, *The Sculpture of Vincenzo Danti*, 501–12.

120. Fortuna wrote to the Duke of Urbino on 9 April 1583, pursuing his request for "un Crocifisso grande di marmo senza la croce d'intorno à due palmi d'un sol pezzo." See Dhanens, *Jean Boulogne*, 351–52: "Parlai poi lungamente à Gio. Bologna, il quale mi mostrò per le opere che ha alle mani, che non può almeno per un anno accettar' opera alcuna essendo necessitato di finir quelle che ha fra mano del *Gran duca*, *Gran Duchessa*, *Cardinale* di Medici e una venere del naturale del Signor Gio Giorgio *Cesarini* per ordine di S. A. et altre che fà di *nascosto*, ma se fosse anche disoccupatissimo, dice alla libera che à lui non darebbe lo animo far di marmo opera si piccola massimo d'un pezzo, nella quale gli andarebbe tempo lunghissimo. D'argento, di bronzo o di rame egli ne ha ben fatti fin à quattro, uno per il Re di *Spagna* come scrissi, uno per *Pio V*, il terzo per il *Gran Duca*, il quarto per la *Gran Duchessa*, che andò à Loreto, de i quali ho pur adesso veduto i modelli et sono pocò meno grandi di due palmi ragionati un per l'altro, tenuti stupendi. Se di tal metalli ella ne volesse uno, egli non ostante le tante occupationi vederebbe di farlo segretamente et penserebbe di sodisfarla, mostrando gran desiderio di servirla et io lo credo, perchè non si lascia uscir nessuna cosa di mano, se non è tirata et condotta con grandissima diligenza, aspirando alla gloria, et che le opere sue pareggino quelle di Michel Agnolo. Dice bene che accettarebbe di farne uno grande del naturale di marmo, come fù quello di Benvenuto che 'l mandò medesimamente al Re di Spagna."

121. See Jack Freiberg, "In the Sign of the Cross: The Image of Constantine in the Art of Counter-Reformation Rome," in *Piero della Francesca and His Legacy*, ed. Marilyn Aronberg Lavin (Hanover, NH: University Press of New England, 1995), 67–87, and Cole, "Perpetual Exorcism."

CHAPTER 7

1. For a fuller version of the reading rehearsed here, see Cole, "Perpetual Exorcism," with further references.

2. Suzanne Butters, "Magnifico, non senza eccesso: Riflessioni sul mecenatismo del cardinale Ferdinando de' Medici," in *Villa Medici: Il sogno di un cardinale*, ed. Michel Hochmann (Rome: De Luca, 1999), 22–45 at 35, and idem, "Ferdinando de' Medici and the Art of the Possible," in *The Medici, Michelangelo, and the Art of Late Renaissance Florence* (New Haven, CT: Yale University Press, 2002), 66–75 at 71.

3. The model for the rider was ready by 1592 and cast in early 1593, with extensive help from Domenico Portigiani. Zanobi Piccardi completed the sockel in January of the same year. The cast bronzes were weighed on 6 May 1594, brought to the piazza the following day, and set up by the 14th. The reliefs were cast between 1596 and March 1598; Domenico Portigiani was paid for casting the bronze inscriptions for the base on 25 April 1599. The best study of Giambologna's two equestrian monuments in Florence is Dietrich Erben, "Die Reiterdenkmäler der Medici in Florenz und ihre politische Bedeutung," *Mitteilungen des Kunsthistorischen Institutes in Florenz* 40 (1996 [1997]): 287–361, which adds to the documentation published by Dhanens, *Jean Boulogne*. On the *Ferdinando*, see also Katherine Watson, *Pietro Tacca*, 160–86 and Jessica Mack Andrick, *Pietro Tacca: Hofbilhauer der Medici (1577–1640): Politische Funktion und Ikonographie des frühabsolutistischen Herrscherdenkmals unter den Grossherzögen Ferdinando I., Cosimo II. und Ferdinando II.* (Weimar: Verlag und Daten bank für Geisteswissenschaften, 2005), 23–43, with further references.

4. The engineering feat involved comes out in a 1604 letter from Duke Ferdinando to the Spanish ambassador in Valladolid, reporting on Giambologna's later, similar equestrian monument for Philip III of Spain: "The thought Your Lordship has put in our heads of having Giambologna make a bronze horse for His Majesty has pleased us a great deal, and we would like for Your Lordship to try to find out more about His Majesty's tastes, regarding the size and the design of the horse and of the statue, for if his thought were to have one the size of ours, we would hope that it could be made inside of two years, and even transported to Alicante, but then one would have to consider the difficulty of getting such a huge machine into the ground, such that it may be necessary to make the statue in more than one piece." See See Mediceo del Principato 4936, fols. 374–75, Archivio di Stato, Florence; the letter was discovered by Edward Goldberg, who partially published it in "Artistic Relations between the Medici and the Spanish Courts, 1587–1621: Part II," *The Burlington Magazine* 138 (1996): 529–40, at 533, n. 26.

5. Already in 1582, when Simone Fortuna wrote of Giambologna's visions for an equestrian monument, he remarked that the sculptor was designing a work that would be "twice as large as the one in the Campidoglio." As it happens, it was in the Campidoglio that Ammanati had worked before moving from Rome to Florence in 1550. See Borghini, *Il riposo*, 591, and Kiene, *Bartolomeo Ammannati*, 12.

6. These were the points of view that had helped determine the form of the piazza in the first place. See Marvin Trachtenberg, *Dominion of the Eye: Urbanism, Art, and Power in Early Modern Florence* (Cambridge: Cambridge University Press, 1997).

7. Bush, *Colossal Sculpture*, 148.

8. Compare Campbell, "Observations on Ammannati's Neptune Fountain," n. 127: "The wording suggest that he is carving into the block with caution and reservations."

9. The same creatures appear in a second drawing in a private collection; see the illustration in Poeschke, *Michelangelo and His World*, 204. For the carving of the hippocamps, see Campbell, "Observations on Ammannati's Neptune Fountain," 114.

10. Catherine Monbeig-Goguel, *Inventaire general des dessins italiens I: Maîtres toscans nés après 1500, morts avant 1600: Vasari et son temps* (Paris: Éditions des Musées Nationaux, 1972), 30–32, who has to date offered the fullest discussion of the drawing, misreads the key phrases "a 6 faccie" and "a 8 faccie," rendering both as "a b faccie."

11. Galeotti cast the medal well after the installation of the marble, which has a substantially different pose, though Campbell has remarked that the image there may be "fantastic" or "may reflect a stage of the project prior to the 1565 temporary installation, perhaps even a pre-1560 stage in the design." See Campbell, "Observations on Ammannati's Neptune Fountain," 116–17. Supporting this conclusion is the fact that "the arcaded aqueduct on the medal recalls those of ancient Rome"; the designer knew that the fountain required water, and that this would be a major accomplishment, but he did not know—as he certainly would by 1565, if not earlier—that the conduits would be underground.

12. See the discussion in Fossi, *Bartolomeo Ammannati*, 81–87, and Kiene, *Bartolomeo Ammannati*, 113–16.

13. The importance of the corner in competitive urbanism is a theme in Joseph Connors's important "Alliance and Enmity in Roman Baroque Urbanism," *Römisches Jahrbuch der Bibliotheca Hertziana* 25 (1989): 207–94.

14. Hurx, "Bartolomeo Ammannati's San Giovannino te Florence," 155.

15. Ibid., 163, compares the facade of San Giovannino to that of the Gesù, though this speaks less to Ammanati's role. As Fossi, *Bartolomeo Ammannati*, demonstrated, 131–33, the facade went up only in the seventeenth century, and Alfonso Parigi used Ammanati's original design only for the lower half.

16. Erben, "Die Reiterdenkmäler der Medici," 359, quoting Settimanni VI, fol. 586, 4 October 1608: "fù eretta su la nostra Piazza la statua del Ser.mo e glorioso Principe Don Ferdinando Medici Gran Duca di Toscana etc. opera dell'ecc.mo scultore Gio. bologna di b.m. mentre si fabbricava la Base di detta statue bisbigliavano i popoli malagevolmente sopportando che il sodd.o Gio. Bologna havessi persuaso S. A. S.ma à fare elettioni di simil luogo per d.'a statua, ma poi che fù vista, e, la Base e la statua accomodata nel proprio luogo, si cangiorno le mormorazioni in benedizioni, affermandosi da molti che il luogo per d.a statua riusciva proporzionata, e che apportava ornamento e bellezza à si bel Teatro, qual è la piazza della Sant.ma Nunziata." For the chronology of the sculpture and its installation, see especially ibid., 335.

17. See the documents in Gaye, *Carteggio*, III, 460–61, and the discussion in Alessandro Cecchi, "Documenti inediti sul San Luca del Giambologna," in Eiche, ed., *Giambologna tra Firenze e l'Europa*, 29–45, esp. 29–31.

18. See Dhanens, *Jean Boulogne*, 279: "Het is een gemeenplaats het RUITERSTANDBEELD te beschouwen als een repliek van de Marcus Aurelius te Rome."

19. For the dating, see Stefano Renzoni's discussion in *Livorno e Pisa: Due città e un territorio nella politica dei Medici* (Pisa: Nistri-Lischi and Pacini, 1980), 367–69, as well as Stefano

Sodi and Stefano Renzoni, *La chiesa di S. Stefano e la piazza dei Cavalieri* (Pisa: Edizioni ETS, 2003).

20. In addition to the specific references below, see the overview in Ewa Karwacka Codini, "La piazza dei Cavalieri," *Architetture pisane* 2 (2004): 6–27.

21. Karwacka Codini in *Livorno e Pisa*, 237, with further references.

22. Demolitions on this building had begun in 1563. The new church was underway in 1565; the roof was added in 1567. Giovanni de' Medici's design for the facade dates to 1594; work was completed in 1606. See ibid., 234–35.

23. Ibid., 238. The building was begun in 1566; the facade was added in 1592–94.

24. Ibid., 240.

25. Ibid., 229–33. The makeover of the old facade had begun as early as 1562, when the stone shields of the captains and commissars of the Pisan Republic were removed. Most of the modifications were complete two years later, and a ca. 1564 drawing shows the palace with the new staircase in place. The *sgraffito* was added in 1564–66.

26. Ibid., 223: "Intento politico convertire il passato nel presente, si manifesteva nella volontà di Cosimo I di abbattere le memorie di libertà e di potenza dell'antica Repubblica Pisana e di imporre una nuova immagine urbana alla piazza come fatto celebrativo ed artistico nello stesso tempo."

27. Renzoni in *Livorno e Pisa*, 371–73.

28. On the sequence of monuments, see John Pope-Hennessy, "Giovanni Bologna and the Marble Statues of the Grand-Duke Ferdinand I," *The Burlington Magazine* 112 (1970): 304–7, and Watson, *Pietro Tacca*; on the context in which the dukes commissioned them, Katherine Poole, "The Art of Conquest: Medici Patronage in Pisa and Siena, 1537–1609," unpublished doctoral dissertation, Rutgers University, 2007.

29. See Guglielmo Enrico Saltini, "Della morte di Francesco I de' Medici e di Bianca Cappello," *Archivio storico italiano* 18 (1863): 19–81, document 16, republished in Erben, "Die Reiterdenkmäler der Medici 1997," 355: "Giambologna da Dovaia, che li spiegò l'intenso suo desiderio havuto sempre di voler fare un cavallo di getto, maggiore per ogni verso un terzo di braccio di quel di Roma, da collocarsi sulla piazza della Dogana dirimpetto alla fronte; domandò quanto voleva per principarlo, ed egli rispose con cuore pusillanimo e timoroso bastargli scudi solo 600." Erben presents the letter as "news about the assigning of the commission," though it presents the project not as a commission, but as an initiative on the artist's part.

30. Dhanens, *Jean Boulogne*, 337. For Danti's statue, see Davis, "Disegno," especially 238–40. The monument stood in the Piazza San Firenze, a block away from where Giambologna would install his own *Cosimo*.

31. For Tadda's role, see the extensive discussion in Butters, *The Triumph of Vulcan*.

32. *Firenze e provincia*, ed. Gianni Bagioli and Anna Ferrari-Bravo (Milan: Touring Club Italiano, 1997), 248–49: "donato nel 1560 da Pio IV a Cosimo I, che volle erigerla in ricordo della vittoria di Marciano contro i senesi, nel luogo in cui ne aveva avuto la notizia." See also the comments in Virginia Bush's classic 1976 study of sixteenth-century colossal sculpture, 276.

33. This was a rather new way to think about the positioning of monuments in Florence. Donatello's *Dovizia*, by contrast, was close to the point marking the crossing of the *cardo* and *decumanus* of the ancient city, but also far enough away from that crossing that it could not easily be seen from either street.

34. Davide Gasparotto, *Giambologna* (Roma: Gruppo Editoriale L'Espresso, 2005), 196: "Abandonando per una volta il principio della 'multivisionalità, Giambologna sembra suggerire qui un punto di vista privelegiato, probabilmente determinato dalla collocazione che il gruppo avrebbe avuto sul cosiddetto Canto dei Carnesecchi."

35. Bocchi (Cinelli), *Le Bellezze*, 211: "Fu questa statua auuta sommamente in pregio dalla felice memoria di Cosimo II, a segno che molte volte passeggiava con la carrozza intorno di essa per goder di sua bellezza."

36. See the discussion in Detlef Heikamp, "Die Säulenmonumente Cosimo I," in *Boboli 90: Atti del Convegno internazionale di studi per la salvaguardia e la valorizzazione del giardino*, ed. Cristina Acidini Luchinat (Florence: Edifir, 1991), 3–17.

37. On the long history of this project, see most recently Litta Maria Medri, *La Dovizia di Boboli: Maria de' Medici nel Giardino di Boboli; quattro soggetti e tre scultori per una statua* (Livorno: Sillabe, 2005), with further references.

38. Heikamp, "Die Säulenmonumente Cosimo I," 3: "Cosimo hatte geplant, die drei Säulen möglichst weitläufig über das gesamte Stadtbild zu verteilen."

39. See Dale Kent, *Neighbours and Neighbourhood in Renaissance Florence: The District of the Red Lion in the Fifteenth Century* (Locust Valley, NY: J. J. Augustin, 1982) and Nicholas A. Eckstein, *The District of the Green Dragon: Neighbourhood Life and Social Change in Renaissance Florence* (Florence: Olschki, 1995).

40. Lapini, *Diario fiorentino*, 112–13: "A' dí 2 di agosto 1554, in giovedi a ore 22 et 1/2, vennono et arrivorno, qui in Firenze, tre poste l'una dopo l'altra, con ghirlande in testa, e ciocche d'ulivo in mano, che arrecavano al duca Cosimo, duca 2.o di Firenze, la felicissima nuova della rotta grande di tutto il campo di Piero Strozzi. E questa gran rotta fu presso a Marciano, in un luogo et in un campo che si chiamava Scannagalli; che fu verificato in tutto il nome, perché vi furono morti di molti Galli, cioè Franzesi. La qual buonissima nuova di subito che detto duca Cosimo ebbe auto, se n'andò alla Nunziata e nella cappella proprio di detta Nunziata, con grandissima devozione si pose in ginocchioni, e li stette vicino a mezz'ora; et in quel mezzo, li frati di detta chiesa cantorno il *Te Deum laudamus*. Et alli 3 detto nel duomo si cantò una Messa dello Spirito Santo, presente detto Duca con tutti i magistrati; et a ore 20 di detto vennono nuove qui in Firenze come li Lucignanesi si erono arresi. E la detta buona nuova il Duca ebbe a dove fe' rizzare la colonna di S. Trinita, per eterna memoria.

 A' dí 4 di detto agosto arrivorno qui in Firenze 50 insegne, che furno portate al duca Cosimo, di quelle dell'esercito del signor Piero Strozzi rotto e sconfitto; che subito il Duca le fe' mettere alle finestre del suo palazzo in piazza, sopra alla ringhiera, volte colla punta allo ingiú, e parte dalla banda di verso la dogana, con parecchi stendarti di cavalli."

41. A similar point could be made about an undated, anonymous *memoria* published by Butters, *Triumph of Vulcan*, 421: "Il luogo ove fu collocata la detta colonna fu appunto dove il

Duca Cosimo ricevè la nuova della vittoria contro l'armi francesi e Piero Strozzi nelo stato di Siena."

42. For the Strozzi in the sixteenth century, see Melissa Meriam Bullard, *Filippo Strozzi and the Medici: Favor and Finance in Sixteenth-Century Florence and Rome* (Cambridge: Cambridge University Press, 1980); Ann Crabb, *The Strozzi of Florence: Widowhood and Family Solidarity in the Renaissance* (Ann Arbor: University of Michigan Press, 2000); and Lorenzo Fabbri, "The Memory of Exiled Families: The Case of the Strozzi," in *Art, Memory, and Family in Renaissance Florence*, ed. Giovanni Ciappelli (Cambridge: Cambridge University Press, 2000), 253–61, with further references to earlier literature. For sixteenth-century conflicts with the Medici, a key source is Benedetto Varchi, *Istoria delle guerre della republica fiorentina, successe nel tempo, che la casa de Medici s'impadronì del governo* (Leiden: Pietro van der Aa, 1723).

43. Leonardo Ginori Lisci, *I palazzi di Firenze nella storia e nell'arte* (Florence: Giunti Barbèra, 1972), I, 265.

44. See Beatrice Paolozzi Strozzi, "'La nostra casa grande': Il palazzo e gli Strozzi, appunti di storia dal Quattro al Novecento," in *Palazzo Strozzi: Cinque secoli di arte e cultura*, ed. Giorgio Bonsanti (Florence: Nardini, 2005), 52–109, especially 74.

45. Ginori Lisci, *I palazzi di Firenze*, I, 223–31.

46. On the bust, see Lapini, *Diario fiorentino*, 188; Gramberg, *Giovanni Bologna*, 62; Dhanens, *Jean Boulogne*, 230, who additionally cites the relevant passages in the *Memorie fiorentine* of Francesco Settimanni. The current facade, by one of Giambologna's students, dates to the seventeenth century, and there's no visual record of what it looked like earlier; still, documents tell us that the 1575 redecoration included the bust we see along with a series of now lost paintings of *uomini famosi* (famous men). The one thing that seems safe to infer is that the bust would have been exactly where we see it now, over the door.

47. For the palace, Ginori Lisci, *I palazzi di Firenze*, II, 26–28. The bust, still in situ, is clearly visible on the right side of the Zocchi etching.

48. Erben, "Die Reiterdenkmäler der Medici 1997," 296, draws attention to the decoration on the armor, but does not connect it to Giambologna's marble.

49. Dhanens, *Jean Boulogne*, 360: "Non apparisce che messer Giovanni Bologna faccia di sua mano le storie, ma si potrà credere che la maggior parte o forse tutte sieno come fatte a lui perchè oltre al dovere esser ridotte a sua satisfattione, non potrà contenersi di non ci dare opera, perchè intervengano dua sua allievi; e quando si trovassi altra strada per farne fare a lui non le farebbe, perchè e tropo fisso a l'opera di un centauro."

50. Ibid., 361: "Giovanni Bologna persiste nel suo proposito di non volere mettere mano nele cose di altri, massime non havendo altro ne l'animo che il centauro, di sorte cha l'altre cose vi hanno poco luogo."

51. Ibid., 361: "Havendo M. Gio. Bologna condotto il centauro molto innanzi se n'andò alla villa circa un mese fa per essere libero in finire una storia che restava per la basa del cavallo di modo che il centauro e detta storia havendo hauto quasi speditione daranno luogo a l'apostolo di sorte che a l'arrivo del marmo potrà M. Gio. applicarvisi con tutto lo studio e con tutta la persona. E certo che questa istoria et centauro gl'avevanno troppo ingombrato

l'animo et la mento. E quando li temporali fussino stati asciutti credo che M. Gio. Bologna harebbe poco atteso a l'Apostolo o forse punto per levarsi dinanzi le due cose che lo stimolavano fortemente, cioè la storia per termine di vergogna poichè per mancamento di qualla la basa se ne stava vedova senza l'altre dua storia, et il centauro per esserne troppo innamorato et infervorato."

52. For the connection between the *Luke* and the *Matthew*, see Herbert Keutner, *Il San Matteo nel duomo di Orvieto: Il modello e l'opera eseguita* (Orvieto: Orfanelli, 1956), and Cecchi, "Documenti inediti sul San Luca del Giambologna, 29–31.

53. Dhanens, *Jean Boulogne*, 363: "Intanto il Centauro si è molto innanzi senza che M. Giov. Bologna habbia havuto altro inanzi alli ochi."

54. Gibbons, *Giambologna,* proposed the convincing comparison, 131–32.

55. I refer to the famous woodcuts of the tragic, comic, and rustic stages in Serlio's second book. See Barnard Hewitt, *The Renaissance Stage: Documents of Serlio, Sabbattini, and Furttenbach,* translated by Allardyce Nicoll (Coral Gables, FL: University of Miami Press, 1958).

56. Borghini, *Il riposo*, 515: "Conciosiache Michelagnolo non attendesse al bel colorito, ne à certe vaghezze di paesi, e di prospettiue, e di adornamenti come fanno gli altri pittori."

57. For the Cinquecento interest in sculptures with multiple points of view, see Lars Olof Larsson, *Von allen Seiten gleich schön: Studien zum Begriff der Vielansichtigkeit in der europäischen Plastik von der Renaissance bis zum Klassizismus* (Stockholm: Almqvist and Wiksell International, 1974); Avery, *Giambologna: The Complete Sculpture*, especially 237; Gibbons, *Giambologna*, 106–45; Schröder, "Versteinernder Blick," 184–85; and Timothy Wutrich, "Narrative and Allegory in Giambologna's *Rape of a Sabine*," *Word and Image* 20 (2004): 308–22.

58. See Trachtenberg, *Dominion of the Eye.*

59. Summers, *The Sculpture of Vincenzo Danti*, 406.

60. Certainly it indicated Giambologna's own privilege and protection under the cardinal-cum-duke, whose letters to the sculptor show what comes across as real affection. See Ferdinando's letter of 26 February 1600 in Dhanens, *Jean Boulogne*, 368: "We hope that, in your desire to work, you remember to look after your health, for that matters above all else, and may the Lord God bring you prosperity and happiness."

61. See Charles Seymour, *Michelangelo's David: A Search for Identity* (Pittsburgh: University of Pittsburgh Press, 1967), 56.

Conclusion

1. Dhanens, *Jean Boulogne*, 16: *"Che di deve ritrarre dal naturale e non imitare la maniera d'alcuno* is als een cristalisatie van J. Boulogne's kunstwil, zoals hij reeds sinds een kwart eeuw tot uiting was gekomen." Also ibid., 319: "Realist, dat is jij uiteraard, dat is het 'genotype' in hem, dat hem aangeboren is en dat levenslang tot uiting komt; doch niet stteds even sterk."

2. Avery, *Giambologna: The Complete Sculpture*, 234.

3. Charles Avery, Anthony Radcliffe, and Manfred Leithe-Jasper, eds., *Giambologna 1529–1608: Ein Wendepunkt der europäischen Plastik* (Vienna: Kunsthistorisches Museum, 1978).

4. Beatrice Paolozzi Strozzi, "Havendo messo il mio studio più nel fare che nel dire . . ." in Paolozzi Strozzi and Zikos, eds., *Giambologna*, 11–12, at 11.

5. See T. J. Clark, *The Painting of Modern Life Paris in the Art of Manet and His Followers* (New York: Knopf, 1985).

ACKNOWLEDGMENTS

This book would not have taken the form it did, and might not have existed at all, had I not benefited from the generosity and intelligence of many dear colleagues and from the support of several wonderful institutions. My first attempts to write on Giambologna and Danti came in an article about the use of wax and clay models ("The *Figura Sforzata*: Modeling, Power, and the Mannerist Body," *Art History* 24 [2001]: 520–51). While working on that, I had regular conversations with Mary Pardo in Chapel Hill, and the paper that became the article was also the first I ever presented at the quadrennial "Provo-Athens" conference, through which I have met many of the Renaissance sculpture specialists I most admire. The discussion of Giambologna's Medici *Mercury* in chapter 3 picks up from a paper that Henry Millon and Therese O'Malley kindly invited me to deliver at a 1999 Center for Advanced Study in the Visual Arts symposium on "Large Bronzes of the Renaissance." Frank Fehrenbach read an early draft of that paper and offered immensely helpful suggestions, and Peta Motture's editorial comments significantly improved the version that appeared in the 2002 acts of the symposium. I've recast elements of my original argument here in response to the skeptical responses that that publication provoked in some quarters. In 2001/2002, while I was at the American Academy in Rome with funding from the Getty Foundation, Patricia Rubin asked me to participate in a lecture series she had organized at the Courtauld Institute on the naming of Renaissance artworks; I ended up speaking on Giambologna's *Sabine*. The discussion in London that spring provided a major primary impetus for my thinking on Giambologna's abstraction, and Prof. Rubin's comments on two subsequent drafts of the paper sharpened my thinking on the artist in general. I presented a slightly different version of the essay, on Evelyn's Lincoln invitation, at Brown University in 2004; it finally appeared as "Giambologna and the Sculpture with No Name" (*Oxford Art Journal* 32 (2009): 337–60). I use many of the sources from that article in chapter 3 of this book, though readers will find that the key points in the chapter are somewhat different.

I became interested in sixteenth- and seventeenth-century representations of movement while researching the paper I wrote for a conference honoring Joachim Poeschke at the University of Münster in 2004, but also delivered at the 2004 "Provo-Athens" conference and at a colloquium in my home department at the University of Pennsylvania. The realization that I should shift the emphasis from movement to stillness, however, developed through a series of conversations I had with Tom Gunning and Davide Stimili at a pair of workshops organized by the Clark Art Institute and the Getty Foundation in 2004/2005. I rewrote the paper I delivered at the Getty for a second pair of workshops organized by Alina Payne at the Kunsthistorisches Institut in Florence and the Radcliffe Institute for Advanced Study in 2007/2008. Karen Beckman kindly read a draft of that essay and steered me from some of the more naive things I had to say about photography (which played a larger role in the essay than they do in this book). It was through the Radcliffe event that I met Sachiko Kusukawa, with whom I had a very helpful conversation about Renaissance taxidermy.

I delivered an abridged version of the "sculpture as architecture" chapter at the University of Pennsylvania's School of Design. David Leatherbarrow's insightful comments on the De Witte portrait in particular led me to rethink my account of that painting. I presented an excerpt from my work on the Salviati Chapel as part of a panel I co-organized with Giorgio Caravale and Maude Vanhaelen for the 2008 Renaissance Society of America Meeting in Chicago and a summary of the chapter as a whole in a series organized by graduate students at Rutgers University. The book's final chapter, on urbanism, was the last one I drafted, and I tested that out on more audiences than most of the others, presenting versions at University College London, Williams College, Princeton University, the University of Pennsylvania, the Kunsthistorisches Institut in Florence, and at Stanford University. I wish to express my thanks to Tamar Garb, E. J. Johnson, Christopher Heuer, Alessandro Nova, and Morten Steen Hansen for the invitations, and to all of those audiences for their comments. I reworked some of what I write in the chapter as it appears here in response to illuminating remarks from Maria Loh and Beatrice Paolozzi Strozzi in particular.

This book required extended periods of research in Europe, and I could never have undertaken it without the leave time provided to me at the University of North Carolina and the University of Pennsylvania. In 2006, at a crucial moment in my reflections on the shape the book should take, I had the good fortune of being able to attend a remarkable semester-long seminar ("Circa 1600") taught by Charles Dempsey, Giovanni Careri, and Michael Fried at Johns Hopkins University. They kindly invited me to present and discuss my project to the group there over the course of an afternoon class; that was the first occasion on which I had to pull together and speak in some detail my thoughts on the project as a whole. The semester was one I will not forget.

I could not have completed the book, and I would not have completed it in the way I did, had it not been for two magical libraries in Florence. The fellowship I held during the 2006/2007 academic year at the Villa I Tatti allowed me to draft a complete manuscript, and conversations with many people there, especially Giorgio Caravale, Ippolita Di Majo, Morten Steen Hansen, Wendy Heller, Nora Stoppino, Giovanni Zanovello, and Maude Vanhaelen, left me better informed on many topics and helped me ask smarter questions. The hospitality

of the Kunsthistorisches Institut during the early summer of 2008, finally, allowed me to finish the book. I owe special thanks to Nicola Suthor and to the Institut's two directors, Alessandro Nova and Gerhard Wolf.

Exchanges with James Ackerman, Claudia Kryza-Gersch, Evelyn Welch, and Patricia Wengraf corrected my understanding of several sites and objects I discuss in the book. Acquiring the photographs for it was expensive and arduous. I owe thanks to the University of Pennsylvania and to Williams College, both of which provided me with subventions; to Isabel Suchanek and Alice Sullivan, who helped me collect the images; and to Michael Slade and Graziano Raveggi, who went out of their way to make the job easier. Finally, I wish to express particular gratitude to Claire Farago, Steven Ostrow, and Madeleine Viljoen, all of whom read the complete manuscript; their criticism and advice made this a better book.

INDEX